HARVARD SQUARE

AN ILLUSTRATED HISTORY SINCE 1950

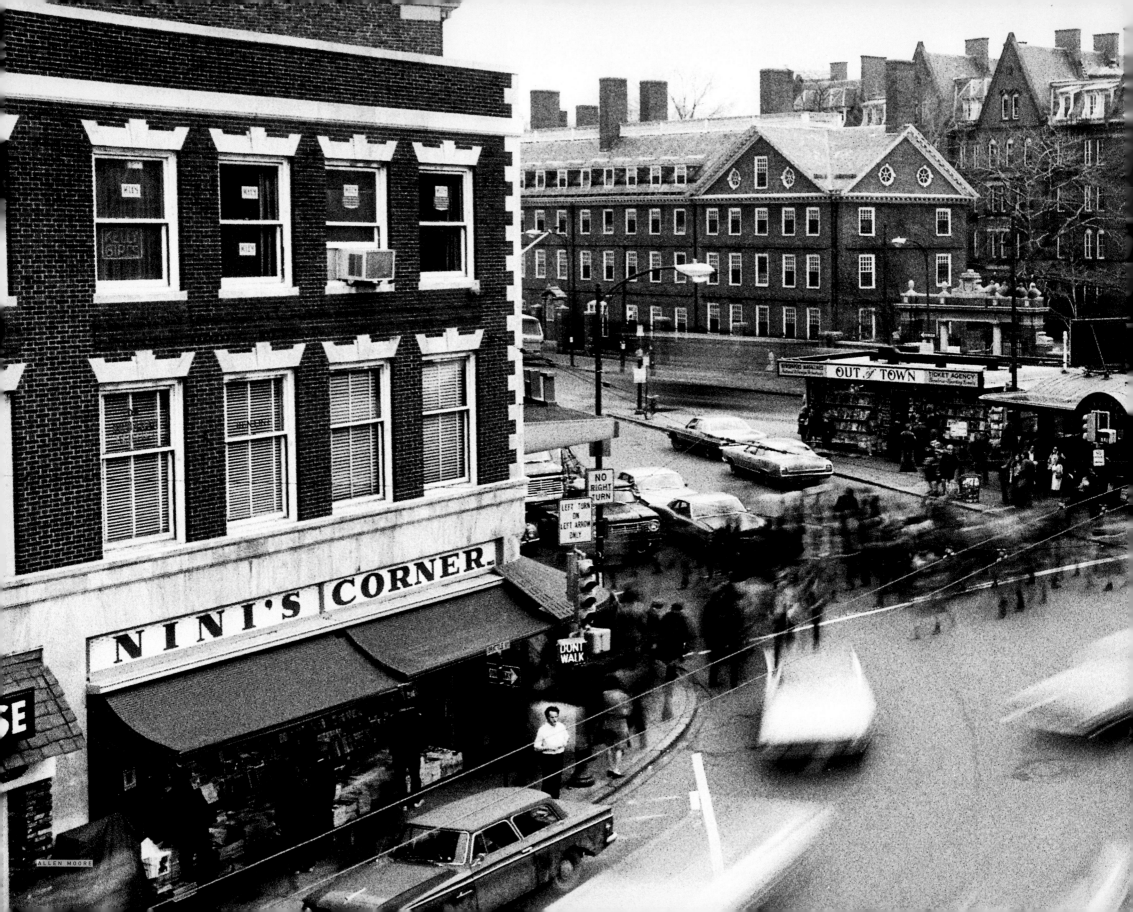

Harvard Square

AN ILLUSTRATED HISTORY SINCE 1950

Mo Lotman

Stewart, Tabori & Chang
New York

Published in 2009 by Stewart, Tabori & Chang
An imprint of Harry N. Abrams, Inc.

Library of Congress Cataloging-in-Publication Data:
Lotman, Mo.
 Harvard Square : an illustrated history since 1950 / Mo Lotman.
 p. cm.
 ISBN 978-1-58479-747-0
 1. Harvard Square (Cambridge, Mass.)—History—20th century.
 2. Harvard Square (Cambridge, Mass.)—Pictorial works.
 3. Cambridge (Mass.)—History—20th century.
 4. Cambridge (Mass.)—Pictorial works. I. Title.
 F74.C1L84 2009
 974.4'4—dc22

 2009005817

Editor: Kristen Latta
Designer: Mo Lotman
Production Manager: Tina Cameron

The text of this book was composed in Chaparral, Myriad, and Goudy Sans.

Printed and bound in China
10 9 8 7 6 5 4 3 2

ABRAMS
THE ART OF BOOKS SINCE 1949

115 West 18th Street
New York, NY 10011
www.abramsbooks.com

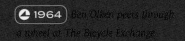 **1964** *Ben Olken peers through a wheel at The Bicycle Exchange.*

HUGH BLACKMER

Table of Contents

HARVARD SQUARE has been my playground,

my workplace, my shopping district, my classroom, and my hangout for about two decades. I always marveled at its vibe and bustle, the sense that I was in a place where really cool—importantly cool—stuff could happen at any given moment. To be here meant more than simply witnessing the street performances, the speed-chess matches, the café poets. It meant that their essence—passion, intellect, creativity, daring—was somehow now a part of me as well.

I've gone dancing at a three-floor Chinese restaurant meat market and had tea in a smoky, pale cellar. I've stood 15 feet from jazz organ legend Jimmy Smith in a packed nightclub and two feet from a man who wheeled a player piano into the middle of the sidewalk. I've watched obscure Kafkaesque stop-frame animation at the Brattle and enjoyed *My Dinner with Andre* with Andre at the Harvard Film Archive. I've ushered at the Hasty Pudding, shopped at Sage's, studied at the CCAE, busked on the street, perused Discount Records, scribbled musings in Algiers, protested in the Pit, and eaten ice cream in a bank vault.

Naturally, I took it completely for granted. Harvard Square existed in its stalwart perfection like the River Ganges, attracting its idiosyncratic pilgrims and flowing endlessly through history, or so I thought.

What happened, of course, is that I eventually became aware of the subtle changes that accumulate imperceptibly into an aggregate of complete transformation. My curiosity piqued, I began to ask questions. What did it used to look like? What did people do here? How has it changed? And how has it remained the same? Surely there must be a book about all of this. The definitive modern history of Harvard Square. Amazingly, there wasn't. Now there is. I hope you enjoy it.

ARLINE LOTMAN

◀ 1983 *The author's very first trip to Harvard Square.*

An aerial overview shows the specific block or blocks covered by the page or spread.

A letter key lists points of interest and matches them to both their location on the aerial overview and subject photographs.

The location shows which street the page or spread relates to.

Ⓐ	The Hong Kong	Ⓖ	One Potato Two Potato
Ⓑ	Bartley's	Ⓗ	Schoenhof's
Ⓒ	Harvard Bk. Str.	Ⓘ	Stonestreets
Ⓓ	Ferranti-Dege	Ⓙ	Pangloss
Ⓔ	Kracker Jacks/ Harvard Bk. Str.	Ⓚ	Bob Slate
Ⓕ	Briggs & Briggs	Ⓛ	Claus Gelotte

lower mass. ave.

BOB SLATE, STATIONER

When

water started leaking through the back wall of his stationery store, threatening the merchandise, with nowhere to go, Bob Slate simply reached down and ripped up the floorboards with his bare hands. As he knew from growing up on a farm and then grinding out a living during the Depression, sometimes you have to do whatever works.

For Slate, starting out in 1930, that included growing his Harvard Square stationery business from inside his cousin's diner on Holyoke Street for three years, even stepping behind the counter to sling hash when necessary. Or sharing his original storefront at 1284 Massachusetts Avenue with a student laundry service and a watchmaker called "Hitchey" who doubled as typewriter repairman and tapped out term papers for a nickel a sheet.

The notoriously frugal and hardworking Slate was popular and visible in the community, serving as president of the Harvard Square Business Association. His industriousness paid off. In 1950, when next-door neighbor Phillips Books moved to a new location, the stationery store moved in, doubling its size. And when LaFrance Stationers bowed out after a 1974 fire at 28–36 Brattle, he opened a second location. That store moved to Church Street in the early '90s, where it

remains, while a third location keeps Porter Square well-stocked with bubble mailers and thank-you notes.

About eighty years and a whole lot of paper clips after he started it, Bob Slate's stationery shop is still only in its second generation of ownership, with Slate's sons Mallory and Justin at the helm. From erasers to Ko-Rec-Type to Wite-Out, and now ink-jet cartridges, Slate's has followed the trajectory of technology and a changing marketplace.

In the old days they would sell typewriters, including the top of the line Hermès, from Switzerland, "with stainless-steel keys and movable ribs on the end of the keys so they didn't lock into each other," said Justin. Since then, they've added art supplies, greeting cards, and gift items. So now you can buy a gilt-edged, pleather-bound personal appointment book and also grab a cheap steno pad.

Some items of yore have even made their way back to the shelves. Sealing wax is no longer a method of keeping correspondence scrolled, but a luxury to evoke the misty passions of another era. Handmade, small-batch letterpress note-cards are printed not because of crude technology but as a revivalist art form. Strolling the aisles of Slate's is not necessary to restock the supply cabinet, but when the place verily buzzes with the romance of the writer's craft, it sure is fun. (12, 132, 133)

Kareem

Abdul-Jabbar was enrolled in summer school at Harvard and came in to look at some bags on the very top shelf at Bob Slate's. The five-foot-tall employee went to get a ladder. Kareem just reached over and pulled them down.

ⓒ c.1970 Ⓐ
Lewandos cleaners had a presence in Harvard Square dating to the 1800s. The Hong Kong, opened in 1954, has since grown to encompass this entire building with nightly entertainment.
(*200, 167)

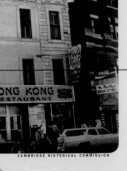

CAMBRIDGE HISTORICAL COMMISSION

ⓒ 1978 Ⓖ
Barrel-top tables, black stools, and cheap, drinks comprised the One Potato Zeitgeist. (128, 132, 133)

HARVARD ARCHIVES

ⓒ 1975 A pedestrian makes the best of heavy snow under a fashionable bubble umbrella.

ⓒ 1978 Ⓒ Ⓓ Ⓔ Harvard Book Store moved to 1284 Mass. Ave. in 1950. In 1971 they added the corner space, which left camera shop Ferranti-Dege sandwiched between the two for about ten years. (167, 202)

HARVARD ARCHIVES

Profiles offer in-depth information about subjects of particular interest.

A bold number following an asterisk means there is a then-and-now comparison photograph, found on the page number indicated.

A caption arrow makes clear which photo it belongs to; each photo is dated.

Pullouts offer funny or interesting anecdotes relating to the main text.

Links show other pages on which you can find images or discussion of this subject.

JOHN UPDIKE

was a Pulitzer Prize–winning author of more than fifty books of fiction, poetry, and literary criticism and a regular contributor to The New Yorker. He graduated from Harvard in 1954.

IN 1950 HARVARD SQUARE

and the nearby business blocks were, to this homesick freshman, a sore—in the dictionary sense of "extreme, very great"—relief from the pressures within the Yard of learning and social adaptation. I would gaze from the windows of the Union toward the gas station pinched in the acute corner of Mass. Avenue and Harvard Street as if at a vanished paradise, where my vanished small-town self would pump free air into his bicycle tires and watch the rickety family car being greasily repaired. On Sunday mornings I would give myself the treat of sleeping through the bells from Memorial Chapel and then walking in the opposite direction from the Union to the drugstore next to the UT; there I would dip into my modest allowance to the extent of a cup of coffee and a cinnamon doughnut at the counter, whose marble top seemed continuous with marble countertops at home. The helpful maps in Mo Lotman's priceless assemblage of photographs tell me that this haven from Latin and calculus was called Daley's Pharmacy. There was an even more intimate escape hatch where Mass. Avenue curved into Boylston Street, just up from the Wursthaus, whose exiguous triangular interior shape accommodated only a few hot-dog addicts at a time; this was, I am reminded, The Tasty sandwich shop. Furtively I sought out places that seemed to me anonymous and exempt from Harvard charm. Later, as I matured enough to join the *Harvard Lampoon* and acquire a Radcliffe girlfriend—feats achieved, I now realize, against considerable odds—she and I nurtured our romance at tables in Albiani's, the Hayes Bickford's, and Cronin's, with always the guilty thrill that I wasn't back in my monk's cell studying the humanities. We huddled in the darkness of the single-screen UT, and descended into the damp chill of the Red Line, whose shrieking cars would take us to Boston. The commercial surround of Harvard Square—the ugliest spot, William Dean Howells called it, on earth—saved me from the academic vapors, as it saves the university from preciosity. For all my four years there, I remained grateful that this colonial and neo-colonial palace of higher learning had pitched itself in a down-to-earth, if not downright grubby, American city.

John Updike

1950 *Pedestrians island-hop across Massachusetts Avenue. The popular cafeteria Albiani's anchors the block.*

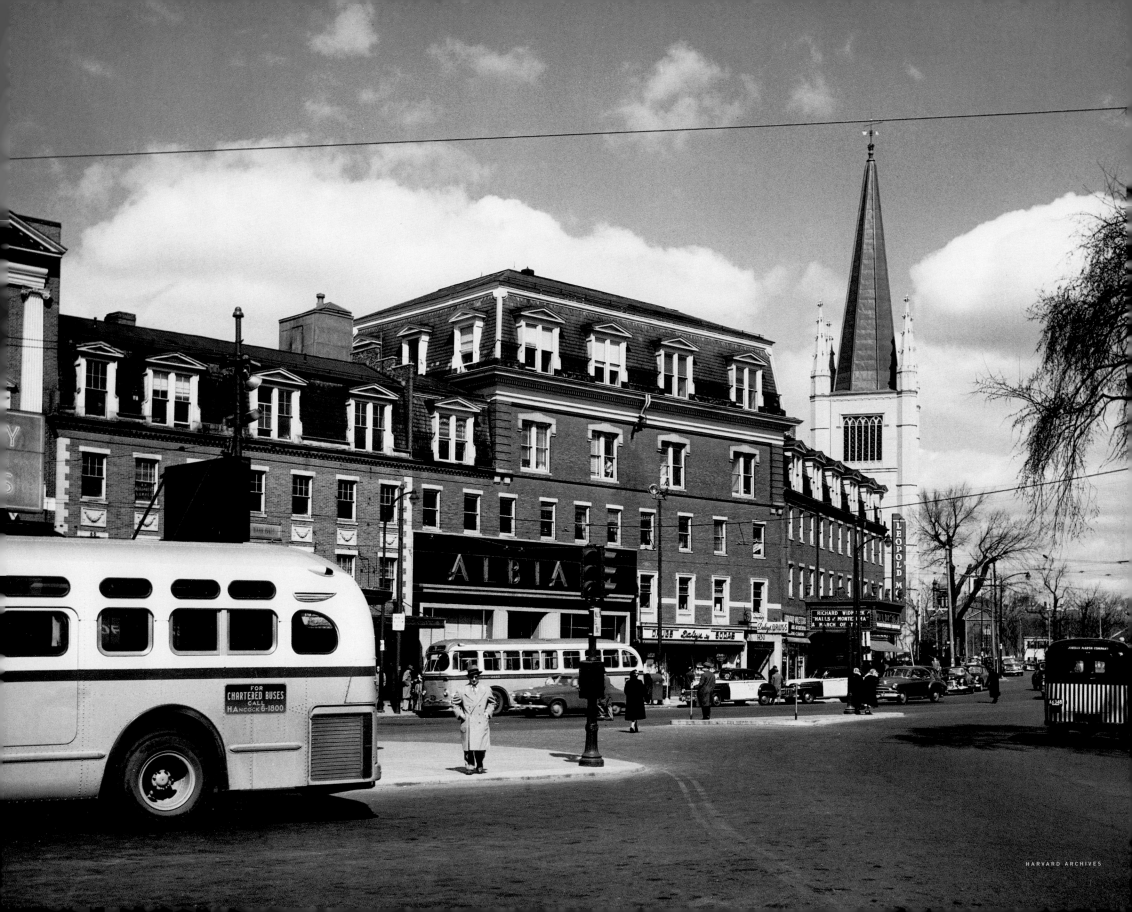

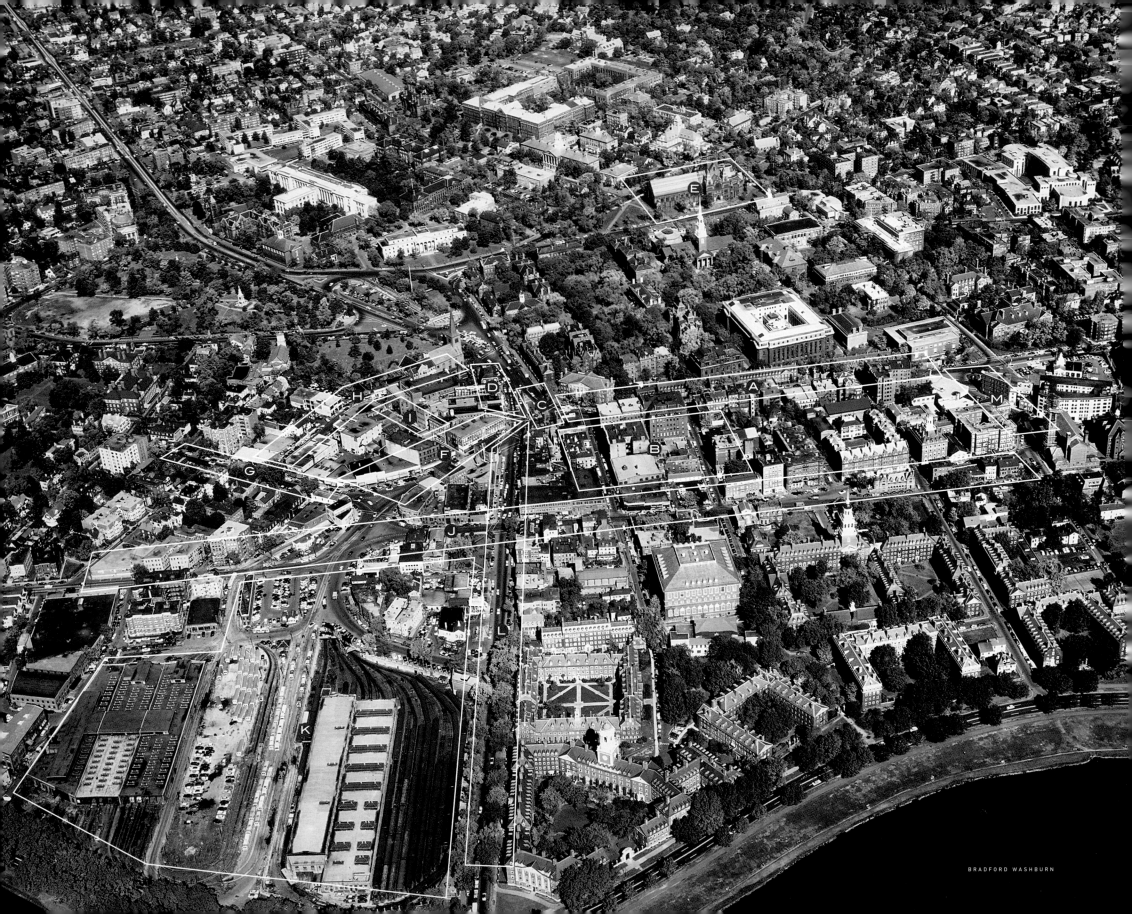

BRADFORD WASHBURN

Ⓐ Lower Mass. Ave.

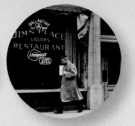

Ⓑ Holyoke & Dunster Sts.

Ⓒ The Center

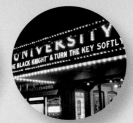

Ⓓ Upper Mass. Ave.

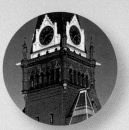

Ⓔ Memorial Hall

Ⓕ Lower Brattle St.

Ⓖ Upper Brattle St.

"IT WAS LIKE A VILLAGE,"

said Herb Hillman, who spent forty years purveying books at Pangloss. Harvard Square in the 1950s was a hometown, a local shopping area where crisscrossing commuters chanced upon friends, family merchants were more neighbor than competitor, and professors rubbed patched elbows with press operators.

The sound of the Square was the screech of the trains echoing around to the Bennett Street rail yards, a vast, sunken expanse of tracks, shacks, and vehicles by Memorial Drive. It was the Harvard band brassing down Boylston Street, enormous bass drum in tow, in the swarm of game days. And it was the loudspeaker of traffic tower maestros, quashing that scourge of the era, jaywalking.

Like many town centers at the time, Harvard Square was filled with ten-cent coffees and a raft of unglamorous but necessary services that keep households running and students groomed. It was a place where a certain dowdy charm was to be found in the patterned Formica of the lunch counters and the geometric slices of sky razored by trolley wires.

But even then, underneath the grime of mass transit, cafeteria grease traps, and barber sweepings, Harvard Square had pocketed certain corners of culture unclaimed by Dubuque or Altoona.

There was a literary spirit which tickled the itinerant reader, whispering from musty stacks of venerable edifices where the Starr, or the Grolier, or the Mandrake was patrolled by tweedy curmudgeons. It called to wordsmiths such as Samuel Beckett, Anne Sexton, and Adrienne Rich as they exposed their young verse to new, hungry ears at the Poets' Theatre, singing distance from Robert Frost's backyard.

Some institutions genetically welded to the identity of the Square calved in the '50s. The Brattle Theatre brought foreign and independent cinema to Cambridge and to America during a golden age of auteurs; Out of Town News pollinated a parochial readership with global images and ideas; a barefoot Joan Baez made Club 47 a national sensation; and Cardullo's unwrapped gourmet foods, presciently recognizing the growth of internationalism that would lead people to and from Cambridge and leave them missing their favorite brand of capers.

The Architects Collaborative (TAC), that seminal collective that Bauhaus proselytizer Walter Gropius founded with his students, would design New York's Pan Am Building from their Brattle Street digs. Meanwhile, TAC protégé Ben Thompson opened a little jewel box down the road called Design Research. With its chic, stylized homewares, fabrics, and furniture, it would slowly usher in a new era of retail the Square had never seen before.

Inklings of a future Cambridge percolated at the margins. There were whispers of Communist sympathizers. Castro, fresh off his revolution and before he had become an enemy of the state, spoke at Dillon Field House in '59 to an enthusiastic crowd of 10,000. A small drug subculture, sometimes coalescing in Albiani's Cafeteria, was developing, if still furtive. And on February 20, 1950, the Cambridge City Council approved a recommendation to extend the subway from its Harvard terminus to Alewife Brook Parkway, which would, three decades later, forever alter the Square.

But ultimately those concerns were mere wisps lost in the daily interchange of a more innocent time, when riots brewed over football rivalries and panty raids instead of wars in Southeast Asia. Charlie Davidson, who created the über-preppie Andover Shop, remembers the village: "It was a wonderful little community at that time."

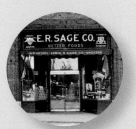

Ⓗ Church St.

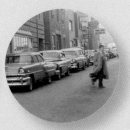

Ⓘ Palmer St.

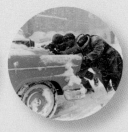

Ⓙ Mount Auburn St.

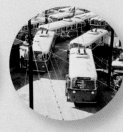

Ⓚ Eliot & Bennett Sts.

Ⓛ Boylston St.

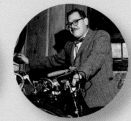

Ⓜ Bow St.

THE 1950s

ADDING MACHINES
1256
Electric and Hand Operated
Remington Rand 10 Key R. C. Allen Full Keyboard
TYPEWRITERS
NEW ENGLAND OFFICE EQUIPMENT COMPANY

ARLINGTON DYE WORKS INC. CLEANERS

ARLINGTON CLEANERS

PLYMPTON ST.

WAY

BRIGGS BRIGGS
PIANOS RECORDS
RADIO

Bob-Slye
STATION
LAUND

GELOTTE CAMERAS
CAMERA EXCHANGE

Liggett Rexall
DRUGS

BARBER SHOP

39492

1 2 260

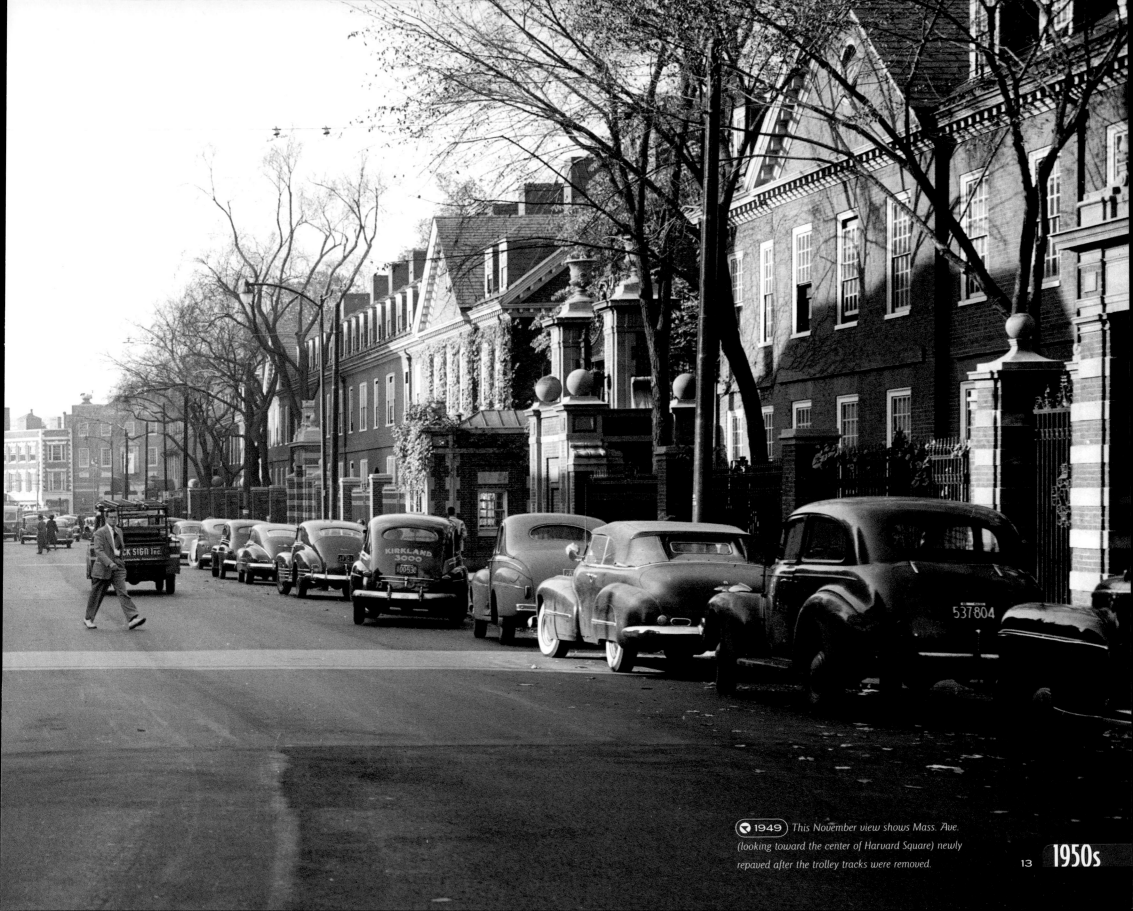

1949 *This November view shows Mass. Ave. (looking toward the center of Harvard Square) newly repaved after the trolley tracks were removed.*

13 **1950s**

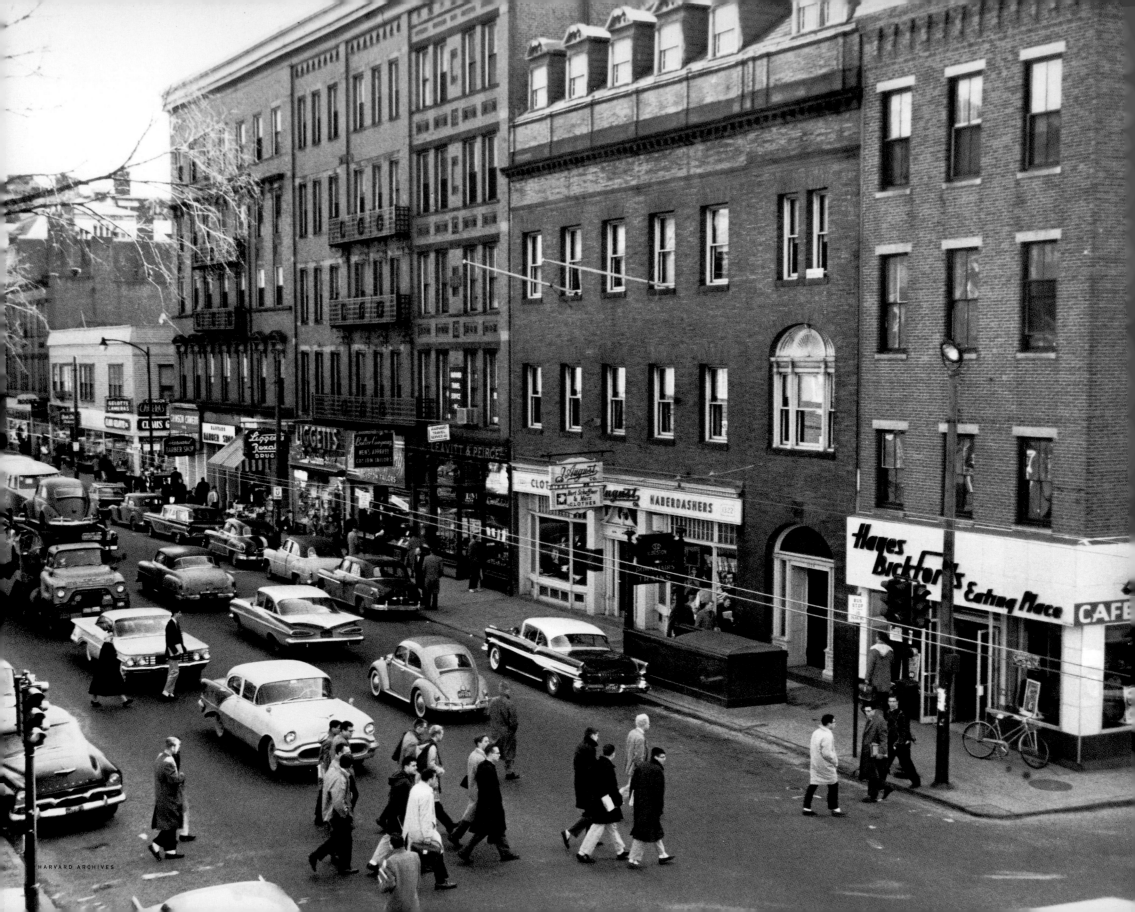

Ⓐ Briggs & Briggs
Ⓑ Lewandos Cleansers
Ⓒ Bill's Place/University Rest.
Ⓓ Schoenhof's Foreign Books
Ⓔ Stonestreets
Ⓕ Tutin's/Pangloss
Ⓖ Bob Slate Stationer
Ⓗ Claus Gelotte Cameras

Ⓘ Crimson Camera Exchange
Ⓙ Harvard Barber Shop
Ⓚ Felix
Ⓛ Liggett's Drugs
Ⓜ Bolter Company
Ⓝ Leavitt & Peirce
Ⓞ J. August
Ⓟ Hayes Bickford's

🔍 c.1959 Ⓝ Ⓞ *Students cross a bustling Mass. Ave., where shops like tobacconist Leavitt & Peirce and clothier J. August date from the 19th century.* {53, 95, 203}

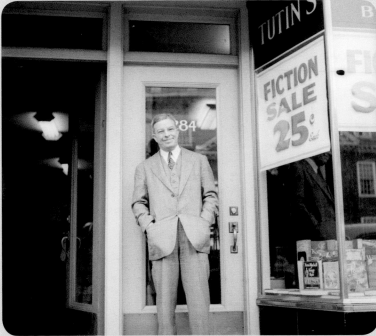

HARVARD ARCHIVES

ROGER BURKE, HARVARD ARCHIVES

HARVARD YEARBOOK PUBLICATIONS, INC.

🔍 c.1959 Ⓟ *An english muffin at "The Bick" was a food group unto itself.* {53, 54, 55}

🔍 1952 Ⓕ *Bill Tutin stands in front of his shop at 1284 Mass. Ave. Tutin opened dozens of bookstores, got them stocked and running well, and then sold them. This one became Pangloss in 1957. The adjacent door is that of Stonestreets men's shop, which closed in 2007.*

🔍 c.1952 Ⓜ *Henry Cox (right) does a fitting at Bolter, one of many menswear stores that offered tailoring in the days when tweed was king.*

Merchant
neighbor Tony Ferranti wistfully remembered the days when Cambridge politicos would congregate in the back. "Everybody was running numbers…if you wanted to bet on some races there was always a bookie back there to take your bet." The delivery guys? "They were all runners."

BOSTON PUBLIC LIBRARY

FELIX

Felix, the shop

specialized in shoe shines, hat blocking, and your basic quotidian goodies: newspapers, magazines, and candy bars. Felix, the man, specialized in making it, immigrant-style, in America. He arrived from Greece with one dollar in his pocket and left this world with a legendary business, a legacy of charity, and the camaraderie of generations of students who knew him as The President of Harvard Square.

From its inception in 1914, Felix was a popular spot for Harvard students, who would often leave stacks of coins on the newspapers they hurriedly absconded with. They counted on Mr. Caragianes and his cousin Bill for a friendly word or to cash a check. Presidents were known to stop by, be they Roosevelts or merely Harvard's Conant.

For the return on his investment, Felix gave back to the Greek community, both here and abroad, with scholarships for 15 Harvard students and fundraising for a new high school in his hometown. "I realized the importance of education… so I decided to try to help others in my homeland who weren't so lucky."

After he passed in March of 1951, the pocket books and magazines continued to flow over sidewalk tables under the shop's striped awning as Bill and then his children Angelo Caragianes and Connie Martel and their families carried on the tradition.

The newsstand had an unceremonious finale in 1970 after Angelo had been brought to court for purveying certain magazines deemed obscene (*Barracuda: Untamed Girls in Action*, anyone?). The landlord simply refused to renew the lease, and the beautiful Art Nouveau storefront was converted into a copy shop.

But the shoeshine and repair business had moved to the basement rear years earlier. Under new ownership, it remained there until 2008, when Felix, the shop, returned to its original home. {168}

Ⓐ Cambridge Trust
Ⓑ Brine's Sporting Goods
Ⓒ Hazen's Lunch
Ⓓ Phillips Books
Ⓔ Billings & Stover/Brine's
Ⓕ Roger's Men's Shop
Ⓖ JA Shulte Cigar/Harvard Smoke Shop

lower mass. ave.

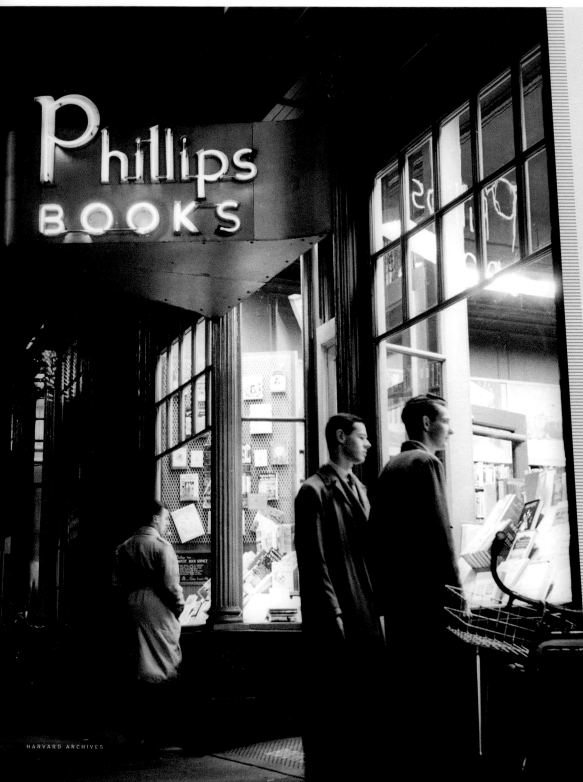

HARVARD ARCHIVES

🔺 1952 Ⓓ *Phillips Books glints seductively to the erudite trolling the Square on a winter's evening. This was its second location. Ellsworth Young ran the shop that his uncle John Phillips founded lower on Mass. Ave. in 1914.*

🔻 1956 *In the '50s, even monkeys dressed better than Harvard students today do.*

🔻 1954 Ⓒ *Students enjoy coffee in a sunny booth at Hazen's. John Whouly started the luncheonette and his son Fred ran it for many years. In 1963, it moved to Holyoke St. to make way for Holyoke Center.*

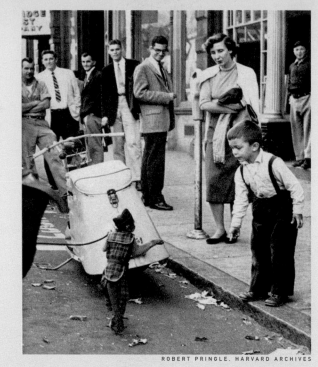

ROBERT PRINGLE, HARVARD ARCHIVES

🔺 c.1959 *Massachusetts Avenue is bustling with pedestrian and vehicular traffic. Holyoke House and Little Hall are pictured, comprising the three handsome brick buildings. This entire block would be razed for Holyoke Center in the 1960s. Note the eastbound traffic, eliminated in 1967.* {54, 59}

ROBERT O'NEIL, RADCLIFFE ARCHIVES

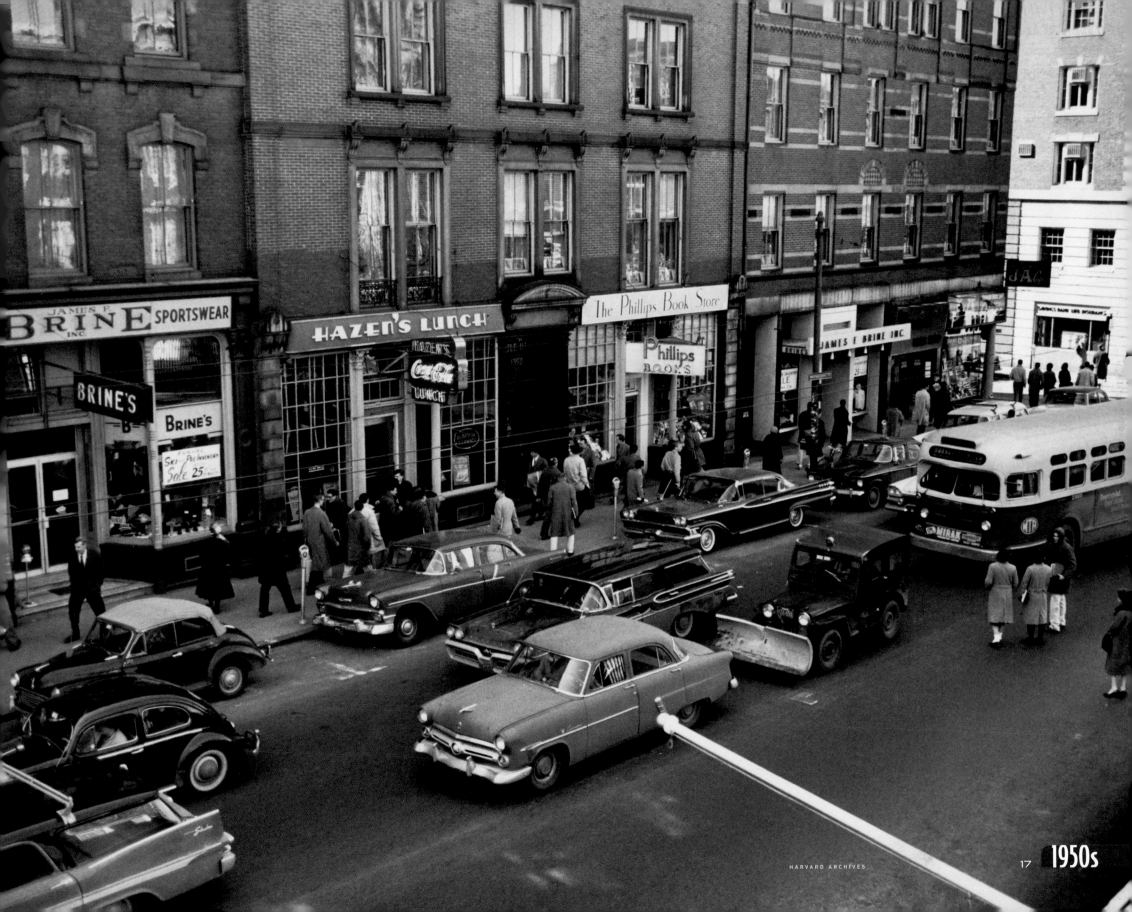

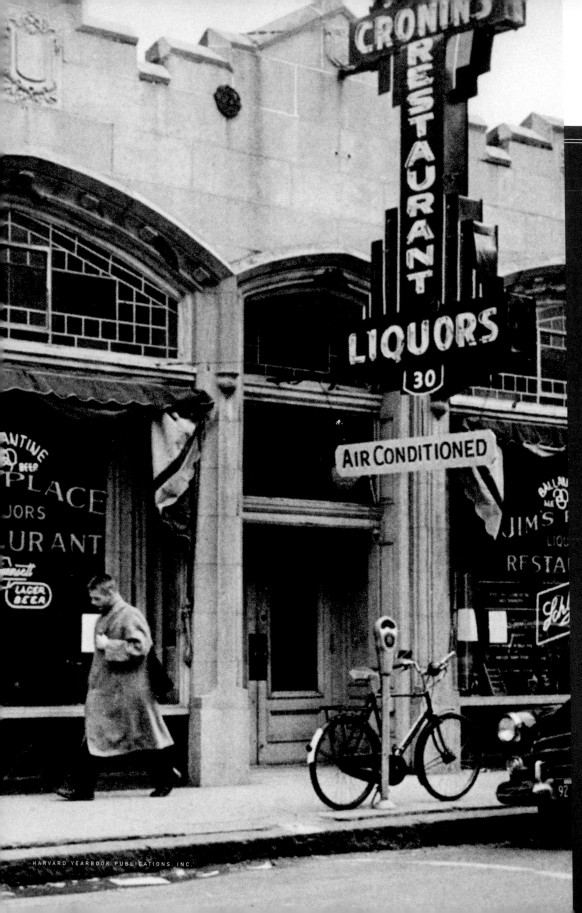

CRONIN'S

"Every

Harvard student found his way to Cronin's bar," recalled Harvard Square optometrist Richard Glugeth. Cronin's, or Jim's Place as it was sometimes called, was de rigeur for post-gridiron binging, be it celebration or lamentation. Up to 3,000 students would belly up on a big weekend with Princeton or Yale in town. "Those nights! We have to stop serving draught beer at eight o'clock; there's not enough glasses in Cambridge," said Jim Cronin Jr. in 1957.

When it was not filled with rowdy, singing football fans, it was a favorite meeting place and hangout that although enormous, oddly provided privacy. "It was all dark wood, and the booths had high sides and backs," said patron William Biddle. There were team trophies and oars hanging from the walls. Sam Smith, '59 grad, thought it "resembled the large waiting room of a railroad station. It had a high ceiling against which ricocheted the voices and clashing silverware of young Cambridge."

Young Cambridge guzzled over 1,000 gallons of beer at Cronin's every week, and it became a rite of passage for those not yet familiar with the dangerous pleasures of imbibing to learn them here. Being of legal age was a secondary consideration. Cash-strapped '50s students could pound "dimies" (eight-ounce glasses of beer for ten cents), or could sink into a steak. Dinners were as cheap as fifty cents.

Jim Cronin Sr. was manifestly credentialed as bar proprietor, having owned a number of successful establishments in Ireland, where he also served as a "rectifier" of whiskey, making sure it was the correct proof. His businesses in Cambridge date back to 1918 and include the first in the city to serve chilled beer and the first to receive a post-Prohibition liquor license. He and brother Tom opened the Dunster St. establishment in the early '40s and handed over the reins to Jim Jr. and his brother John in 1950. Jim Sr. died in '53, and Junior continued the pub in the unpretentious Irish tradition, still sometimes affably tending bar.

Eventually, Cronin's had to make way for the University Health Services Building (part of Holyoke Center) and so in the early '60s, the popular pub moved to its inconvenient second home at 114 Mount Auburn St., next

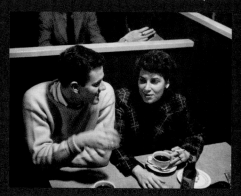

to the bus yard. Jim Jr. brought some of his Dunster St. decor and low prices with him, but couldn't retain the cachet or the clientele of the original. By the '70s, after a protracted legal battle with striking waitresses eroded business significantly, the cavernous, dark pub was often nearly empty. In 1978 Cronin's was sold. The mythic watering hole may be gone, but the nostalgia remains. Woody Chapman, Harvard grad and former employee of Brattle Enterprises, sums up the mystique as follows: "I used to see Dylan Thomas puking his guts out coming out of Cronin's." This is a problem Jim Cronin Jr. never had to worry about. Ironically the proprietor of Harvard Square's most legendary bar was a teetotaler.
(40, 57, 83, 125)

⬥c.1956 Ⓔ *Nicholas Lombardi Jr. does what he does best. LaFlamme looks much the same over a half century later.*

HARVARD YEARBOOK PUBLICATIONS, INC.

BURGERS,

eggs, frappes, coffee…if you liked cheap diner food, Harvard Square was the place for you. Whether they called themselves cafeterias, luncheonettes, restaurants, arcades, or counters, these inexpensive eateries were ubiquitous in 1950s Harvard Square. Crammed with students and locals, they also catered to a 24-hour population of MTA workers who punched the clock at the Bennett Street Rail Yards. In addition to the dedicated establishments like Mike's Club (right), there were also lunch counters within a five-and-dime (Woolworth's), a grocery (Harvard Spa), and even a tobacconist (Leavitt & Peirce).

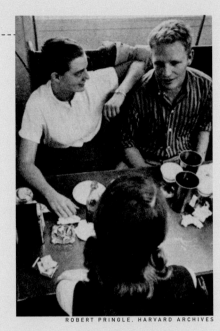

ROBERT PRINGLE, HARVARD ARCHIVES

⬥c.1957 Ⓝ *Mike's Club claimed to make the "largest frappes in the world." The Kennedys and Norman Mailer were known to stop by.*

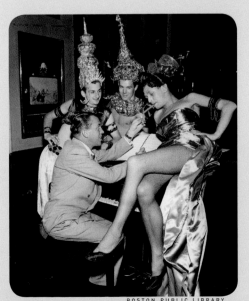

BOSTON PUBLIC LIBRARY

⬥1950 Ⓛ *Ed Sullivan pays a visit to the Hasty Pudding Theatre when cross-dressing was a comedy bit and not yet a lifestyle choice.* {57, 170, 206}

McKinley

was president when Arthur LaFlamme, Canadian emigré, opened up an inconspicuous barbershop in what was then a brand-new building on Dunster Street. One assumes he was very good at his trade, because unceremoniously, his barbershop has continued to serve patrons in the same location since 1898, making it the oldest in Massachusetts and one of Harvard Square's hidden historical gems.

If LaFlamme, who died in 1930, were to walk into his shop today he would see few changes since the time when a haircut cost 35 cents. The handsome wood paneling and cabinets, luxurious by today's standards, are original. The barber chairs, though reupholstered, have cradled fannies since the 1920s. Even the custom-lettered, push-lever cash register, though no longer in use, remains on display.

The continuity also applies to barbers and customers who often stick around for decades. Frank Machachio cut hair there for more than forty years. Second owners Nicholas Lombardi and John Capolupo for more than thirty. Lombardi recalled shearing four generations of one family. Nick Jr., his brother Fred, and Charlie Ferrara all served for almost forty years before retiring.

Like many barbershops, LaFlamme had to tough it out through the hippie era. Not all of them made it. Said current owner George Papalimberis, "When I started 1966 cutting hair, was the regular haircuts, you know everybody get short haircuts, then The Beatles came…" The Beatles were only the beginning of long hair styles that would last more than a decade. Many Harvard Square barbershops went out of business during that era, including Ray's, Dunster, Holyoke, University, Harvard, Ivy, J. M. Polcari, and Plympton.

Having owned three barbershops in Cambridge, including the Custom Barber Shop on Brattle Street since 1978, George was entrusted to carry on the tradition. The place was run down and they were down to two chairs a day when he arrived in 1984. "Now we are nine," he said.

It's easy to see how George's thoughtful, open manner would attract loyal heads. Some of those have belonged to important people, including prime minister Karamanlis of Greece and governors Dukakis, Weld, and Romney. Of course, in years past, the Kennedys all stopped by and Harvard presidents Lowell and Eliot were once regulars.

What makes the job so satisfying? "Talking to other people," said George, "from the stupid person to the smartest here in this country."

19 **1950s**

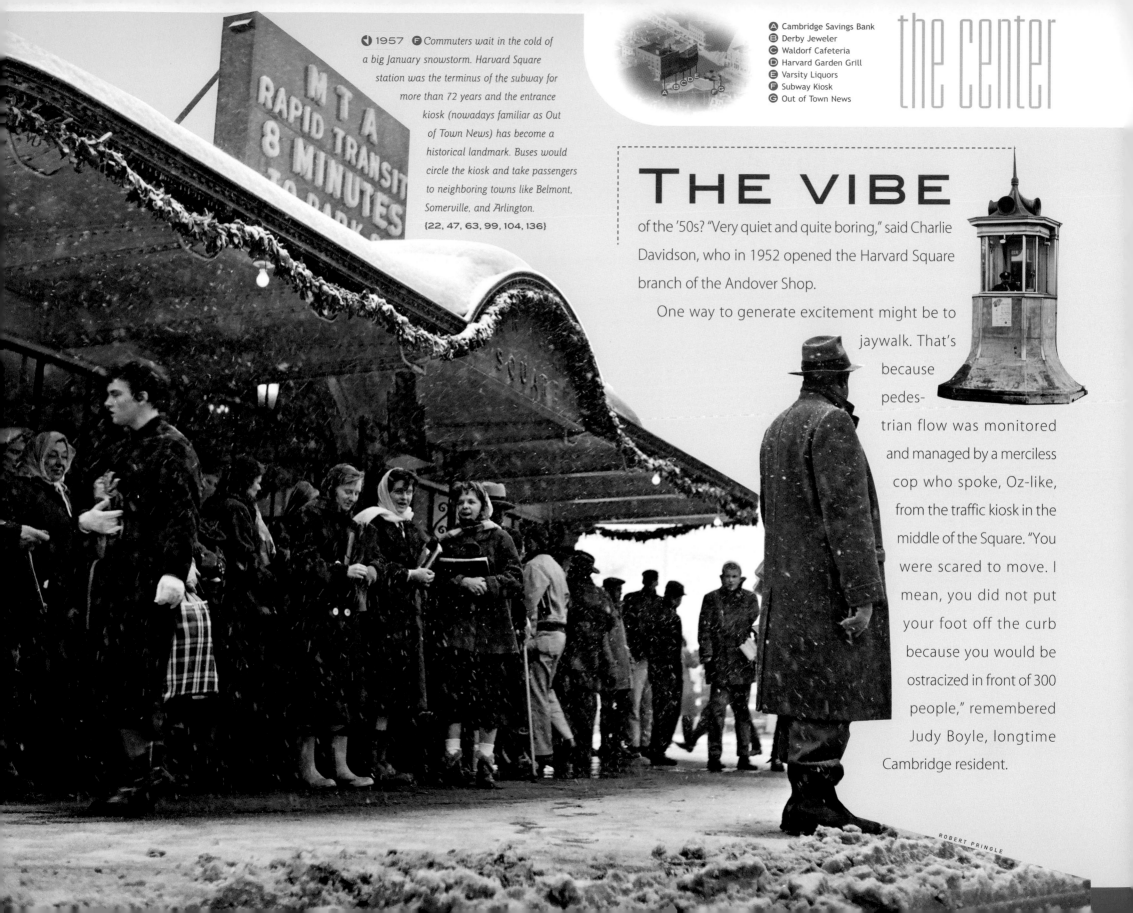

1957 **F** *Commuters wait in the cold of a big January snowstorm. Harvard Square station was the terminus of the subway for more than 72 years and the entrance kiosk (nowadays familiar as Out of Town News) has become a historical landmark. Buses would circle the kiosk and take passengers to neighboring towns like Belmont, Somerville, and Arlington.*
{22, 47, 63, 99, 104, 136}

Ⓐ Cambridge Savings Bank
Ⓑ Derby Jeweler
Ⓒ Waldorf Cafeteria
Ⓓ Harvard Garden Grill
Ⓔ Varsity Liquors
Ⓕ Subway Kiosk
Ⓖ Out of Town News

THE VIBE

of the '50s? "Very quiet and quite boring," said Charlie Davidson, who in 1952 opened the Harvard Square branch of the Andover Shop.

One way to generate excitement might be to jaywalk. That's because pedestrian flow was monitored and managed by a merciless cop who spoke, Oz-like, from the traffic kiosk in the middle of the Square. "You were scared to move. I mean, you did not put your foot off the curb because you would be ostracized in front of 300 people," remembered Judy Boyle, longtime Cambridge resident.

ROBERT PRINGLE

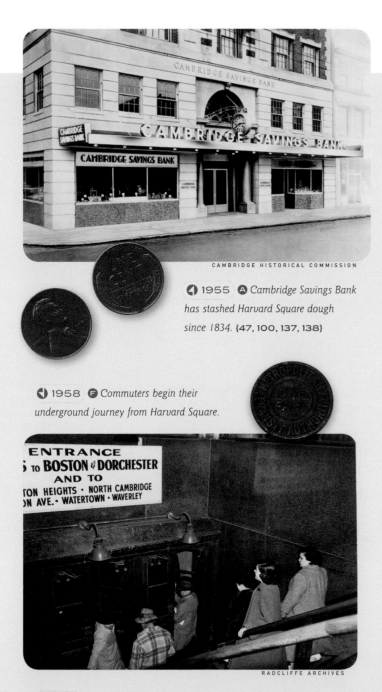

CAMBRIDGE HISTORICAL COMMISSION

◀ 1955 Ⓐ *Cambridge Savings Bank has stashed Harvard Square dough since 1834. {47, 100, 137, 138}*

◀ 1958 Ⓕ *Commuters begin their underground journey from Harvard Square.*

ENTRANCE
S TO BOSTON & DORCHESTER
AND TO
TON HEIGHTS · NORTH CAMBRIDGE
ON AVE. · WATERTOWN · WAVERLEY

RADCLIFFE ARCHIVES

◥ 1951 Ⓔ *A new traffic direction tower, from which police officers would terrorize would-be jaywalkers for a generation, is almost ready to be unveiled. Behind it is Varsity Liquors, where many an underage Harvard student scored booze since 1937. The landmark store, which people often set as an outdoor meeting point, closed in 1988. It was briefly reincarnated on Eliot Street in 1990.*

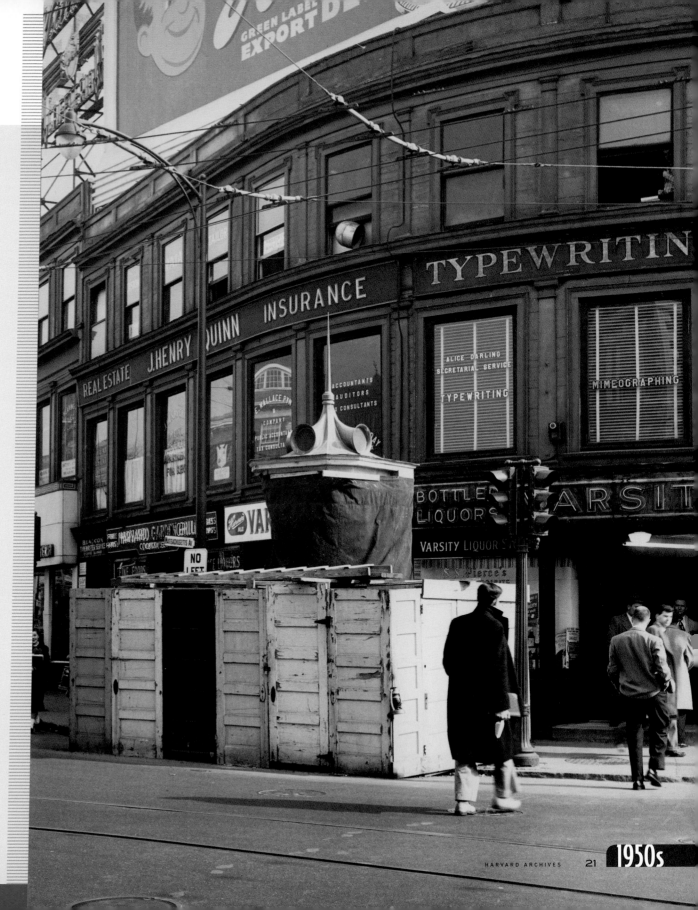

1950s

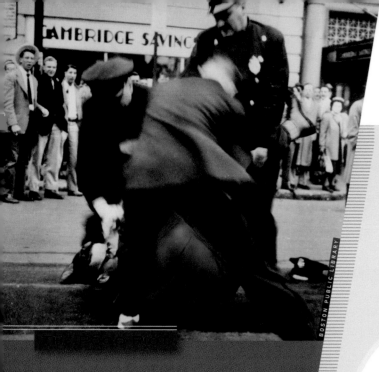

BOSTON PUBLIC LIBRARY

⚓ **1952** *It was supposed to be a drive-by. General Eisenhower was on a campaign swing through Harvard Square on October 21 when 20,000 people staged a near-riot and stopped his motorcade. Demonstrations of affection from the boisterous crowd scratched his car and twisted its antenna. Ike managed to escape with a torn coat sleeve and the presidency.*

POLITICS AND HARVARD SQUARE

have often gone together. In 1952, in addition to the infamous Pogo Riot (left) both major-party presidential candidates visited the Square in October's campaign home stretch. Democrat (and Harvard grad) Adlai Stevenson paid a low-key visit, which included Sunday services at the First Church and a stop at the Hotel Commander. Republican (and ultimate victor) Dwight Eisenhower was mobbed by a crush of 20,000 onlookers (opposite).

In April of 1959, Cuban premier Fidel Castro spoke to a crowd of 10,000 at Harvard's Dillon Field House (under a police escort larger than his revolutionary army). Opinions of the man were somewhat different than they might be today.

"Now, you have to understand that this was a Harvard crowd, cool and laid-back to the nines," wrote Neil Bradford Olson, who attended the event. "Well, I turned around and stared into rows of Harvard types, a few of whom I recognized, screaming and waving their right fists at Fidel! Some were waving Cuban flags, jumping in the air and waving both arms."

When

the hotel manager contained the crowd of Stevenson supporters, he mistakenly excluded someone in the candidate's entourage, saying he "didn't like his looks." It was Humphrey Bogart.

"Unwittingly

my roommate and I started it without meaning to," said Peter Solmssen of the fracas begun over an illustrated possum. Dissatisfaction with major-party political candidates is not just a recent phenomenon, but in 1952, cartoonist Walt Kelly took it a step further when he launched the "Pogo For President" campaign, featuring the titular character of his popular daily strip. Harvard undergrads Solmssen and Larry Savadove managed to get Kelly to agree to speak at the school on May 15th. The plan was for a friend, John Sack, to get a little spirit going for the rally, at which point the kids would arrive from dinner with Kelly on the back of a convertible. "We had such a good time with him that we spent longer over dinner than we should have," remembered Solmssen. They were running very late, rendering a metastasizing crowd impatient. Students stalled an electric bus by detaching its cables, and soon the cops arrived to restore order. Whether it was keen social satire or just puerile inanity, Pogo's fictional run at the White House ended with very nonfictional beatings and arrests. Among the arrestees? Future Pulitzer Prize–winning author and journalist, David Halberstam. Only at Harvard.

⚓ **1955** *A postcard shows the stereotypical view of Harvard Square, centered on the subway kiosk.* {2, 3, 102}

CAMBRIDGE HISTORICAL COMMISSION

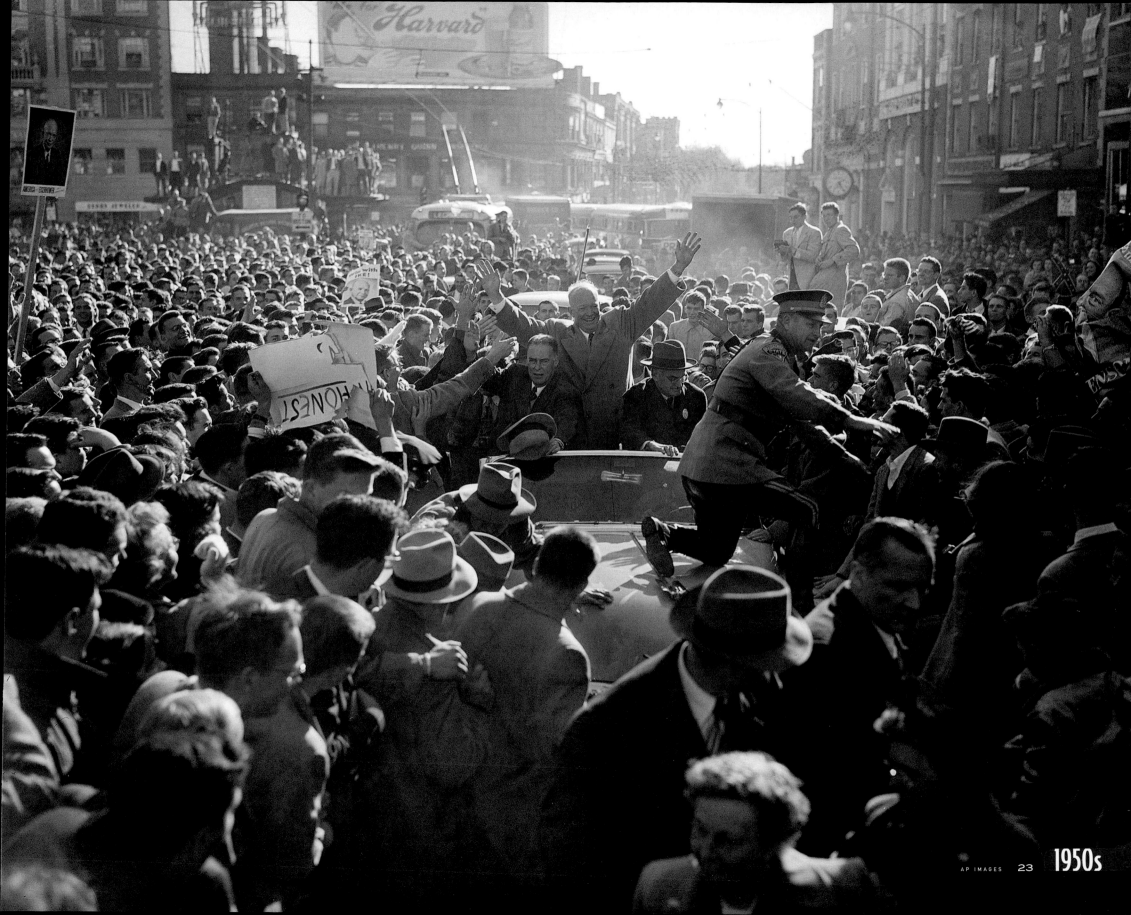

A Harvard Coop
B Harvard Trust
C Tedford Harvard
D Jack Williams Magic Gardens
E Harvard Do-Nut Shop
F Tealcraft Handkerchief Company
G Albiani Lunch Co.
H Daley's Pharmacy
I Harvard Valeteria
J University Theatre
K Leopold Morse

upper mass, ave.

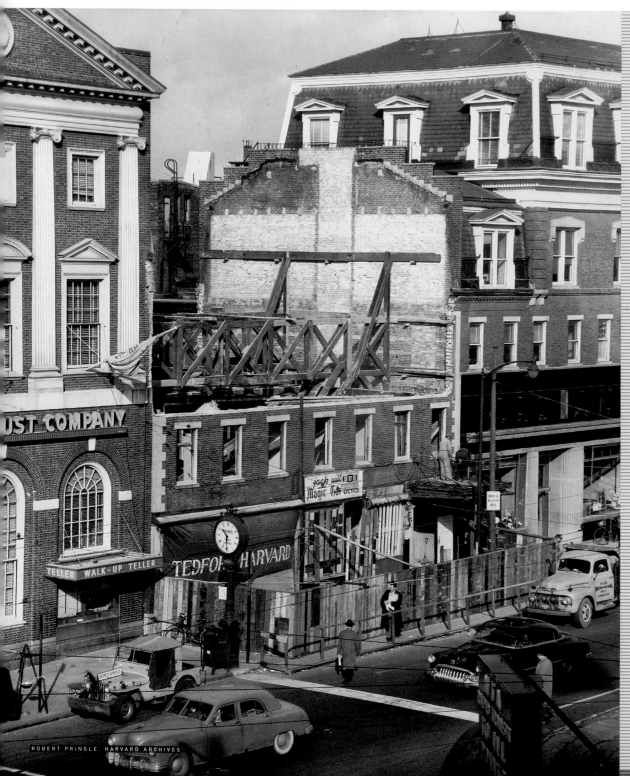

ROBERT PRINGLE. HARVARD ARCHIVES

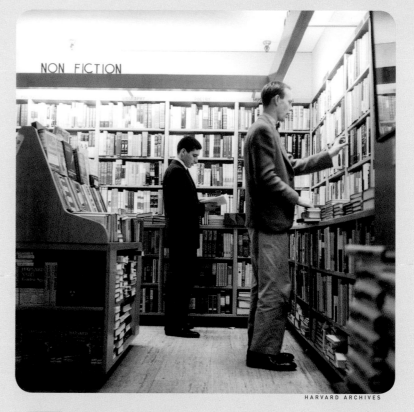

HARVARD ARCHIVES

◀ 1955 ⓑ *Construction progresses on Harvard Trust's new digs.* {63, 105}

◀ c.1950s ⓐ *Trolley wires criss-cross the sky in front of the Coop.*

RADCLIFFE ARCHIVES

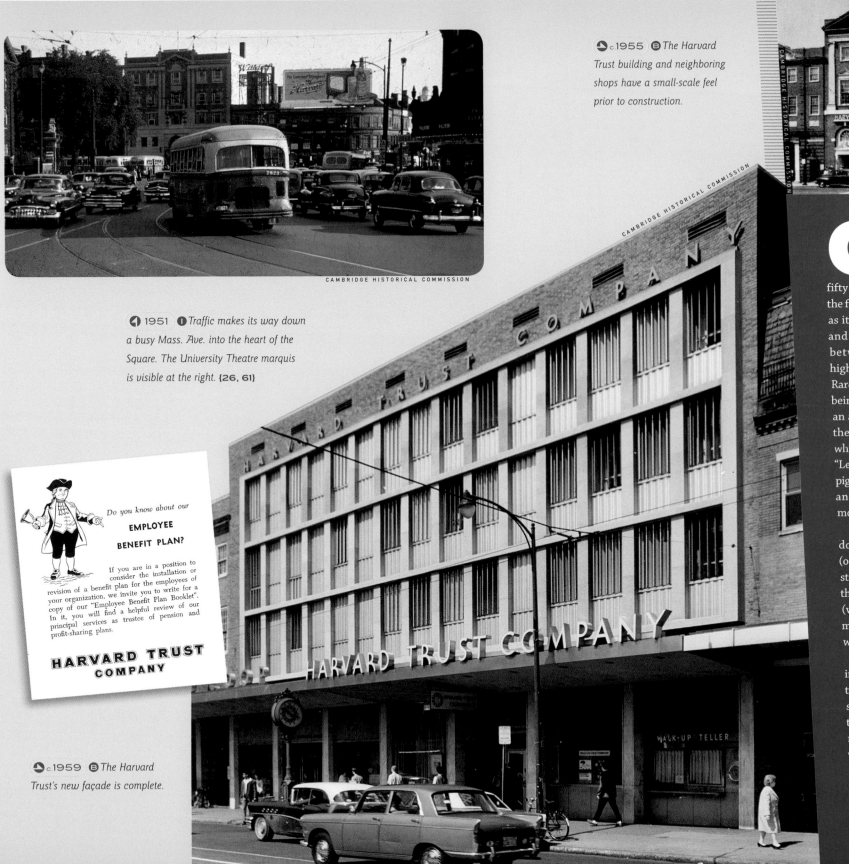

⬆ c.1955 🅱 *The Harvard Trust building and neighboring shops have a small-scale feel prior to construction.*

◀ 1951 ❶ *Traffic makes its way down a busy Mass. Ave. into the heart of the Square. The University Theatre marquis is visible at the right.* {26, 61}

Do you know about our

EMPLOYEE BENEFIT PLAN?

If you are in a position to consider the installation or revision of a benefit plan for the employees of your organization, we invite you to write for a copy of our "Employee Benefit Plan Booklet". In it, you will find a helpful review of our principal services as trustee of pension and profit-sharing plans.

HARVARD TRUST COMPANY

⬆ c.1959 🅱 *The Harvard Trust's new façade is complete.*

TRUST MAKEOVER

Over

fifty drawings were submitted to design the façade of the Harvard Trust Company as it underwent a wholesale renovation and expansion in 1956. In the battle between Georgian and modern, the higher-ups gave the nod to the future. Rarely does one fault bank executives for being radical. Nonetheless, this is what an acerbic *Crimson* writer had to say of the large concrete awning, or "shelf," which was spawned during this exercise: "Let's make it a nesting place for local pigeons. Or let's run up a block and tackle and turn it into a parking place for motorscooters."

The renovation including tearing down 1410 Massachusetts Avenue (opposite page), which had been constructed in 1832. Crews then dismantled the façade of the original Trust building (visible above) and a new steel skin merged the two buildings into a unified whole (left).

The expansion, in addition to evicting several smaller businesses, allowed the Coop to nearly double its selling space by leasing the bottom floor of the overhauled Harvard Trust. The new twin atria of the Coop would welcome visitors for approximately forty years.

And what of the shelf? It stretched all the way to the corner of Church Street until around 1980, when it was mercifully pared back.

25 **1950s**

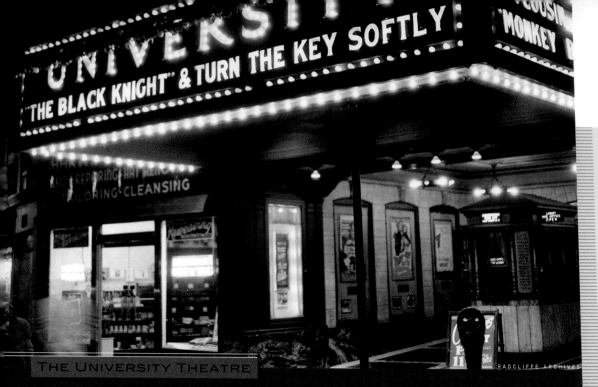

THE UNIVERSITY THEATRE

RADCLIFFE ARCHIVES

"They had these

big, huge velvet drapes," remembered Janet Cahaly, longtime Harvard Square denizen. The drapes were just one indication of the importance of the UT, or University Theatre, in the social fabric (pardon the pun) of 1950s Harvard Square. The Uni, as it was also known, was an old-fashioned one-screen movie house, ornamented, gilded, and crawling with ushers.

"You met kids there on Saturday morning and if it was your birthday you got a hundred pennies," said Janet's sister, Judy Boyle. On an average Saturday, 1,000 like-minded tots would jostle in for a magic show and the matinee. This was when the theatre seated a mind-bending 1,889 patrons. Some of those patrons could splurge for a seat in the mezzanine, where the legendary wicker seats lasted through generations.

If they were Hollywood pictures, they played at the University, and in the '50s, Hollywood was big. "That was a golden age…two double bills a week," said Woody Chapman, Harvard class of '56. Cahaly also fondly recalled the double features. "We used to race down on the bus to Harvard Square and we would go to the Wednesday afternoons and we would see two review pictures, which would be two A pictures, because usually you had an A picture and a B picture."

The University had an influential student clientele dating all the way back to its pretalkie opening in

1926. Right from the beginning, long before *Rocky Horror Picture Show*, there were midnight "smokers," Saturday night vaudeville shows for students, which sometimes got rowdy. Students also spiked attendance après-exams. But The University was always a strong community house where a hit film could sell 5,000 tickets a day for a short run.

No one would mistake Massachusetts Avenue for Sunset Boulevard but Harvard Square has had its brush with celluloid glory. In October of 1950, one of the first films to be shot on location in Harvard Square, *Mystery Street*, starring a young Ricardo Montelban, premiered at the Uni. And a year later, manager Stanley Sumner helped organize a 15-limo motorcade of Hollywood sparkle through the Square, powered with the wattage of screen vixen Dorothy Lamour and suspense maestro Alfred Hitchcock, among others.

In 1961, after becoming a bit ragged at the edges, the UT was sold to the Brattle Theatre group. They undertook substantial renovations including new adjustable seats, a new screen, and new projectors. The much-improved space, rechristened The Harvard Square Theatre, offered second-run Hollywood features for a buck twenty-five, interspersed with occasional current films and live performance. The Uni was history, but the theatre in its many incarnations would provide much more entertainment in the years to come.

"IF THERE IS A typical Harvard undergraduate

costume of today," said the *Harvard Alumni Bulletin* in 1952, "it is the expensive tweed sports jacket, coupled with a pair of chinos, a button-down white shirt (sometimes worn without tie), and a pair of dirty white buckskins (or well-shined loafers)."

That costume needed constant upkeep, thus there must be a raft of services such as tailors, men's shops, cobblers, and of course barbers to freshen the whiffle cuts.

"I came into the Square in the early '50s when the Square was a personal place," said George Avis, who owned the Tasty sandwich shop for forty years, "When I would go, for instance, to the Harvard Coop to buy a suit or a shirt, the attendant measured my neck and measured my sleeve…I said, 'Oh, it's okay,' and he said, 'No, it's not okay, this suit has our label on it and I want it to be perfect.'"

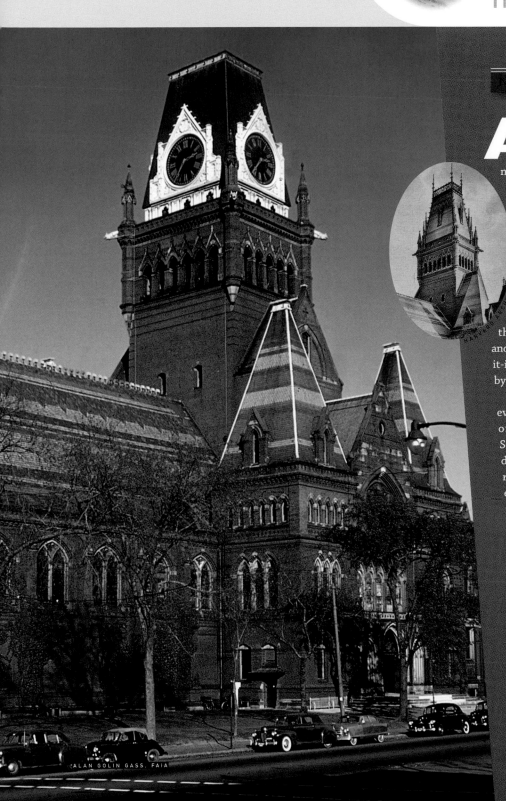

1952 The Memorial Hall tower possessed an enormous clock from 1897 until the 1956 fire, but the roof had been stripped of most other ornamentation in the '40s.

ALAN GOLIN GASS, FAIA

MEMORIAL HALL FIRE

Albeit

not, strictly speaking, right in Harvard Square, Memorial Hall's stately tower has presided over it since the high victorian gothic edifice was erected in 1878. But that spire has not always looked the same. The many faces it has sported include the original design with patterned shingles and florid copper trim (left, inset), the said same with clock (below), and the dowdy, please-ask-what-time-it-is mug into which it had devolved by the 1950s (left).

No Harvard makeover, however, could achieve the effects of the dramatic fire of September 29, 1956, that devoured the steep roof. In the days before endowments were measured in billions, reconstructing the tower must have been low on the priority list. Several generations came of age knowing only of the flat-topped, post-inferno iteration of Memorial Hall. In 1999, after more than 40 years, the tower roof, in its original glory, was triumphantly restored. It would have been hard to believe such an exemplary work of architecture could actually be improved upon. It has. {232}

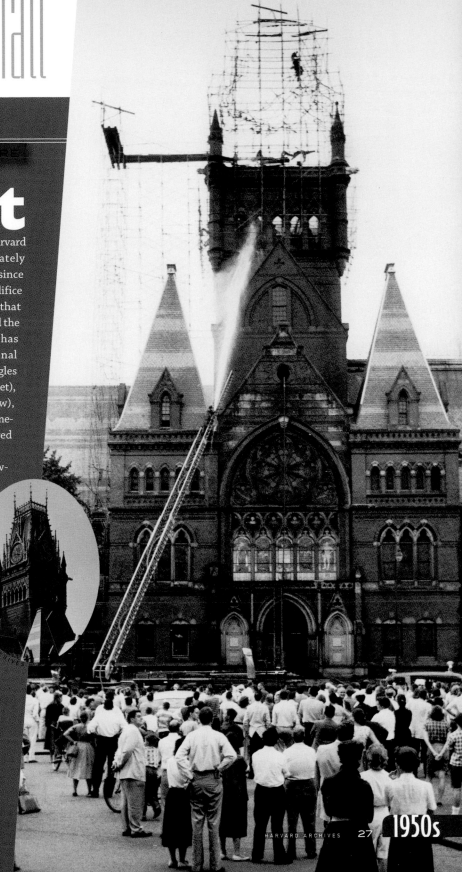

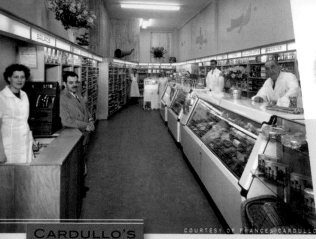

CARDULLO'S

COURTESY OF FRANCES CARDULLO

🔺 1950 Ⓛ *Opening night at Cardullo's Delicatessen shows a comparatively uncluttered store. Frank Cardullo is second from the left.*

🔺 1950 ⓌⓎ *Corcoran's was a department store founded in Cambridge in 1881, but new to Harvard Square in 1949. It would last until 1987. Miss Cannon's shop catered to Cambridge children from the '20s to the '60s.*

Frank Cardullo

himself was a big event in Harvard Square, an outsized personality who shaped the Square through his civic activism, boosterism, and entrepreneurship. Two of his businesses would come to define the Square's appeal for decades. One of them was the Wursthaus, which closed in 1996; the other is Cardullo's, still going strong over a half century later.

Cardullo, a Sicilian immigrant, opened his first restaurant at age 21 after only seven years in the States. A perfectionist and workaholic, he opened restaurant after restaurant, whether hot-dog stand, oyster house, tavern, or what he claimed was America's first authentic trattoria (Harvard Square wasn't quite ready for that one in 1955). "Tough, rough, nasty—and fair—that's a good restaurateur," he said in his autobiography.

Sheldon Cohen, another major player in Harvard Square's identity, remembered him fondly: "He had the technique, the art, the culture. I mean, he had the finesse of really merchandising."

With a visible presence in the Square, always in his signature three-piece suit, Cardullo was probably as well known for his community involvement as for his restaurants. "He had a lot of pull in Harvard Square," remembered Phyllis Brown, who with her husband, Al, ran Kupersmith Florist for decades. Said Al, "He used to have a breakfast club. They'd have the mayor…chief of police…and they ran Cambridge."

"He was every bit the politician," affirmed Frances Cardullo. He was deeply involved in government, charities, and community groups, serving on five state commissions and as president of the Lions Club. He had the type of connections that could get him an invitation to the Nixon inaugural and get Frank Sinatra to perform for the Greater Boston Association for Retarded Citizens, his favorite cause.

In 1990 he gazed back: "I honestly don't think that the average outside person would believe what a packed life I have led." {98, 154, 190}

"I remember

the opening night of Cardullo's," said Frances Cardullo, who was about ten years old on April 1, 1950, "It was a big event in my father's life because he had always dreamt of a European-type deli in Harvard Square."

Despite the Italian name, the initial inspiration grew out of the German deli counter at Frank Cardullo's Wursthaus restaurant, and on opening day there was a heavy emphasis on German cold cuts, canned vegetables, and chocolates. Convincing locals to go upscale with expensive imported edibles took a few years, but Cardullo was ahead of the curve in recognizing Harvard Square's burgeoning internationalism.

Much of his success is owed to an Atlas-like work ethic and savvy marketing. "I was displaying very expensive merchandise in the window. People would stop and look and then walk right by. I kept watching this happen, and finally decided to buy some baskets—tomato baskets—which I set in the window and filled with Campbell's Soup, sardines, small cans of tuna fish, any inexpensive items I could think of. That one change started people coming in, looking around, and buying," he wrote in his 1990 auto-biography.

In 1961, Cardullo's doubled in size to its current layout, and the range of merchandise grew to include such epicurean curiosities as lampreys in aspic and crystallized grapefruit peel.

Delicacies from Japan, Indonesia, Greece, Mexico, and India tempted the discriminating gourmand, along with the European staples of biscuits, teas, coffees, patés, jams, and chocolates. There was a large spice section, and even some basic kitchenware like teapots, coffee brewers, and fondue sets.

Other than modifications to the product mix and more merchandise crammed quite literally almost to the ceiling, there have been virtually no changes since. "When I came in here, I was going to change everything," said Frances in 2000, "Then I said, 'You fool! Don't change anything!' Because you'd be surprised at how many Harvard graduates come in and say, 'Look! It's just the way it was!'"

That being said, she did bring Cardullo's into the 21st century, computerizing the inventory and point-of-sale system, and adding a mail-order and Internet presence to make the store much more efficient and profitable. She was able to triple sales in five years after officially taking over the shop in 1993. "You find out what the current wave is and you ride it until it crests," she said.

These days the narrow aisles are akin to one-way streets with two-way traffic. Bottlenecks, however, allow you the opportunity to longingly peruse 105 brands of chocolate bars, where you can make your selection based on cocoa content, country of origin, or palette-stretching ingredients such as cumin or hot peppers.

The deli counter is still a draw here, with Italian cold cuts and delicious sandwiches ranging from the gourmet (duck confit with Gruyère and fig spread) to the pedestrian (turkey). There are shelves of coffees, cocoas, and an almost uncomfortably vast library of teas, supposedly the largest in New England. A shrinking selection of jams is still broad enough to contain both loganberry and lingonberry. Since 1987 they've also had a fine beer and wine selection.

"Oh my God, it's a huge sense of responsibility to run this store and to try to make the right decisions and maintain it as a landmark in the Square. Tremendous responsibility," said Frances. Towards the end of her life, she was under increasing pressure with high rents and demographic changes.

Upon her passing in 2009, three of her children, none of whom had been involved in the business just a few years prior, took on that tremendous responsibility. They will bring Cardullo's legacy into the future. Cambridge is counting on it. Otherwise, where will we get a jar of pickled walnuts? {212}

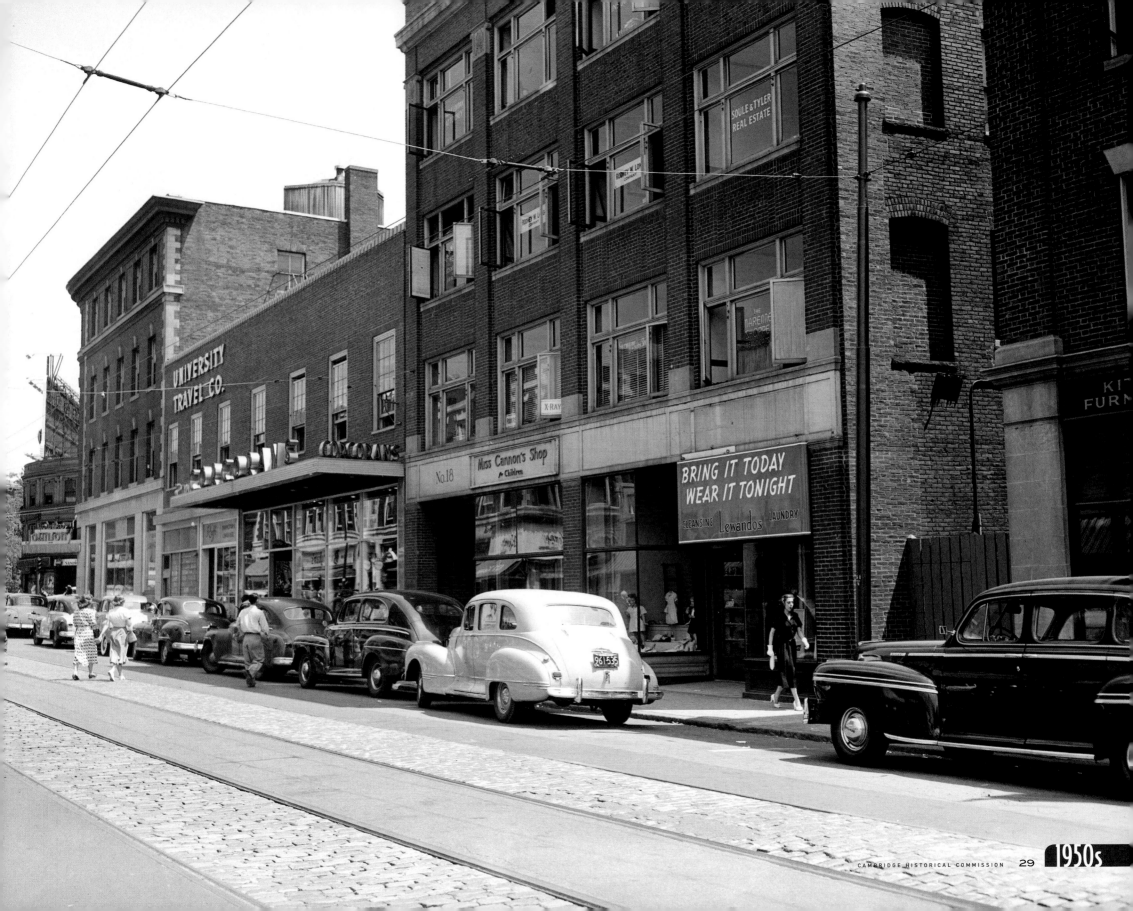

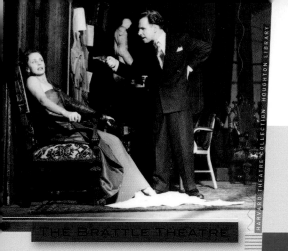

THE BRATTLE THEATRE

Ⓐ Cambridge Federal Savings & Loan
Ⓑ U.S. Post Office
Ⓒ The Brattle Theatre
Ⓓ Cambridge Center for Adult Ed.
Ⓔ O'Hara Hat Shop
Ⓕ Blue Door Yarns
Ⓖ Chipp Inc., Men's Furnishings
Ⓗ Newcomb's Bakery
Ⓘ Fanny Farmer Candy Shop
Ⓙ Lewandos Cleaners
Ⓚ Lewdon's Millinery
Ⓛ The Brown Shop
Ⓜ Colstone's Restaurant
Ⓝ Brattle Pharmacy
Ⓞ Olsson's

🔺 1950 Ⓒ *Jessica Tandy and Hume Cronyn, shown here in* The Little Blue Light, *were two of the more famous actors to grace the stage of the Brattle Theatre during its short-lived run as a playhouse.*

🔺 1953 Ⓒ *Captain from Kopenick was the first film shown at The Brattle Theatre.*

🔺 1953 Ⓒ *The Brattle prepares for its conversion to the art-house movie theatre for which it would become renowned.*

CAMBRIDGE CAMBRIDGE
NOW PLAYING
BRATTLE THEATRE HARVARD TR 6-4226
 SQUARE
New England's Finest Showcase for Foreign Films

A Critics Circle Award Picture
CAPTAIN from KOPENICK
(Der Hauptman Von Kopenick)

"A tumultuous comedy directed at all mankind, where a uniform means
more than the men who salute it—A real classic!"
Academy of Motion Picture Arts & Sciences

MON.-FRI. 5:30 CONTINUOUS SAT.-SUN. 2:30
 DAILY

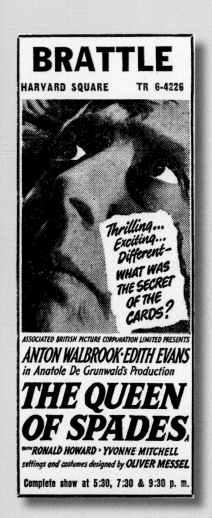

The Brattle's

imprint goes beyond merely boilerplate nostalgia for the vanishing indie art house. The theatre and its creators are enmeshed in the history of American cinema-going. Founders Cy Harvey and Bryant Haliday overturned censorship laws, almost single-handedly brought foreign films to United States audiences, and created the Humphrey Bogart revival that made *Casablanca* a retroactive classic. If that wasn't enough, Brattle Enterprises went on to create a retail and food-service juggernaut with some of the most popular bars in Cambridge and the international soap-store chain Crabtree & Evelyn, which began unassumingly in the basement of the building.

To understand the genesis of the Brattle Theatre we need to go back to 1889, when the Cambridge Social Union, the forerunner of today's Cambridge Center for Adult Education, built a simple but handsome clapboard structure known as Brattle Hall at 40 Brattle Street.

The Cambridge Social Dramatic Club was the first of several groups to stage theatre performances in the space all the way up to the 1940s, including, most famously, a production of *Othello* with Paul Robeson in the title role. At other times it hosted dances, church services, lectures, and even police calisthenics.

Meanwhile, student Jerome Kilty put together The Veterans' Theatre Workshop, a surprisingly successful troupe of Harvard thespians who had served during the war. Among them were Harvey, Haliday, and future Broadway director Albert Marre. When the Social Union needed to unload Brattle Hall in 1948 for financial reasons, Haliday purchased it and the Workshop went commercial.

For the next several years, the Brattle Theatre became a year-round repertory theatre doing serious classics mixed with new works including the U.S. premiere of Chekhov's *Ivanov*. Thornton Wilder was on the board of directors and name actors such as Zero Mostel, Jessica Tandy, Hume Cronyn, and Cyril Ritchard would make their way through Cambridge for the opportunity to play parts often unavailable on Broadway. The theatre's consistent quality was unfortunately rivaled only by its insolvency.

At the same time, Cy Harvey was off on a Fulbright to the Sorbonne, and in the gloom of postwar Paris he sought solace at the famous Langlois Cinémathèque, where one could drink in the masters of European film at three screenings daily. "It was probably the best film museum in the world," he said. When he came back to Cambridge a newly minted film buff, he found the Brattle Theatre thirty grand in the red and on the verge of closing. Film seemed like a great solution. Thus in 1953, Haliday and Harvey created a partnership and recharted the course of the Brattle Theatre from plays to foreign cinema.

Using a rear-projection system with mirrors, as found on ocean liners, they converted the theatre on the cheap and allowed for a balcony. That system is still in use today.

Almost immediately the Brattle started having an impact beyond its 280 seats. On May 5, 1955, the State Supreme Court heard their case against the constitutionality of the Massachusetts censorship law after the Swedish film *Miss Julie*, an August Strindberg play which featured an illicit affair, was banned from screening on Sunday. The judge agreed that such prior restraint was unthinkable. "That was the start of getting rid of censorship in this country," proclaimed Harvey.

In 1956 the pair created Janus Films, an independent U.S. distributor that with Harvey's cinema smarts culled the gems of the great European directors during their most celebrated periods, before anybody was celebrating. They brought Stateside the first two films of a then-unknown Fellini. There was Antonioni and Truffault. There was *Summer With Monica*, "then of course we had every Bergman film for the next twelve years," Harvey said. Indeed, when *The Virgin Spring* won the 1960 Oscar for best foreign film, it was Cy Harvey who stepped onto the dais to collect the statuette and bring it to Bergman in person on his next trip to Sweden. Harvey sums it simply, "We had the first important library of films."

But perhaps the legacy most closely associated with the Brattle Theatre would be the revival of a certain mostly forgotten actor. "Bogart films were really rediscovered at the Brattle," said Woody Chapman, former employee, who explained Bogie's strange appeal as follows: "He's the imperfect little man, he's small, he's got a speech impediment."

On April 21, 1957, just a few months after the actor's death, the inaugural Bogart festival was launched at the Brattle. It was the beginning of a beautiful friendship, so to speak, between the film *Casablanca* and Harvard Square denizens, who would reward not only the theatre with loyal patronage but also two spin-off bars, The Casablanca and The Blue Parrot.

"It was my favorite," said Harvey in 1992. "I thought Bogart was probably the best American actor who ever lived." After a few showings, "The audience began to chant the lines. It was more than just going to the movies. It was sort of partaking in a ritual." People would cheer and sing the "Marseillaise." Actor and Harvardite John Lithgow said in 1990, "It was group therapy during exam periods. Like the kids do now with *The Rocky Horror Picture Show*, we'd recite all the lines from *Casablanca*."

Harvey's legacy at the Brattle continued even after he left for Connecticut in the early 1970s. But keeping it alive has not always been profitable and the theatre has fallen on hard times along the way. Under the stewardship of J. D. Pollack and Susan Hallack, the theatre briefly revived the performing arts in the mid-1980s, with ongoing shows by the Brattle String Quartet and Spalding Gray's New England premiere of his acclaimed

monologue *Swimming to Cambodia*. But under heavy financial pressure, the Brattle filed for Chapter 11 and in November of 1986 the screen, briefly, went dark.

Under the new management of Connie White and Marianne Lampke, slowly the Brattle emerged from bankruptcy. The pair instituted the now-familiar vertical programming scheme where each day of the week features a different film genre or director.

To mark the building's centennial, massive renovations begun in 1990 restored the edifice to its 1907 appearance, removing the awning, relocating the entrance to the lower level, and excising additions such as the former Casablanca and the

lobby. The exterior's aluminum siding was replaced with cedar shingles and brick, and the theatre boasted a new projection room and screen, new lamps, lenses, and bathrooms. In January of 1991, the Brattle triumphantly re-opened in the configuration familiar today.

It would be nice to think that a theatre such as the Brattle would thrive on packed houses of engrossed cinephiles night after night forever. The truth is that the Brattle, in order to keep to its acclaimed repertory programming in the face of diminishing audiences, has been forced to do so under the aegis of a nonprofit cultural foundation that requires fund-raising and patrons. It seems ever on the brink of extinction, and yet thus far has managed to survive. That it has is testament to the devotion of Ivy Moylan and Ned Hinkle, who took the reins in 2001 after several years as film-geek employees.

They put in a new screen and new carpets, floors, and seats, and instituted an emergency $400,000 fund-raising drive in 2005 to keep it operable. Though its future is never assured, many people stepped up to the plate and the Brattle is, momentarily, out of the woods. Why not just go home and watch *Blow Up* on DVD? As Hinkle explained, "To really get the full experience of a film you have to see it in a theater with an audience of strangers on a big screen with a bag of popcorn." Even Harvey allows it was an easier sale in his day. Times were different. "That was the golden age of cinema." [72, 76, 111, 148]

OPENING SOON!
New England's Finest Showcase for
FOREIGN FILMS
WATCH *for* OPENING DATE

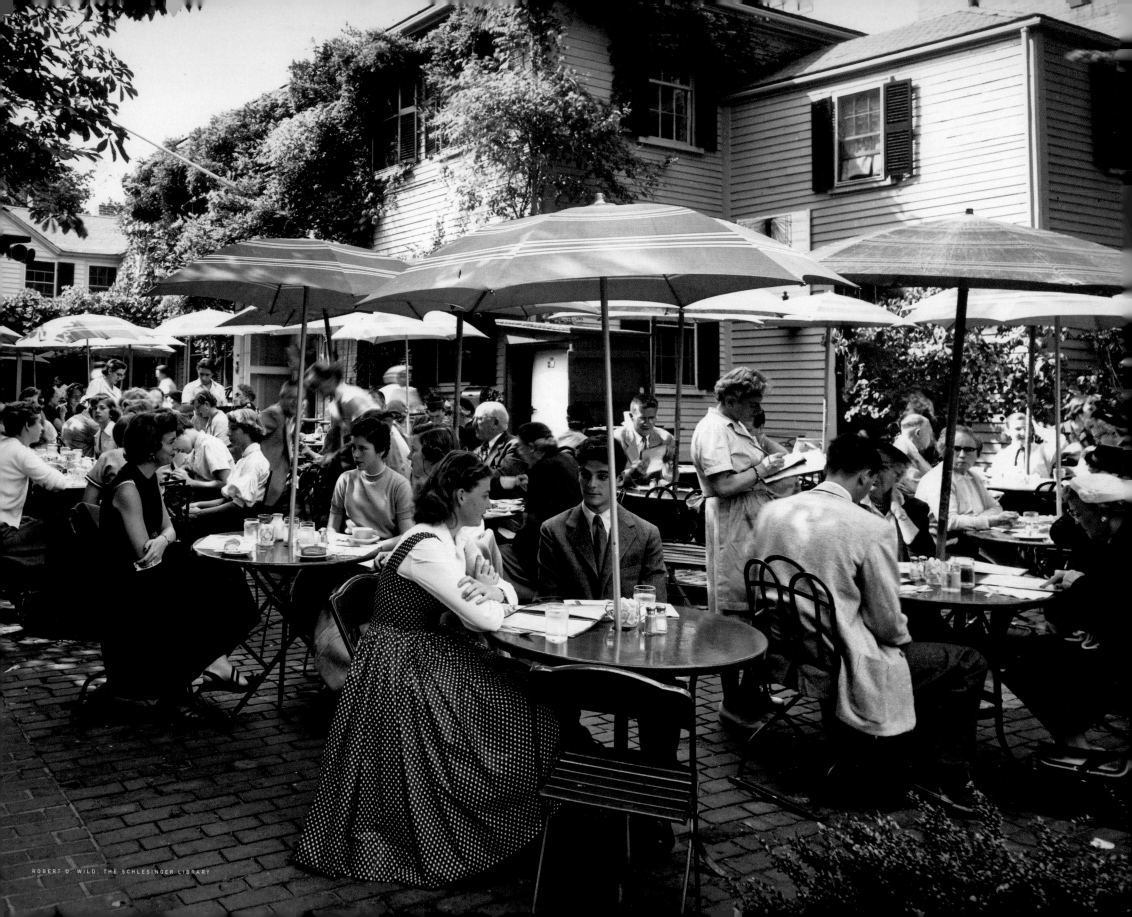

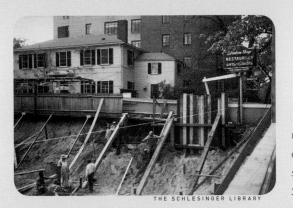

THE SCHLESINGER LIBRARY

brattle st.

A The Brattle Inn
B Stop & Shop
C Colonial Drug
D Sam Sing Laundry
E Eddy's Shoe Repair
F Hillside Cleansers
G The Window Shop

🔺 **1958** *Workers dig the foundation for a new brick edifice at 52 Brattle St., which will eventually house apartments and street-level shops. The Window Shop is in the background.*

◀ **1950** G *Eleanor Roosevelt, just a few years after the White House, visited the Window Shop and ordered cookies for her grandchildren. In the foreground is Elizabeth Aub, in the rear Alice Broch.*

THE SCHLESINGER LIBRARY

THE WINDOW SHOP

Anna
Freud, daughter of the famed psychiatrist, came into the shop one day. She preferred to remain incognito but her cover was blown by the dirndl she was wearing— one of several she had ordered through a friend and had sent over- seas. Sometimes a dirndl is not just a dirndl.

There is

more than meets the eye with the Window Shop, which served its last Sacher torte in 1972. This Cambridge institution was more than an authentic Viennese pastry shop, more than a sophisticated dress emporium, and more than a garden restaurant. It was a stepladder out of limbo for hundreds of refugees and immigrants who were able to escape holocaust or poverty.

The Window Shop was the brainchild of Harvard professors' wives who wanted to help European refugees assimilate, financially and culturally, into America. The shop would provide training, employ- ment, and assistance, through scholarships and grants, and in return the employees would bring their skills in dressmaking (and later crafts and baking), which the Window Shop purveyed to the masses. The assistance was modest but critical, allowing employees to, for example, work through the summer by providing funds for their children to attend camp.

The original one-room operation above The Oxford Grille on Church Street had a large window and not much else, thus the name. At its 1939 inception, the meager dressmaking income went to help students and their wives, but the mission gradually expanded to include refugees and immi- grants from all over the world. It was an informal place where a temporary job could turn into decades- long employment.

Ilse Heyman was an employee in the clothing department for 25 years who is a living example of the shop's legacy. She lost her family to the holocaust but survived Auschwitz herself through the compas-

sion of the Phillips Corpor- ation, which was subver- sively aiding the concen- tration camp victims. "Phillips saved my life and the Window Shop gave me a new life," said Heyman, who had to countenance anti- Semitism in a Boston factory job before finding refuge on the left bank of the Charles.

She cites Mary Mohrer as the creative engine that made the shop go. Mohrer, a Viennese teacher of languages and arts who managed the gift shop, unwittingly did the shop a big favor when she showed up to work in a dirndl, the typical Austrian peasant dress. When customers saw it, they asked for copies and a new fad was quickly launched. "Once they started to make the dirndls, they started to make money," said Heyman.

A move to a larger 102 Mount Auburn Street in the '40s allowed the Window Shop to introduce perhaps their most beloved product: the Viennese pastries. Goodies like Linzer cakes and Mozart tortes enticed European professors to reminisce, gastro- nomically, about their childhoods. "These things were very labor-intensive and they used only butter and the best ingredients," added Heyman.

But it was after the shop decamped to 56 Brattle in 1947 that it came into full flower. Now with a restaurant and perhaps the only patio seating in the Square, the Window Shop began offering European comfort food like goulash and schnitzel. Alice Cope became the third president and Alice Broch sewed together a large and explosive kitchen crew, itself a goulash of nationalities and experience. By the mid-'50s there were over sixty employees and hundreds of customers daily at its peak.

It was a favorite among Radcliffe administration and students alike, as well as visiting parents and afflu- ent Cantabrigian ladies. "It had that European flair to it," remi- nisced Frances Antupit, whose photo studio was above the Wursthaus for decades.

Eventually the shop, through its successes, became more commercial, and as the trade of handmade clothes waned, Mohrer traveled the world in search of fine garments. The dresses were unique and expensive. Then there was the beauti- ful Doris Hall jewelry, the Norwegian silver, the Swedish glassware, the pottery. "It was a treasure trove of just exquisite taste," said Heyman.

With Broch's departure in '64, the cuisine suffered and the Window Shop began a decline that led to its eventual closure in 1972. However, the scholarship fund continued for 15 more years, helping over 900 additional students transition to financial solvency. Often those grants would be eagerly paid back many fold by successful former recipients. Explained Heyman, "It was given in the spirit of humanity." (219)

DANIELA DAVIS DIRNDLS.COM

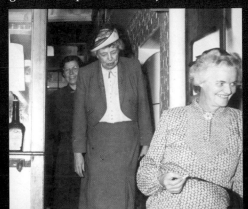

33 **1950s**

A Sage's Market
B Elaine-Claire Women's Clothes
C The Paul Revere Shop
D Church St. Garage
E St. Thomas More Book Shop
F Clark & Mills Electric Co./
 The Prep Shop

G Young Lee Restaurant
H Town and Travel Clothing
I Christian Sci. Reading Rm.
J First Church Unitarian
K Rizzo Tailor
L The Swiss Watchmaker
M Jean's Beauty Salon

N Campbell & Sullivan Fish
O Chez Dreyfus
P Brody Furs
Q Upper Story Gift Shop
R Cantabridgia Book Shop
S Oxford Grille

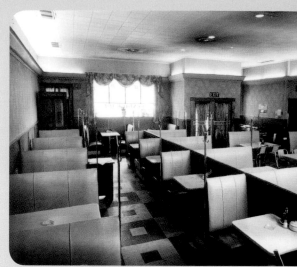

CAMBRIDGE HISTORICAL COMMISSION

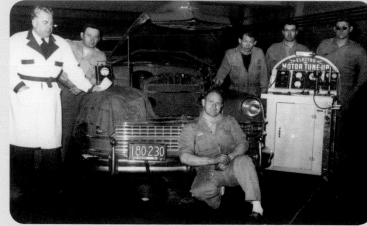

COURTESY OF BOB ADAMS, SOMERVILLE.COM

1953 G *Young Lee, later Young & Yee, offered basic Chinese food in this location from 1949 until 2001.* {79, 151}

c.1951 D *Mechanics pose at the Church Street Garage.* {117}

1953 O *Chez Dreyfus was one of the few upscale spots in the '50s. Monsieur Dreyfus poses in the dining room (left).* {117}

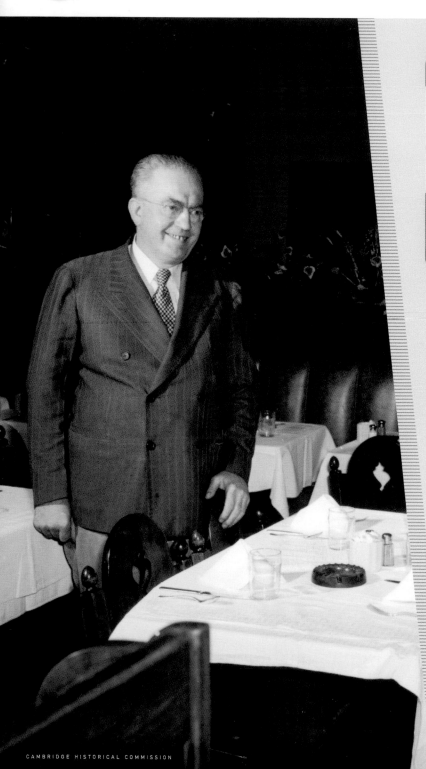

CAMBRIDGE HISTORICAL COMMISSION

Chez Dreyfus

FRENCH CUISINE

MENU

44 CHURCH STREET · CAMBRIDGE · MASSACHUSETTS
KIRKLAND 7-4311

CAMBRIDGE HISTORICAL COMMISSION

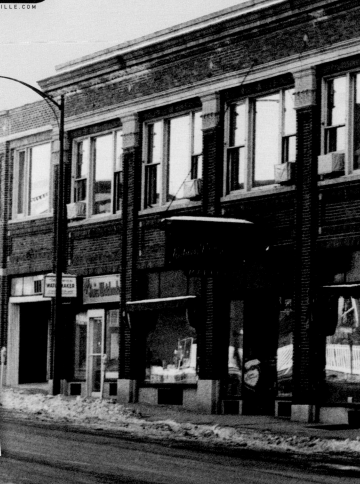

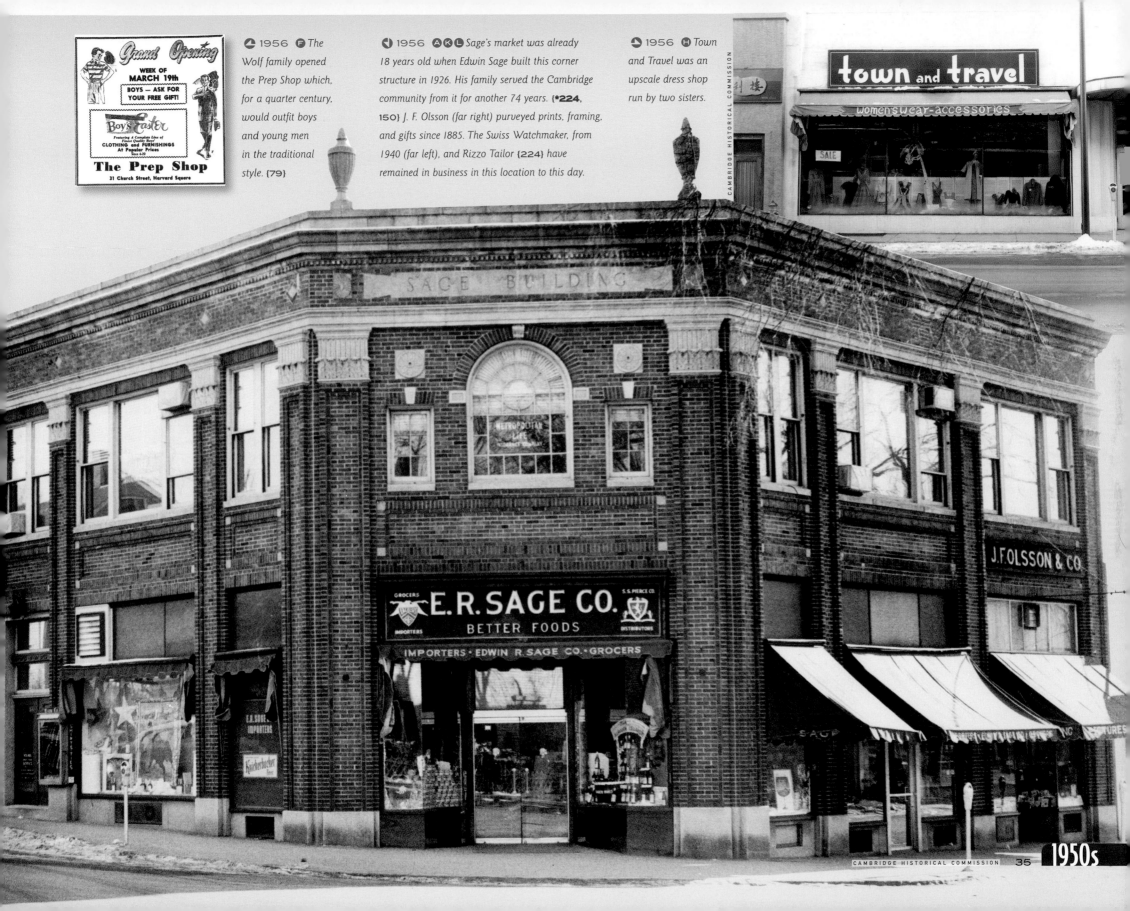

1956 **F** The Wolf family opened the Prep Shop which, for a quarter century, would outfit boys and young men in the traditional style. {79}

1956 **A** **K** **L** Sage's market was already 18 years old when Edwin Sage built this corner structure in 1926. His family served the Cambridge community from it for another 74 years. {*224, 150} J. F. Olsson (far right) purveyed prints, framing, and gifts since 1885. The Swiss Watchmaker, from 1940 (far left), and Rizzo Tailor {224} have remained in business in this location to this day.

1956 **H** Town and Travel was an upscale dress shop run by two sisters.

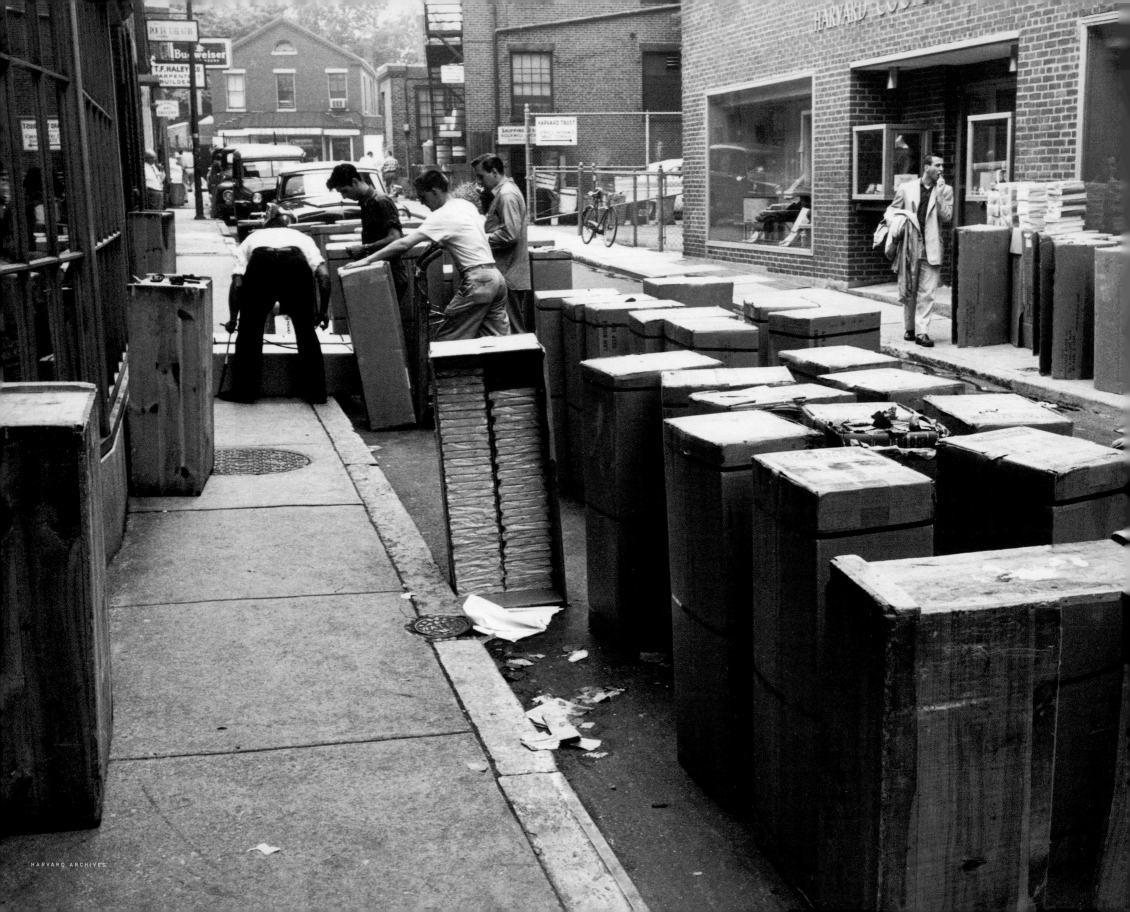

1959 Books are unpacked at the back of the Coop. {24, 26, 66, 104, 118, 152, 177, 210}

CAMBRIDGE HISTORICAL COMMISSION

Ⓐ Paul Shuster Art Gallery
Ⓑ The Poets' Theatre

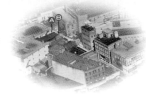

PETER SOLMSSEN RADCLIFFE ARCHIVES

1955 These small brick buildings would all be razed for the Coop's annex in the mid-'60s and Palmer Street would become pedestrian-only.

c.1951 Adrienne Rich was one of many successes to come out of the Poets' Theatre.

1950 Ⓑ The Poets' Theatre's whimsical logo was typical Edward Gorey.

In a small

brick building down a back alley in the hidden heart of Harvard Square, something unusual was brewing. In 1950, the greatest English-language poets of a generation were gathering with the rather audacious idea of creating a dramatic outlet for their new masterworks. The Poets' Theatre, with hopes of an Elizabethan-style verse renaissance, was born.

Like most youthful, idealistic, creative endeavors this one was replete with unbalanced ledger sheets, infighting, sexual politics, and homemade posters. Unlike most such undertakings, the homemade posters were drawn by Edward Gorey and the founders went on to win Pulitzer prizes and become poets laureate.

It may be impossible to list all of the members of the Poets' Theatre, but among them were Dick Eberhart, Violet (Bunny) Lang, Donald Hall, Robert Bly, Lyon Phelps, John Ashbery, and Frank O'Hara. They were a disparate group with different ideas about what made for good writing or theatre, but they came out of a unique time when poetry in Cambridge and Boston was at full blossom. Robert Frost, Robert Lowell, and Archibald MacLeish were the established players, while fledgling arrivals such as Sylvia Plath, Anne Sexton, and Ted Hughes were just beginning illustrious (and in Plath's case, tragic) careers.

The tiny theatre held a capacity of 49; with no real backstage, the performers would often line up before their entrances outside next to garbage cans and change costumes in neighboring shops. Their collective indigence meant wearing many hats. Gorey, who would later gain fame through his deliciously morbid Victorian children's tales, was the set designer and graphic illustrator for the early works. Meanwhile everyone would be acting, accounting, painting, sweeping up—and occasionally jumping into bed with each other.

Nora Sayre, in her memoir *Grand Street*, explained how the theatre had a countercultural punch seldom found in the buttoned-down '50s. "The Poets' Theatre also had a congregational purpose—it was home for poets and performers in a period when artists were often classified as freaks, when academia was repressive, when homosexuality was regarded with horrified fascination."

Despite the DIY ethos, the Poets' Theatre succeeded in its artistic efforts. "No play, no verse drama or prose drama which we have done, too, would be produced in this theatre unless it met a certain minimum requirement of excellence in writing," said Lyon Phelps in 1958. That excellence was honed through the opportunity the theatre provided for poets to wood-

shed new works, to experiment, and to commune with audiences who would occasionally offer unsparing criticism. The acting was often exceptional, and the theatre debuted plays by Samuel Beckett, Archibald MacLeish, and William Alfred.

Fund-raisers and larger productions were often held off-site at Sanders Theatre, The Fogg Museum, or the Brattle Theatre, among other places. This allowed the PT to showcase such luminaries as Truman Capote, Mike Nichols & Elaine May, and perhaps most famously, Dylan Thomas, whose reading of "Under Milk Wood" in 1953 was his U.S. premiere.

After Lang, who some credit as the most driving force in the Poets' Theatre, passed at a tender 32 in 1956, things were never quite the same. Nonetheless, productions continued until a fire destroyed their tiny home. After a year's hiatus, the PT resumed in a new location for a few seasons. But by 1962 the initial run was over.

Whither the Poets' Theatre? Although the ideals of that first company endure, still bubbling to the surface with revivals, fund-raisers, and even several-season runs now and again, the cultural moment has passed. The wistful may take heart: Donald Hall was chosen, nearly 60 years after he helped found the Poets' Theatre, as the poet laureate of the United States.

1956 Ⓑ James Merrill's The Immortal Husband *unfolds on the PT stage.*

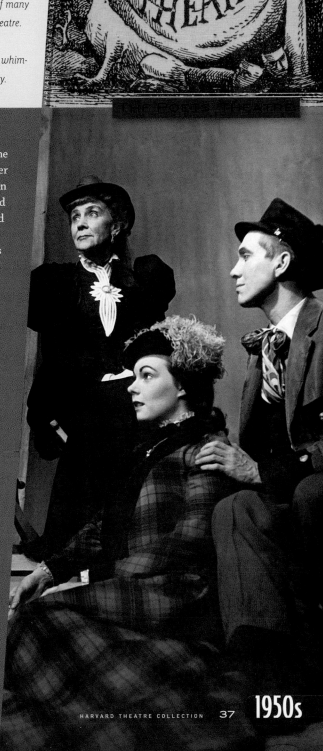

A Arthur Parker's Restaurant
B Cahaly Brothers Sundries
C Garber's Driving School
D Ryan's Sandwich Shop/
 Elsie's Lunch
E Sills & Co./
 The Andover Shop
F Tennis & Squash Shop

G *The Harvard Lampoon*
H Kent Roger Clothier/
 Starr Bookshop
I Capriccio/Café Mozart
J Gold Coast Valeteria
K Harry's Arcade/Tommy's Lunch
L Fournier Furniture Exchange/
 Club 47

lower mt. auburn st.

BERTHA COHEN

When "the witch

of Harvard Square" turned up dead on February 1, 1965, there was no state funeral, just a checking account with over one million dollars in cash—or so the rumor goes. Bertha Cohen, a diminutive woman with superlative credentials as one of Harvard Square's greatest eccentrics, had quietly amassed one of the largest real-estate empires in Cambridge.

How she did it is somewhat of a mystery, although her reputation as a niggardly slumlord was not. "It was Dickensian," said Club 47 co-founder Joyce Chopra of Cohen's 999 Memorial Drive basement work-room, replete with a finger-pointing Office sign. Piles of rent checks lay strewn about until she or her assis-tant, Mrs. Cahill, would enter them in the books by hand, reportedly under a 15-watt lightbulb.

Cohen, at no more than five feet tall, cut a memorable figure as a novella-caliber character study, with poor hygiene, ragged clothing, and a giant sour-smelling copper ring fixed about her neck that contained all the keys to her many properties. She was known to stockpile bottles and other refuse leftover from previous tenants. "She collected glass that she found beautiful from broken windows," added Chopra. A tough negotiator with seemingly nothing to lose, she rented her properties as is and let gravity and time have their way. "She would not spend a nickel on anything," said Ed Mank, another Cambridge real-estate developer.

She had emigrated from Poland at the age of 22 and began work in a Boston depart-ment store where a punishing frugality somehow allowed her enough paycheck savings to begin her foray into real estate. Her first purchase was the residential Strathcona Hall at 992 Memorial Drive, which was to be her home.

Mank recalled meeting with her to negotiate a never-inked sales deal in her filthy apartment where Cohen offered him and his associate apéritifs. "She served them to us brim-full but the glass was rimmed with soot. Conse-quently we tried to get her out of the room so we could throw it into the plants."

Despite her miserly, embit-tered, oddball reputation, Bertha Cohen did have some fans. "I've always had a soft spot for Bertha," said Chopra, who found that Cohen had been very supportive of her and her fledgling business.

Although she neglected her properties, she also kept the rents very low, which might have helped keep the Square affordable for as long as it was. Once she passed, some rents quintupled and businesses like Goodwill were forced to move or shut down. That may be why former renter Charlie Davidson proclaimed, "Bertha Cohen was one of the greatest things to ever happen to Harvard Square." {81}

ROGER BURKE, HARVARD ARCHIVES

◆ c.1952 E *Marty Sills of Sills & Co. appraises a length of fabric.*

Garber's AUTO DRIVING *School*

◆ 1950s C *Boston native Bernard Garber founded Garber's Auto Driving School in addi-tion to the nationally known Garber Travel.*

◆ 1950 F *Mount Auburn St. offers plenty of parking. This view, looking toward Holyoke Street, shows the familiar row of retail in the Manter Hall School building (with awnings) including the Tennis & Squash Shop, which is still there today. {82, 228} In the distance is the block which was demolished in 1960 for Harvard University's Health Center, the first stage of Holyoke Center. {59}*

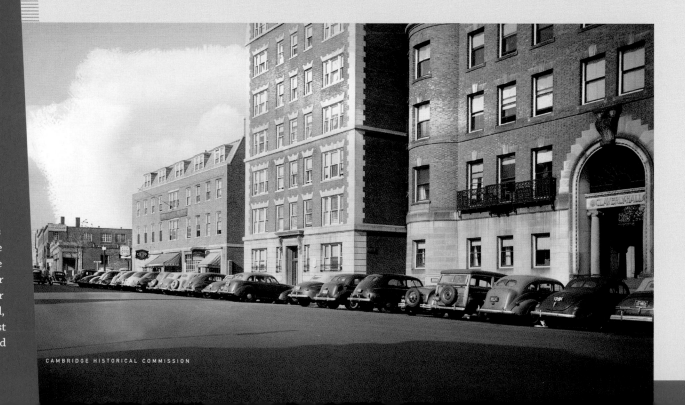

CAMBRIDGE HISTORICAL COMMISSION

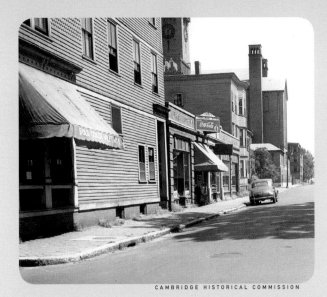

A c.1950 **J K L** *Benny Jacobson's Gold Coast Valeteria provided laundry and shoe repair for fifty years. The far half of the low building was Fournier Furniture Exchange until Club 47 opened in 1958. Harry's Arcade, later Tommy's Lunch, sits in between. {122}*

B 1958 **L** *Club 47, where Joan Baez was discovered, opens as a jazz venue. This is their original menu cover. {46, 80, 152}*

C 1958 **G** *A February snowstorm makes for tough going in front of The Harvard Lampoon. {82, 193}*

47 mount au burn 47 mount **jazz** *coffee house* rn 47mount auburn 47 mount auburn 47 mount aubur

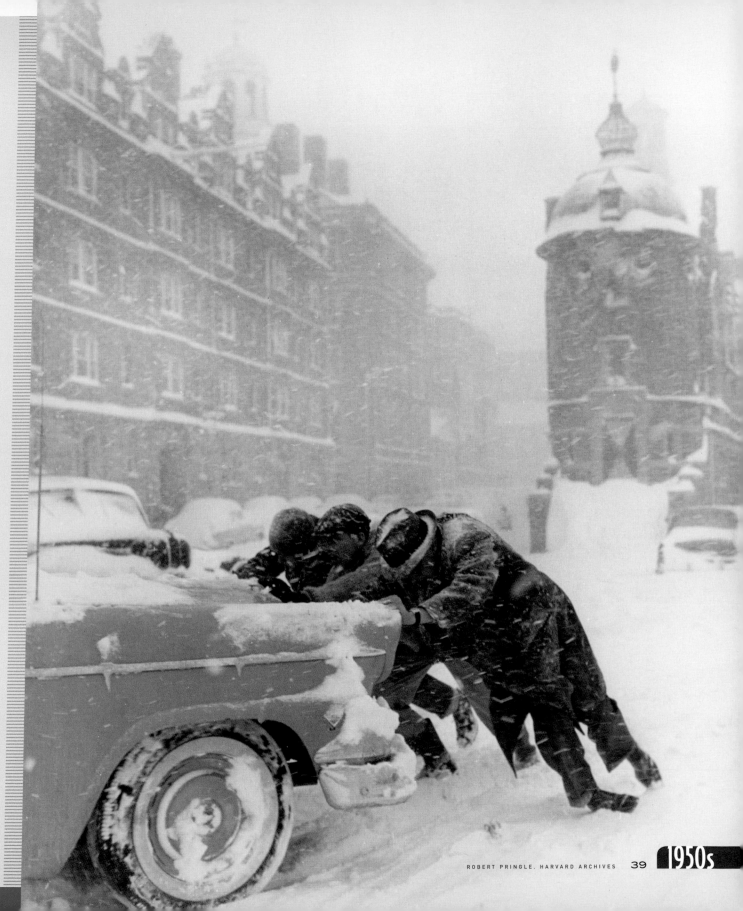

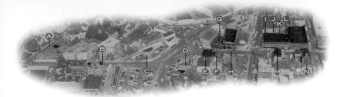

Ⓐ U.S. Post Office	Ⓗ Robie Auto Rental	
Ⓑ The Crimson Café	Ⓘ Harvard Square Garage	
Ⓒ Mobilgas	Ⓙ Tulla's Coffee Grinder	
Ⓓ McCartney's Garage	Ⓚ Joe the University Tailor	
Ⓔ Hamilton Liquors	Ⓛ CT Chin Laundry	
Ⓕ Barclay Club/Armenian Church	Ⓜ Harvard Provision	
Ⓖ The Cosmos Press	Ⓝ J. Press Clothing	

upper mt. auburn st.

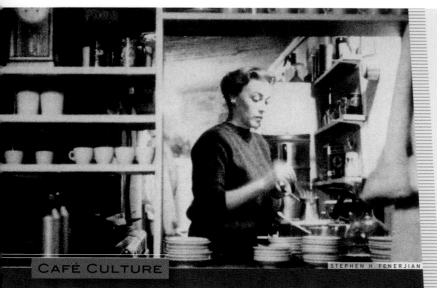

STEPHEN H. FENERJIAN

CAFÉ CULTURE

Harl Cook's

statuesque Norwegian wife (above) was the eponymous inspiration for Tulla's Coffee Grinder, a small, unpretentious café at 89 Mt. Auburn. Coffee was in her blood since her grandfather made a business of beans on shipping runs to Java. Cook called the Boston area "a hick town when it comes to coffee," something that could still be heard in the '90s, as Starbucks plotted its dark-roast invasion.

But the Grinder was brewing more than just espresso. It was an informal yet influential outpost for the stirrings of a music scene that was about to help reshape Cambridge's identity. Club 47, opened two years later, was inspired by Tulla's. So were the troubadours, like a teenage Joan Baez, who often wandered through the Grinder before they gained fame at the 47.

There were a handful of such spots near the Mt. Auburn axis that started gestating Harvard Square's bohemian proclivities toward the tapered end of the '50s. Patty Osnos's tiny Capriccio,

on Plympton Street, had chalk drawings on the walls, roaming guitarists, and fifty-cent coffees. It was replaced by Café Mozart, Morris Yarrow's refined offering which veered towards the classical, with antique furnishings and an authentic Russian samovar for tea-brewing.

In 1959, Café Pamplona opened at 12 Bow. It has stood the test of time, remaining in its perpetual cavelike austerity to this day. Owner Josefina Yanguas, with continental street cred, recognized the importance of the communal "third space" (neither home nor office) before marketers came up with the term. {45, 162, 195}

Although many of the spots proved ephemeral, collectively these hangouts became part of a lasting café culture. They demonstrated a European sophistication that Cantabrigians now jonesed for as much as their caffeine.

◐ 1953 Ⓑ *The Crimson Café was briefly part of a developing jazz scene until the Cambridge licensing commission shut down the music, which was outlawed in public bars at the time. When Cronin's was forced from Dunster St. in the early '60s this spot would become their new location.* {83}

CAMBRIDGE HISTORICAL COMMISSION

◐ 1955 Ⓒ *Mobilgas on the corner of Mt. Auburn and Eliot Streets was one of five gas stations located in Harvard Square. Now there are none.*

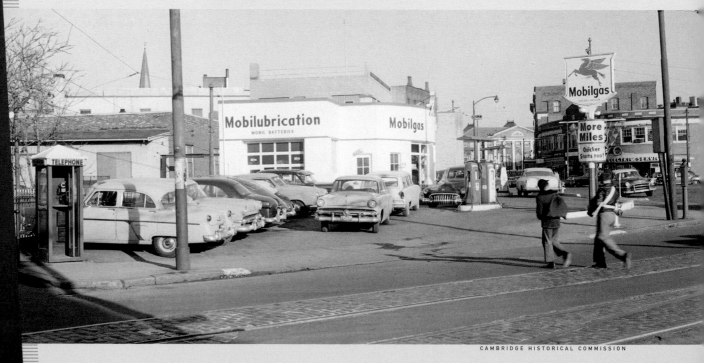

CAMBRIDGE HISTORICAL COMMISSION

eliot & bennett sts.

Ⓐ MTA Rail Yards/Car Barns
Ⓑ City Parking Lot
Ⓒ Domenico Carbone, Barber
Ⓓ Porter's Lunch
Ⓔ Gardner Rooming House
Ⓕ Grover Lawrence Spark Plugs

CAMBRIDGE HISTORICAL COMMISSION

◐ 1959 Ⓐ *A view of the rail yards looking southwest shows buses parked in perfect formation where the Charles Hotel stands today. {161} The tower in the upper right corner belongs to the monastery of the Society of Saint John the Evangelist.*

STEPHEN M. SCALZO COLLECTION

◐ 1959 Ⓐ *The Bennett St. Rail Yards were the resting place and service center for the enormous fleet of vehicles that made up the MTA's Cambridge-bound rolling stock. As the terminus of the subway, Harvard Square station hosted an average of over 44,000 riders daily during the 1950s, not to mention passengers of the numerous trolley and trolley-bus lines. The yard, although an eyesore, was a major source of employment and almost round-the-clock activity which contributed to the Square's vitality. It would eventually be replaced by Harvard's Kennedy School, JFK Park, and the Charles Hotel. {127, 158}*

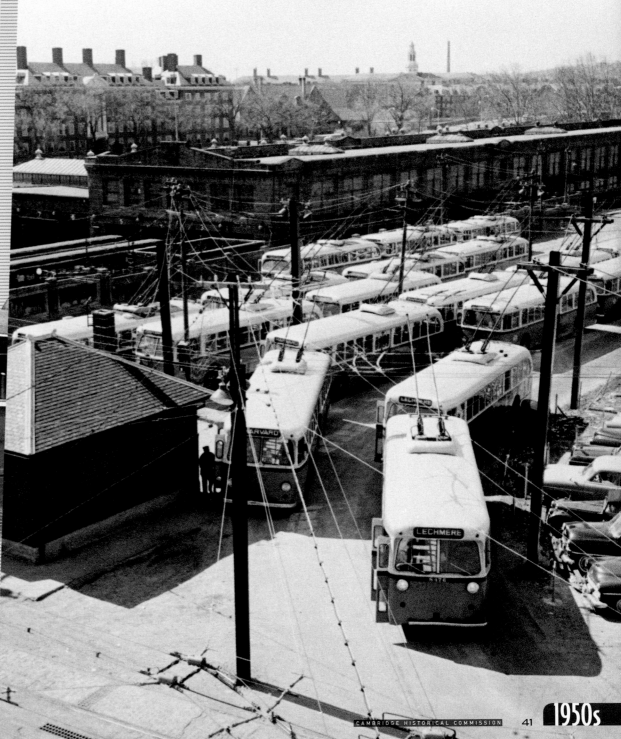

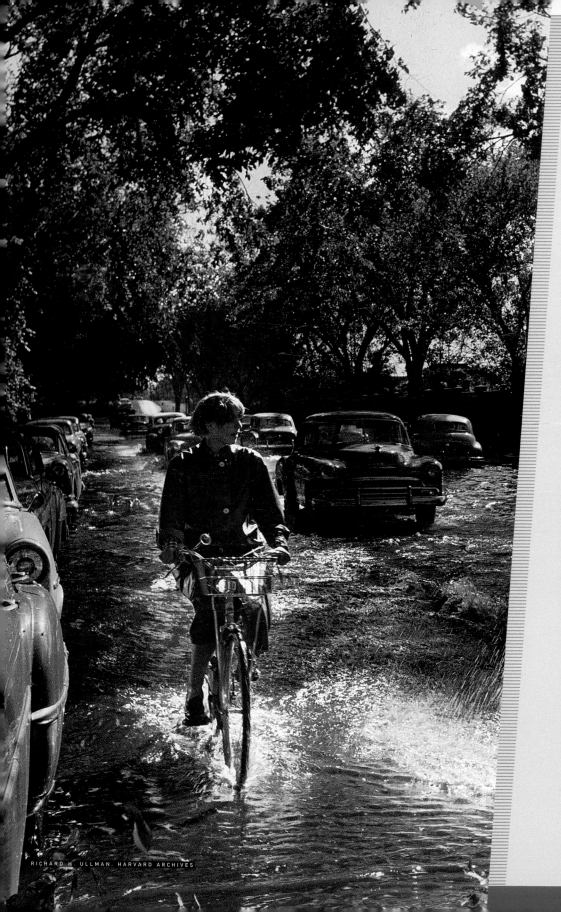

1954 A cyclist braves floodwaters in the wake of Hurricane Carol. The August 31 storm was one of New England's most destructive, with 80–100 mph winds.

1952 At The Mandrake Book Store, one could find brand-new philosophy, psychology, and art texts in fine leather- and clothbound editions. Proprietor Irwin Rosen (right) was both extremely knowledgeable and notoriously ornery. He distrusted his competition, frowned at paperbacks, and refused to even buy a cash register. The shop moved in the '70s from its 9 Boylston location to Story St., where it remained until his death in 1997.

boylston st.

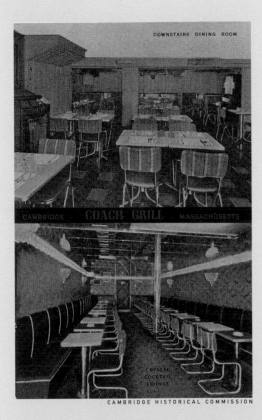

DOWNSTAIRS DINING ROOM

COACH GRILL

CAMBRIDGE · COACH GRILL · MASSACHUSETTS

CRYSTAL COCKTAIL LOUNGE

CAMBRIDGE HISTORICAL COMMISSION

➊ c.1959 *Boylston Street (JFK Street since '82) is a panoply of signs competing for attention.*

➋ c.1960s ⊙ *The Coach Grill was one of many unpretentious restaurant/ bars in the Square. It bowed out in the early '70s.*

➌ c.1950s Ⓐ *Howard Johnson's had two floors of dining and, long before his presidency, a young French soda jerk named Jacques Chirac. Also in this spot: Cardullo's short-lived Trattoria (with oyster bar and 112 cheeses).*

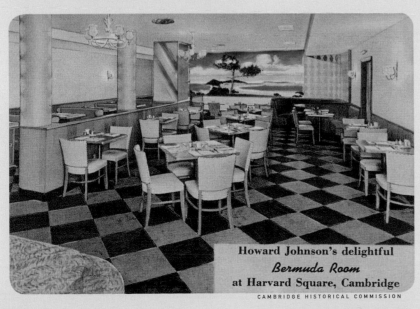

Howard Johnson's delightful
Bermuda Room
at Harvard Square, Cambridge

CAMBRIDGE HISTORICAL COMMISSION

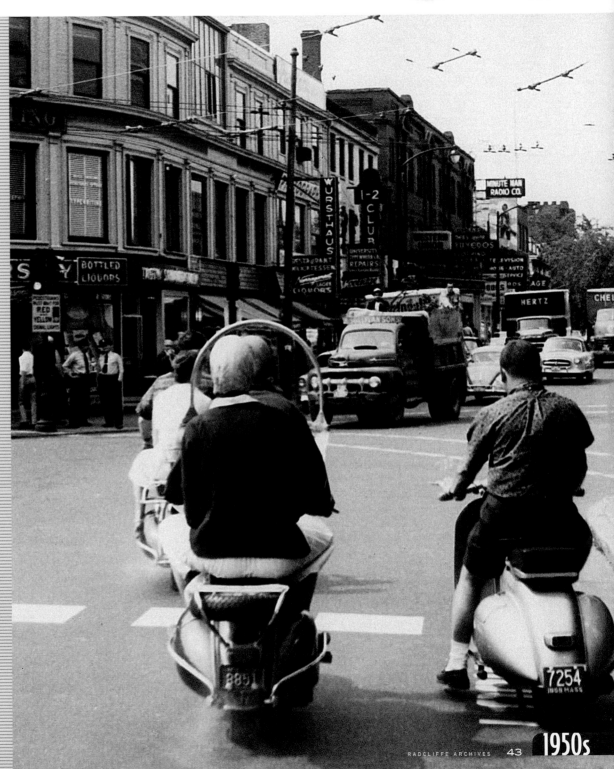

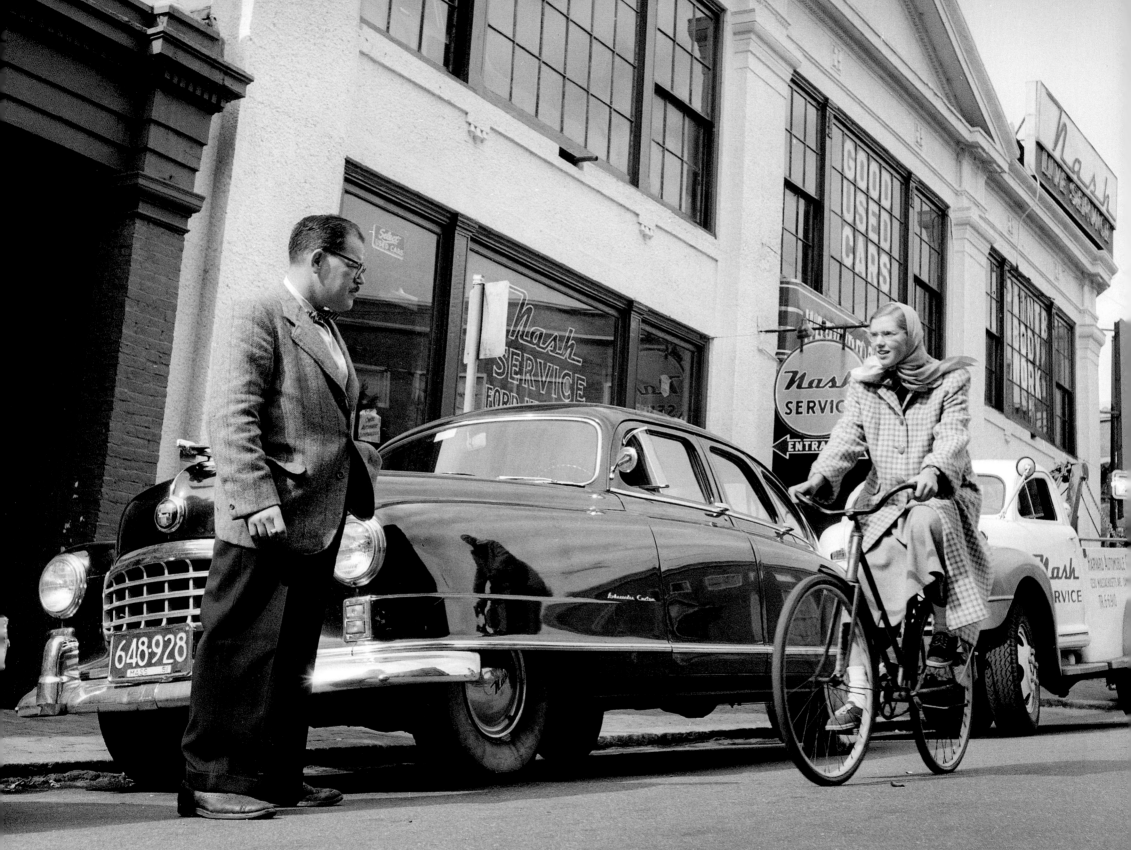

bow St.

Ⓐ The Bicycle Exchange
Ⓑ Sullivan Market / Café Pamplona

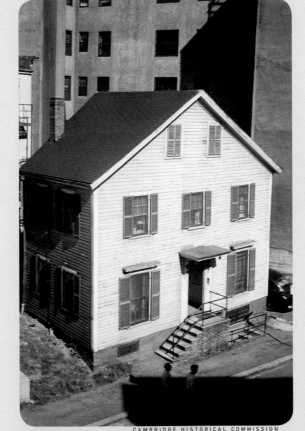

CAMBRIDGE HISTORICAL COMMISSION

◀ **1952** Ⓐ *Sam Miller worked as a mechanic at the Bicycle Exchange for many years.*

◀ **1952** Ⓐ *Ben Olken stands amid the merchandise of the business he devoted his life to.*

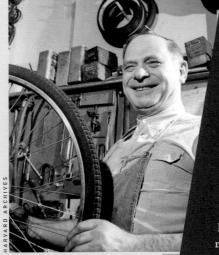

HARVARD ARCHIVES

HARVARD ARCHIVES

THE BICYCLE EXCHANGE

◀◀ **1949** Ⓑ *12 Bow Street was the home of controversial excommunicated priest Father Leonard Feeney before it was sold in 1957. Josefina Yanguas converted the small basement into the cultishly adored Café Pamplona, which remains there to this day.*
{40, 162, 195}

BOSTON PUBLIC LIBRARY

During

the annual Harvard-to-Wellesley Road Race, sponsored in part by the Bicycle Exchange, there was always one particularly determined competitor. "My dad made up a bike for him," explained Richard Olken, "and he'd just ride one-footed." It seems Tom Grove only had one leg. "He was a fantastic athlete."

Understand,

a bicycle in 1932 was a novelty item often with wooden rims; the average adult didn't know how to ride one, let alone a six-year-old. At that time, Ben Olken was a young entrepreneur whose new business, The Student Exchange, was making small coin selling law notebooks and rehabbed items out of a basement. But it was the bicycles that ultimately inspired Olken; he learned about them, he found them, he fixed them, and with the newly renamed Bicycle Exchange, he pedaled them into the American mainstream.

Within a few years, Olken owned number three Bow Street and was the first permanent Raleigh dealer in the United States. Systematically, he began breaking down the barriers to acceptance, first with lessons and rentals (25¢ an hour), then by importing and distributing the best bikes. In 1951, he traveled to England, where he discovered Dawes cycles and was one of the first to bring European-style racing and touring bikes to this country.

Olken's love of two-wheelers was not limited, however, to the pedal-powered variety. In '56 he became the first distributor of Italian motor scooters. Through the '60s, Harvard Square became a center of mopeds in the United States with Lambrettas, Ducattis, and BMWs sizzling down Bow or Brattle.

Meanwhile, Ben's son Richard, who had worked in the shop since barely a teenager in 1958, took over day-to-day operations in 1973, just as the bicycle boom was hitting the streets. Fifteen hundred bikes flew out the door of the shop in '72. In '74, at the peak, it was five times that number. Cycling had arrived, and in the Northeast, much of its itinerary had been planned by the Bicycle Exchange.

What to do in the off-season? Picture two cyclists pedaling furiously, neck-and-neck, in an all-out, one-kilometer sprint. Except you pass them easily on foot to pay for your inner tube at the cash register. That was Thursday evenings in the '80s, where hard-core competitors could keep their racing skills honed on custom-made indoor stationary racing machines with rollers and optical scanners. Leading-edge, high-end equipment was the rule; in that mesozoic pre-Lycra era, you could even protect your goods in chamois-lined soft-wool racing shorts (suspenders optional).

Today if you stand on the corner of Mass Ave. and Bow you might see an inconspicuous sign proclaiming it "Ben Olken Corner," tribute to the workaholic people-loving entrepreneur who put New England on wheels. "The biggest source of pride for him was the people who worked here and went on to be something," says Richard Olken of his dad, "That was the legacy that he liked the best." {5}

1950s

I GREW UP as a faculty brat at one so-called preparatory school and attended another, but arrived in Harvard Square supremely *un*prepared—for anything. For the academic rigors (in the case of some of the more ossified professors, rigors mortis), for the culinary wasteland, for unsupervised life in general.

The Square was tidy (graffiti had not yet been invented, though the layer-upon-layer of event flyers on every vertical surface had something of the same effect) but downscale, not the resplendent beacon to consumerism that it has become. I would describe it as "drab."

There really were no decent restaurants providing respite from the cafeteria. The Hayes Bickford's was decidedly Formica and fluorescent. (A particularly thrifty friend pointed out to me that hot water, ketchup, salt, and pepper were free there, and one could make a sort of tomato soup with them. It made me appreciate the cafeteria.) Tommy's Lunch? The name says it all.

The Club 47 Mt. Auburn was the center of my personal map of the universe, that bulge in the Einsteinian space-time continuum. A block from my digs at Leverett House, it provided an irresistible alternative to studying. There, in this little eighty-seat room with the fogged-up windows, one could sit literally at the feet of the greats of folk music, blues, bluegrass—Bill Monroe and the Bluegrass Boys, Flatt & Scruggs, Sleepy John Estes, John Hurt, Jesse "Lone Cat" Fuller, Bukka White, Peggy Seeger, and Ewan MacColl. The feast was endless.

They also hosted the local folkies, players from all walks of life—a typewriter repairman, a psychopharmacologist (a real, not recreational, one), salesmen, self-professed "housewives." Then there were the students from privileged backgrounds, singing with quasi-religious fervor about the travails of work in the coal mines, picking cotton, life on the chain gang. The incongruity was inescapable, but could be finessed with sufficiently intense sincerity. A membership at the Club 47 was the musical equivalent of a year in the Peace Corps. The songs were great, and the scene that flourished in that tiny room influenced the music of the world.

1967 *Pedestrians mob the crosswalk to the subway kiosk in what has become a familiar scene.*

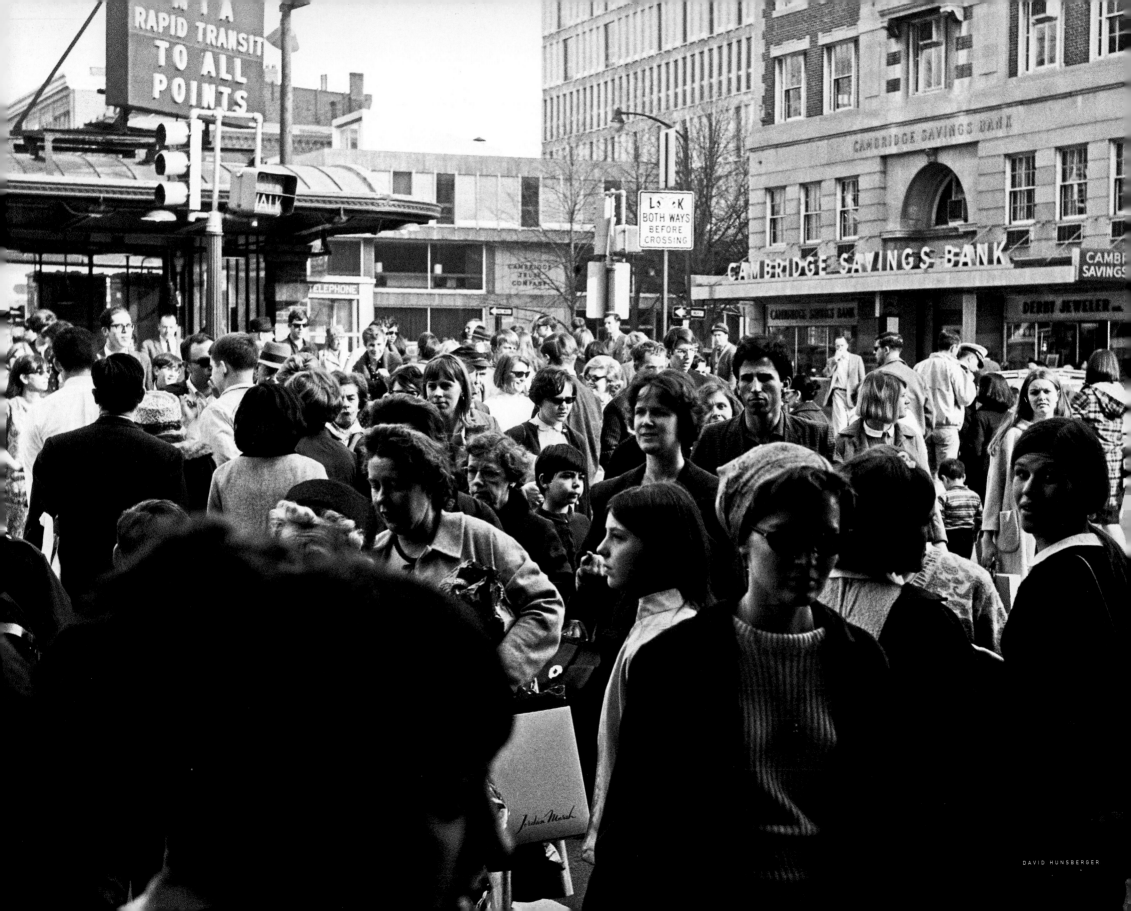

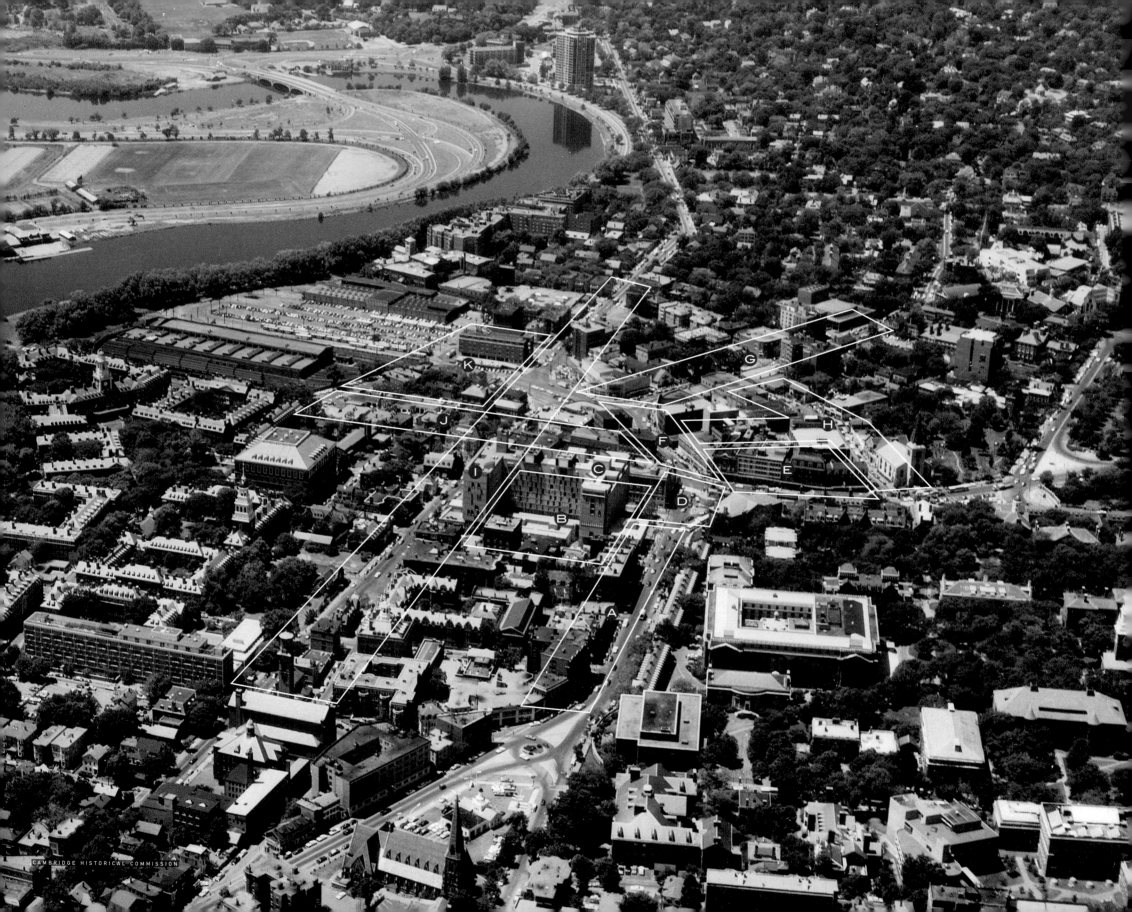

Ⓐ Lower Mass. Ave.

Ⓑ Holyoke & Dunster Sts.

Ⓒ Holyoke Center

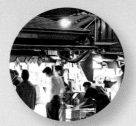
Ⓓ The Center

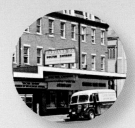
Ⓔ Upper Mass. Ave.

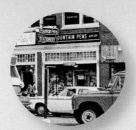
Ⓕ Lower Brattle St.

"EVERYTHING CHANGED

after the '60s. OK? For everybody in the whole country," said Janet Cahaly, longtime resident and merchant. Harvard Square itself cannot take credit for those changes, but it distilled and embodied them. There were perhaps three or four places in the nation that became magnets for culture, thought, and disaffected youth. Harvard Square was one of them. The Square came into its own, arguably the most dynamic version of itself, so much so that decades later some still set store by this high-water mark only to be continually disappointed by the iterations that have followed.

It was an exciting time that featured both the best and worst of civilized society—new journalism, vital music, free-spirited discourse, and bohemian style, right alongside drug abuse, vagrancy, generational discord, and political violence.

The intellectualism synonymous with Cambridge had a popular currency that it would later lack. At the decade's first blush, "the best and the brightest," young Cambridge-educated idealists, set up a virtual D.C. branch of Harvard, with their own John Kennedy in the ultimate seat of influence. By decade's end, two Kennedys were dead and that phrase was soon to be coined in irony by another Harvard man, David Halberstam, in his scathing exposé on the war in Vietnam. The war would rend society and even Harvard Square in two, with demonstrations and bloodshed both on and off campus.

In between, Harvard Square discovered drugs and music and culture from all over the world. Then the world discovered Harvard Square. "What you've got to understand about the square is that it isn't a place. It's a thing. You know what I mean? Like Stratford-on-Avon. Sure, it's on a map, and there are even roads leading to it. But it's really a poem, not a town," spoke a suitably far-out student in a 1969 *Holiday* article.

Harvard Square was suddenly the hip place to be, and it was absolutely mobbed. Funky boutiques, purveying sandals to candles, proliferated. "You could go to Harvard Square any time of the day or night and get something to eat, go hang out at a bookstore literally all night long," remembered Charlie Sullivan of the Cambridge Historical Commission. A *New Yorker* quote of the time was emphatic: "Cambridge is a great center—as great, perhaps, as any in the world now. It has a strange magnetism."

That magnetism lured musicians, who basked in the glow of the nation's premier folk venue, Club 47, or later, rock concerts in Harvard Stadium and on the Cambridge Common. Van Morrison would compose his seminal album *Astral Weeks* while living on Green Street in 1968.

The Square also enticed throngs of bored local and suburban kids with sometimes-illicit excitement and intrigue. Christine Williamson was among the more innocent of the circling teens seeking to slake their many appetites. "There were drugs on every corner, and there were drug dealers on every corner," she remembered. The beat cop hassled and prodded. "He used to follow the kids around and say, 'Screw you, maggots,'" she recalled. But it was a losing proposition; they were everywhere.

As the curtain fell on the '60s, Harvard Square found itself utterly transformed into a countercultural mecca, a simmering stew of intellectuals, artists, musicians, drifters, and activists. With that transformation, it permanently ceased to be a quiet little college town and became a destination. The echoes of that transformation are still felt to this day.

Ⓖ Upper Brattle St.

Ⓗ Palmer & Church Sts.

Ⓘ Mount Auburn St.

Ⓙ Boylston St.

Ⓚ Winthrop & Eliot Sts.

THE 1960s

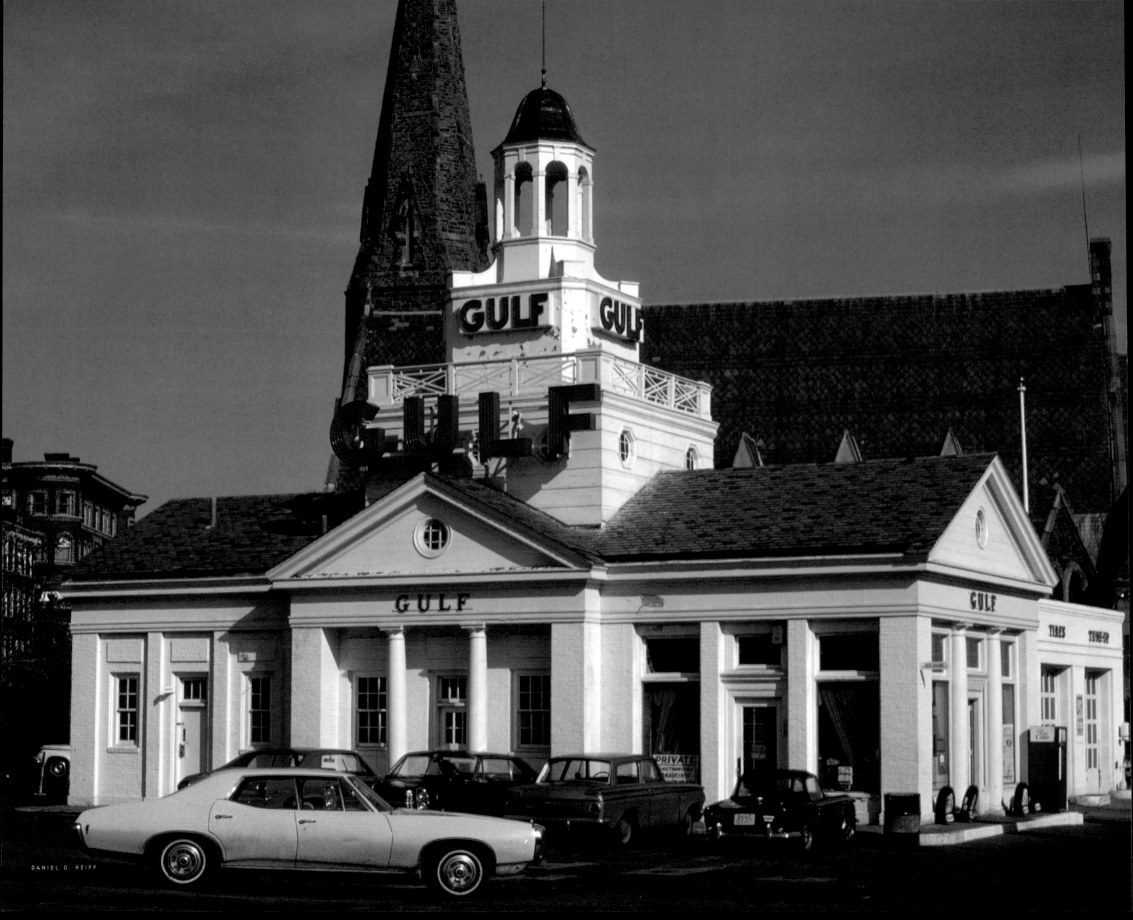

Ⓐ Gulf
Ⓑ Lewandos
Ⓒ The Hong Kong
Ⓓ Bartley's Burger Cottage
Ⓔ Harvard Book Store
Ⓕ Ferranti-Dege Cameras
Ⓖ Williams Clothier/ Krackerjacks

Ⓗ Briggs & Briggs
Ⓘ University Restaurant
Ⓙ Schoenhof's Foreign Books
Ⓚ Stonestreets Clothing
Ⓛ Pangloss Book Store
Ⓜ Bob Slate, Stationer
Ⓝ Claus Gelotte Cameras

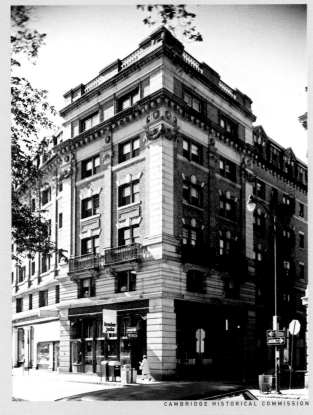

CAMBRIDGE HISTORICAL COMMISSION

⏺ 1964 Ⓐ *If gas stations went to college. the Gulf at the edge of Harvard Square would have graduated summa cum laude.* {132}

⏺ 1965 Ⓘ *A March snowstorm falls outside the Chaprales brothers' University Restaurant.*

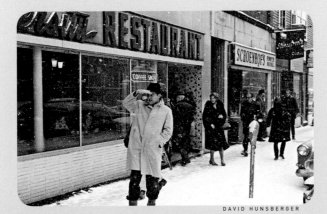

DAVID HUNSBERGER

HUGH BLACKMER

⏺ 1968 Ⓖ *Krackerjacks was an upscale boutique trying to cash in on counterculture chic. much to the resentment of the actual counterculture.*

⏺ 1964 Ⓕ *Ferranti-Dege founder Tony Ferranti makes an adjustment to a lens in the popular camera shop. which he ran for more than a half century.* {15, 92, 95, 98}

⏺ c.1964 Ⓓ *Florence gets ready to take an order at Bartley's.* {92, 200}

HUGH BLACKMER

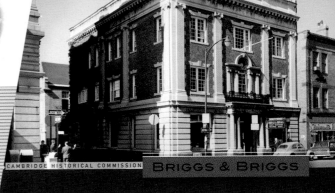

CAMBRIDGE HISTORICAL COMMISSION

BRIGGS & BRIGGS

Fred Humphreys

—whose grandfather, Herbert Olson, bought out the place in 1927—figures Briggs & Briggs was one of the oldest record stores in the country. "There was about a seven-year span between when [records were] invented and when we were selling them." Those newfangled shellac discs made up just a portion of the items that the musical Briggs brothers hawked from their shop, one of the most enduring in Harvard Square's history. After opening near Church Street in 1889, the emporium soon moved to the corner of Massachusetts Avenue and Plympton, where it kept Greater Boston supplied with sheet music, radios, and instruments for the entire twentieth century.

Olson's angle was pianos—he tuned, repaired, and sold them. When he passed away in 1938, his son-in-law, Ormand Humphreys, took over the business and ran it for the next 53 years. After World War II, the elder Humphreys decided to put a room in the basement to showcase the merchandise, "like a living room," explained Humphreys. A person could chill out, try the TVs and radios, or best of all for a low-budget student with time to kill, sample 78s in one of the audio booths. The latter were so popular that lines of waiting listeners often formed.

By the mid-'60s, when Fred and his brother Paul were both working the store, LPs came shrink-wrapped, so the booths disappeared. But another craze detonated: "When the folk boom came along, everyone had to have a guitar." They sold $65,000 worth of them in 1965-66. They also did a smaller business with instruments like flutes and trombones and even for a little while, sitars.

It was not the only music store in the area, but as Humphreys explained, "If a teacher in Framingham wanted a student to get a particular Haydn sonata for piano, there were very few places to get it." Briggs & Briggs soon became the sheet-music capital of the region. It was the kind of offering that made the Harvard Square of yesteryear a specialty shopping mecca, a status it may be difficult for newcomers to appreciate.

In 1999, Briggs & Briggs parted, leaving Harvard Square without any place to get a kazoo, trumpet, or complete score to Steely Dan's *Kid Charlemagne*. The rent had gotten expensive, but the whole model of music retail had changed, and such stores faltered everywhere. Bringing Beethoven home in the old days meant stacks of platters. Said Humphreys, "Now you can put the whole nine symphonies in a little box." {12, 133}

⊿ 1965 *Signs entice but traffic is thin on a July day.* {*203}

⊿ 1967 *Even banks started getting groovy in the late '60s.*

⊾ 1961 Ⓑ *The Harvard Barber Shop, from 1915, was one of many long-standing businesses on lower Mass. Ave.*

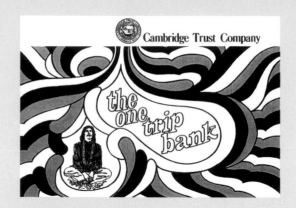

Cambridge Trust Company

the one trip bank

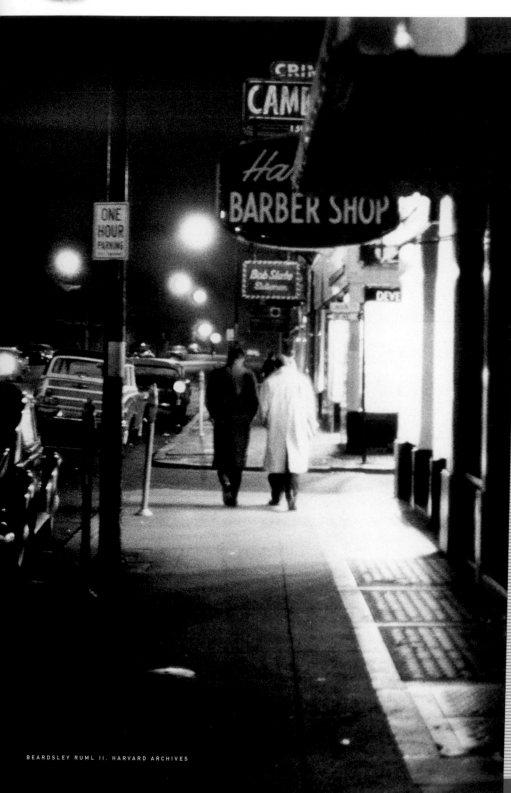

BEARDSLEY RUML II. HARVARD ARCHIVES

DR. TIMOTHY Leary, famed

for his promotion of hallucinogens and alternative lifestyles, fittingly set up shop at, and was summarily booted from, Harvard. "Tune in, turn on, drop out" could have been a travel-brochure slogan enticing thousands of disenchanted youth to migrate through Cambridge. Though diverse, they each arrived for their own coming-of-age chautauqua, an anticollege of sorts, which could include renouncing their middle-class backgrounds; experimenting with or abusing mind-altering substances; panhandling or pilfering; sneaking into Harvard lectures; chilling in crash pads, parks, or sidewalks; and leaning on the easy but sometimes superficial acquaintances of like-minded souls.

"Hangers-on in Cambridge enjoy solid status," described the *New York Times*, "and one can see them almost everywhere, blocking the sidewalks and doorways in eternal demonstration of their reluctance to leave wherever they are or whatever it is they are doing." *Time* magazine called them "The Womb-Clingers," and they were to become a regular feature of Harvard Square for decades.

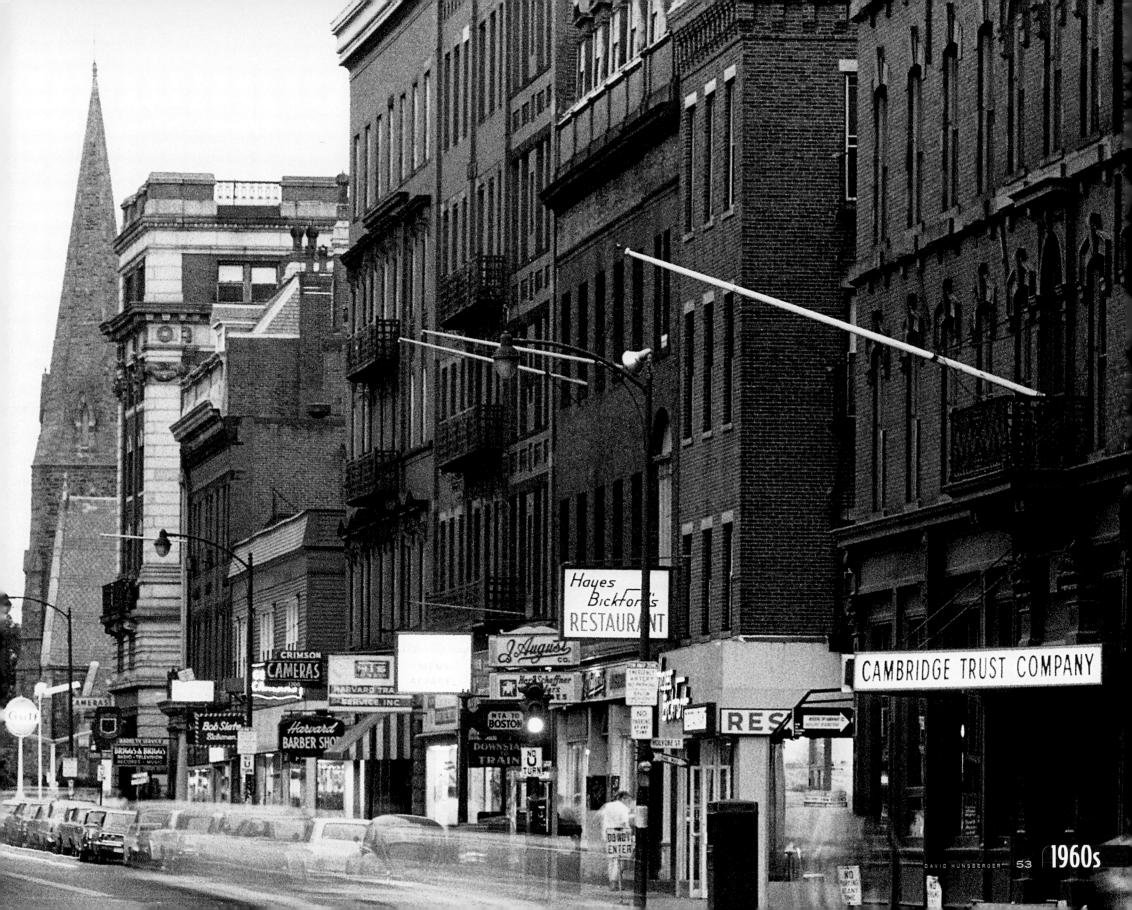

CRIMSON CAMERAS

Hayes Bickford's RESTAURANT

J. August CO.

Hart Schaffner Marx

CAMBRIDGE TRUST COMPANY

HARVARD TRA SERVICE INC

Bob Slate Stationer

BRIGGS & BRIGGS RADIO · TELEVISION RECORDS · MUSIC

Harvard BARBER SHOP

MEN'S APPAREL

MTA TO BOSTON

DOWNSTAIRS TO TRAIN

NO TURN

RES

NO PARKING AT ANY TIME

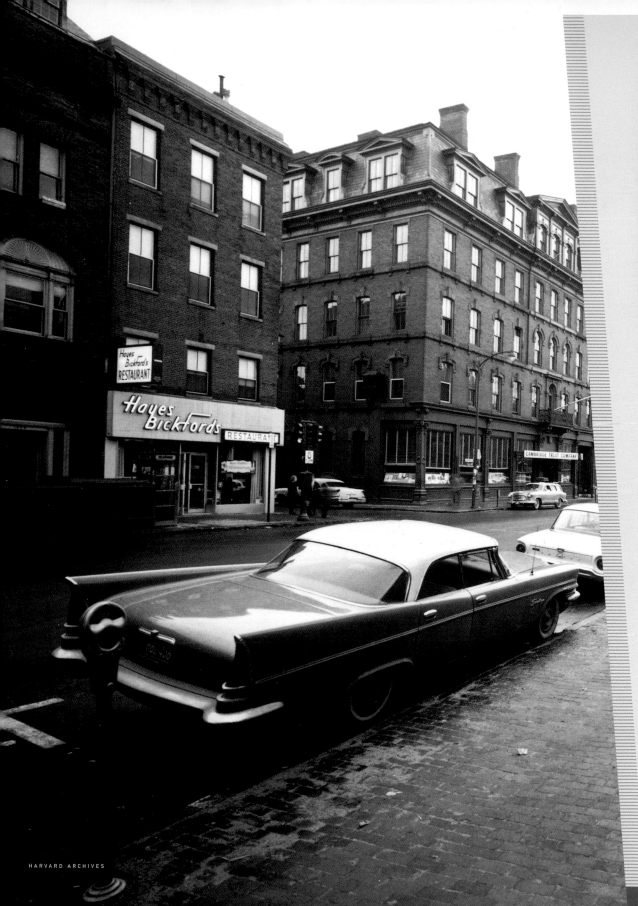

HUGH BLACKMER

🔺 1963 Ⓗ *Fins are not the only thing on their way out. The block to the right of Hayes Bickford's is about to be razed for Holyoke Center.* {17, 59}

◀ c.1964 Ⓕ *The Indian is already a century old in this pose alongside the manager of venerable tobacconist Leavitt & Peirce.* {14, 95, 168, 169, 202}

🔻 1964 Ⓐ *Phil Levine chats on the phone in his shop, Crimson Camera, at a time before indoor smokes were a no-no.*

HUGH BLACKMER

lower mass. ave.

Ⓐ Crimson Camera
Ⓑ Harvard Barber Shop
Ⓒ Felix
Ⓓ Harvard Travel Service
Ⓔ Bolter Co. Menswear
Ⓕ Leavitt & Peirce
Ⓖ J. August
Ⓗ Hayes Bickford's

BEARDSLEY RUML II, HARVARD ARCHIVES

Bickford's Buddha

Some days I'm afflicted

with Observation Fever

omnivorous perception of phenomena

not just visual

like today in Bickford's Harvard Square

sitting still seeing everything

watching a lot of beautiful animals

walk by

turning & turning in their courses

A goofy chick at the next table

just escaped a psycho ward

telling everyone she's "a lost squirrel"

and the manager kicking out hippies

and Cambridge Deacon Hell's Angels …

© 1968 LAWRENCE FERLINGHETTI

"There is

something refreshingly obscene about the Bick at three in the morning," said the *Harvard Crimson* in 1967. The Hayes Bickford's (familiarly known as "the Bick" or, during a certain era, the Hayes Beatnik) became the de facto hangout for all-night bull sessions and cheap, unspectacular meals. English muffins were the specialty, but a cup of coffee would be enough to buy you an hours-long seat at the cafeteria where gas station attendants, Harvard professors, hippies, and grand-mothers would mix, sometimes uncomfortably.

The price point and the hours of opera-tion—24 of them daily for most of its existence—were the draw, but there was something else to be had at this particular location. Bob Siggins, a member of the folk group the Charles River Valley Boys, remembered it thusly: "People were falling in and out of that place. It was like Gertrude Stein's without the host."

Hayes Bickford's was in actuality a rather large regional chain of cafeterias, one of several (Albiani's and the Waldorf being two others) that coexisted in Harvard Square for many years. "But," explained Herb Hillman, longtime Square merchant, "the Harvard Square Hayes Bick was not like any other."

That particular mix of clientele and conversation may be what helped the Harvard Square Bick wheedle its way into a number of pop-culture references before it shuttered in 1970. It's mentioned in a handful of books, including *A Beautiful Mind* by Sylvia Nasar. Ryan O'Neal gazes through its plate glass windows looking for Ali McGraw in a memorable scene from *Love Story*. And perhaps most fittingly, it was enough to inspire beat poetry—Lawrence Ferlinghetti's *Bickford's Buddha*. {14, 15, 46, 53}

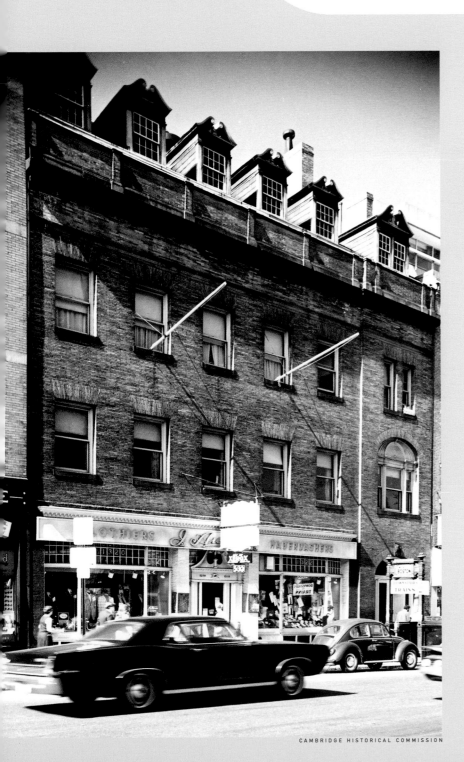

CAMBRIDGE HISTORICAL COMMISSION

🕐 1968 Ⓖ
Stalwart J. August continues to sell clothes as it has done since 1891. {14, 95, 203}

🕐 1962 Ⓕ *Influential cartoonist, Cambridge resident, and avid smoker Al Capp of Li'l Abner fame enlists Moonbeam McSwine as spokesvixen for Leavitt & Peirce.*

AH SMOKES 'CAKE BOX MIXTURE', EVEN THOUGH AH HAIN'T A HARVARD MAN—NOR NEVER EVEN MET ONE.!!

© CAPP ENTERPRISES, INC.

55 | 1960s

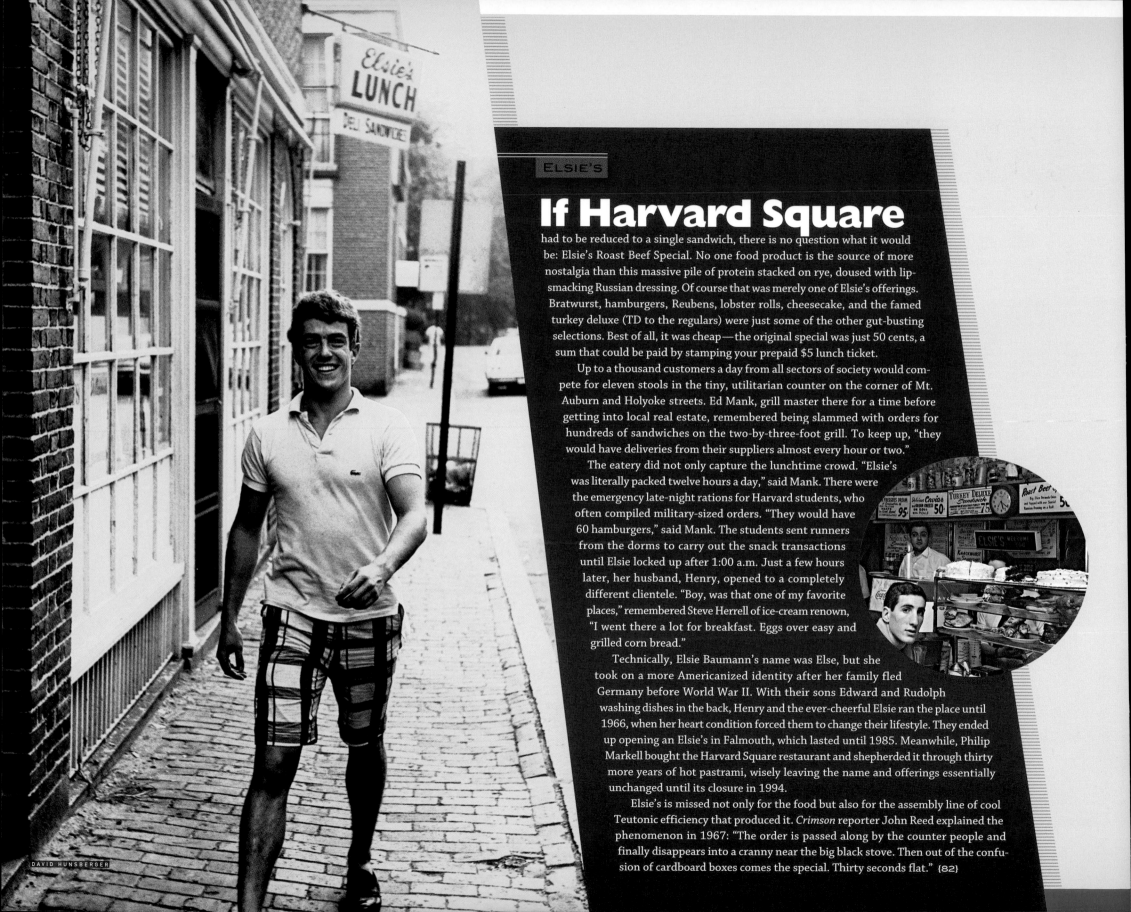

If Harvard Square

had to be reduced to a single sandwich, there is no question what it would be: Elsie's Roast Beef Special. No one food product is the source of more nostalgia than this massive pile of protein stacked on rye, doused with lip-smacking Russian dressing. Of course that was merely one of Elsie's offerings. Bratwurst, hamburgers, Reubens, lobster rolls, cheesecake, and the famed turkey deluxe (TD to the regulars) were just some of the other gut-busting selections. Best of all, it was cheap—the original special was just 50 cents, a sum that could be paid by stamping your prepaid $5 lunch ticket.

Up to a thousand customers a day from all sectors of society would compete for eleven stools in the tiny, utilitarian counter on the corner of Mt. Auburn and Holyoke streets. Ed Mank, grill master there for a time before getting into local real estate, remembered being slammed with orders for hundreds of sandwiches on the two-by-three-foot grill. To keep up, "they would have deliveries from their suppliers almost every hour or two."

The eatery did not only capture the lunchtime crowd. "Elsie's was literally packed twelve hours a day," said Mank. There were the emergency late-night rations for Harvard students, who often compiled military-sized orders. "They would have 60 hamburgers," said Mank. The students sent runners from the dorms to carry out the snack transactions until Elsie locked up after 1:00 a.m. Just a few hours later, her husband, Henry, opened to a completely different clientele. "Boy, was that one of my favorite places," remembered Steve Herrell of ice-cream renown, "I went there a lot for breakfast. Eggs over easy and grilled corn bread."

Technically, Elsie Baumann's name was Else, but she took on a more Americanized identity after her family fled Germany before World War II. With their sons Edward and Rudolph washing dishes in the back, Henry and the ever-cheerful Elsie ran the place until 1966, when her heart condition forced them to change their lifestyle. They ended up opening an Elsie's in Falmouth, which lasted until 1985. Meanwhile, Philip Markell bought the Harvard Square restaurant and shepherded it through thirty more years of hot pastrami, wisely leaving the name and offerings essentially unchanged until its closure in 1994.

Elsie's is missed not only for the food but also for the assembly line of cool Teutonic efficiency that produced it. *Crimson* reporter John Reed explained the phenomenon in 1967: "The order is passed along by the counter people and finally disappears into a cranny near the big black stove. Then out of the confusion of cardboard boxes comes the special. Thirty seconds flat." {82}

holyoke & dunster sts.

DAVID HUNSBERGER

◀ 1965 Ⓠ *A man bearing packages strides past Reliance Bank on a frigid December day.* {206}

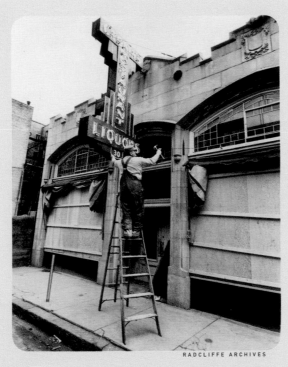

RADCLIFFE ARCHIVES

◀ 1961 *It's the end of an era. Favorite bar Cronin's nears demolition for the University Health Services, phase one of Holyoke Center construction.* {18, 40, 83, 125}

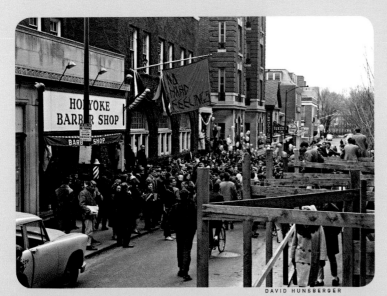

DAVID HUNSBERGER

◀ 1969 Ⓚ *Dunster Street looks much different after Holyoke Center is complete. The vantage point is nearly identical to the photo above.*

◀ 1965 Ⓔ *A crowd gathers outside the Hasty Pudding Theatre as Lee Remick claims the annual Woman-of-the-Year prize.* {19, 170, 206}

CAMBRIDGE HISTORICAL COMMISSION

1960s

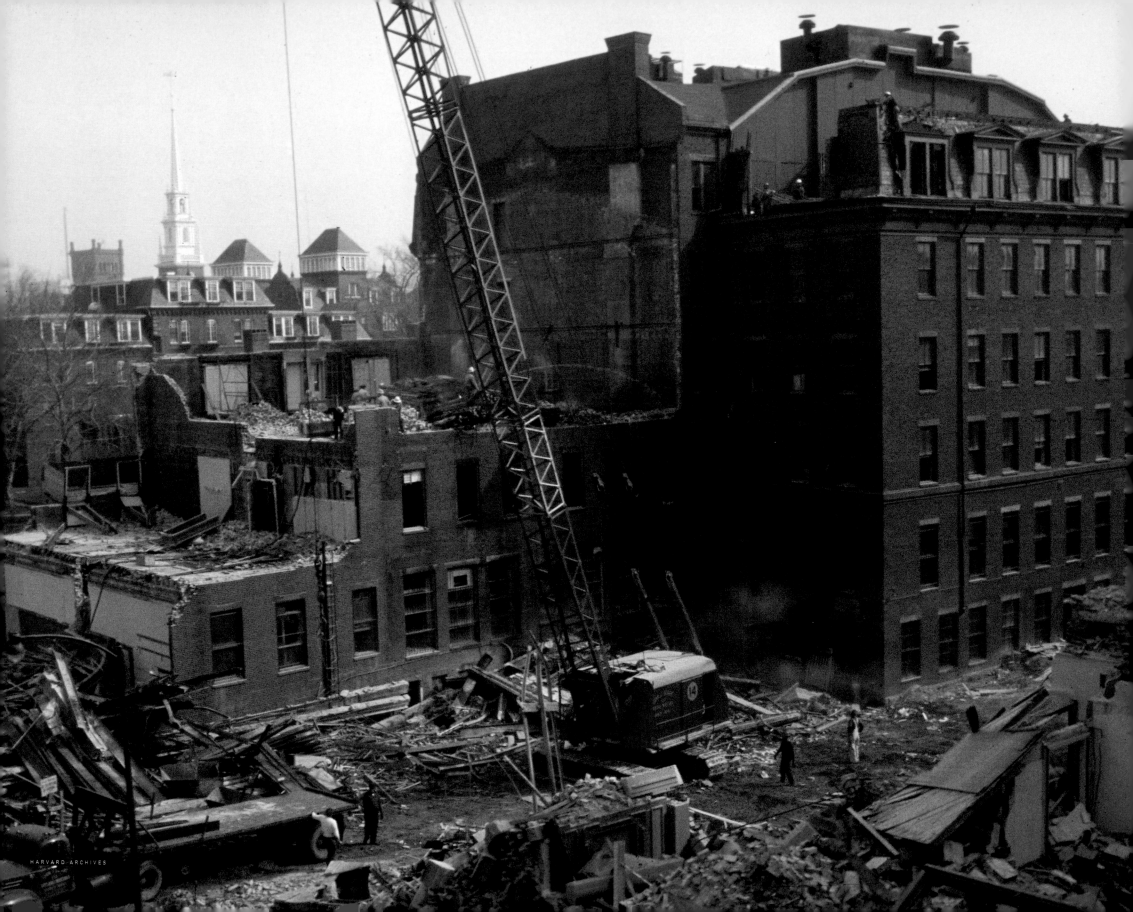

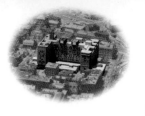

"Here

at last is an audaciously beautiful building in the delightfully slummy mess around the Harvard Yard," said *The New Republic* of Holyoke Center. Well, there's no accounting for taste. Between 1960 and 1966, Harvard University ushered in the modern architectural era when it razed an entire block of Harvard Square and replaced it with a massive concrete superstructure designed by their own dean of the Design School and Bauhaus acolyte, Josep Lluís Sert. The victims included Holyoke House (1870) and Little Hall (1854), five-story brick buildings that matched the others on Massachusetts Avenue in height and style, as well as several other lesser buildings with façades on Dunster, Holyoke, and Mount Auburn streets. The biggest non-aesthetic casualties were some of the Square's iconic businesses, displaced or vanished. Phillips Books, Cambridge Trust, and Roger's Men's finagled their way into the new, bunkerlike space, Cahaly's and Brine's survived migrations, while fabled bar Cronin's and Hazen's Lunch suffered from moves elsewhere. The winner was clearly Harvard.

But even if cold, out-of-scale, boxy architecture was not your bag, you could appreciate the psychological effect of this radical redesign. It was a bold statement that provided Harvard a strong outpost in the Square and provided the Square with its first "skyscraper" (at ten stories). In today's preservation-minded and socially conscious world, Holyoke Center may not have been built, and in that sense its construction was hardly future-minded. But it may have been saying, "pay attention, interesting stuff is going to happen here," and in that way, it was prophetic. {17, 38, 54, 57, 95, 101, 129, 135, 205}

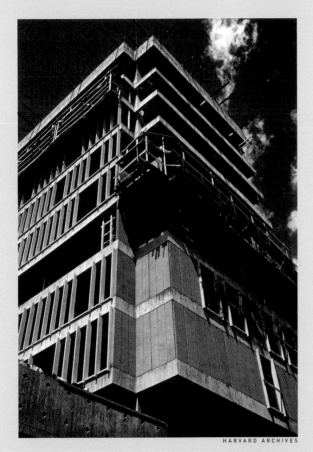

HARVARD ARCHIVES

🔺 **1964** *No, this is not a war zone, but Harvard's Holyoke Center construction did involve the destruction of an entire block of Harvard Square.*

🔻 **1963–68** *A new look comes to Massachusetts Avenue. At the right of the frame, unchanged, is Cambridge Savings Bank.*

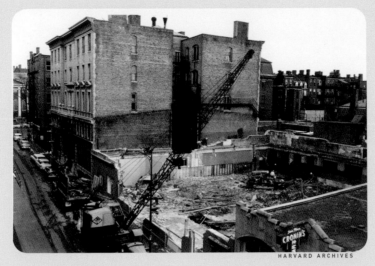

HARVARD ARCHIVES

🔺 **1961** *The University Health Center, the first part of Holyoke Center to be built, rises from the rubble.*

🔺 **c.1960** *Demolition begins, clearing the block between Dunster and Holyoke streets.*

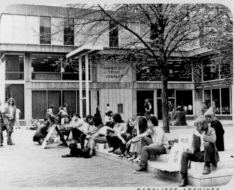

RADCLIFFE ARCHIVES

🔺 **c.1960s** *Forbes Plaza, the space in front of the new Holyoke Center, quickly becomes a hangout spot.* {95, 135, 170, 205}

KODAK SAFETY FILM · KODAK PLUS X PAN FILM

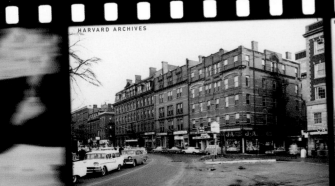

HARVARD ARCHIVES

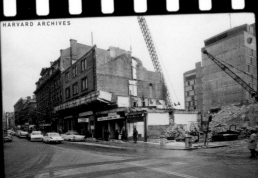

HARVARD ARCHIVES

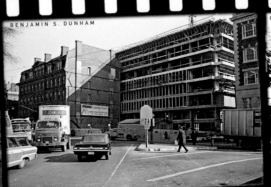

BENJAMIN S. DUNHAM

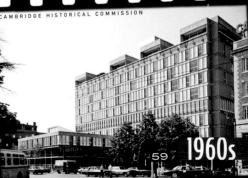

CAMBRIDGE HISTORICAL COMMISSION

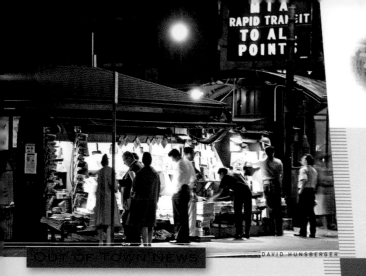

OUT OF TOWN NEWS

DAVID HUNSBERGER

Ⓐ Cambridge Savings Bank
Ⓑ Derby Jeweler
Ⓒ Waldorf Cafeteria
Ⓓ Harvard Garden Grill
Ⓔ Varsity Liquors
Ⓕ Subway Kiosk
Ⓖ Out of Town News

the center

◆ 1965 *The Square is aglow with the enticements of a summer's evening.* {25}

◀ 1961 Ⓖ *Sheldon Cohen doing what he does best, selling newspapers.*

What Sheldon

Cohen did with his life and with Harvard Square is extraordinary. He single-handedly developed a market for foreign and intercity news, created a late-night bookstore stocked with unique journals, developed and served as director for a new bank, nearly tripled the membership of the Harvard Square Business Association as its president, and helped launch an ongoing annual street festival. His indefatigable boosterism, visibility, and entrepreneurship earned him the sobriquet "mayor of Harvard Square."

Cohen was one of twenty acquaintances who founded Charlesbank Trust in the '60s. He explained succinctly, "We all got together. We wanted to start a bank. We started a bank." He served as director, and they had a nice spot in Harvard Square at the corner of Boylston and Brattle. The bank was eventually sold to US Trust in the '80s.

Cohen also started the popular bookstore Reading International, which spent a quarter century (until the early '90s) on the corner of Brattle and Church. It was an extension of the newsstand in a way, with 40,000 titles in stock, including a tremendous selection of foreign and obscure books, magazines, and journals. It enticed with outdoor sales, dollar bins, and long hours. You just couldn't get this stuff anywhere else, and it's part of the reason Harvard Square was a special place.

Then there's Mayfair. Cohen liked Frank Cardullo's Oktoberfest and thought there should be a street festival for the spring season. Cohen created the executive director position at the Harvard Square Business Association. The first director, Sally Alcorn, oversaw the inaugural festival in 1984. Originally it took place in the Cambridge Common, but it migrated to the Square itself and continues to this day, drawing upward of 100,000 people with hundreds of street vendors and live music.

For all this and more, the delta-shaped spit of real estate in the center of Harvard Square has been christened Sheldon Cohen Island. {28, 109, 154, 186}

©LAWRENCE MANNING/CORBIS

If a newsstand

can be famous, then Out of Town News, smack dab in the epicenter of Harvard Square, is the Julia Roberts of newsstands. To appreciate the significance of this particular piece of Harvard Square iconography, you need to remember the difference between now and the pre-Internet world, where instant access to worldwide media was impossible.

There were seven newspapers in Boston (and two editions of the *Globe*) in 1947 when Sheldon Cohen's father passed away, leaving Sheldon to take care of his mother and younger brother, Fred. He inherited the newsstand next to the subway kiosk in Harvard Square, where he continued selling the local rags until 1955. That's when he noticed students, looking for jobs and interested in relocating, asking for newspapers from other cities. "I studied every newspaper in the country. That's how I created Out of Town News," said Cohen.

The stand was the place to find Italian fashion magazines for the Newbury Street set, foreign tabloids like *Paris Match*, and the *Cork Examiner* for Irish ex-pats. "I helped create the *Washington Post* here," he said, explaining that prior to his efforts, you could not get the D.C. paper, nor the *New York Post*, in Boston. In the end, there were roughly 130 cities and twelve countries represented in smudged newsprint and glossy magazine pages. Out of Town News was like a chicken coop stuffed with connections to the world beyond—nostalgic links to home for some, exotic calling cards for others—surrounded by the commotion of circling traffic, subway commuters, and troubadours.

In some ways, Out of Town News was Harvard Square in microcosm, and the internationalism of both grew together—the newsstand always at the center, and Sheldon Cohen always at the helm. "I hawked and worked 18 hours a day, seven days a week," he announced. In the process, Cohen became known by almost everyone who passed through the Square, which was just about anyone—mayors, city councilors, Tip O'Neill, the Kennedy brothers, and through the years, to John Kerry.

Cohen added a ticket agency and, in 1976, an electronic ticker with community news and sports scores. But the big change came with the Red Line extension in the '80s. A large, modern entrance was created, leaving the original subway kiosk, a historical marker, to be repurposed. That Out of Town News should inhabit it seems so laughably logical as to be fated. The newsstand, magazines spilling out onto the red brick plaza under red neon and the copper roof of another time, is almost certainly the most photographed locus in Harvard Square.

Brother Fred was eleven years old when he started working at the newsstand, and was managing it even after Cohen eventually sold to Hudson News in 1994. It remains a good newsstand with a large selection in a great location—still a preferred rendezvous for meeting friends—but when you can get the *London Daily Mirror* instantly online for free, a $10 hard copy a day late is a hard sell, so the selection and sales numbers changed. But Cohen has no regrets. "You do it for fifty years, it's time to move on." {2, 100, 102, 104, 129, 136, 139, 174, 208}

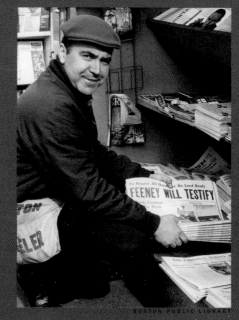

FEENEY WILL TESTIFY

BOSTON PUBLIC LIBRARY

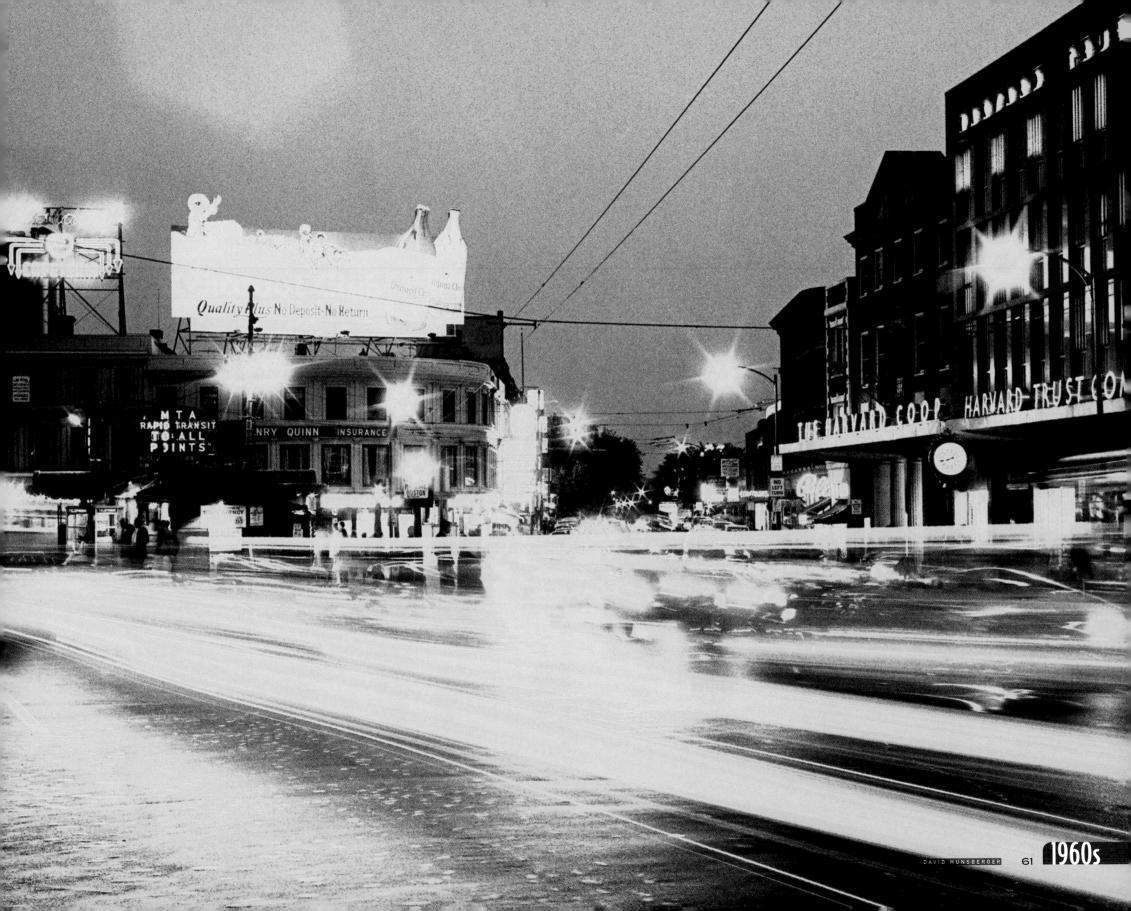

1960s

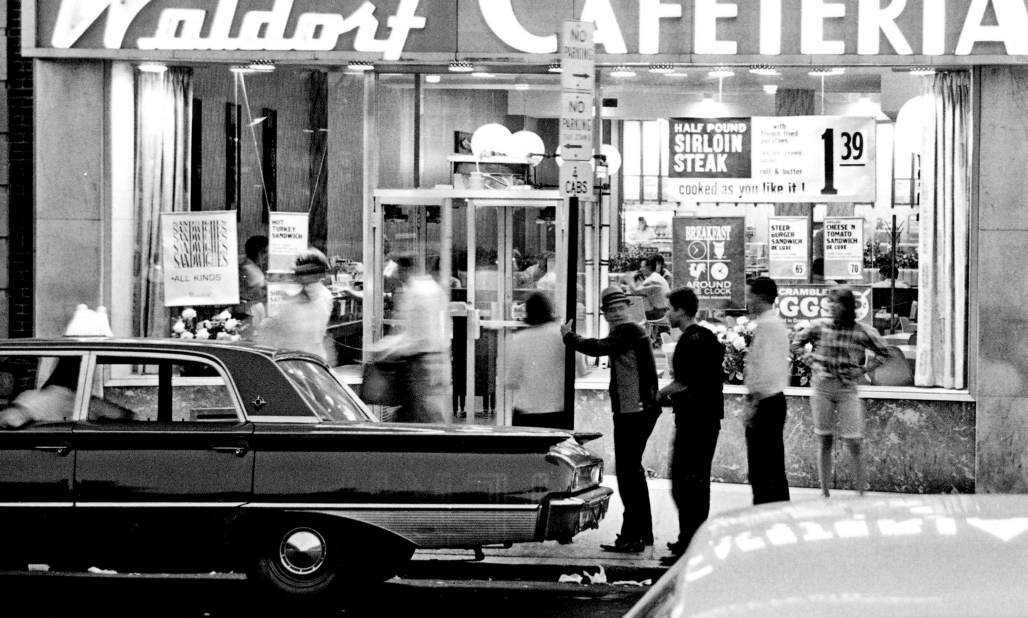

DAVID HUNSBERGER

◐ 1965 ⓒ *The Waldorf was one of a number of all-night lunch counters.*

◓ 1963 Ⓕ *Commuters wait for the subway in Harvard station.*

◑ 1966 *A few hardy souls brave a heavy January snowstorm.*

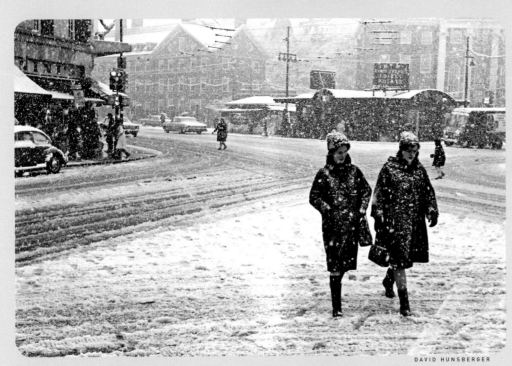

DAVID HUNSBERGER

DAVID HUNSBERGER

◐ 1965 Ⓓ *Folks loiter outside of the decades-old Harvard Garden Grill, a basic neighborhood bar with cheap drinks, questionable food, and a jukebox. It closed in the early '70s.*

◓ 1965 ⒻⒼ *A classic view of the subway kiosk shows Out of Town news to the right. The construction on the storefront is the transformation of Albiani's cafeteria into Brigham's.*

the center

Ⓐ Cambridge Savings Bank
Ⓑ Derby Jeweler
Ⓒ Waldorf Cafeteria
Ⓓ Harvard Garden Grill
Ⓔ Varsity Liquors
Ⓕ Subway Kiosk
Ⓖ Out of Town News

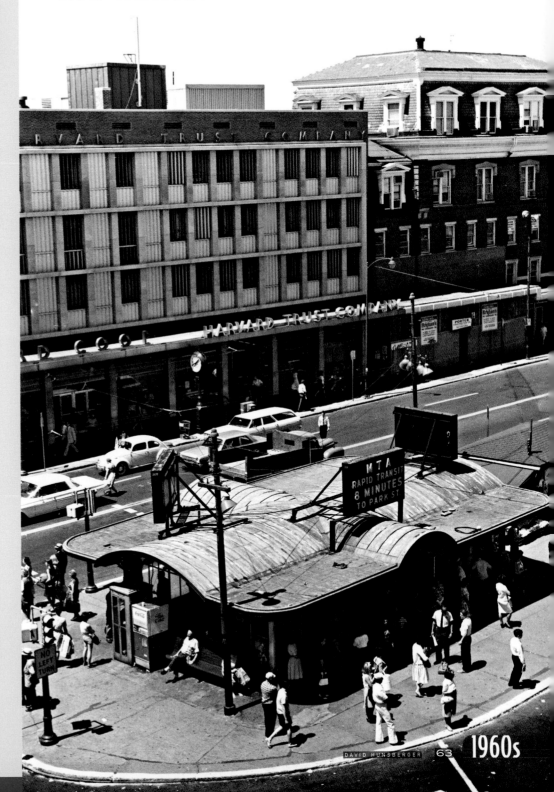

DAVID HUNSBERGER

1960s

BENJAMIN S. DUNHAM HARVARD YEARBOOK PUBLICATIONS INC.

Ⓐ Harvard Coop
Ⓑ Harvard Trust
Ⓒ Albiani Lunch Co./Brigham's
Ⓓ College House Pharmacy
Ⓔ Harvard Valeteria
Ⓕ Harvard Square Theatre
Ⓖ Magic Garden/Browser's Club Gift Shop
Ⓗ Student Valet Service Cleaners

upper mass. ave.

JESSIE WHITEHEAD

"There is

one person that sticks in my mind," said Rupert Davis of Schoenhof's, "Jessie Whitehead." One of Harvard Square's most charming idiosyncrasies is its constantly replenishing supply of oddballs, and oddballs don't come much better credentialed than the daughter of the brilliant British mathematician-philosopher and Harvard professor Alfred North Whitehead.

"She added to the personality of the place," said Davis. The main reason for this was that wherever she went, so went her pet cockatiels, conveniently attached to her person via string. She was kicked out of Harvard's Widener Library, according to Square merchant Herb Hillman, because "the parrot would shit on everything." Throw in a British accent, a stutter, and odd pronouncements, and you've significantly upped the eccentricity quotient.

Jessie was a fixture on the streets of Harvard Square, where her daily circuit would take her to the Bick and the Starr Bookshop. Harvard grad Hugh Blackmer recalls overhearing a conversation she was having with a mother and child on one such day. "'Do you know, I'd give you one of my birds for that baby.' The mother blanched and left as soon as she could," said Blackmer.

She had other peculiar notions. When she retired from her position at Harvard University, "they asked her what she wanted as a retirement gift," said Dick Sens, another Harvard grad, "and she said 'a buzz-saw.'" According to legend, that is precisely what she received.

A more in-depth interaction with her may have revealed an incredibly intelligent, deep-thinking person who was true to herself and in love with nature. But to most, she was simply the bird lady. And the bird lady spoke her mind. Folk scene photographer Steve Fenerjian remembered hearing her one day. She averred, "You see the weirdest people in Harvard Square."

◀ 1965 Ⓕ *The Harvard Square Theatre, recently renovated in the mid-century aesthetic, offers a Jimmy Stewart or Marlon Brando flick to choose from.* {26, 95, 151, 223}

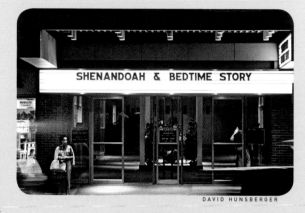

DAVID HUNSBERGER

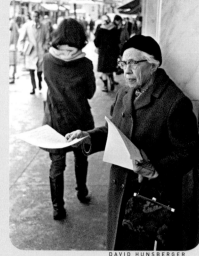

DAVID HUNSBERGER

◢ 1967 Ⓒ *Eager customers crowd the counter at Brigham's, the Square's most popular spot for a cone.*

◤ 1967 Ⓐ *This elderly woman was often handing out pamphlets in front of the Harvard Coop.*

◀ 1968 ⒸⒹⒺⒻ *It's a beautiful spring day on Mass. Ave.* {9, 105, 140}

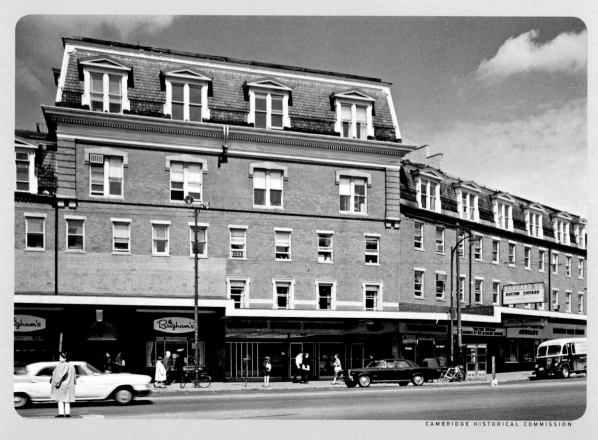

CAMBRIDGE HISTORICAL COMMISSION

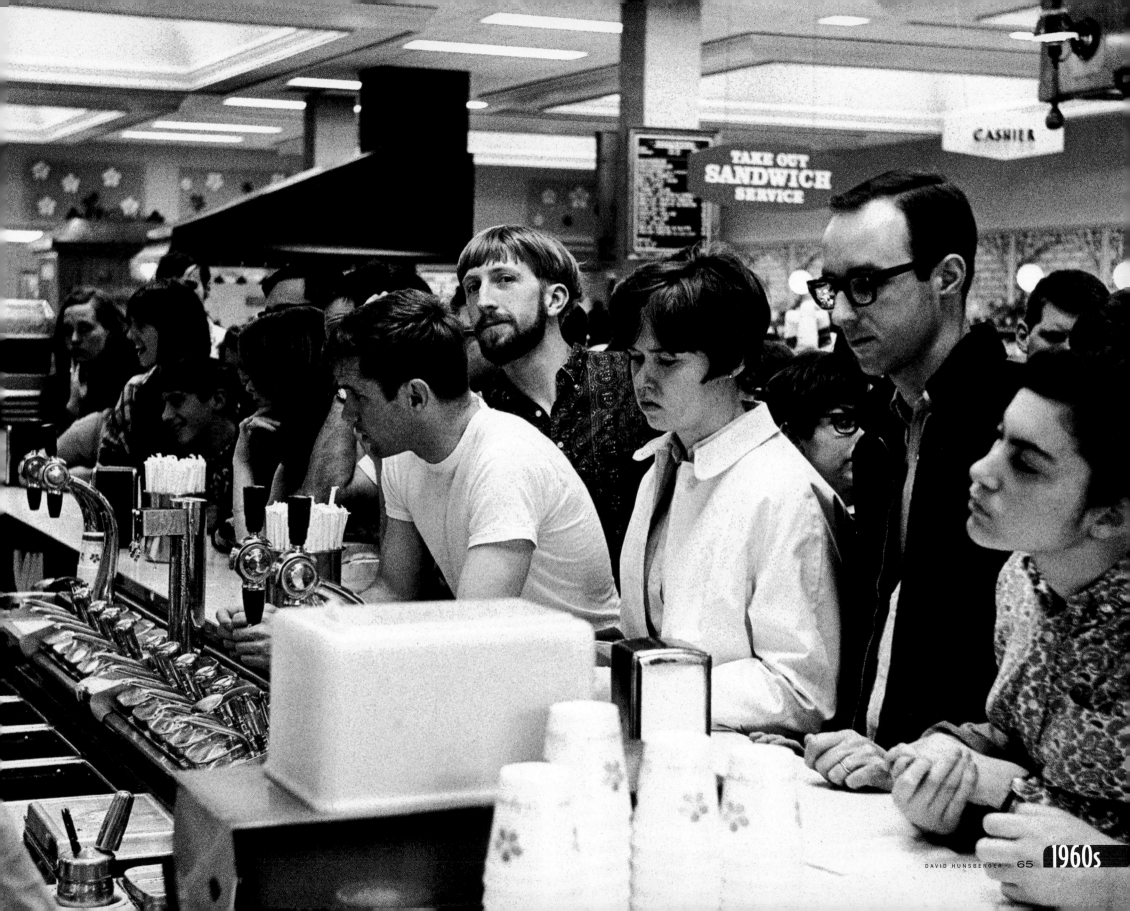

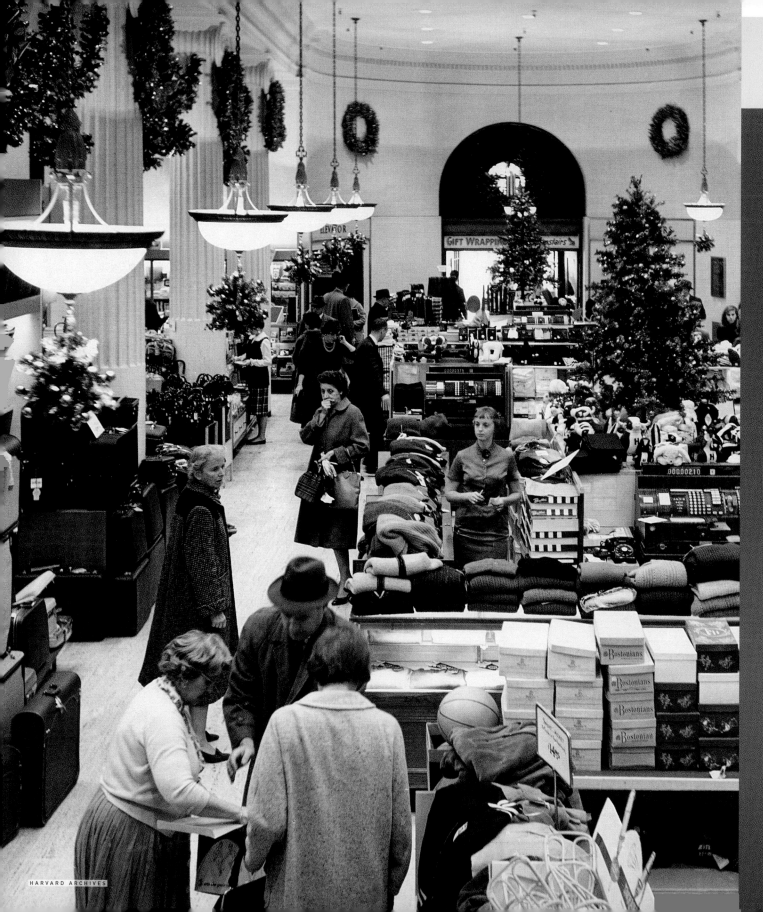

DAVID HUNSBERGER

As the first

college in America, it makes sense that Harvard should spawn the first college cooperative in the States. It's just surprising that it happened in a fruit store. Yes, the Coop (rhymes with "loop," not "blow-pop"), now with 60,000 dues-paying members, and $45 million in annual sales at six branches, began as a few shelves in a fruit market and later in a tobacco store before settling into a century of profitability and growth as Harvard Square's commercial anchor.

The idea was born of indignation over price gouging for student necessities such as coal and ink. In February of 1882, a Harvard junior, Charles Hayden Kip, crammed 41 people into his dorm room to discuss his idea for a cooperative. They drew up a constitution, set up provisions for electing officers, and created a business model. Members would be charged a $2 fee (lowered to $1 the following year), only cash would be accepted at the store (students seemed to rack up a lot of debt even in the nineteenth century), and the surplus would be plowed back into the business. Eventually, members would receive annual rebates based on how profitable the year was, a tradition which continues to this day.

By the next month, the neonatal Harvard Cooperative Society was already selling notebooks, ink, books, and periodicals, and had contracted to sell coal and wood and take furniture on consignment. Arthur Waterman, from the class of 1885, became the first manager and took to his position and its salary enough so that he actually quit his studies, perhaps unwittingly beginning an amusing thread of suc-

upper mass. ave.

- (A) Harvard Coop
- (B) Harvard Trust
- (C) Albiani Lunch Co./Brigham's
- (D) College House Pharmacy
- (E) Harvard Valeteria
- (F) Harvard Square Theatre
- (G) Magic Garden/Browser's Club Gift Shop
- (H) Student Valet Service Cleaners

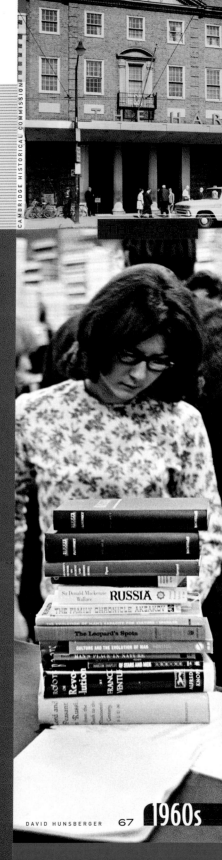

◀ 1965 (A) *The Coop's Palmer Street annex is busy even in July.*

Given

Harvard Square's deficiency in public restrooms, lines often form for the Coop's small, ill-kept facilities—even with their idiosyncratic toilet tissue squares and, for many years, powdered soap.

cessful Harvard dropouts that includes Ogden Nash, Bonnie Raitt, and Bill Gates.

In 1903 the Coop arrived at its current address, where it was eventually able to construct a brand-new edifice in 1925. It is that building that still houses the high-visibility main store. But what and who occupied that building, its neighbor on Massachusetts Avenue, and its annex on Palmer Street, has changed considerably in the intervening years.

Aside from the standbys—books and clothing—there was seemingly no limit to what merchandise mix might be attempted there. That has included up

to 21 tailors during the stodgy men's store days, plus shoes, furniture, cutlery, cameras, ski equipment, cosmetics, housewares, paints, and even services such as laundry, luggage transfer, and a notary public. "The only thing we didn't carry was major appliances," said Allan Powell, who worked his way up to corporate general manager from stock boy in 1965.

For most of its life, the Coop was a messy maze of merchandise spread illogically over several split-level floors of several buildings, but it had a shabby charm and a consistency that has long since gone out of fashion. Jerry Murphy, current president, had gone to Harvard twenty years prior to his hiring in 1993.

"When I came back," he said, "the insignia [mugs and glasses] were in the exact same place..."

Cambridge merchant J. P. Botindari described it succinctly as a "big department store that had every book in the world." Indeed in the bookstore capital of Harvard Square, the Coop was king, with 70,000 titles and a near-monopoly on the student textbook business by the mid-'70s. But for a time it also had the largest record department in New England (second floor, Palmer Street annex). Harvard Square became ground zero for recorded music in the Boston area, especially as CDs took hold in the '80s. An art print and poster business was started in the '60s by a intuitive employee as a couple of tables and grew into a $3.5 million juggernaut; it was one of the Coop's most unique offerings for two or three decades.

Perhaps the biggest change of all came on the heels of a surprising financial decline in the early '90s. The general store concept was faltering as an economic model and to survive, the Coop had to engage in a massive restructuring in 1997. Half of the Massachusetts Avenue frontage, what had been the stationery and cosmetics departments, reverted to BankBoston, the landlord at the time. The other half was gutted, and Barnes & Noble was contracted to run the new book department and in-store café that now fills it. Financially, this was a successful maneuver, and the leaner Coop now stocks 140,000 titles, the most ever. Lost, however, were the men's and women's departments, the housewares, the electronics, and the strong sense of place that the Harvard Coop had always projected. At least there is one thing that has remained the same since 1883—the membership fee. It is still just one dollar. {24, 26, 36, 104, 118, 152, 177, 210}

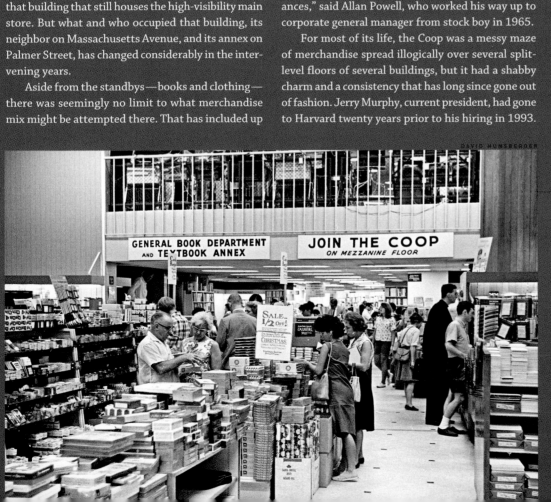

GENERAL BOOK DEPARTMENT AND TEXTBOOK ANNEX

JOIN THE COOP ON MEZZANINE FLOOR

SALE! 1/2 OFF!

DAVID HUNSBERGER

- **A** Woolworth's
- **B** St. Clair's Yard of Ale
- **C** Fanny Farmer/Kupersmith Florist
- **D** Cardullo's
- **E** Montgomery-Frost-Lloyd's Opticians
- **F** Brigham's/Pewter Pot Muffin House
- **G** Simpson Jeweler
- **H** Nini's Corner
- **I** Lewandos/Cappy's
- **J** Miss Cannon's/Paraphernalia
- **K** University Travel
- **L** Corcoran's

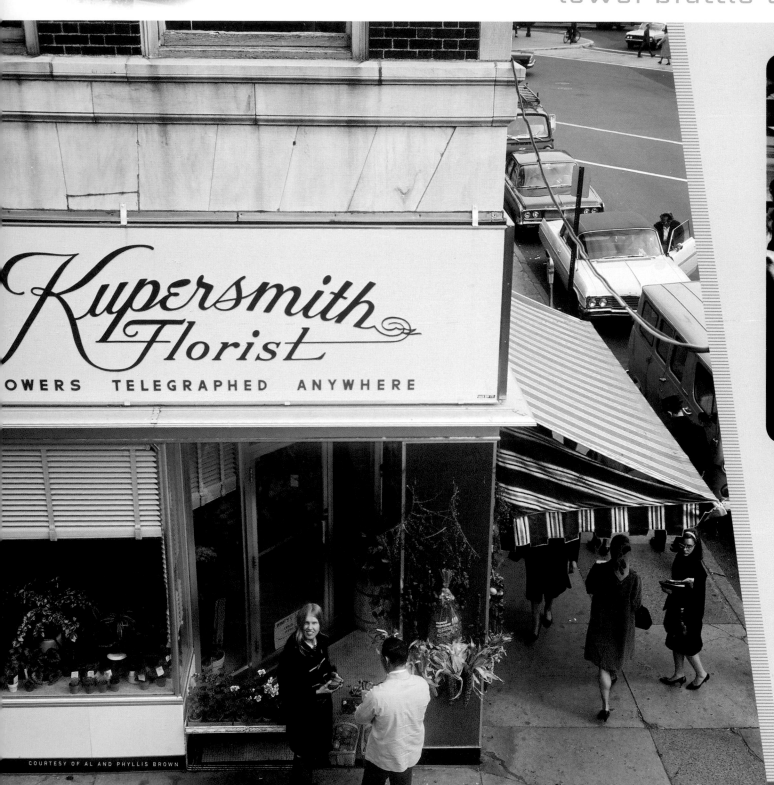

Kupersmith Florist

OWERS TELEGRAPHED ANYWHERE

COURTESY OF AL AND PHYLLIS BROWN

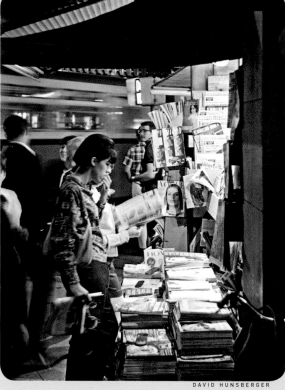

DAVID HUNSBERGER

◄ 1967 H *Browsers peruse the selection at Nini's Corner while others hurry past.* {2, 102, 109, 143, 178}

◄ c.1966 C *Kupersmith Florist settles into its second, larger location at 8 Brattle. Sam Kupersmith opened the original down the street in 1936; daughter Phyllis and her husband Al Brown ran the shop from 1969 until it closed in 1990.*

◄ 1965 F G H *Brattle St. glows in July twilight. Brigham's nears its move around the corner to Mass. Ave.* {109, 143}

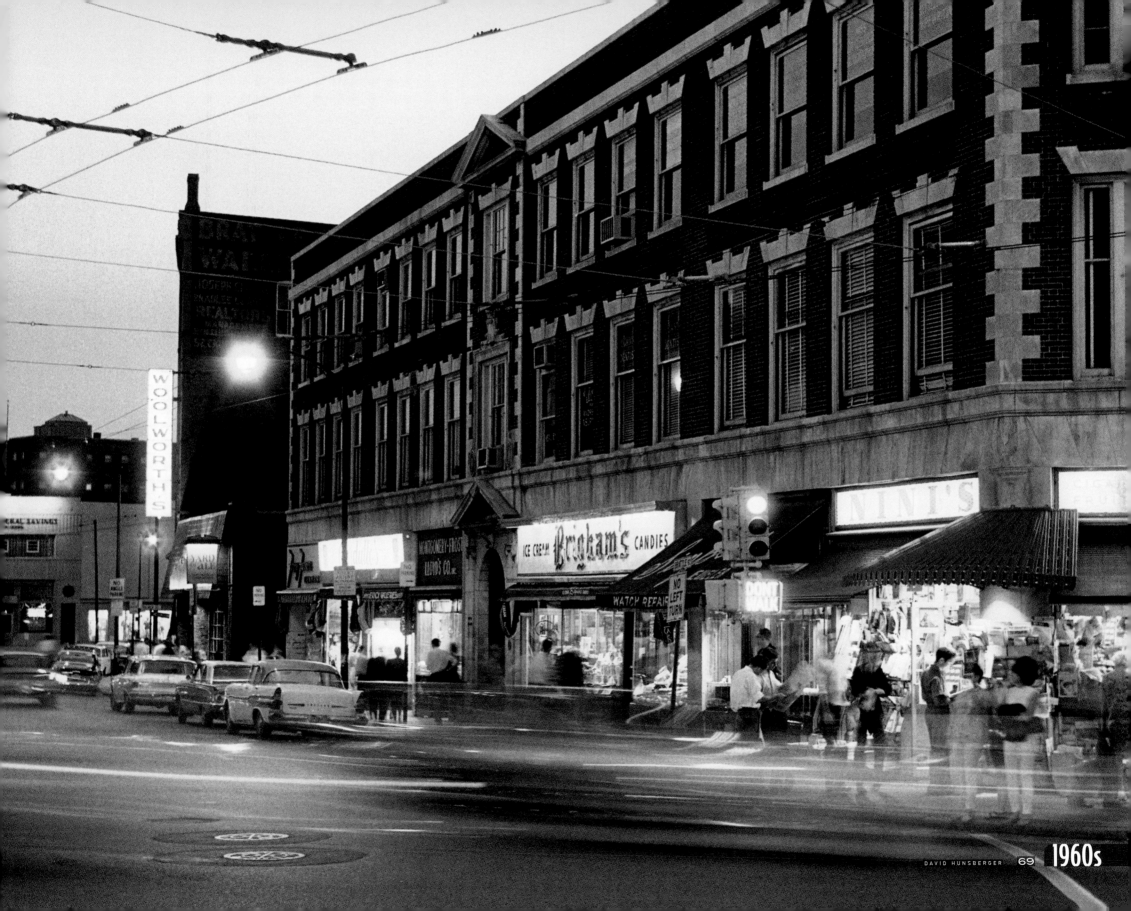

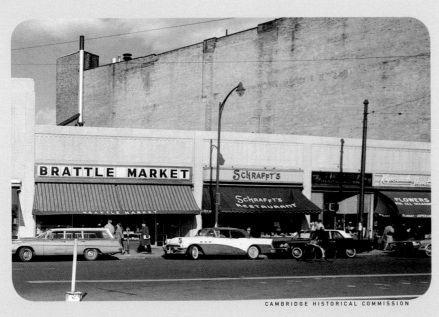

CAMBRIDGE HISTORICAL COMMISSION

🔹1967 ⒶⒷⒸⒹⒺ *The Oxford Shop (far left) was a clothing store owned by brothers Sandy and Victor Cahaly. They would end up having a falling out, splitting the store down the middle, and never speaking to each other again.*

🔹c.1960 ⒼⒽⒾ *Schrafft's, like Bailey's which succeeded it, had chocolates and an ice cream fountain. It was also one of the popular spots for the "ladies who lunch."*

🔹1967 Ⓛ *Brattle Square proves to be a challenge to pedestrians. The curved building on the right contains Art-Craft Industries, one of two yarn stores in the Square at the time. After a fire, the entire structure was razed in 1974 and replaced with what became the home of WordsWorth Books*

BOUTIQUES

and specialty shops—rarities in the dowdy Harvard Square of the '50s—multiplied in step with the influx of consumers and more adventurous tastes. Nowhere was this better expressed than in Truc (see pp. 65–66), a basement burrow of inter-locking shops where a hip Square denizen could suit up for bohemia. Located in the Brattle Theatre complex, Truc (French for "thing") included fashionable duds, kitchen gadgets, a poster gallery, candle shop, and toy store. Running out of space, co-owner Cy Harvey pressed the cleaning equipment room into service for the brainstorm that would become his only business thereafter: a soap store. He later named it Crabtree & Evelyn.

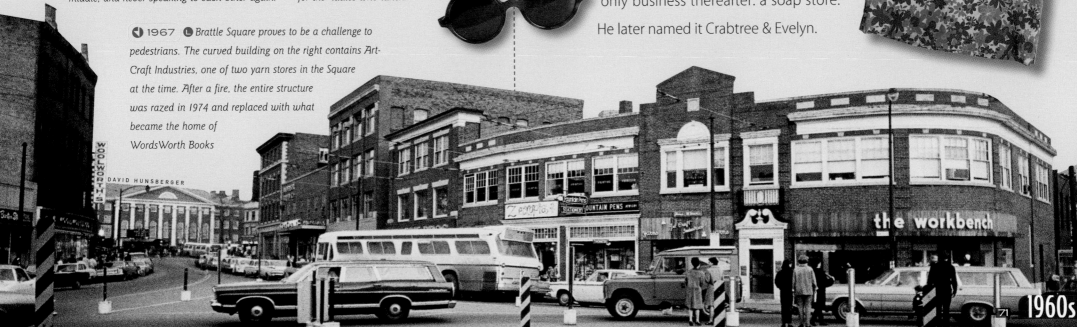

DAVID HUNSBERGER

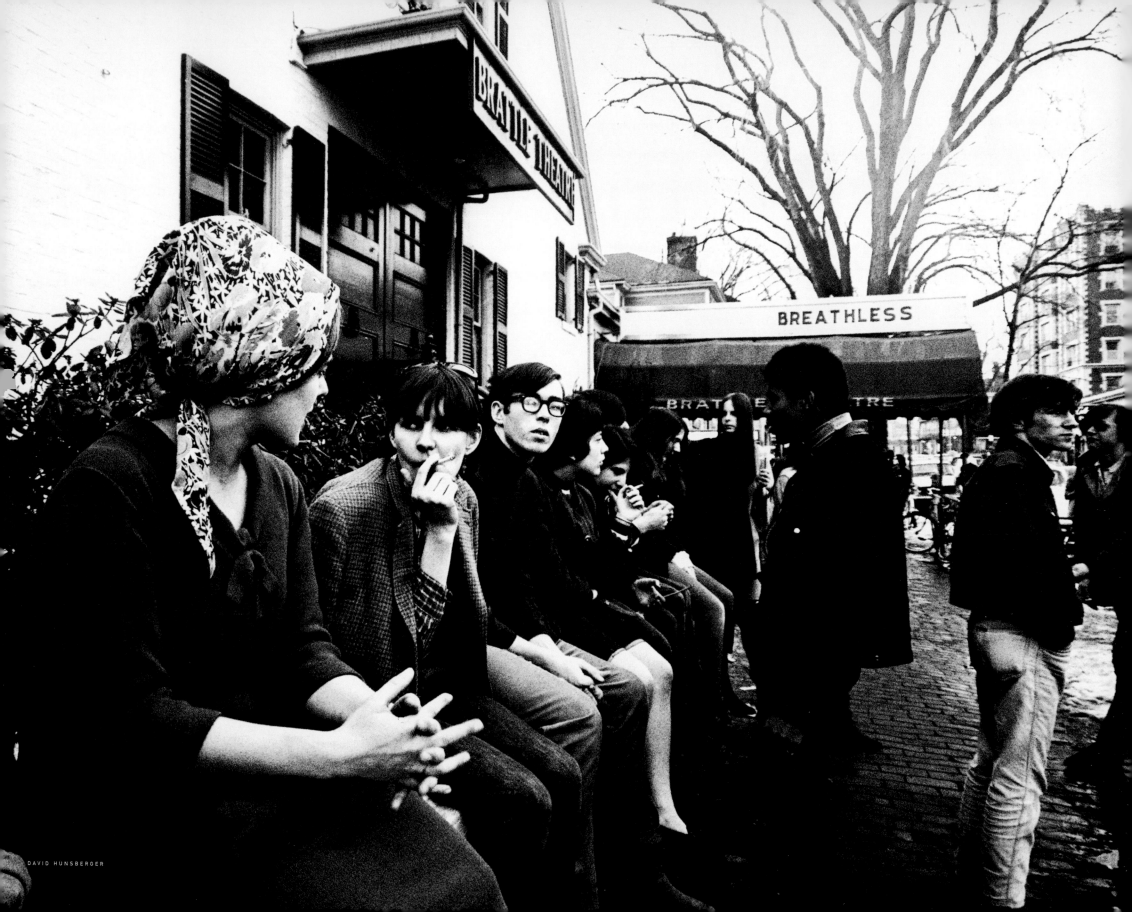

upper brattle st.

- Ⓐ Cambridge Federal Savings & Loan
- Ⓑ Touraine
- Ⓒ Brattle Theatre
 Truc
 Club Casablanca
 The Blue Parrot
- Ⓓ Camb. Ctr. for Adult Ed.
- Ⓔ Howes Cleaners
 Kitty Haas
- Ⓕ Lewdon's Millinery/ Camb. Camera & Marine
- Ⓖ Paperback Booksmith
- Ⓗ Cardell's
- Ⓘ Brattle Pharmacy
- Ⓙ J. F. Olsson

CAMBRIDGE HISTORICAL COMMISSION

🔼 1967 Ⓓ *The Cambridge Center for Adult Education remains unchanged. The William Brattle House is one of the oldest in Cambridge, dating from 1727.* {110, 149, 219}

🔽 1967 Ⓒ *Godard's Breathless is the type of foreign cinema that made the Brattle Theatre's reputation. The front wall is a nice perch for people watching.* {30, 76, 111, 148}

🔼 1967 Ⓑ *Touraine (later Cherry, Webb, & Touraine) was a large women's clothing store. This building would be demolished in 1990 for One Brattle Square.* {182}

Great Clothes Jewelry Gifts Kitty Haas 42 A Brattle

🔼 c.1969 Ⓖ *Paperback Booksmith, "dedicated to the fine art of browsing," changed the industry by organizing paperbacks by author instead of publisher, as had been the custom. Marshall Smith's Harvard Square shop was number two of a chain that grew to about 80 stores. For several years, it never closed, making it likely the only 24-hour bookstore in the country.*

🔽 1968 Ⓔ *Kitty Haas had one of the first true boutiques in the Square, opened in the '40s. She was still selling jewelry 60 years later.*

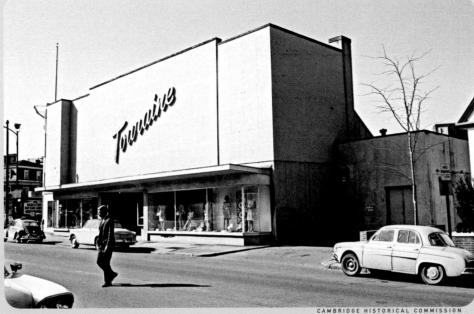

CAMBRIDGE HISTORICAL COMMISSION

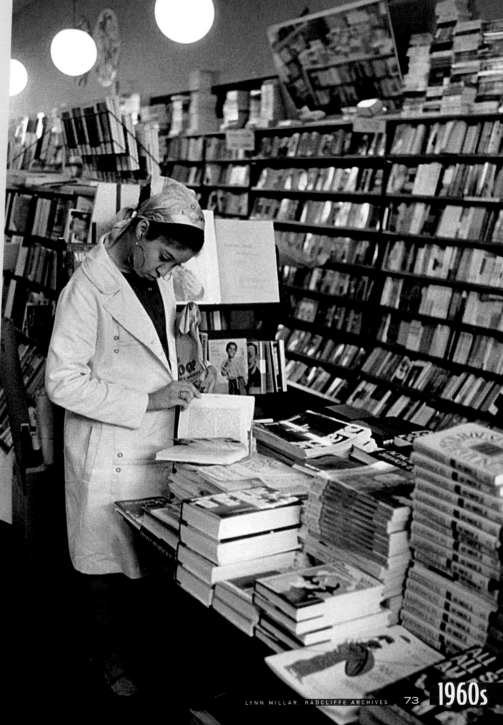

LYNN MILLAR, RADCLIFFE ARCHIVES

1960s

Ⓐ The Brattle Theatre
Club Casablanca
The Blue Parrot
The Grand Turk
Truc

upper brattle st.

DAVID HUNSBERGER

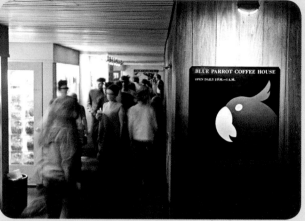

DAVID HUNSBERGER

⬆◀ 1967 | **Ⓐ** *The Grand Turk was a short-lived upscale bar/restaurant that morphed into Upstairs at the Casablanca. The wicker settees would become notorious trysting spots.* {88, 146}

◀◀ 1967 | **Ⓐ** *The Blue Parrot was another Casablanca spin-off in the Brattle Theatre complex. The popular coffeehouse, opened in 1957, was named after the rival bar to Rick's in the film. It spent 30 years in the Square, the last 16 on Mount Auburn St.* {76, 124, 160} *The space below became Algiers in 1971.* {149, 183, 216}

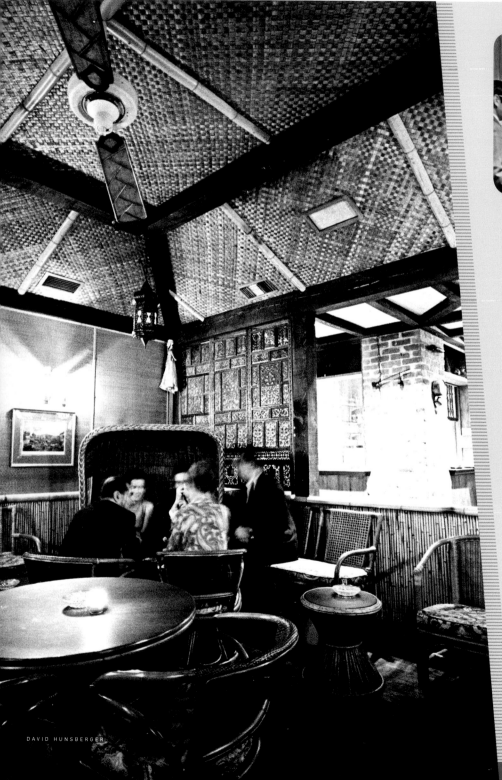

DAVID HUNSBERGER

DAVID HUNSBERGER

◀ 1967 ▲ *Colorful paper lanterns were just some of the groovy parapher-nalia you could pick up in Truc, the warren of boutiques in the lower level of the Brattle complex.* {76}

◥ 1967 ▲ *The original Casablanca was dark, smoky, and alluring. The signature red and white striped bar awning is just visible in the upper left.* {88, 146}

◣ 1967 ▲ *The Blue Parrot naturally needs a mascot. Mr. C. H. would be Cy Harvey, the entrepreneur who created, with Bryant Haliday, all of the nightspots and shopping shown here.*

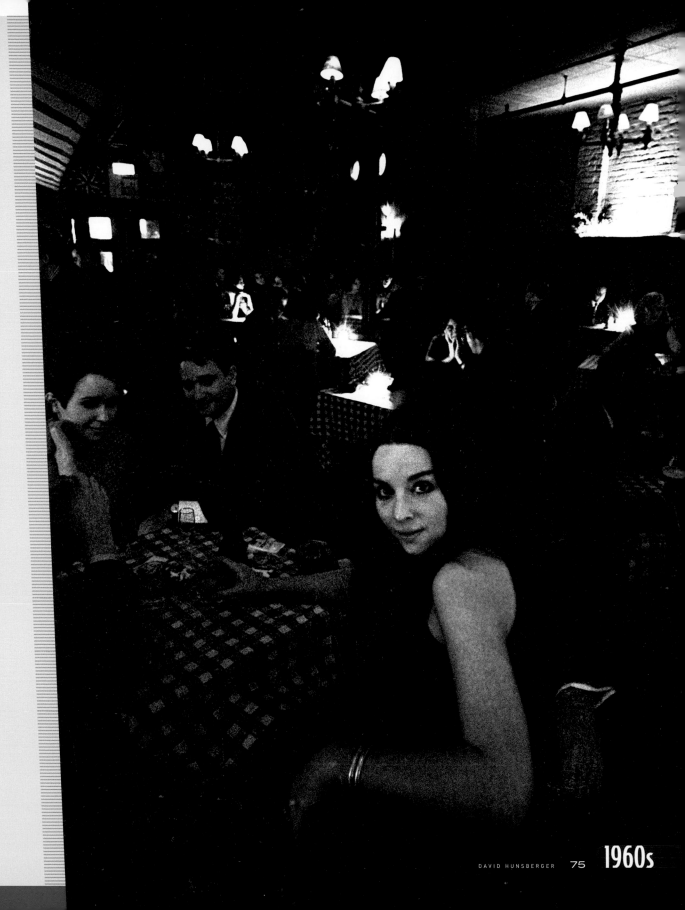

Ⓐ The Brattle Theatre
The Blue Parrot
Truc
Ⓑ Blue Door Yarns
Vermont Tweed Shop
Bernheimer's Antique Arts

Ⓑ Chieko's House of Batiks
Brattle Arms Beauty Salon
Stork Time
Ⓒ Brattle Inn
Leather Design Shop

upper brattle st.

DAVID HUNSBERGER

🕭 1967 Ⓐ Café culture reaches maturity in the Blue Parrot. {74, 124, 159}

🕭🕭 1967 Ⓐ Hip clothing and beeswax candles are among Truc's many offerings. {75}

DAVID HUNSBERGER

🕭 1967 Ⓐ The Brattle Theatre is packed. The ceiling beams give the feeling of an inverted ship's hull, which is fitting, since the rear-screen projection system was copped from ocean liners. {30, 72, 111, 148}

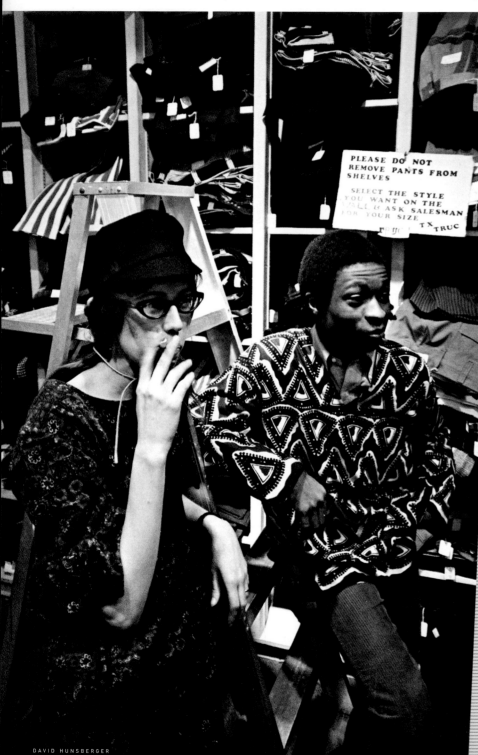

PLEASE DO NOT REMOVE PANTS FROM SHELVES

SELECT THE STYLE YOU WANT ON THE WALL & ASK SALESMAN FOR YOUR SIZE

TX TRUC

DAVID HUNSBERGER

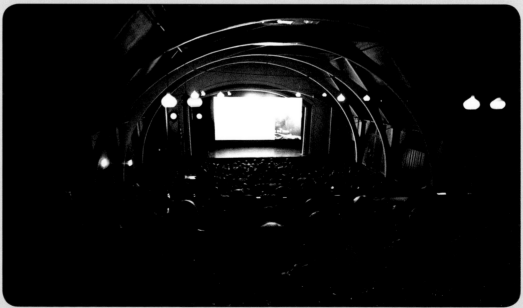

DAVID HUNSBERGER

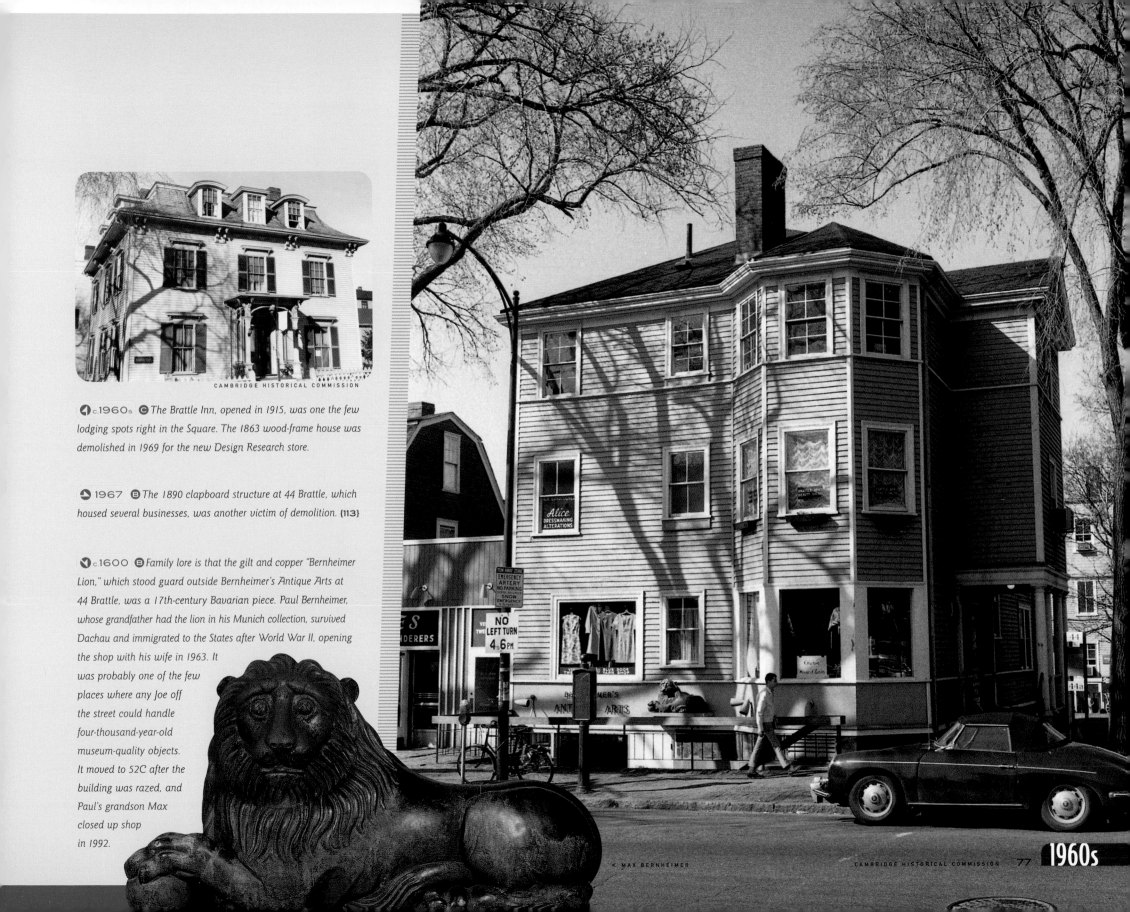

CAMBRIDGE HISTORICAL COMMISSION

▲ c.1960s ⓒ *The Brattle Inn, opened in 1915, was one the few lodging spots right in the Square. The 1863 wood-frame house was demolished in 1969 for the new Design Research store.*

◢ 1967 ⓑ *The 1890 clapboard structure at 44 Brattle, which housed several businesses, was another victim of demolition. {113}*

▼ c.1600 ⓑ *Family lore is that the gilt and copper "Bernheimer Lion," which stood guard outside Bernheimer's Antique Arts at 44 Brattle, was a 17th-century Bavarian piece. Paul Bernheimer, whose grandfather had the lion in his Munich collection, survived Dachau and immigrated to the States after World War II, opening the shop with his wife in 1963. It was probably one of the few places where any Joe off the street could handle four-thousand-year-old museum-quality objects. It moved to 52C after the building was razed, and Paul's grandson Max closed up shop in 1992.*

< MAX BERNHEIMER

A AR Music Room
B The Workbench/Simon & Sons
C Versailles et la Petite Galerie
D Ralph Hair Stylist/Eleganza
E The Window Shop
F Loeb Drama Center
G Design Research

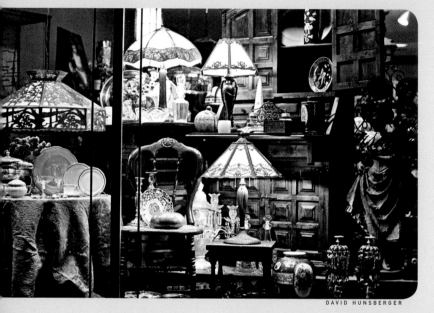

DAVID HUNSBERGER

NEW YORK TIMES/RADCLIFFE ARCHIVES

1965 C Versailles et
la Petite Galerie at 52C Brattle
is aglow with the trappings
of the refined lifestyle.

1960 F The brand-new Loeb
Drama Center opens in its modernistic
structure. The Radcliffe Health Center
was razed to make way for it.

1964 G Marimekko fabrics ushered in a new
fashion sense for the '60s and Design Research was
responsible for introducing the trendy Finnish patterns
to the United States. This building, too, would be razed
to make way for Harvard's Gutman Library. {11, 113}

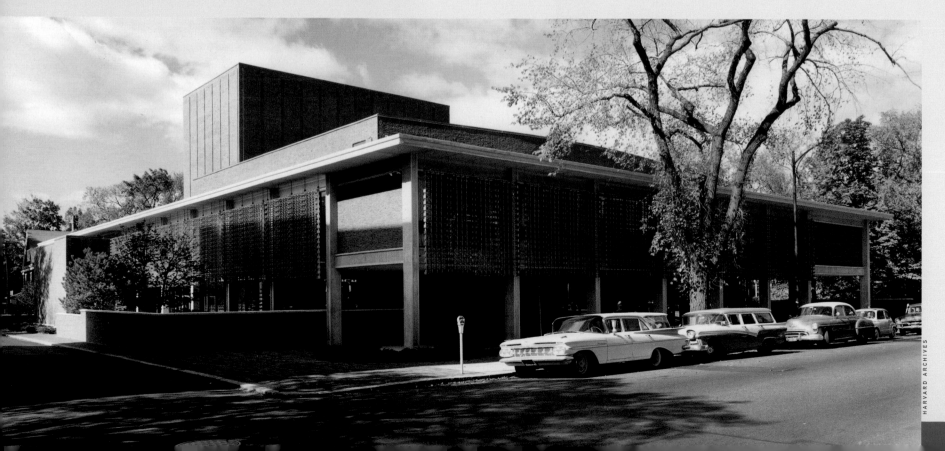

HARVARD ARCHIVES

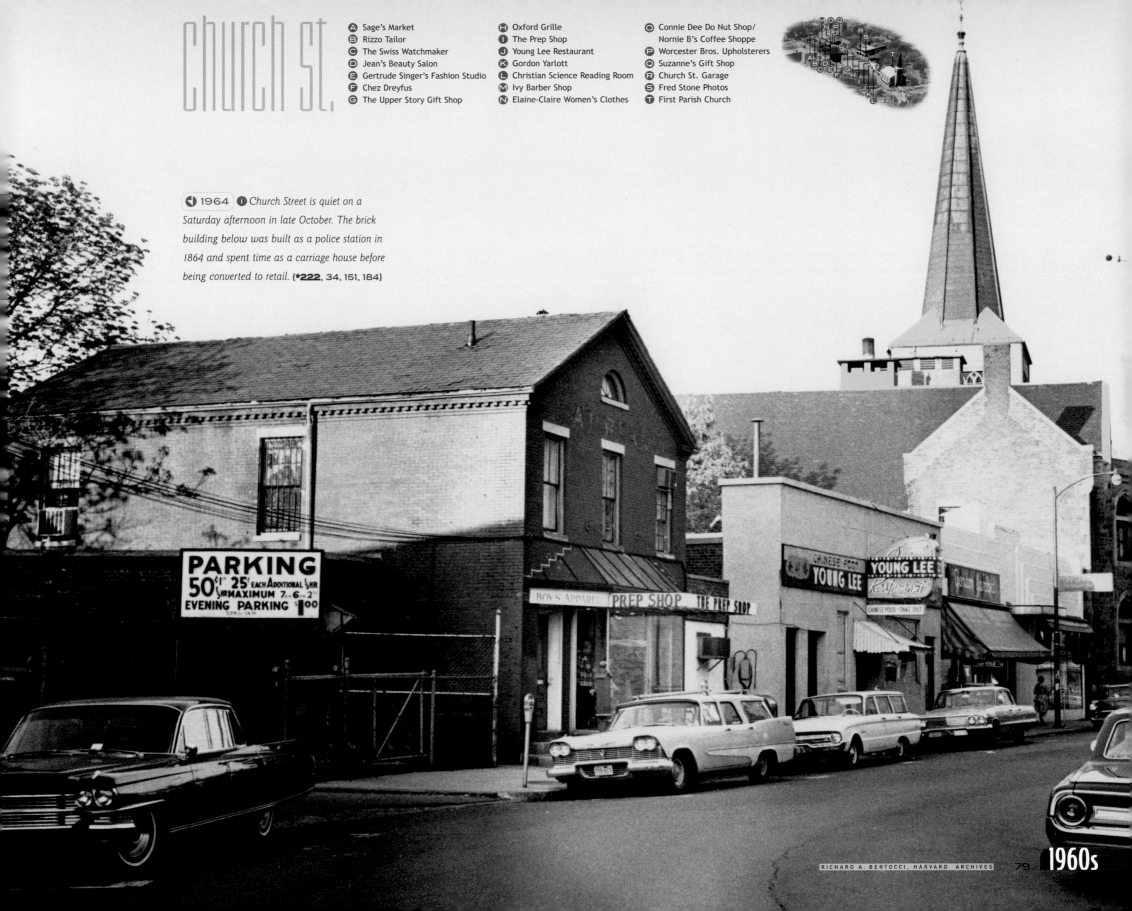

Church St.

- Ⓐ Sage's Market
- Ⓑ Rizzo Tailor
- Ⓒ The Swiss Watchmaker
- Ⓓ Jean's Beauty Salon
- Ⓔ Gertrude Singer's Fashion Studio
- Ⓕ Chez Dreyfus
- Ⓖ The Upper Story Gift Shop

- Ⓗ Oxford Grille
- Ⓘ The Prep Shop
- Ⓙ Young Lee Restaurant
- Ⓚ Gordon Yarlott
- Ⓛ Christian Science Reading Room
- Ⓜ Ivy Barber Shop
- Ⓝ Elaine-Claire Women's Clothes

- Ⓞ Connie Dee Do Nut Shop/ Nornie B's Coffee Shoppe
- Ⓟ Worcester Bros. Upholsterers
- Ⓠ Suzanne's Gift Shop
- Ⓡ Church St. Garage
- Ⓢ Fred Stone Photos
- Ⓣ First Parish Church

◀ 1964 ❶ *Church Street is quiet on a Saturday afternoon in late October. The brick building below was built as a police station in 1864 and spent time as a carriage house before being converted to retail.* {***222**, 34, 151, 184}

1960s

🎵 c.1960 🎤 Joan Baez, still a teenager, packs them in during one of her last regular gigs at the 47.

🎵 1963 🎤 Al Wilson (later of Canned Heat) blows on the harmonica with Geoff Muldaur on washboard and Fritz Richmond on washtub bass in one of the impromptu musical conglomerations that would form and reform all the time at Club 47.

JOHN BYRNE COOKE

STEPHEN H. FENERJIAN

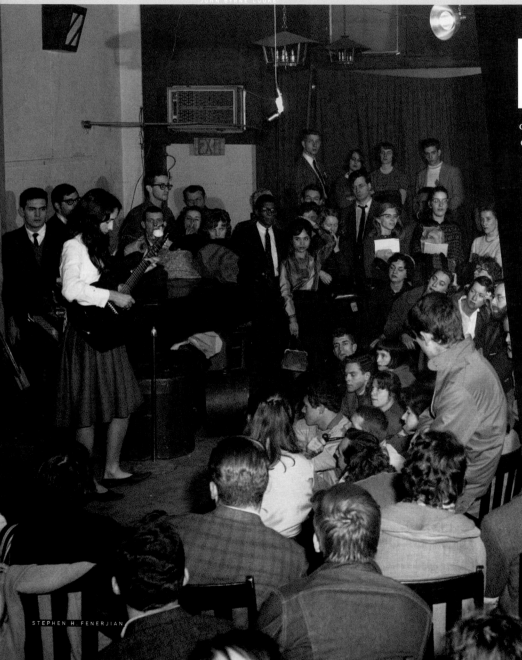

STEPHEN H. FENERJIAN

Most

of the seminal events, the happenings, the moments of exquisite synergy in life are unplanned. The folk revival begun in a spartan storefront at 47 Mount Auburn Street was an unplanned happening that kept happening, unlocking a musical heritage, launching careers, changing the face of music, and magnetizing Cambridge. The eddies of that original explosion still reverberate today.

The genesis of Club 47 and its offspring Passim was an unlikely one. In 1958 businesses in Harvard Square were usually the province of middle-aged men. Nonetheless it was two 20-year-old Brandeis grads, Joyce Kalina (now Joyce Chopra) and Paula Kelly, who decided—somewhat on a whim—to open up a coffeehouse. "I didn't want to learn how to type, that's really mostly it," explained Joyce.

"It was going to be a place where people came and read and where interesting conversation would take place," she said. And that it was. But the pair also wanted culture. "We had an art gallery there, we had exhibitions, we had readings," she said, "It was more than music." But music was definitely the focus. 47 Mount Auburn was a jazz club.

They had to contend with the old boy network almost immediately. Obnoxious Cambridge cops—unable to imagine anything savory happening behind those dark-curtained windows—tried to shake them down; when that failed, they closed the place for not having an entertainment license. So, as an end run around the prohibition, the 47 went nonprofit, nominally private, and charged people a one-time $1 membership fee; thus the "club" in Club 47.

One night a man by the name of Peter Robinson came by and tried to get the pair interested in booking a young folk singer he knew who was quite talented. Happy with their jazz programming, they rebuffed him multiple times. The house band was The Steve Kuhn trio, with Chuck Israels on bass. Even as an undergrad, Kuhn had played with Coleman Hawkins and Chet Baker and had appeared on national television. Israels later spent years in Bill Evans's band.

Finally, Robinson decided to rent the whole place out in order to prove it would be worth their while. He got his point across. The singer was Joan Baez.

Baez was the tinder for a folk explosion, igniting the scene before leaving for bigger stages. It is impossible to overestimate her impact on Club 47. She was, quite simply, a sensation. Yet she was hardly a poster-girl siren. She was aloof, unadorned, and occasionally outfitted in handmade burlap clothes. There was little stage patter and the songs she sang were often dirgelike. Joyce remembers her as an anxious, lovesick teenager with a nasty, arrogant streak. But at only 17 years of age, she had an intensity and natural vocal ability that stunned audiences into worshipful silence. Stephen Fenerjian was a friend and photographer who recalled that when she sang a cappella, "you could hear a pin drop in Club 47."

"She was young and beautiful, with long, flowing black hair. She played and sang with more feeling than anyone I had ever seen before," former Byrds member

lower mt. auburn st.

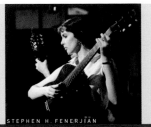

▲ c.1960 C Club 47 co-founder Paula Kelly peers out from the kitchen pass-through. She and Joyce Kalina set the place up themselves.

STEPHEN H. FENERJIAN

▲ c.1960 C Debbie Green casts a spell at the 47. She taught Baez how to play much of her early repertoire.

◄ c.1960 C Jackie Washington was a regular.

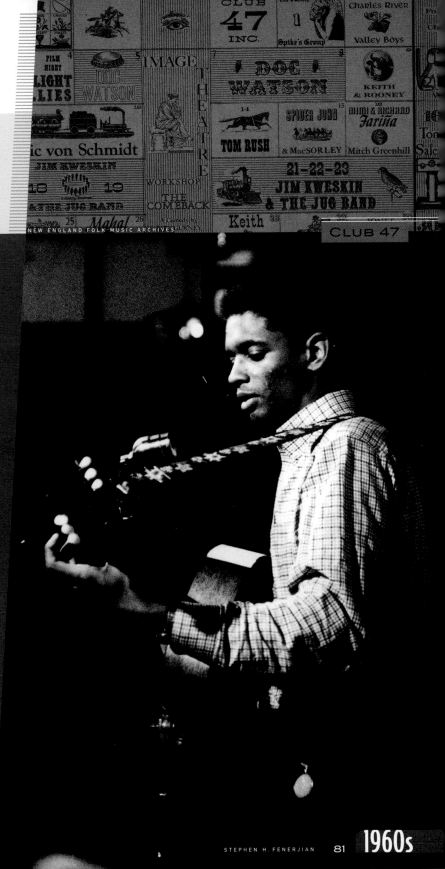

CLUB 47

NEW ENGLAND FOLK MUSIC ARCHIVES

Roger McGuinn remembered of a 1960 visit, "I was in love that autumn, with the colors and smells of Cambridge, and with Joan Baez."

Initially the crowds that gathered came for her and her alone. But soon she was the gateway drug to the world of folk music. What started as an experiment for the slow weeknights became an ongoing musical and cultural exchange, a flush scene with impromptu jam sessions spreading sporelike throughout basements and kitchens and coffeeshops in Cambridge. Word spread and the home-team talents of The Charles River Valley Boys, Jim Kweskin, Jim Rooney, and Eric von Schmidt were being joined by national road trippers, crashing on friendly couches. Some were weaving new mantles of renown, such as Joni Mitchell, Judy Collins, and Taj Mahal. Others were old-time blues or bluegrass players who were being discovered by a wider audience, such as Muddy Waters, John Lee Hooker, and Bill Monroe. A new generation of fans genuflected at their wizened authenticity.

What was clear was that Cambridge was a kingmaker in the folk world. To have played the 47 meant that doors opened

CLUB MOUNT AUBURN 47
This certifies that 56
JAN 12 1962
is a member for the year 19...........19.........
 Officer

◄ 1964 B *Doc Watson (right) was one of many who gained fame through Club 47. Ralph Rinzler (left) was instrumental in exposing obscure southern musicians such as Watson to broader audiences.*

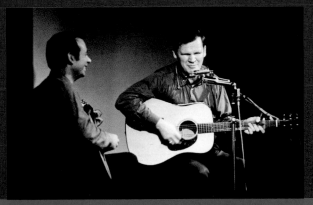

for you: gigs, recording contracts, the Newport Folk Festival. That was why a young Bob Dylan, brought to Cambridge by Joan Baez, played for free in between sets, although he never had an official gig at the club.

With the infusion of new people and the tremendous popular interest, Club 47 became less of a living-room jam session and more of a business. Joyce left to pursue a successful directing career; Paula couldn't handle everything herself, and a board was created to run the club, eventually (somewhat coldly) pushing her out. They weren't the only ones doing the pushing.

"Get your goddamn folk music out of here." That's what landlord Bertha Cohen, so supportive at the outset, said to the club in 1963. This prompted the move into the space on Palmer Street, which the club petitioned to have readdressed from #29 to #47. Their finances a mess, they hired a seasoned manager, Byron Linardos, to put them on the straight and narrow. It was he who had the audacity to actually collect admission at the door. It was Linardos who urged Tom Rush to bring a young Joni Mitchell, whose songs he was covering, down to the States. And it was Linardos who encouraged a mediocre banjo player who called himself Taj Mahal to bang out blues on the piano.

After Byron left, Jim Rooney took over and the club was losing money. Rent was more expensive in the new location. The previous acts were becoming more popular and playing with full bands, which precluded gigging at the 47. And without a liquor license or other revenue, the finances just didn't work.

In 1968, Club 47 closed. Normally these types of stories end there, with nostalgic tropes such as "things were never quite the same." However, somehow this story doesn't end there and is still being written today.
{39, 46} *continued as Passim, p. 152*

STEPHEN H. FENERJIAN 81 **1960s**

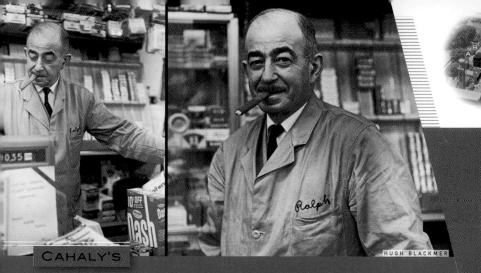

CAHALY'S

HUGH BLACKMER

A Club 47
 Cahaly's Market
 Serendipity
 Tommy's Lunch
B Gold Coast Valeteria
C Starr Book Shop
D The Harvard Lampoon

mt. auburn st.

There

are a few family dynasties that have peppered Harvard Square with disproportionate influence. One of the biggest would have to be the Cahalys. In addition to the convenience store that Michael and Ralph ran (with, for a time, brothers Jim and Fred), Michael's sons, Sandy and Victor, owned adjacent Brattle Street clothing shops for decades; Ralph's son John created the hippie boutique Serendipity, which ended a forty-year run in 2007, and Sandy's wife, Janet, has owned the Carriage House Salon since 1998, which still coifs heads today.

Perhaps the most beloved and trafficked of these enterprises was Cahaly's market, opened in 1928 and then spending the next 56 years in four locations on Mount Auburn Street. With its prime position at the corner of Boylston and Mt. Auburn streets, the first spot was one of the few stores in the Square with late-night hours, quickly ensconcing it as a critical stockpile for both detergent-and-milk missions and comic-book and candy-bar runs. Add a soda fountain, a breakfast club of professors, and pearls of wisdom from the owners and you have a neighborhood institution.

Mustachioed, cigar-chomping, and fluent in several languages, the family don, Michael Cahaly, seemed a perfect fit for Harvard Square, where he would lecture at Harvard on Middle Eastern history, between dispensing advice to several generations of students across the register. "So the kids would come in and they'd say things like, 'Mike, you know I've got a date this weekend and you know, I need

some cash. Can you cash a check?'" explained Janet Cahaly. "And he'd say, 'Well, how much money?'...'Well, five bucks should be enough,' and he'd say, 'That's too much to be spending...I'll give you three dollars. That's all you should be spending.'"

Ralph Cahaly (above), by contrast, was as easygoing and loquacious as Mike was stern and focused. The two brothers were, almost literally, night and day; Mike opened the place in the morning and Ralph closed it down in the evening.

Through its several moves, Cahaly's lost the fountain but retained a reliant clientele, including the pickers and espresso-pullers of Club 47 and other coffeeshops on lower Mt. Auburn. When the 47 moved in 1963, Mike retired, and Ralph and his son John stretched into the adjacent space. John would go on to run the market, including during its brief focus on ice-cream and baked goods, until it finally sold its lease to a branch of Sage's in 1984.

Ultimately, Cahaly's was no more nor less than a great, well-stocked bodega. But it was reflective of the deep community ties in Harvard Square that are harder to find these days. A person could spend his entire life behind the counter of his grocery and know his customers personally. When Ralph Cahaly passed in 1972, the funeral procession paused briefly in front of the market. {71, 122}

Each year for

25 years, *The Harvard Lampoon* had recognized one unlucky screen star with the ignominious "Worst Actress of the Year" award. And each year for 25 years, the insulted thespian ignored them. Until 1966. That's when Natalie Wood, upping the irreverent undergrads at their own game, demanded an invitation to accept the "honor" in person.

On April 23rd, she got her wish. The *Lampoon* was kind enough to supply their guest with an escort, reportedly the least attractive male student at Harvard. Huge crowds gathered outside the Lampoon castle for the festivities, where a sporting Ms. Wood accepted her award while graciously acknowledging that there were others more deserving than she. {39, 95, 123, 103}

DAVID HUNSBERGER

An amazed supplier spoke to the Cahalys one day. "Do you realize that you're the largest purchaser and distributor of toilet tissue in Massachusetts? What do you do with all this stuff?"

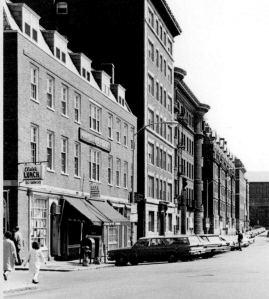

CAMBRIDGE HISTORICAL COMMISSION

c.1960s

Saks had an outpost in the Manter Hall building during the '60s, sandwiched between stalwarts Elsie's and the Tennis & Squash Shop. {228, 38}

DANIEL D. REIFF

🔺1969 Ⓗ *Cronin's second location was a bit less convenient and a bit less mythic than its first, but it nonetheless spent 18 years here, about as long as its time on Dunster Street.* {18, 40, 57, 125, 194}

🔺1967 Ⓖ *Le Brittany was a French Restaurant partially owned by Maurice of La Patisserie and real estate developer Lou DiGiovanni.*

CAMBRIDGE HISTORICAL COMMISSION

🔺1967 Ⓘ *Hamilton Liquors, more upscale than the typical liquor store, spent decades in the historic Chapman Heirs house. The structure had been turned sideways in 1924 and would, years later, be moved again to front Winthrop Park.* {125, 229}

🔻1967 Ⓔ *The Post Office's purpose-built 1953 facility was a sizable improvement over the previous location in Brattle Square. This building was replaced with a modern facility in 2001.*

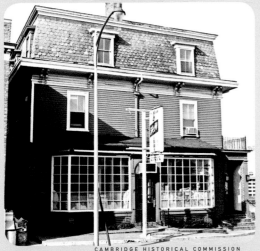

CAMBRIDGE HISTORICAL COMMISSION

CAMBRIDGE HISTORICAL COMMISSION

UNITED STATES POST OFFICE

CAMBRIDGE 38 MASS

A Zwicker Bros. Gulf
B Crimson Garage
C The Arlecchino Rest.
 Jolly Beaver Coffee Shop
 Iruña
D Patisserie Française
 The Cock-Eyed Dove Gifts

E Antartex Sheepskin Shop
 College Pharmacy
F Whitney's
G Angelo's Pizza/Joe's Pizza
H Charlie's Snack Bar
I Milty's Deli/David's NY Deli
J Bob's Harvard Bar/Maison
 de Robert Beauty Shop

K Corcoran's
L The Mandrake Bookstore
M Lowry Opticians
N Billings & Stover
O The Tasty
 The Wursthaus
 RJ Glugeth Optometrist

P Western Union
 Coach Grill
 Crimson Men's/Shoes
 King's Tavern
 Minute Man Radio
Q Harvard Square Garage
R Furniture-In-Parts

boylston st.

↗ 1963 O P

Boylston Street is a charming tangle of motley signs. {43, 119}

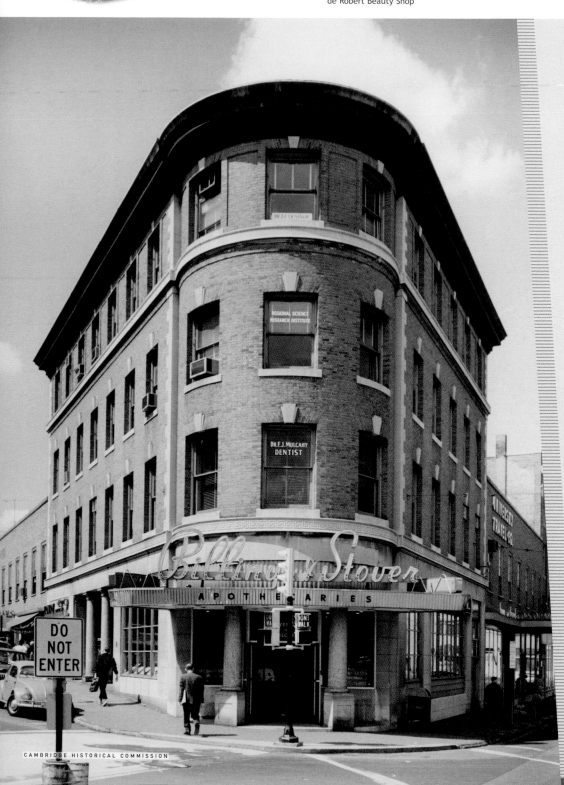

CAMBRIDGE HISTORICAL COMMISSION

↗ c.1960s N *Billings & Stover was one of the longest-running businesses in Harvard Square's history; the drugstore was founded in 1854. About 14 of those years were spent at the visible corner of Boylston and Brattle.* {114, 216}

↗ c.1960s P *Paul Koby had a prominent portrait photography studio above the Wursthaus. His protegé Frances Antupit would buy the business in 1978.* {190}

↘ c.1960s O *The Wursthaus offered a huge international beer selection.* {155, 190}

CHARLES DEMETROPOULOS

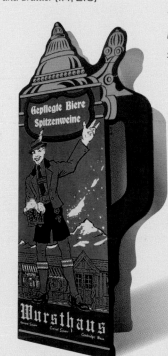

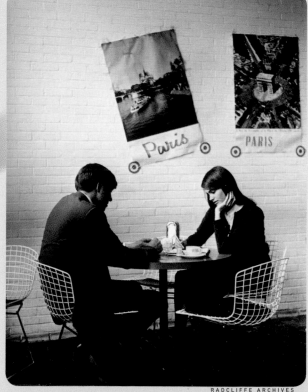

↗ c.1960s D *The Patisserie Française went through several owners and names but survived at 54 Boylston (later, JFK Street) until 1996. It was one of the first cafés to offer dark roast coffee.* {86, 121}

RADCLIFFE ARCHIVES

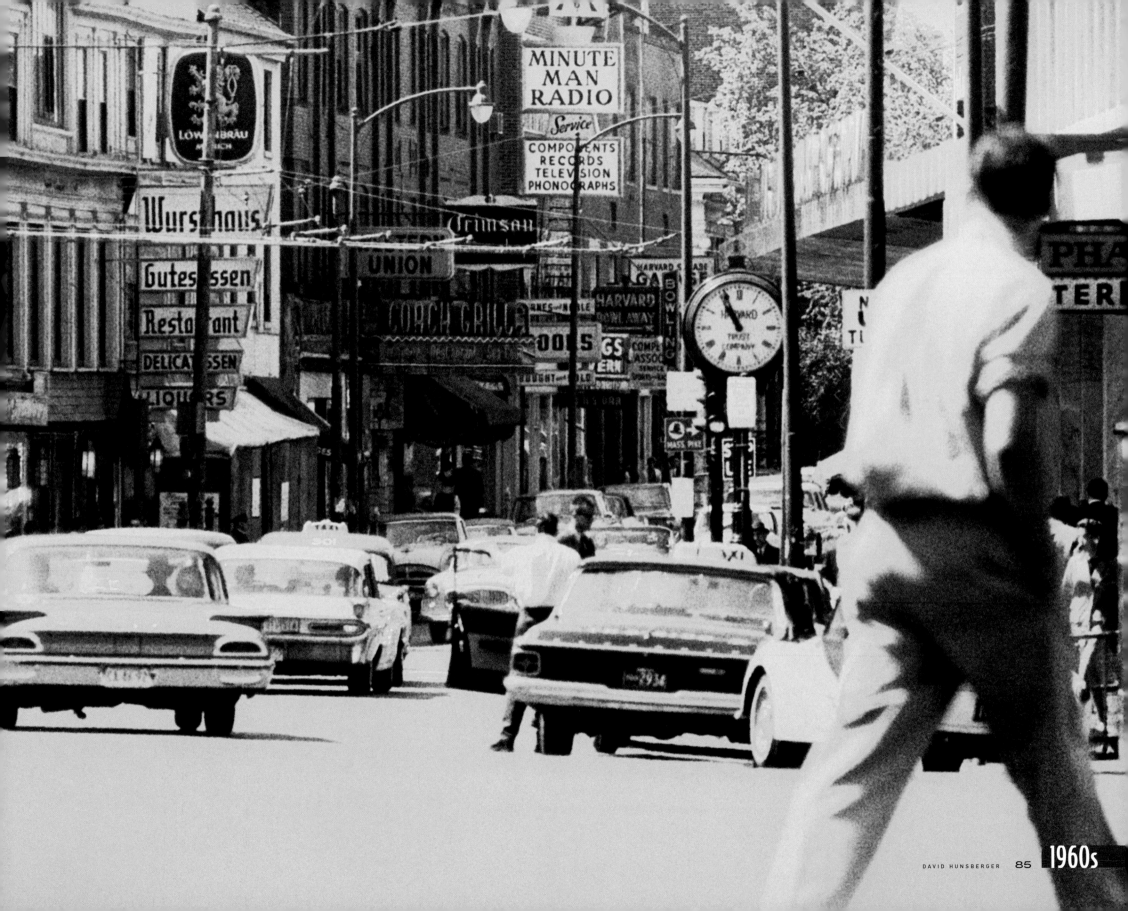

A Audio Lab
B Henri IV
 Discothèque Nicole
C Charlie's Kitchen
D Treadway Motor House
E Winthrop Park

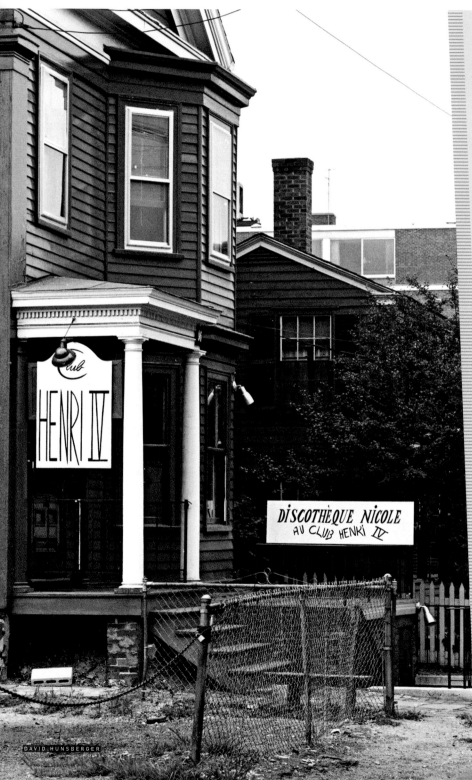

DAVID HUNSBERGER

▲ 1965 B Henri IV was known to many as the "Hungry Cat" because of the French pronunciation. Genevieve MacMillan, a French GI Bride, started the restaurant's four-decade run in 1950, added the Discothèque Nicole, and also created the Patisserie Gabrielle (later, the Patisserie Française) across Boylston St. The 1845 house itself was designated a landmark in 1989; it is most familiar to people as the original House of Blues. {186}

CAMBRIDGE HISTORICAL COMMISSION

▲ 1967 Harvard's Pi Eta Club overlooks a somewhat shabby Winthrop Park, a few years before the space was converted into Grendel's Restaurant. {153, 186, 225}

◀ c.1960 D The brand new Treadway Motor House is built via air rights over an existing public parking lot. The unusual arrangement is still in place today, with metered spaces under what is now the Harvard Square Hotel. {235}

CAMBRIDGE HISTORICAL COMMISSION

1969 *Even Harvard could not escape anger over the Vietnam War as students seized University Hall in April. The administration's controversial decision to send in riot police led to a bloody confrontation with 45 injuries and 184 arrests, which further galvanized the movement. A student strike and massive rallies of up to 10,000 people followed, which did eventually provoke some concessions from the university, including removing ROTC from campus and creating an Afro-American studies department.*

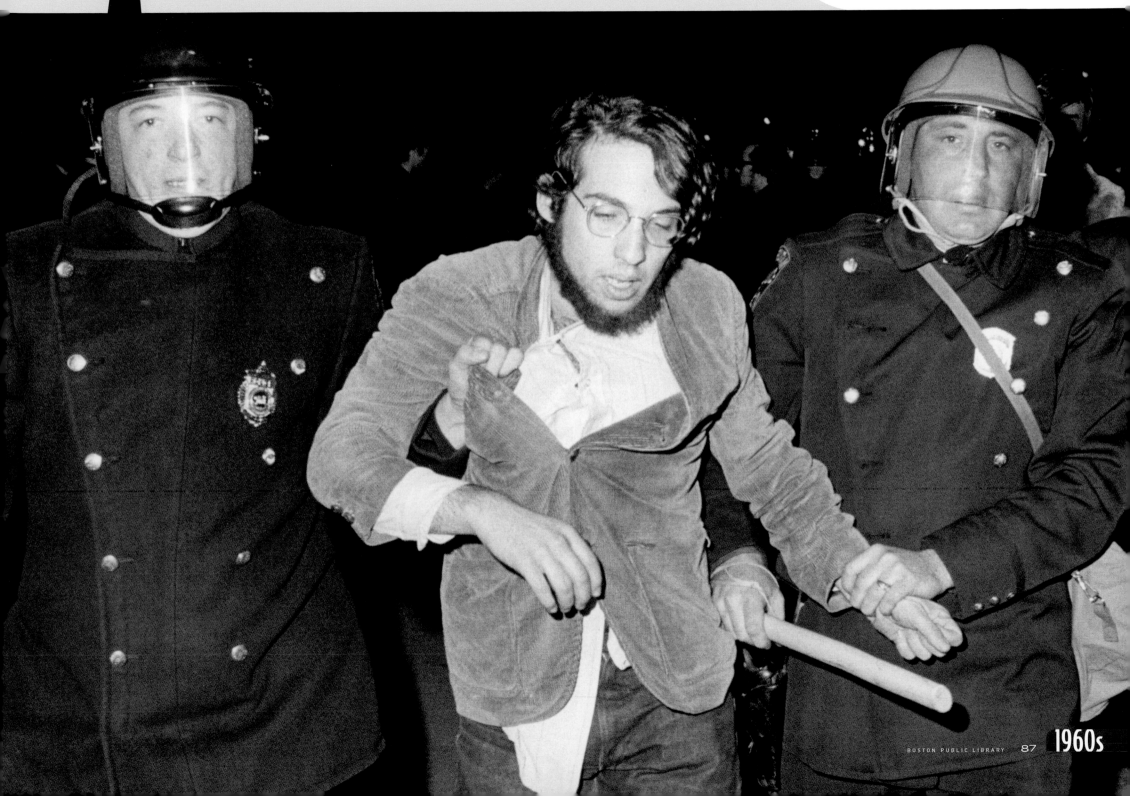

WILLIAM F. WELD

is an attorney and author who served as governor of Massachusetts from 1991 to 1997. He graduated from Harvard Law School in 1970 and lived in Cambridge for 38 years.

I WAS A BORED

third-year student at Harvard Law School in the spring of 1970, working at the State House in Boston as a volunteer legislative analyst. One Saturday I picked my way through a thoroughly stoned antiwar crowd on the Boston Common and boarded the Red Line at Park Street. When I arrived at Harvard Square, the station was in flames.

The Vietnam War, civil disobedience, a growing drug culture, and freewheeling sexual mores dominated the Square. I anchored the drinking, as opposed to the smoking, wing of Harvard Square in the early 1970s. After Veal Oscar at Ferdinand's, escargots at Chez Jean, canard à l'orange at Harvest, moussaka at the Acropolis, or a burger and Alabama sauce at Charlie's Kitchen, we would ineluctably drift to the Club Casablanca on Brattle Street for a few refreshments, presided over by the charismatic but slightly irascible Dutchman Govert van Schaik (later shot to death by a would-be patron denied entry), or the always ebullient Sari Abul-Jubein. Edith Piaf and Charles Aznavour ruled downstairs, Creedence Clearwater and the Stones above. From there it was off to Jack's or the Inn Square Men's Bar (a misnomer) with Reeve

Little and Bonnie Raitt. We encouraged Bonnie, and she made out all right in time.

Politics was central to the intellectual life of the Square. Everyone thought globally. Then came the big flip. After Nixon resigned on August 9, 1974, Harvard Square turned on a dime. The third-year law students whom I interviewed for my firm that fall were suddenly more interested in profits per partner than the war on poverty.

Likewise, my priorities had shifted. I got married and bought a house between Brattle Street and Huron Avenue. The bars were replaced by stores: Olsson's for tiny animals and sacs of miniature groceries, Calliope for baby blankets and fuzzy-wuzzies, Kupersmith for flowers, Brine's for Frisbees and balls and skates.

The arc of the 1970s in Harvard Square took me from self-indulgent third-year law student to a married, homeowning, taxpaying, churchgoing father of three. This trajectory was mirrored elsewhere in the Square. People had had enough. They returned to thinking locally.

William F. Weld

COURTESY OF WILLIAM F. WELD

1970 *Fires are set and windows broken as antiwar riots bring violence to the Square.*

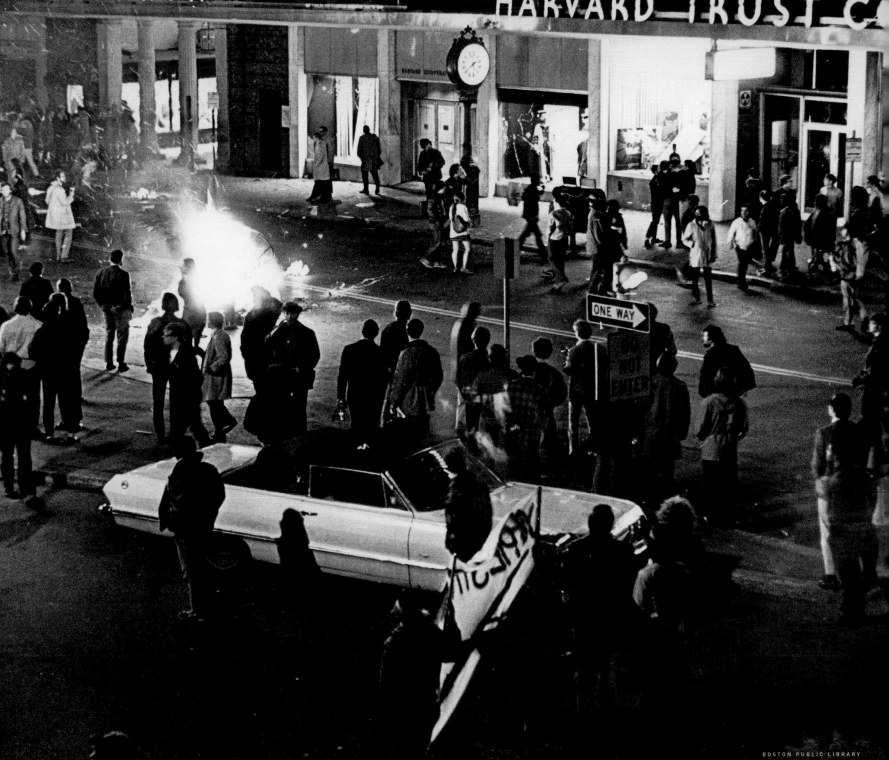

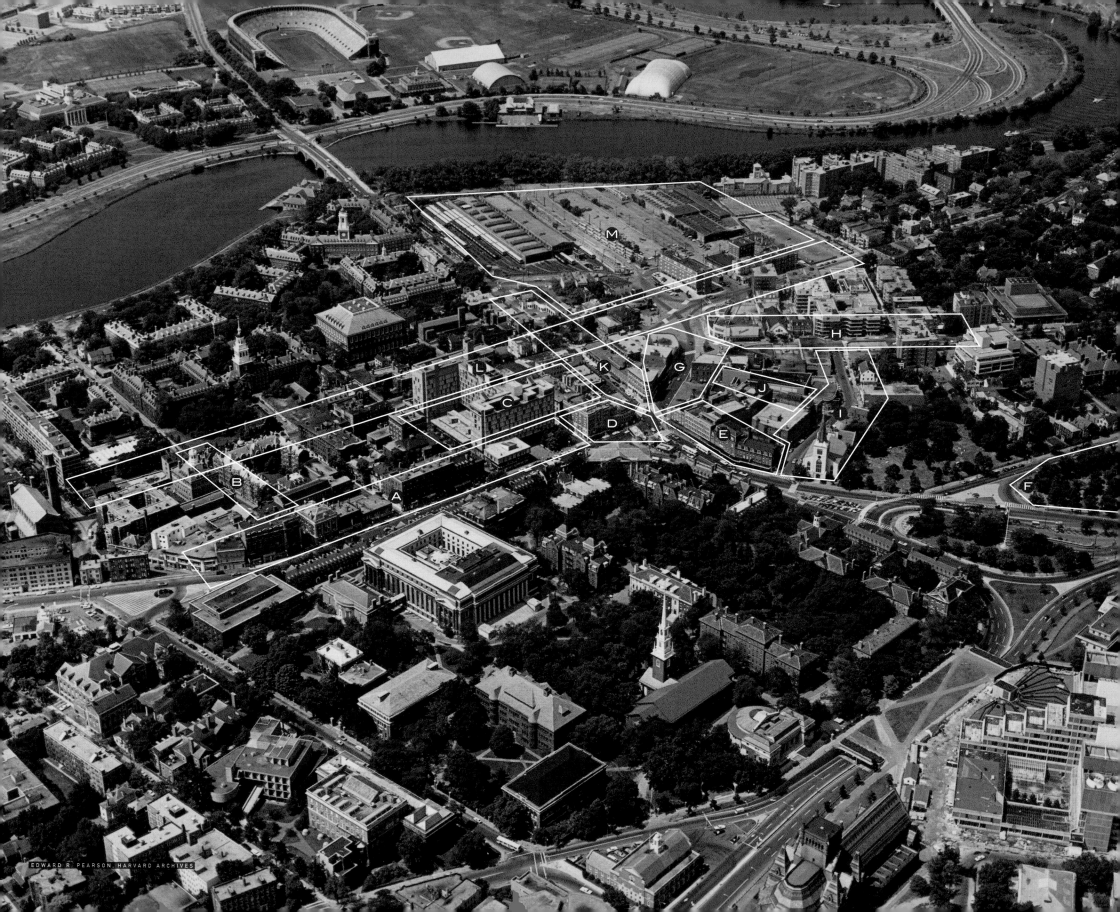

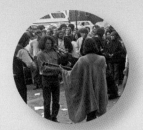

A. Lower Mass. Ave.

B. Plympton St.

C. Holyoke & Dunster Sts.

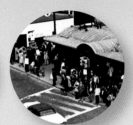

D. The Center

E. Upper Mass. Ave.

F. Cambridge Common

G. Lower Brattle St.

"IT WAS REALLY UGLY,"

said shopowner Ann Lerner of the riots. The tumult of the Vietnam era reached its highest pitch as the decade dawned, and Harvard Square became ground zero in a generational battle that left it shattered and bloody. But hallmarks of a cultural transformation had already appeared—like a street clinic for an estimated three to four thousand transients, the alternative Group School, where teachers smoked up with students, and "Free Wheel," a glorified hitchhiking service created from old postal trucks.

There was a flip side to this societal reorientation. Once the riots subsided, youthful passions could instead be channeled into a colorful explosion of culture and personal expression. "I had a term for it," said ice cream entrepreneur Steve Herrell of Saturdays in the Square, "I used to call it The Carnival." Harvard Square had become a bright, bell-bottomed swirl of acrobatic individuality, altered consciousness, and fervent communalism. A sojourn through the streets meant a pageant of white-faced mimes and spangled jugglers, blind banjo pickers and home-thrown pottery mongers, Krishna chanters and black-caped Satanists.

"It was the second busiest place I'd ever been to, the first being Manhattan," remembered Mike Volpe, who arrived as a teenager. The Square's recent boom made for a petri dish of mom & pop outfits offering everything from water beds to earth shoes to antique gum-ball machines. Even the *New York Times* acknowledged, "There is perhaps no thicker concentration of small businesses in this country than in Harvard Square's winding streets and alleys."

The intersection of creativity and commerce set the stage for innovation. The Spa launched a confectionery craze as frozen yogurt first issued forth in soft, fruity helices from their health-food counter on Brattle Street. At Out of Town News, Paul Allen lit up when he saw the first microcomputer, the Altair, on the cover of *Popular Electronics*. Allen rushed back to

Harvard, where he and his friend Bill Gates had been waiting for just such a breakthrough. Microsoft was born.

Cambridge matured into a music mecca; new clubs such as Jonathan Swift's and Jack's nurtured a rock, jazz, and blues scene, while Passim kept the folk flame alive. Locals Ric Ocasek and Ben Orr played as a duo in the Idler before The Cars made it big. Top talent such as Janis Joplin, Jimi Hendrix, and Led Zeppelin electrified massive crowds in Harvard Stadium, while free, populist shows on the Common made names of hungry, wiry rockers such as the Allman Brothers through tendrils of marijuana smoke. The Harvard Square Theatre hosted Dylan and Bowie and Bonnie Raitt. *Real Paper* columnist Jon Landau, blown away by Raitt's opening act, would famously gush, "I saw rock-and-roll future and its name is Bruce Springsteen." Laundau would go on to manage him.

Toward the end of the '70s, changes were underfoot, literally, as construction began on the subway extension. Development had already sparked mutterings of escalating rents, invading chains, expensive tastes. Today those concerns seem either prescient or quaint. Harvard Square was enjoying a golden age. The sensory stimulation and the bustle, the roaming dogs and braided strangers made not a crush, but a cocoon. There was a gentleness, a positivity that welcomed all, regardless of quirk. "My basic word to describe Harvard Square at that time is contentment," said then-reporter April Smith. "You felt like you belonged."

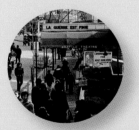

H. Upper Brattle St.

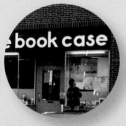

I. Church St.

J. Palmer St.

K. Boylston St.

L. Mount Auburn St.

M. Eliot & Bennett Sts.

THE 1970s

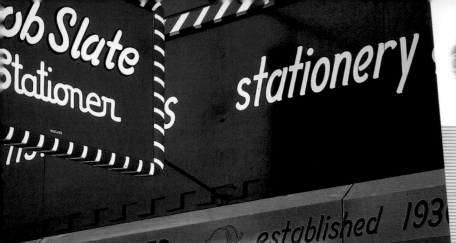

A The Hong Kong
B Bartley's
C Harvard Bk. Str.
D Ferranti-Dege
E Kracker Jacks/ Harvard Bk. Str.
F Briggs & Briggs
G One Potato Two Potato
H Schoenhof's
I Stonestreets
J Pangloss
K Bob Slate
L Claus Gelotte

lower mass. ave.

BOB SLATE, STATIONER

RODGER KINGSTON

When

water started leaking through the back wall of his stationery store, threatening the merchandise, with nowhere to go, Bob Slate simply reached down and ripped up the floorboards with his bare hands. As he knew from growing up on a farm and then grinding out a living during the Depression, sometimes you have to do whatever works.

For Slate, starting out in 1930, that included growing his Harvard Square stationery business from inside his cousin's diner on Holyoke Street for three years, even stepping behind the counter to sling hash when necessary. Or sharing his original storefront at 1284 Massachusetts Avenue with a student laundry service and a watchmaker called "Hitchey" who doubled as typewriter repairman and tapped out term papers for a nickel a sheet.

The notoriously frugal and hardworking Slate was popular and visible in the community, serving as president of the Harvard Square Business Association. His industriousness paid off. In 1950, when next-door neighbor Phillips Books moved to a new location, the stationery store moved in, doubling its size. And when LaFrance Stationers bowed out after a 1974 fire at 28–36 Brattle, he opened a second location. That store moved to Church Street in the early '90s, where it

remains, while a third location keeps Porter Square well-stocked with bubble mailers and thank-you notes.

About eighty years and a whole lot of paper clips after he started it, Bob Slate's stationery shop is still only in its second generation of ownership, with Slate's sons Mallory and Justin at the helm. From erasers to Ko-Rec-Type to Wite-Out, and now ink-jet cartridges, Slate's has followed the trajectory of technology and a changing marketplace.

In the old days they would sell typewriters, including the top of the line Hermès, from Switzerland, "with stainless-steel keys and movable ribs on the end of the keys so they didn't lock into each other," said Justin. Since then, they've added art supplies, greeting cards, and gift items. So now you can buy a gilt-edged, pleather-bound personal appointment book and also grab a cheap steno pad.

Some items of yore have even made their way back to the shelves. Sealing wax is no longer a method of keeping correspondence scrolled, but a luxury to evoke the misty passions of another era. Handmade, small-batch letterpress note-cards are printed not because of crude technology but as a revivalist art form. Strolling the aisles of Slate's is not necessary to restock the supply cabinet, but when the place verily buzzes with the romance of the writer's craft, it sure is fun. {12, 132, 133}

Kareem

Abdul-Jabbar was enrolled in summer school at Harvard and came in to look at some bags on the very top shelf at Bob Slate's. The five-foot-tall employee went to get a ladder. Kareem just reached over and pulled them down.

c.1970 A
Lewandos cleaners had a presence in Harvard Square dating to the 1800s. The Hong Kong, opened in 1954, has since grown to encompass this entire building with nightly entertainment. {*200, 167}

CAMBRIDGE HISTORICAL COMMISSION

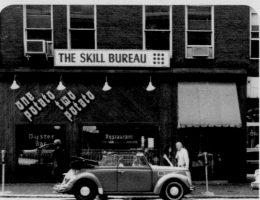

HARVARD ARCHIVES

1978 G
Barrel-top tables, black stools, and cheap, drinks comprised the One Potato zeitgeist. {128, 132, 133}

1975 A pedestrian makes the best of heavy snow under a fashionable bubble umbrella.

1978 CDE Harvard Book Store moved to 1284 Mass. Ave. in 1950. In 1971 they added the corner space, which left camera shop Ferranti-Dege sandwiched between the two for about ten years. {167, 202}

HARVARD ARCHIVES

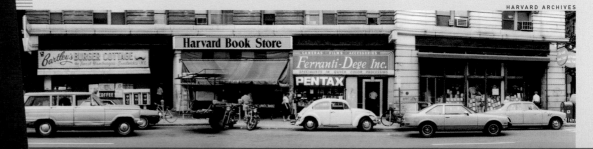

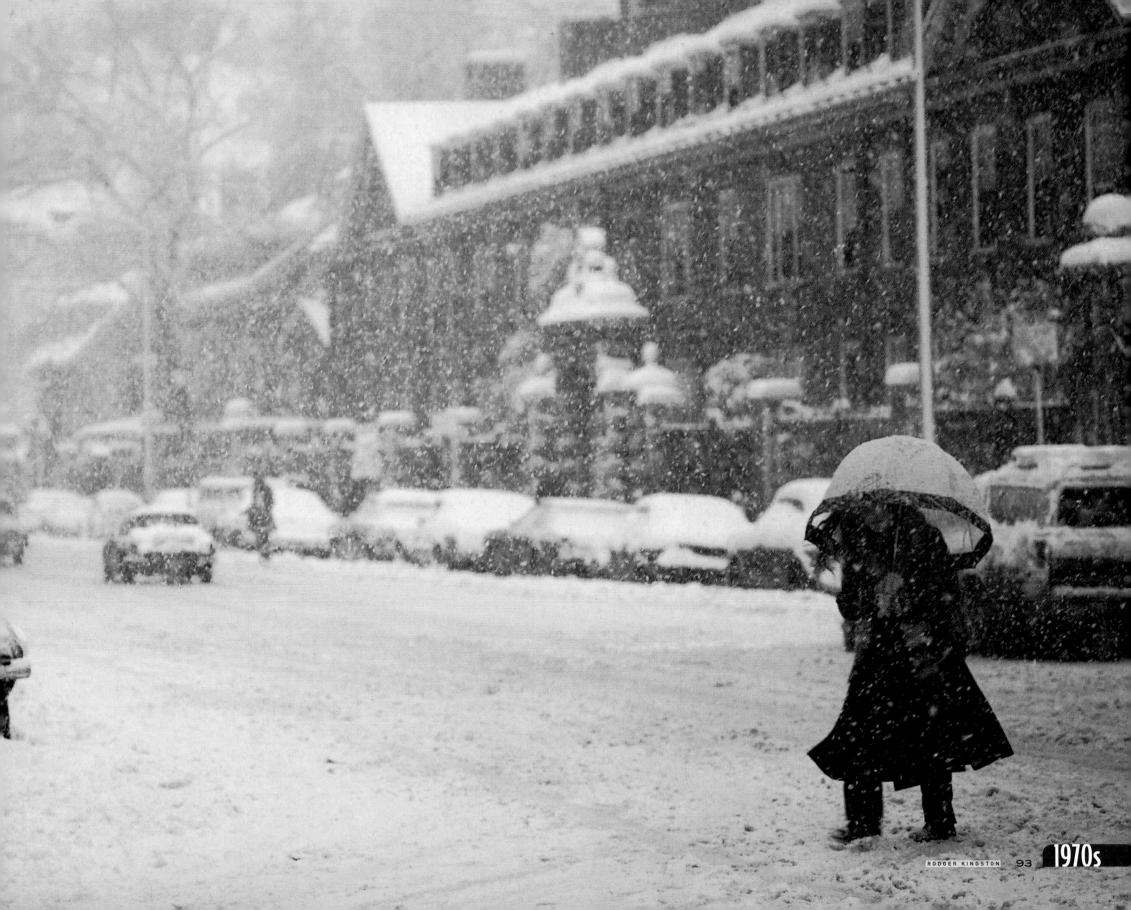

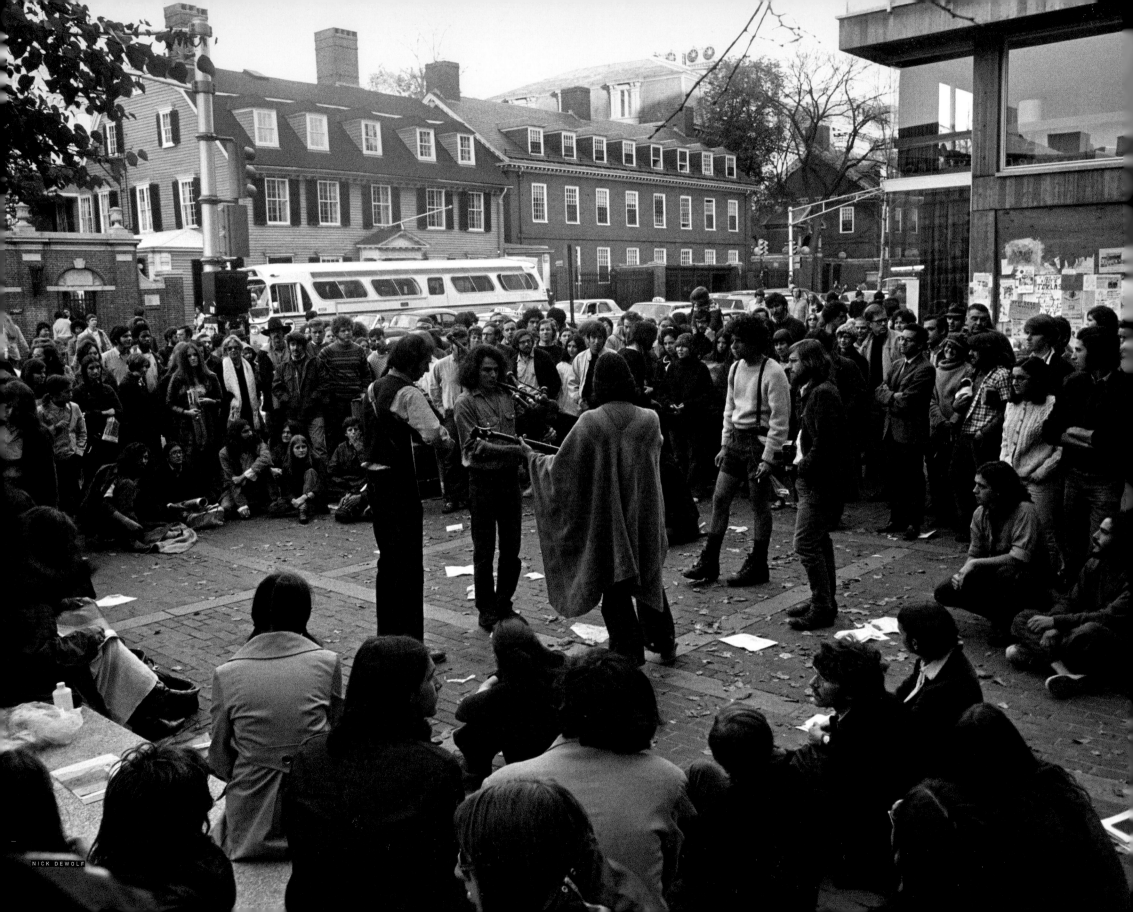

Lower Mass. Ave.

- Ⓐ Harvard Camera Exchange/Ferranti-Dege
- Ⓑ Harvard Barber Shop
- Ⓒ Gnomon Copy
- Ⓓ Harvard Travel Service/Belgian Fudge
- Ⓔ Slak Shak/Serendipity
- Ⓕ Leavitt & Peirce
- Ⓖ J. August
- Ⓗ As You Like It/Yenching
- Ⓘ Cambridge Trust
- Ⓙ Holyoke Center

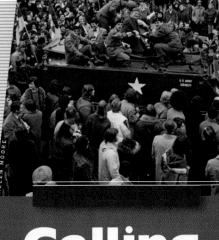

◀ c.1970s Ⓒ Gnomon Copy was started by MIT engineers and turned into a local chain. When opening in 1970 they agreed to restore and preserve this beautiful wooden Art Nouveau storefront.

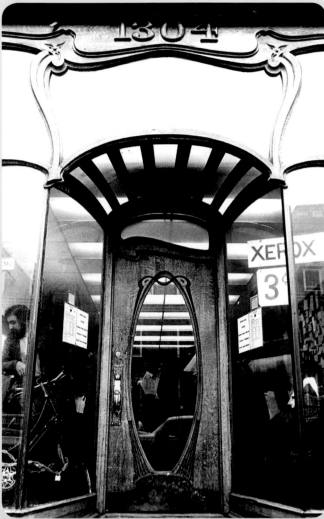

COURTESY OF THE BOSTON PHOENIX

HARVARD ARCHIVES

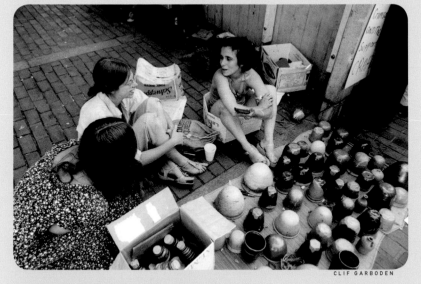

CLIF GARBODEN

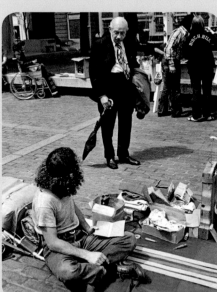

KEN KOBRÉ

◀ c.1974 Ⓙ Pottery was just one of the many items peddled on Forbes Plaza in front of Holyoke Center. {59, 129, 135, 205}

◀ c.1972 Ⓙ Two men size each other up across the generation gap.

◀ 1978 A street level montage shows storefronts as subway construction gets under way. This block would remain nearly unchanged until 2007. {14, 53, 203}

Calling

him "the biggest fraud in history," *The Harvard Lampoon* invited (or dared) John Wayne to come to Harvard Square to collect a prize they created just for him, The Brass Balls Award. What could be better than a face-off between the living icon of wild-west machismo and the national head-quarters for leftist intellectualism? Only putting said icon in a tank, riding down Massachusetts Avenue to an assault of snowballs and demonstrating Native Americans.

It all happened on January 15, 1974. Justin Slate remembered the occasion. "I've never seen anything like it in Harvard Square, before or ever since. It was just absolutely jammed." The Duke, to be fair, used the occasion to promote his new movie, *McQ*. He rode to the Harvard Square Theatre for the award presentation and some Q&A, where he successfully deflected such hard-ball questions as, "Is it true your horse filed separation papers?"

Not everyone enjoyed the shenanigans. When the Pentagon brass found out about the Fort Devens military convoy, they were none too pleased and launched an internal investigation. Some people just don't have a sense of humor.

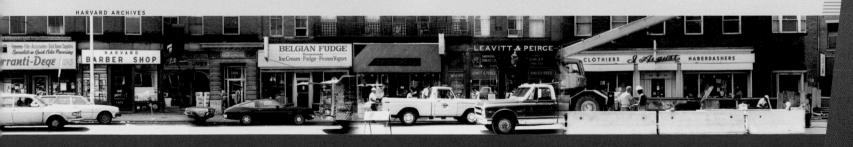

1970s

Plympton St.

- **A** Starr Book Shop
- **B** Pizza Pad/Harvard Pizza
- **C** The Grolier Book Shop

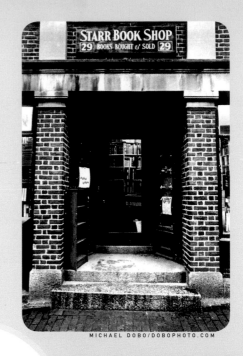

STARR BOOK SHOP
29 BOOKS BOUGHT & SOLD 29

MICHAEL DOBO/DOBOPHOTO.COM

🔺 **1972** **C** *Beat poet Lawrence Ferlinghetti stops by the Grolier and poses with owner Gordon Cairnie. Below them is Louisa Solano, who succeeded Cairnie.*

🔺 **c.1973** **B** *Harvard Pizza served a basic pie for ten years from this corner.*

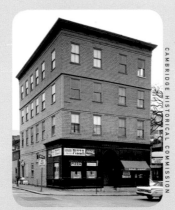

CAMBRIDGE HISTORICAL COMMISSION

🔺 **c.1970s** **A** *Brothers Milton and Ernest Starr launched their used bookstore on Mt. Auburn Street in the '30s. It moved here, to the basement of the Lampoon Castle, in the '50s, where it remained family-run until eviction in 2002. The Starr was known for its scholarly texts, its knowledgeable proprietors, and its dust-coated, precarious stacks of randomly ordered tomes.*

ELSA DORFMAN

THE GROLIER

PETER SOUTHWICK

The Boston

area is no stranger to firsts and oldests, but it is far less acquainted to onlys. The Grolier Book Shop at 6 Plympton Street was, for most of its life, the only poetry-focused bookstore in the United States. It exists as a kind of literary fantasy-made-real, the sort of thing one might expect to see in a *Harry Potter* movie. That it exists at all is a testament to the two people who spent almost eighty years between them caring more about the stewardship of this anachronistic bibliohaven than more mundane niceties such as rent.

In truth, Gordon Cairnie, who founded the shop with a short-lived partner and his own personal library in 1927, and Louisa Solano, who owned it from his death in 1973 until 2006, were very different people. Cairnie, an ornery Harvard grad and World War I vet, kept the Grolier as a kind of good-ol'-boy poet lounge, where elites of verse such as Conrad Aiken, Donald Hall, and Robert Lowell would share conversation or the red couch.

Concerns such as actually selling a book seemed secondary to the independently wealthy Cairnie, who opened his shop irregularly and had signs posted at the entrance reading, in hand-etched majuscules "NO TEXTBOOKS OF ANY KIND! JUST POETRY & LITERATURE!" Those lucky enough to get on his good side would eventually be offered a key to the ponderous wooden door, allowed to let themselves in, and perhaps even mind the disorganized shop during its frequent off-hours. In the process, the Grolier developed into a cherished club for lovers of poetry.

Solano had already frequented and worked in the shop for years when she assumed ownership. She recognized that it was going to need to be at least marginally profitable if it was to survive, and she made a number of changes. The stock, which previously had numbered between two and four thousand, swelled to about 16,000. She narrowed the focus of the shop to just poetry, but broadened its appeal by unstuffing its stuffiness: new poetry, world poetry, and women's poetry were all added to the steep shelves. This encouraged a more democratic clientele. "Gordon definitely liked people who were upper-class, had money, were beautiful," Solano said in 2004. "When I took over, the first thing I did was to take down the signs."

Nevertheless, profitability has never been something the Grolier has been, uh, well versed in. Even with the influx of tourists, Solano once explained,

> *In the late 1950s, Cambridge cops rushed to the Grolier to shut down Allen Ginsberg as he staged a reading of the notoriously controversial—and banned—Howl.*

"It's a landmark. It's a monument. It's a symbol of what intellectual Harvard Square should be. But they don't buy anything here." Fortunately, as landlord, Harvard University has been supportive of the shop and forgiving of the rent, which is one reason it still survives on its razor-thin margins. That could be because Harvard recognizes that the Grolier is the literal embodiment of the Harvard Square mystique.

From T. S. Eliot to Allen Ginsberg to Robert Pinsky, the Grolier customer register and the modern poetry pantheon are pages from the same anthology, so to speak. The Grolier Poetry Prize, founded by Solano in 1973 and still going strong, has launched new careers, including 2007 Pulitzer winner Natasha Trethewey. Solano's autograph parties and reading series also help ensure that the Grolier remains deeply intertwined with the art.

When Solano finally decided to retire in 2006, Wellesley professor, published poet, and longtime Grolier-lover Ifeanyi Menkiti stepped in to save this Harvard Square shrine. His optimism will hopefully keep it running for decades to come. It is a noble responsibility. As former U.S. poet laureate Donald Hall said, "The Grolier Poetry Book Shop is the greatest poetry place in the universe."

holyoke & dunster sts.

Ⓐ Elsie's
Ⓑ The 24/The Rendezvous
Ⓒ The Andover Shop
Ⓓ Gino Hair Salon
 Upper Crust
Ⓔ The Hasty Pudding Club
Ⓕ Rogers of Harvard Sq.

Ⓖ Settebello
Ⓗ Thomas More Book Shop
Ⓘ Phillips-Brentano's Books
Ⓙ The Cambridge Shop
Ⓚ Roten Galleries/
 Audio Components/
 Hair Care by Dunster

Ⓛ C'est Si Bon/Piroschka
Ⓜ Finer Things Antiques/
 Rogers of Harvard Sq.
Ⓝ The Crimson Shop
Ⓞ LaFlamme Barber Shop
Ⓟ Fair Exchange Furniture
Ⓠ Reliance Co-operative Bank

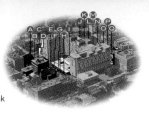

c.1973 Ⓗ *The Thomas More Book Shop (named after the saint) was a center of Catholic intellectualism which hopscotched around the Square for 54 years until it closed in 1989.*

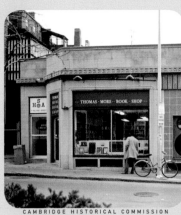

CAMBRIDGE HISTORICAL COMMISSION

CAMBRIDGE HISTORICAL COMMISSION

c.1973 Ⓑ *The 24 was one of many restaurants to inhabit this nondescript storefront over the years. Hazen's preceded it, and The Rendezvous followed.*

c.1973 Ⓓ *Gino, an upscale hair salon, makes its new home in a mid-nineteenth-century house. Gino Ruotolo still styles there to this day.* {206}

c.1973 Ⓒ *The Andover Shop is the sine qua non of prep outfitters. Charlie Davidson opened the original in Andover in 1948 and the Harvard Square branch in 1952. Both stores (and Charlie) were still going well into the 21st century. He built this building in 1961, where his business offers traditional tailored menswear, much of it using original fabrics. He outlasted nearly all his competitors.* {*206, 11}

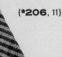

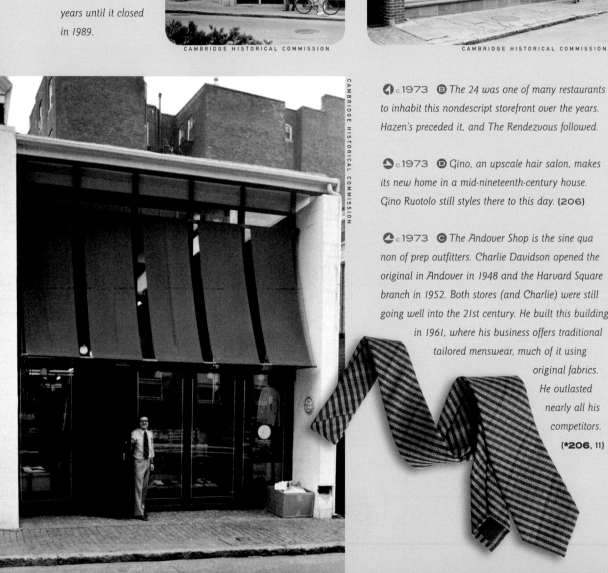

CAMBRIDGE HISTORICAL COMMISSION

CAMBRIDGE HISTORICAL COMMISSION

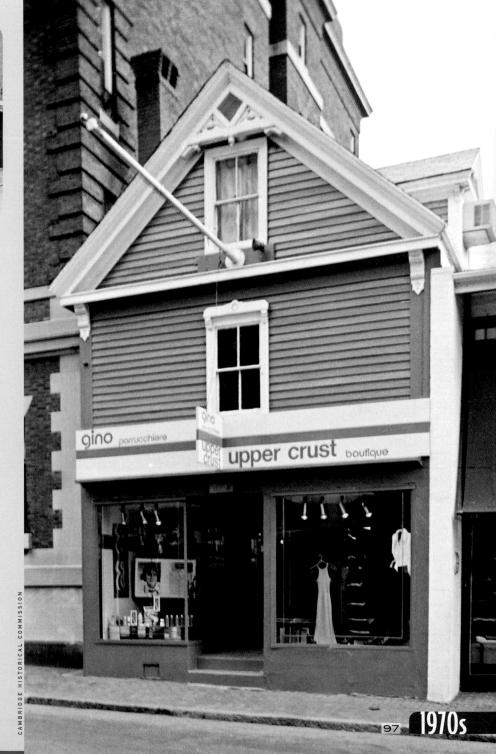

gino *parrucchiere*
upper crust boutique

of police in riot gear marching down Massachusetts Avenue. Protesters hurling rocks. Shattering plate glass. Overturned cars. Tear gas. Looting. Fire. From 1969 to 1972, civil unrest plagued Harvard and the Square.

"It was like you see in the movies—the frontline of a battle." That's how Frank Cardullo, who stood amid the chaos with a pistol in his belt, remembered the riots.

When the Vietnam War took its toll on America, society's seams opened at their most obvious fissures. Cambridge, with its multicultural stew and uneasy mix of longtime merchants, working-class residents, elite intellectuals, independent artists, and homeless wanderers, was ripe for such a breach.

As the love-thy-neighbor ethos soured into disillusionment, Harvard Square became darkened by violence. Many thought Harvard Square had passed the point of no return. Some left forever. The storefronts would bear the scars of those battles, with bars and grates, into the Reagan era.

The spring and summer of 1970 proved the most brutal. The mayhem of April 15 was called the worst civil disturbance in Massachusetts history. The now faded details are shocking.

It began with a large, peaceful rally against military use of taxes on Boston Common. One and a half thousand of the demonstrators, under the banner of the November Action Coalition (a splinter group of the infamous radical organization Students for a Democratic Society [SDS]), branched off and marched all the way down Massachusetts Avenue. Their stated purpose was to protest the arrest of Black Panther leader Bobby Seale.

However, when they reached Harvard Square at 7:00 p.m., police arrived in formation, and things quickly devolved. Protesters streaked through the streets smashing nearly every first-floor shop window in the Square. Harvard sealed off the campus. The demonstrators began pitching rocks, bricks, and bottles at the police, some of whom tossed them right back. The crowd swelled to 3,000. Nightstick beatings ensued and the

opponents faced off in a series of charges and countercharges that lasted five hours.

Youths lobbed Molotov cocktails into Northeast Federal Savings Bank. The Harvard Coop drapes were set on fire, as were trash cans, and briefly, the subway kiosk, where demonstrators mounted the roof and hurled rocks and epithets at the approaching riot police. Authorities responded with tear gas, slowly beating back the demonstrators until finally, at 1:00 a.m., the streets were cleared. At 1:45 a curfew was set and responders began the task of cleaning up the detritus of a generation's rage. Square merchant Tony Ferranti explained, "It was a whole bursting forth of a lot of resentments because people knew they were being screwed."

That evening was the worst, but it was just one sleepless episode in a years-long night of perpetual unease. There would be three more significant riots that year, culminating in an October bombing of Harvard's Center for International Affairs, which could be heard in Allston. It would be two or three years before Harvard Square truly settled down.

From the time that Washington set up camp in the Common, Cambridge has been on the leading edge of thought, controversy, and some-

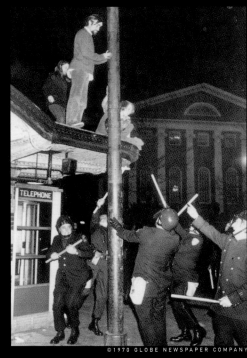

times revolution. The riots were a nasty chapter in a story that seems to repeat itself. But perhaps they sent a message that people need to hear from time to time: you can't wage war abroad and expect peace at home.

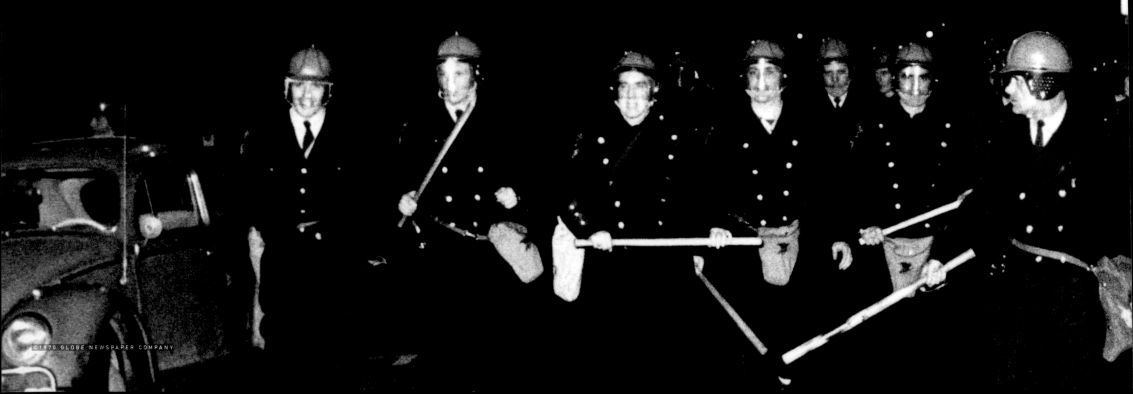

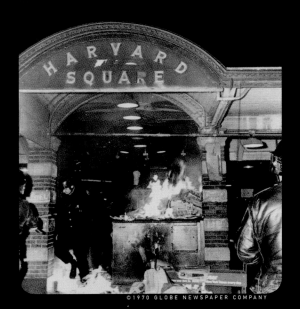

©1970 GLOBE NEWSPAPER COMPANY

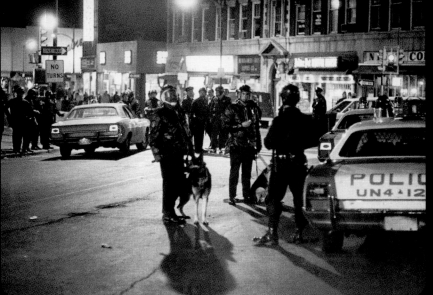

BOSTON PUBLIC LIBRARY

By the Numbers:

5 hours

$100,000 worth of damage

3,000 demonstrators

2,000 police from 7 jurisdictions

2,000 guardsmen ordered readied

Hundreds of shop windows broken

214 injuries, including 35 officers

35 arrests

14 police cars' windows smashed

Dozens of blazes started

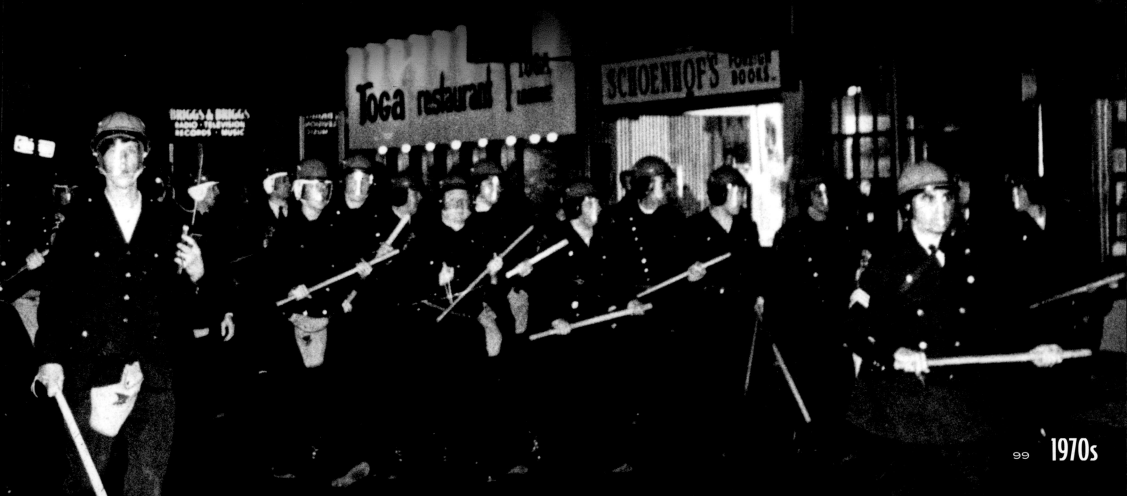

Ⓐ Cambridge Savings Bank
Ⓑ Hungry Charley's/Mug 'n Muffin
Ⓒ Elkins Galleria of Footwear/
 Taha Shoes
Ⓓ Varsity Liquors
Ⓔ Subway Kiosk
Ⓕ Out of Town News

the center

THE XEROX

machine may seem insignificant in comparison to, say, the Internet, but it was quite the invention for the information-hungry activists and scenesters of Harvard Square. Copy shops sprouted quickly— one, notably, inside the clothing store J. August— and now anyone could mass-produce pamphlets, tracts, handbills, flyers, posters, and newsletters. The avalanche of pulp and its paper-thrusting promoters took decades to abate.

A U.S. INFANTRY COMPANY JUST CAME THROUGH HERE!

VIETNAM VETERANS AGAINST THE WAR

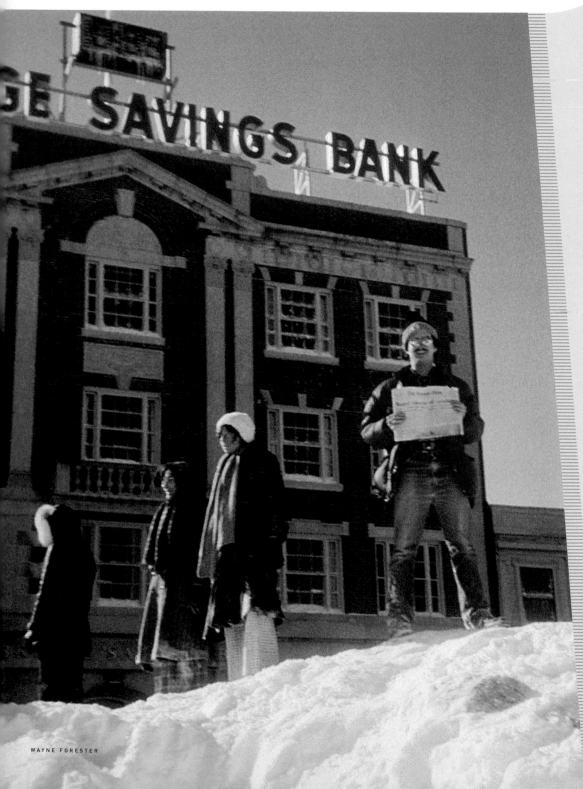

WAYNE FORESTER

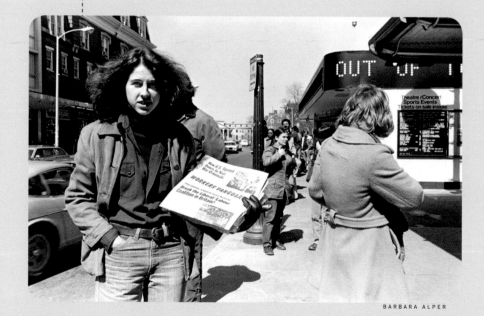

BARBARA ALPER

🔺1978 Ⓐ *Gigantic snow mounds front Cambridge Savings Bank following the Blizzard of '78. The February 6–7 storm dumped 27.1 inches of snow on Boston—the most ever recorded for a single storm. Scores died, thousands were injured, and the city was paralyzed for a week. In Harvard Square, cross-country skis became the favored mode of transport. The nor'easter remains the mythic standard against which all other extreme weather in New England is judged.* {21, 47, 137, 138}

◀1977 *Marxist newspapers were just one type of literature in the arsenal of ubiquitous pamphleteers.*

🔻c.1970s *Cabbies have always added color to the center of the Square.*

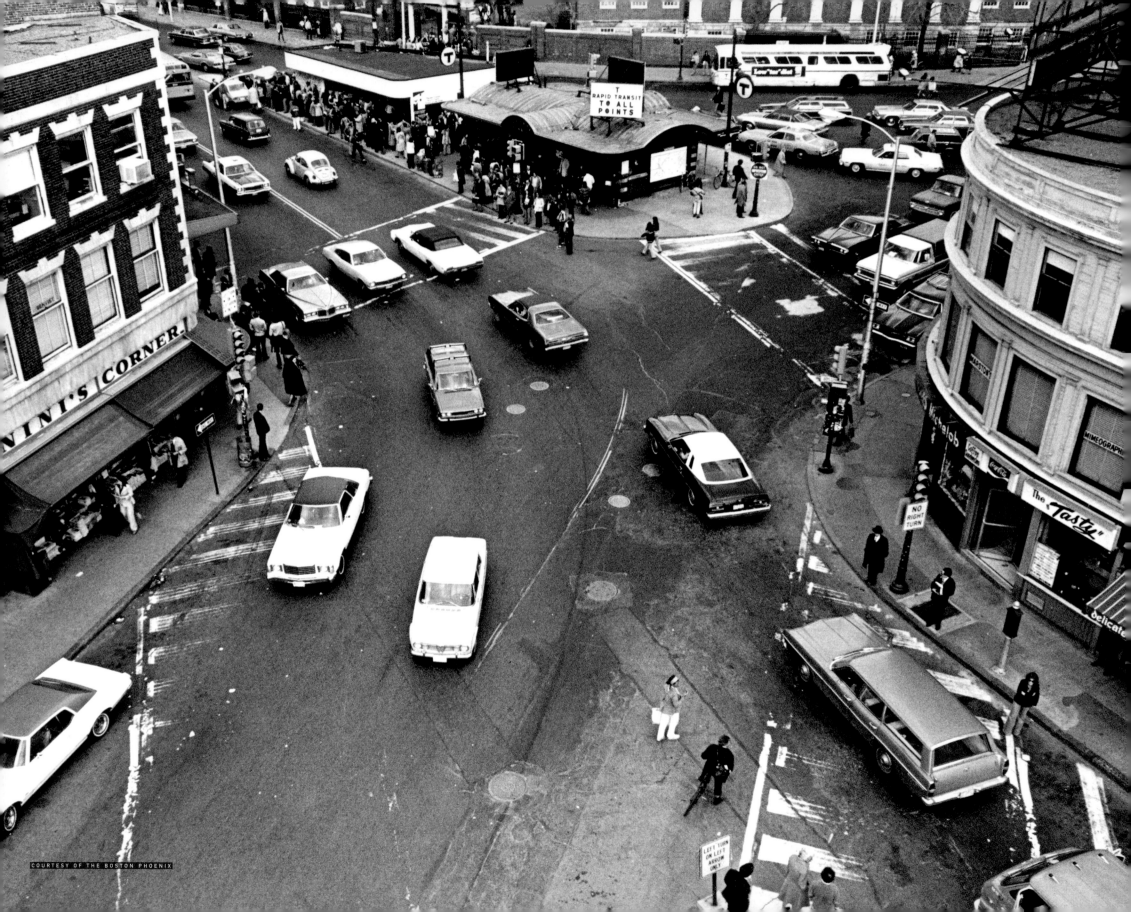

Ⓐ Cambridge Savings Bank
Ⓑ Hungry Charley's/Mug 'n Muffin
Ⓒ Elkins Galleria of Footwear/
 Taha Shoes
Ⓓ Varsity Liquors
Ⓔ Subway Kiosk
Ⓕ Out of Town News

HARVARD ARCHIVES

🔴 1972 Ⓔ Cambridge artist Barbara Westman was known for her whimsical illustrations of Harvard Square and environs, capturing the haute-hippie zeitgeist of the late '60s and early '70s.

🔴 c.1970s The pretzel man makes his rounds.

🔴 c.1977 Ⓔ The classic view of the Square centers on the traffic island. Soon, this vista would be permanently altered as the subway extension upends traffic patterns and forever blocks westbound Mass. Ave. vehicles (upper right) from going straight to Brattle St. (lower left). {2, 3, 22}

🔴 1979 Ⓔ The sooty walls of the subway station near the end of the line. A brand-new megastation would come online with the MBTA's Red Line extension of the '80s. {136}

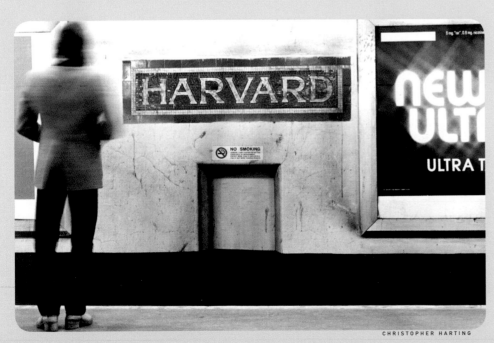

CHRISTOPHER HARTING

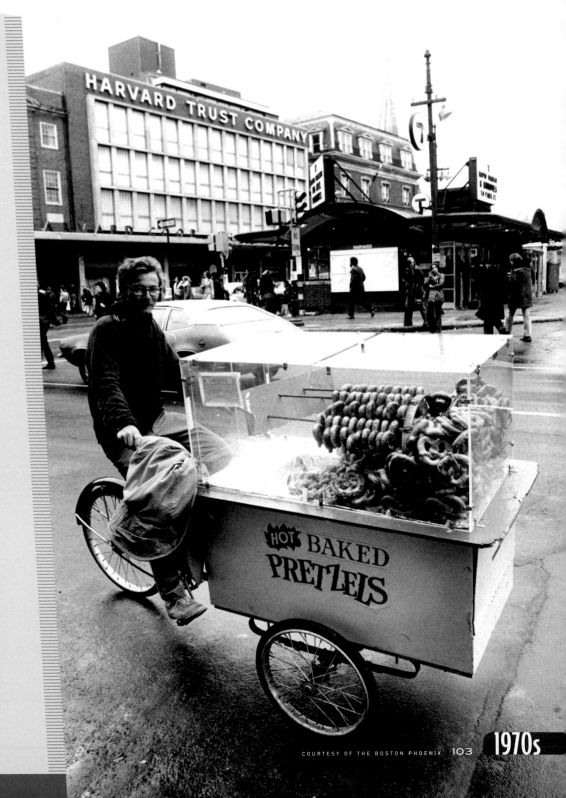

A Harvard Coop
B Harvard Trust/Baybank
C Brigham's
D College House Pharmacy/CVS
E Harvard Valeteria
F Harvard Square Theatre
G Store 24
H Stu. Valet Svc./Golden Temple Emporium

upper mass. ave.

🔵 1976 Ⓑ *The Square is frozen into a perfect tableau.* {20, 63}

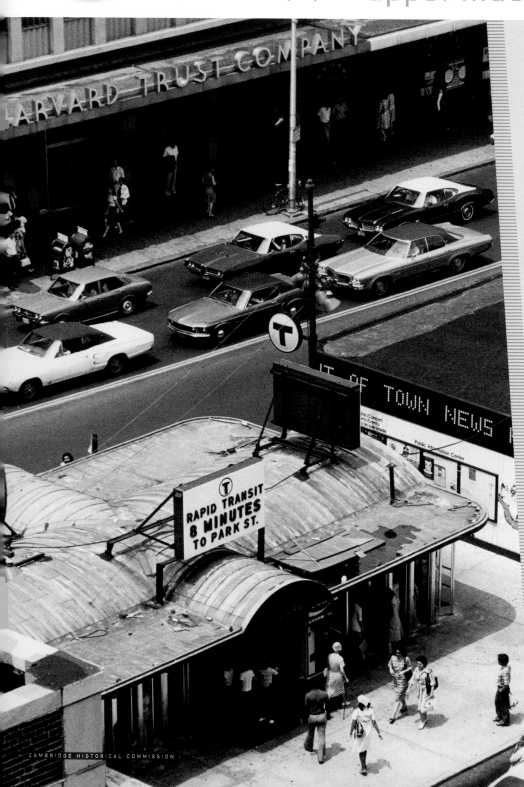

CAMBRIDGE HISTORICAL COMMISSION

NICK DEWOLF

STEVE NELSON/SNPIX.COM

🔵 c.1971 Ⓐ *Billy Martel spreads the word about adult ed in front of the Coop.*

🔵 1970 Ⓐ *A browser takes in the Coop's insignia section. Ponchos were easier to spot in those days.* {24, 26, 36, 66, 118, 152, 177, 210}

🔵 c.1979 *The heart of the Square becomes a staging area for the subway construction. Note the concrete awning has been removed from the buildings on Mass. Ave. north of BayBank.* {25}

🔵 c.1972 Ⓐ *Protesters try to drum up support for a peace march.*

ANTYDILUVIAN

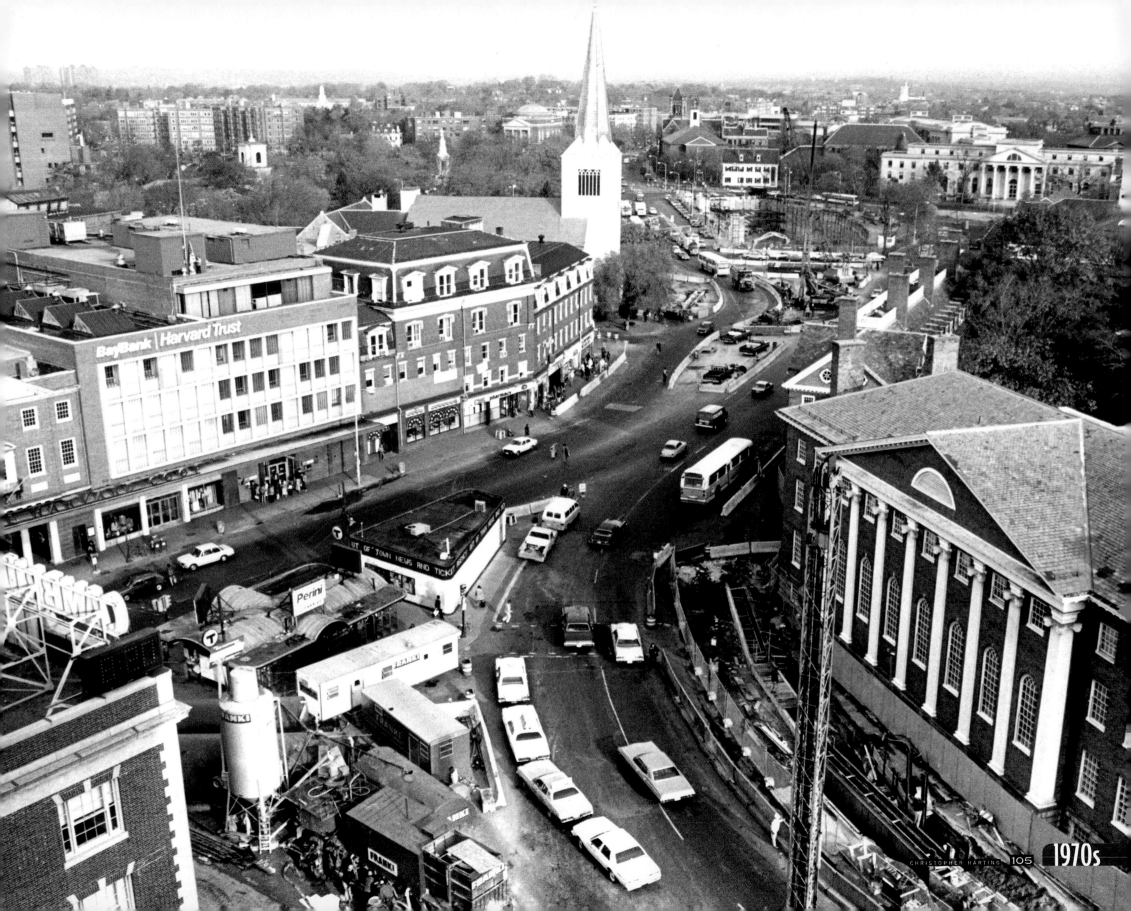

1970s

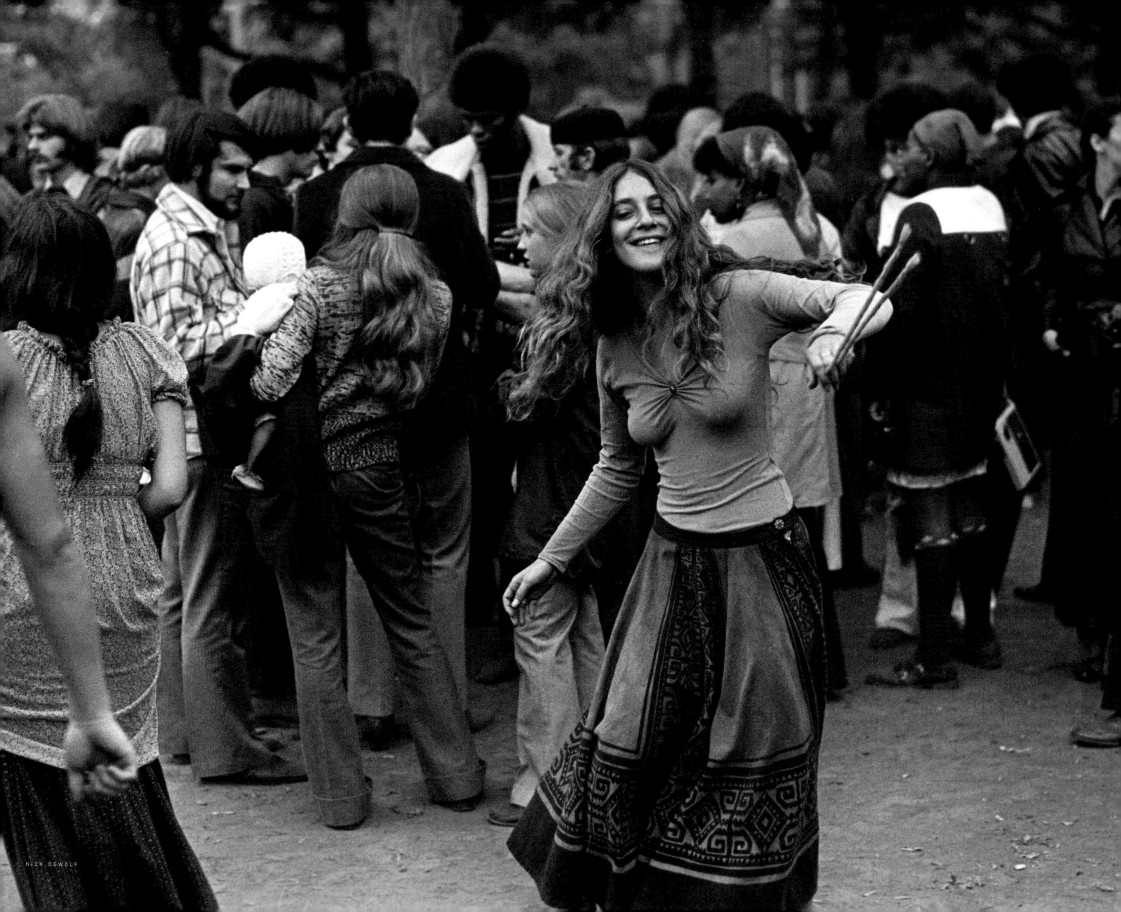

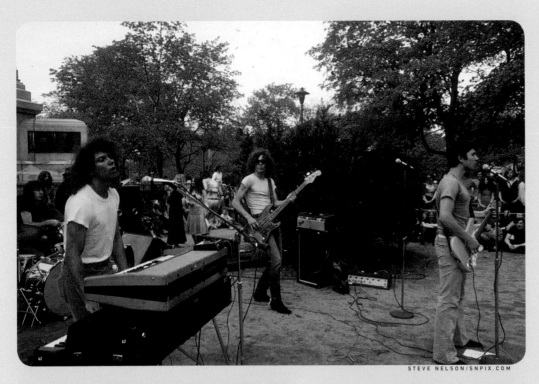

➊ c.1971 *The Modern Lovers rock out in front of the monument. Front man Jonathan Richman is considered one of the fathers of punk. Keyboardist Jerry Harrison later joined Talking Heads.*

STEVE NELSON/SNPIX.COM

ROB CHALFEN

➊ 1972 *Blind New York avant-garde composer Moondog, who always dressed in Viking garb, visits the summer scene at the Common.*

ANTYDILUVIAN

➊ 1972 *A crafts fair draws a nice crowd.*

➊ 1973 *A jam session invokes an ecstatic response.*

➊ 1970 *Totally groovy, sister.*

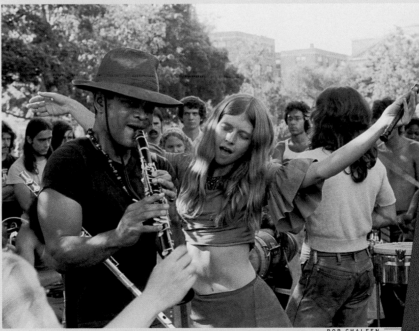

ROB CHALFEN

NICK DEWOLF

The psyche-

delic, marajuana-suffused atmosphere and the credo of free love that descended upon Cambridge may not have originated here, but the hippie movement transformed the place quickly into Haight-Ashbury, eastern branch. While the Square served ably as headquarters, a free spirit needs to sink her toes into Mother Earth and let down her frizzy hair. For that, there was the Cambridge Common.

Beginning in 1968, the Common was transformed every warm Sunday afternoon into a bohemian free-for-all, with drum circles, bead-sellers, tranced-out dancers, and a ton of pot. The main draw, however, was free rock concerts. Organized on the cheap in the spirit of community, the shows were a rite of passage for Cambridge youth and a launching pad for bands such as a then-little-known Lynyrd Skynyrd and The Allman Brothers (who spent about a month in Cambridge and played there regularly). More common were the local groups such as The Ill Wind, Bead Game, and most famously Jonathan Richman and the Modern Lovers.

Like most things that seem too good to be true, the Concerts on the Common had a short shelflife. The Cambridge City Council shut down the festivities in a 1974 resolution. Until then, however, as former concertgoer Lyz Boudreaux recalled, "It was complete debauchery, in broad daylight."

107 **1970s**

Ⓐ The Workbench/
 WordsWorth Books
Ⓑ Audio Components
Ⓒ George's Folly/
 Bob Slate
Ⓓ Dickson Bros.
Ⓔ The Lodge

Ⓕ Corcoran's
Ⓖ The Spa
Ⓗ Cappy's Shoe Repair
Ⓘ Charlesbank Trust
Ⓙ Kupersmith Florist
Ⓚ Cardullo's
Ⓛ Montgomery-Frost-Lloyd's

Ⓜ Pewter Pot Muffin House/
 Greenhouse Coffee Shop
Ⓝ Nini's Corner
Ⓞ Brattle Sq. Florist
Ⓟ Brine's Sporting Goods
Ⓠ Arlace Shoes/NE Music City
Ⓡ Superior Market/

Ⓡ Paperback Booksmith
Ⓢ Bailey's Restaurant
Ⓣ J. McKenna Gifts/
 Derby Jeweler
Ⓤ The Jewel Box
Ⓥ Woolworth's
Ⓦ Zum Zum

lower brattle st.

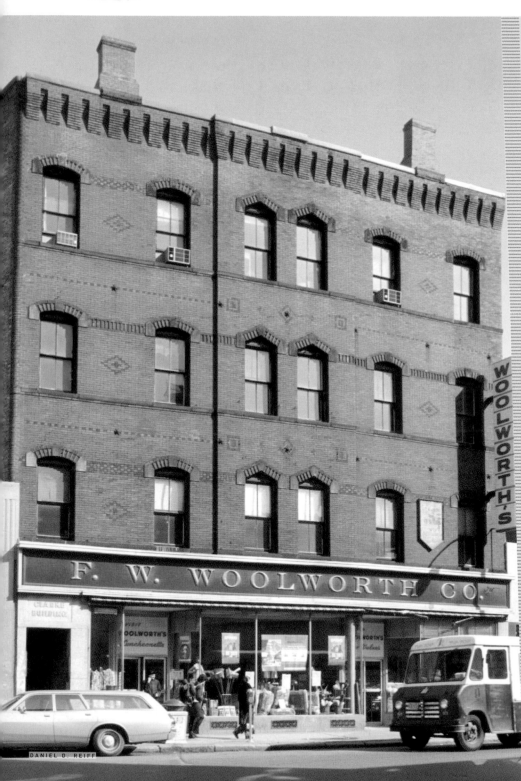

DANIEL D. REIFF

COURTESY OF THE BOSTON PHOENIX

⚓ 1973 Ⓢ Bailey's, serving fine choc-olates and ice cream, catered to a genteel clientele in the high-Victorian style of marble counters, wire-backed chairs, and metal sundae dishes. Here, the Boston chain celebrates its centennial, though the Harvard Square shop dated only from 1965. {143}

◀ c.1971 John Westerfield was a frequent busker.

⚓1970s Ⓦ
Zum Zum was a small beer and brats chain, razed in 1978.

STEVE NELSON/SNPIX.COM

⚓ 1973 Ⓥ Woolworth's enjoys the waning years of Harvard Square's low-rent milieu. In 1978, property owner Lou DiGiovanni would renovate the building as part of a new retail and office complex called The Atrium that stretched to Church Street. That project would oust the 39-year-old five-and-ten and raze the neighboring Zum Zum and Chez Dreyfus on Church. {117}

◀ c.1972 Ⓥ Woolworth's lunch counter was a spot for a cheap meal.

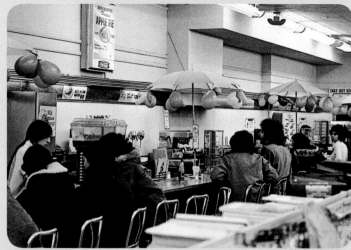

ANTYDILUVIAN

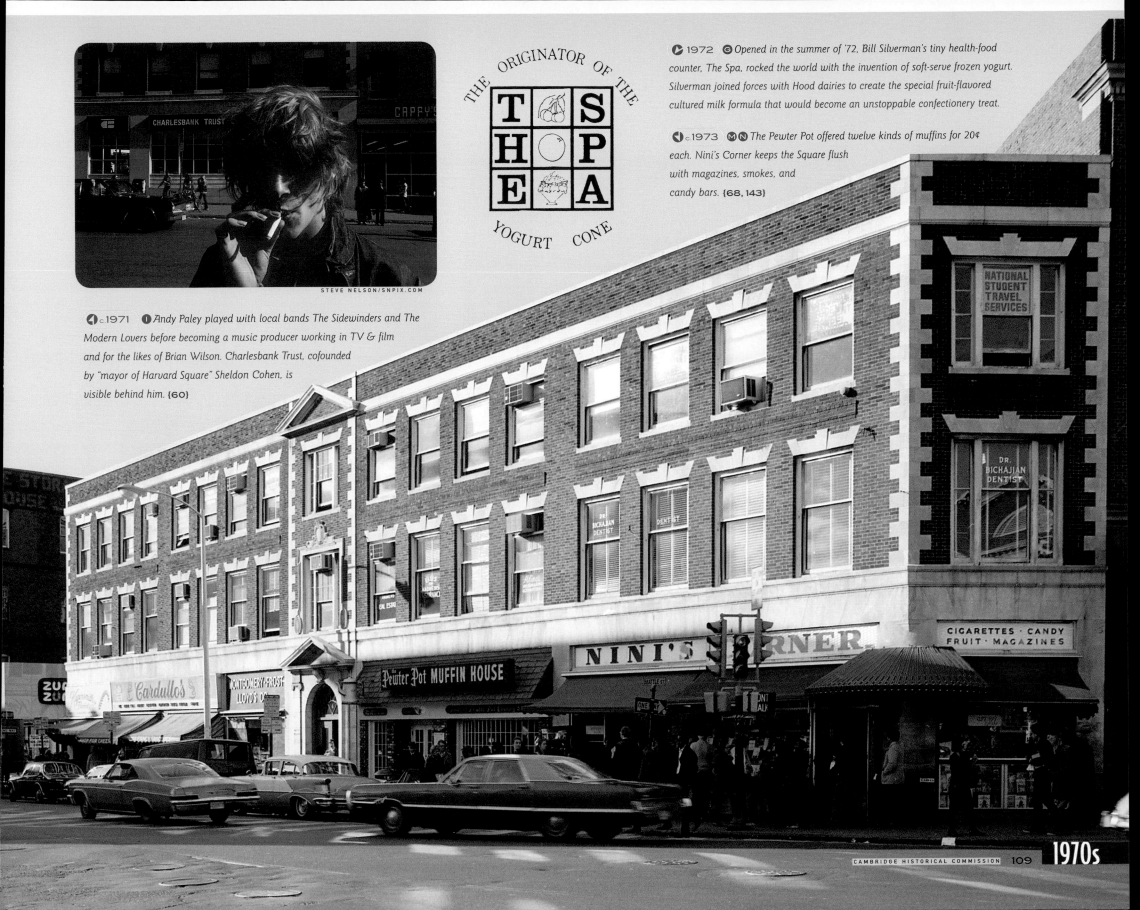

THE ORIGINATOR OF THE

T S
H P
E A

YOGURT CONE

STEVE NELSON/SNPIX.COM

1972 Opened in the summer of '72, Bill Silverman's tiny health-food counter, The Spa, rocked the world with the invention of soft-serve frozen yogurt. Silverman joined forces with Hood dairies to create the special fruit-flavored cultured milk formula that would become an unstoppable confectionery treat.

c.1973 The Pewter Pot offered twelve kinds of muffins for 20¢ each. Nini's Corner keeps the Square flush with magazines, smokes, and candy bars. {68, 143}

c.1971 Andy Paley played with local bands The Sidewinders and The Modern Lovers before becoming a music producer working in TV & film and for the likes of Brian Wilson. Charlesbank Trust, cofounded by "mayor of Harvard Square" Sheldon Cohen, is visible behind him. {60}

THE CCAE

COURTESY OF THE CCAE

Ⓐ Northeast Federal Savings & Loan/
Freedom Federal Savings & Loan
Ⓑ Touraine
Atlantic Sound
Joan & David
Ⓒ The Brattle Theatre
Casablanca
Algiers

Ⓒ Truc
Adams Apple Candles
Sunstar
Poster Gallery
The Kitchen
Ⓓ Cambridge Center for
Adult Education

The picturesque

sunflower-colored wood-frame home at 42 Brattle Street does not immediately strike one as a place to foment unrest. "This house literally was New England headquarters for revolutionary activity," said Jim Smith (in the straw hat, back row, above), director of The Cambridge Center for Adult Education, noting that Washington himself walked these creaky floorboards. William Brattle, who built the abode in 1727 and gave the street on which it sits its name, was an avowed Tory, thrown unceremoniously from the premises at the time.

The William Brattle House would go on to become command center for a revolution of a different kind. This one espoused a radical view that learning was an end unto itself, a lifelong pursuit where adults could voluntarily study subjects that interested them and take an active role in their own education. It's good to be reminded that Cambridge had earned its street cred as a hotbed for intellectual and countercultural thought long before the 1960s.

The Cambridge Social Union, the precursor of the CCAE, dates back to the centennial. It purchased the Brattle mansion at the end of the 19th century to provide a place for wholesome diversion and intellectual stimulation. After a small respite, in 1938 it was officially given its current moniker and began offering 19 courses to 273 members.

By the 1950s, there were 1,600 students enrolled in 70 courses, such as "Bach for Beginners" and "The Art of Découpage." In those days about 40 percent of the students were from Cambridge, as opposed to about 25 to 30 now. Though adult ed is not the exclusive domain of women it once was, men are still outnumbered by about a three-to-one margin.

Nowadays you can meet a very broad swath of the populace from all around Boston, Cambridge, and the outlying suburbs, participating in over 500 classes and events in 74 categories at the Center, from "Vivid Journaling" to "Ceviche and More." This revolution seems to have paid off. Said Jim, "The people that come here are the people that value education highly, education broadly defined, and you know that's true because they voluntarily spend their time and money when they don't have to." {73, 149, 219}

Every December the CCAE turns into Holly Fair, a Christmas market with local artisans set up in every room and belly-warming goodies like mulled cider.

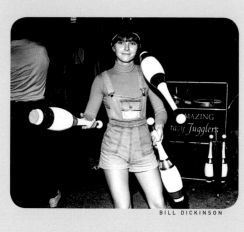

BILL DICKINSON

🎪 1977 The Amazing Fantasy Jugglers were a favorite street-performing troupe. Pictured is Lana Reed. {145}

🎭 c.1972 Brattle Walk was a short-lived experiment creating a pedestrian-only zone on Brattle Street. The adjoining merchants were not pleased.

🎭 c.1976 The Shakespeare Brothers (Trent Arterberry, Alan Krulick, and Steve Aveson, l–r) combined mime, wordplay, and shtick to draw huge crowds. {145}

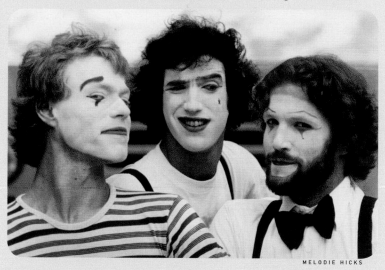

MELODIE HICKS

🏛 c.1974 Ⓐ This handsome Art Deco building housed a series of savings and loans before being demolished in 1990 for One Brattle Square. {182}

CAMBRIDGE HISTORICAL COMMISSION

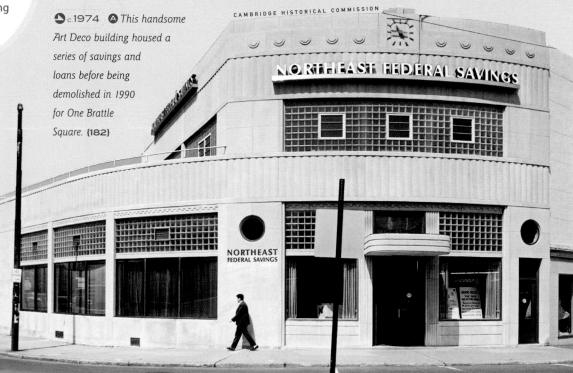

NORTHEAST FEDERAL SAVINGS

NORTHEAST FEDERAL SAVINGS

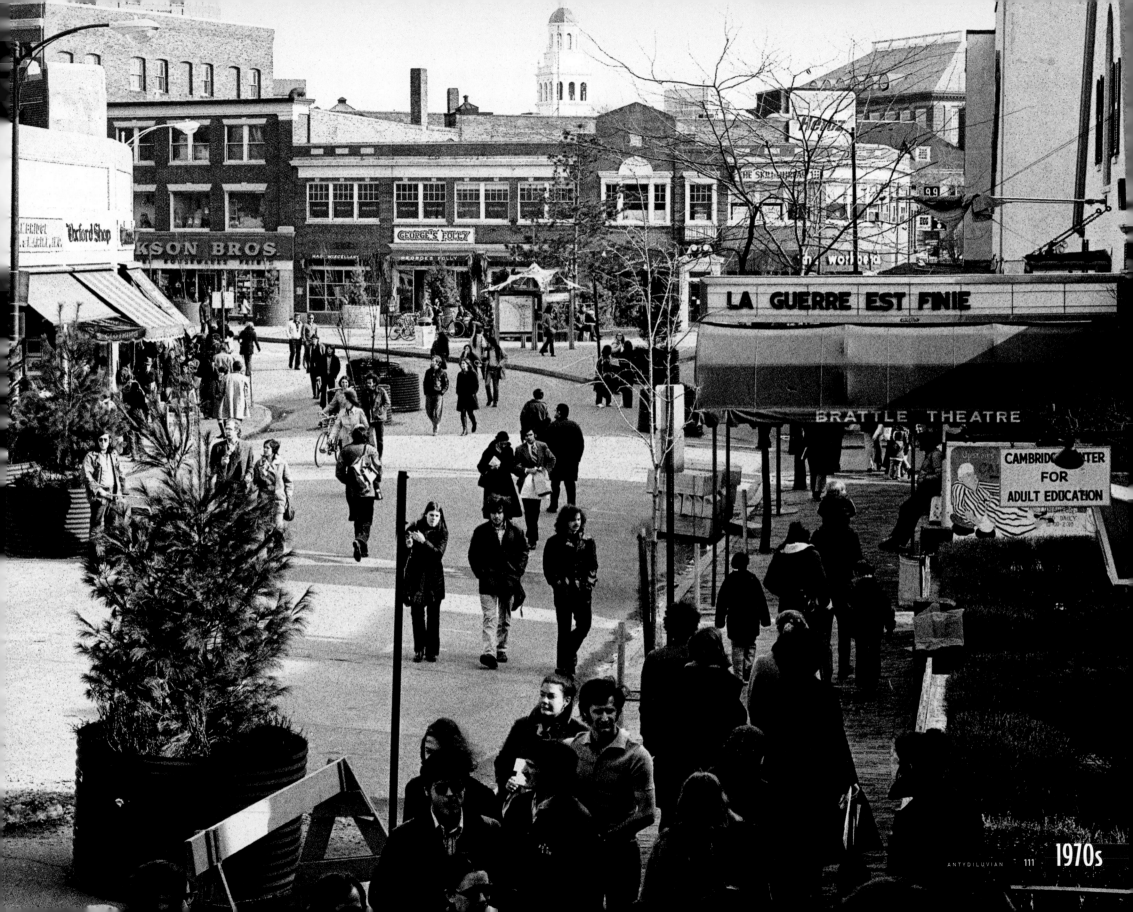

1970s

brattle st.

Ⓐ Ahepa Travel
Ann Taylor
Botolph Gallery
Charrette
Sundog
Taj Boutique

Ⓐ The Print Shop
Stone Reprographics
Fabrications
ⓑ Design Research
Ⓒ Olson Electronics
ⓓ Simon & Sons

Ⓔ Versailles et la
Petite Galerie
Ⓕ Andre Beauty Salon
Ⓖ Eleganza
Ⓗ The Window Shop/
Blacksmith House Bakery
Ⓘ Loeb Drama Center

NICK DEWOLF

1970 ⒶⒷ *A young woman cradles her Square loot while in the background, the Sert-designed 44 Brattle St. takes the place of an 1890 clapboard building.* {77}

1972 Ⓐ *An archway is created when a cantilevered 44 Brattle touches the edge of the new Design Research, inviting pedestrians down a walkway that would, beginning in 1975, lead to Ben Thompson's acclaimed Harvest Restaurant.* {182}

ANTYDILUVIAN

EZRA STOLLER © ESTO

Harvard

Square is a laboratory. For most of its modern life it has been the ultimate test market, launching a number of local and national chains from its small but influential radius. But before the Square could introduce the world to its own retail innovation, someone had to introduce retail innovation to the Square. That person was Ben Thompson, and that innovation was Design Research.

Design Research, often known simply as DR, was a revelation. In utilitarian 1953 it began offering an alternative aesthetic—sleek, modernist furniture, homewares, and clothing that were clever, functional, and elegant. These were not cheap baubles for the poster-and-beanbag-chair set. These were expensive, game-changing pieces that suddenly created a buzz, luring people to make a special trip to the otherwise quiet end of Brattle Street.

Ben Thompson's credentials and interests ran deep. A founding member (with Walter Gropius) of the famed Architects Collaborative, a retailer, and a restaurateur, he believed in integrating architecture and design into real life. The ultimate expression of this was the "festival marketplace," the shopping/eating/pedestrian/street-performer enchantment that he first cast on Boston's Faneuil Hall complex. That 1976 redevelopment concept—so successful that the area is often said to be the top tourist destination in the city—was subsequently exported all over the nation.

The germ of that idea can be traced to Design Research headquarters. Through the 1960s, DR had become a well-known brand with branches blooming in multiple cities. But it was Thompson's modernist glass flagship store, opened in 1969, that merged form and function and made retail into event and spectacle. It was considered a triumph, "for by day or night, its all-glass walls glisten with changing color and light," said the *Architectural Record* at the time. As Thompson himself described, "the aliveness and activity within become the point of display." That aliveness sometimes included gimmicks such as beautiful blond girls handing out oranges to browsers.

"They'd have some new stuff—some amazing colors, some new designs—that was completely unlike anything your parents would have or approve of," said Cambridge Historical Commission director Charlie Sullivan. "It's hard to convey how radical they were."

Much of the inspiration for DR's later style had come from a visit to the Finnish pavilion at the Brussels World Fair in 1958. It was there that Thompson made one of his more lasting discoveries: fashionista Armi Ratia. Her bright, boldly patterned Marimekko prints, offered exclusively through DR, subsequently became a national phenomenon with 20,000 dresses flying out of the stores annually and bolts of her material encapsulating an era's aesthetics.

Ben Thompson's influence is still resonating despite DR's 1979 closure. More than thirty years after it opened, his Harvest Restaurant still welcomes patrons in its original location in the Square. And the style ethos that Design Research launched was studied carefully in a visit by the designer of a new firm in 1966. Though no longer cutting-edge or expensive, this store, with Marimekko prints gracing the bedspreads, took over the space for thirty years as the heir to the DR legacy. It's Crate & Barrel. {11, 77}

> **"I** remember going to apply for a job at DR, you had to be blond," said a longtime Cambridge resident. "The man said, 'Well you know… everybody's from Finland and Norway…. Can you speak with an accent?'"

EZRA STOLLER © ESTO

brattle st.

"First

thing you do is weigh out the powders," explained Bob Landers. "Then you mix them up in a mortar and pestle and lay them out on glassine paper. Then you get the empty gelatin capsule and you'd weigh each capsule and fill them individually." In about a half hour, a skilled pharmacist like Landers could make enough capsules to fill a small bottle and type up the label.

This tactile theatre of torsion balances, colored potions, glass cabinets, and alphabetized wooden drawers was the world of Billings & Stover, the oldest pharmacy in Massachusetts and one of Harvard Square's longest-running businesses. Founded in 1854, it outlasted the then-new brick building that housed it by about forty years. Landers is well equipped to document the changes, having spent sixty years as an employee there, twice as long as Charles Stover himself owned the place.

In fact, the apothecary was a mature forty-four years old by the time Stover and his partner Elmer Billings took over from their boss, John Hubbard, who bought it from founder Abraham Wiley. When Landers began his tenure in 1942, Billings & Stover was still in its original narrow location in Little Hall on Massachusetts Avenue, where in the rear, up to eight pharmacists measured powders, poured off freshly mixed topicals such as calamine or zinc oxide, and even hand-molded individual suppositories (cocoa butter was the substrate, in case you were wondering).

In the front of the store were the indulgences that probably led you to a druggist in the first place: tobacco and confectionery on the left, a marble soda fountain (curiously without stools) on the right. There were also three telephone booths. Jeremiah Mahoney, the owner since 1929, was still compounding medicines himself.

The fountain didn't last past 1947; the prescription business was too good. Like some of the other era-spanning Square merchants, Billings & Stover had quite the clientele, including the Roosevelts, John Kennedy, historian Arthur Schlesinger, Polaroid inventor Edwin Land, Raytheon founder Laurence K. Marshall, and several presidents of Harvard. In the days before the university had its own health services, it was also a primary resource for students, with, for some time, an on-call overnight pharmacist who could be summoned by bell.

For decades, the pharmacy business changed little. In 1971, the venerable drugstore moved to its third and final location, at 41A Brattle Street, after a fourteen-year stint in the graceful curved corner of Boylston and Brattle. When Mahoney passed the legacy on to John Madanian in 1978, he had been only the fourth owner in 120 consecutive years of dispensing medicine.

Madanian upscaled the shop, but things were already starting to change. Pharmacists were no longer hand-mixing drugs, and the delivery and charge accounts were phasing out. By the time Phyllis Madanian inherited the store after her father's passing in 1984, chains such as CVS were casting a long shadow.

Under pressures that all independent pharmacies faced at the end of the 20th century, Billings & Stover began pulling from the past to elongate its future. The younger Madanian drew from a boutique nostalgia: beaver-bristled shaving brushes, imported soaps, Kent of London handmade hair brushes, and 4711, "which was the original cologne," she pointed out. As the prescription business tailed off, Madanian carried Billings & Stover to a disappointing yet sweet finish in 2002. She reincarnated the soda fountain after 50 years, modeled from vintage photos and dispensing original-recipe rickeys, fizzes, and egg creams. She took up fudgemaking for the last decade and went through 150 pounds a week. After years of tending to the ill and watching longtime customers pass away, it was a welcome shift. "I loved the part that made people happy." {84, 216}

Presiding

eternally over the store was the numerically ordered collection of ledger books, containing a copy of every single prescription filled since July 1854.

⏪⏩ c.1970s I

Reading International was an outgrowth of Sheldon Cohen's Out of Town News. With 2,000 journals and periodicals, including foreign, scholarly, and obscure titles, it was a perfect fit for the Square's multicultural, intellectual crowds. {60}

ANTYDILUVIAN

🔊 1977 F Buddy

Demaras poses in front of Buddy's Sirloin Pit, an unusual spot for cheap flame-broiled burgers. It was located inside Cardell's.

▶ c.1973 F G

Cardell's was about as old-school as a cafeteria can get, with sawdust on the floor, octogenarian busboys wearing beanies, and such lost delicacies as finnan haddie— peat-smoked haddock.

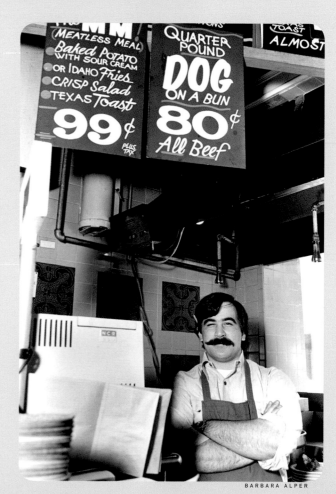

BARBARA ALPER

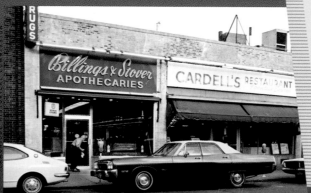

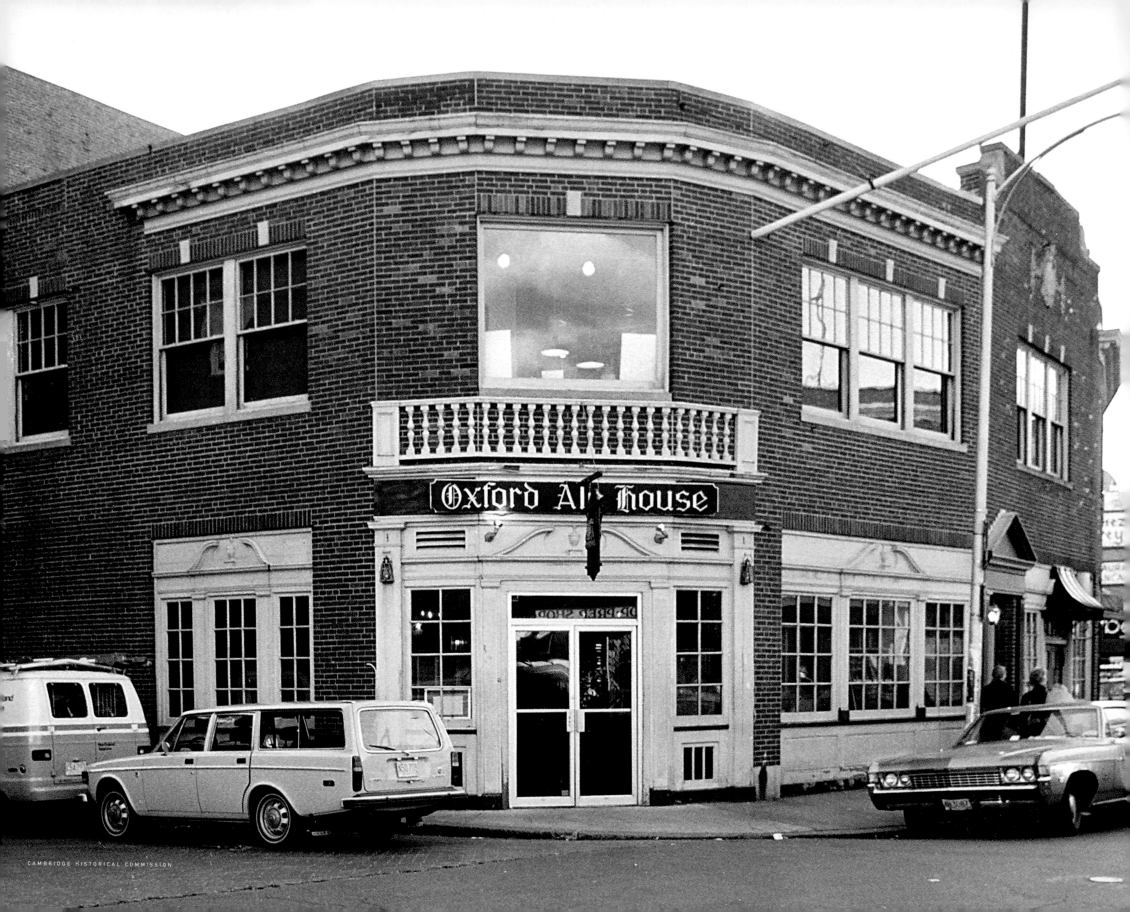

Church St.

- Ⓐ Sage's Market
- Ⓑ Rizzo Tailor
- Ⓒ The Swiss Watchmaker
- Ⓓ Christopher Flower Shop
- Ⓔ Gertrude Singer's
- Ⓕ CG Howe Dry Cleaners/ANZ
- Ⓖ Saraswati Gifts
- Ⓗ Nornie B's
- Ⓘ The Underling Lingerie
- Ⓙ Stork Time Maternity
- Ⓚ Slak Shak/Baak Gallery
- Ⓛ Chez Dreyfus
- Ⓜ The Book Case
- Ⓝ Oxford Grille/ Oxford Ale House
- Ⓞ Church St. Garage
- Ⓟ The Book Case Annex
- Ⓠ The Prep Shop
- Ⓡ Young & Yee
- Ⓢ Gordon Yarlott/ London Harness Co.
- Ⓣ Christian Sci. Rdg. Rm.
- Ⓤ First Parish Church, Parish Hall

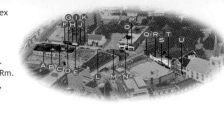

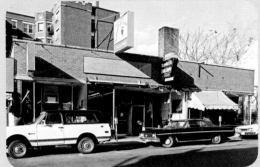

CAMBRIDGE HISTORICAL COMMISSION

◀ c.1973 Ⓗ *Nornie B's offered coffee and donuts for the swivel-stool set for about 20 years.*

◀ c.1973 Ⓝ *The Oxford Ale House (formerly The Oxford Grille) was a major bar scene in the Square with live music and a young, often brawling crowd that sometimes included the Boston Bruins.*

◀ c.1973 Ⓜ *The Johnson family ran The Book Case, one of the Square's largest used bookstores, from 1965 to 1993.*

CAMBRIDGE HISTORICAL COMMISSION

◀ c.1973 Ⓛ *Chez Dreyfus already looks a little ragged about five years before its eventual demolition. The Atrium, a large commercial building linking through to Brattle Street, would arise in its place.* {34, 108}

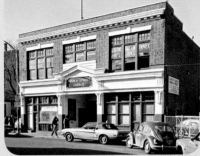

CAMBRIDGE HISTORICAL COMMISSION

◀ c.1973 ⓄⓅ *The Book Case finds extra room in the Church Street Garage building. The 1912 structure would be razed in about 1980.* {34}

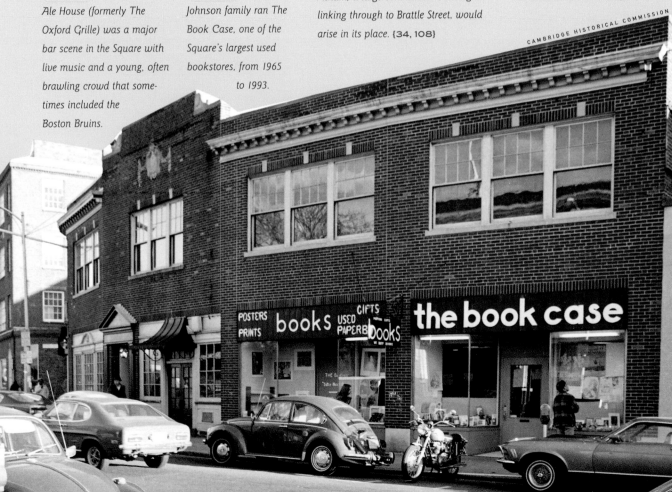

CAMBRIDGE HISTORICAL COMMISSION

THE NAMELESS COFFEEHOUSE

Cambridge

has long bloomed with the flowers of folk music, be they prefamous buskers or established crooners dazzling the faithful at Club Passim. But not one block away from that exalted institution is a much less well-known congregation that has been celebrating troubadours for more than forty years. It's the Nameless Coffeehouse and it remains one of Harvard Square's hidden treats.

Founded in 1967 as a youth group of the First Parish Unitarian Universalist Church for which Church Street is named, the first weekly (now monthly) coffeehouse is the oldest donation-only coffeehouse in New England.

What this means for the public is that anyone, regardless of means, is welcome; there are few places where such a diversity of ages and incomes mesh so well. What this means for the coffeehouse is that everything is volunteer-run, from the booking, to the setup, to the food service.

In the kitchen, volunteers bond while slapping together PB&Js and pouring mugs of tea and cocoa for listeners at the break, all for small suggested donations. In the cozy chapel, doubling as a green room, guitar cases lounge on pews as friendly musicians make new connections. With four or five acts playing short sets, there is a sometimes jarring amount of variety and a lot of opportunity for networking.

The performers are not typically big names, but they play the wood-paneled Parish Hall with honesty, and the connection with the audience—many of them regulars—is palpable. If you're lucky, you may even catch great artists in their salad days, such as Ellis Paul, Patty Larkin, Tracy Chapman, or The Nields, who have all done stints here.

Taking part in the Nameless Coffeehouse experience, where even the audience is politely asked to help fold chairs and rack them at the end of the show, is a true community effort. Much like an Amish barn-raising, the investment everyone puts in is paid back many times over in good feeling and sometimes years-long loyalty. This is Cambridge at its Cambridgiest.

1970s

COURTESY OF THE NAMELESS COFFEEHOUSE

POSTERS PRINTS books USED PAPERBOOKS GIFTS the book case

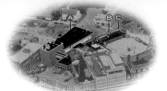

palmer st.

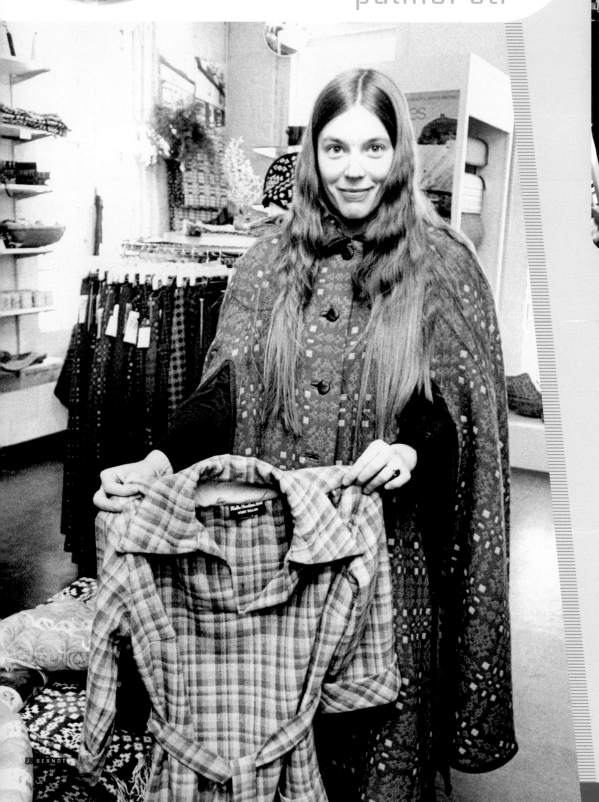

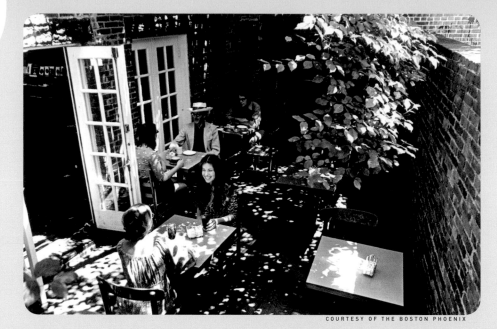

COURTESY OF THE BOSTON PHOENIX

Ⓐ c.1978 Ⓒ *Fannie Tuttle shows off some merchandise at Wallis Woolen Mill.*

Ⓐ c.1970s Ⓑ *Passim's patio makes a nice spot for a beverage on a beautiful afternoon.* {152}

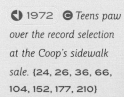

Ⓐ 1972 Ⓒ *Teens paw over the record selection at the Coop's sidewalk sale.* {24, 26, 36, 66, 104, 152, 177, 210}

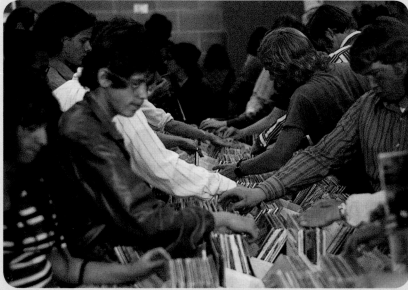

ANTYDILUVIAN

J. BERNDT

boylston st.

⊘ 1979 Ⓑ The Fabulous Thunderbirds, with Jimmy Vaughn on guitar and Kim Wilson on vocals and harmonica, rev up the stage at Jonathan Swift's, one of the Square's top music venues. {154}

⊘ c.1973 Ⓐ Ⓕ Discount Records was a browsing spot for 25 years, closing in 1996. Minute Man Radio, with its signature spinning clock, was a Harvard Square staple from 1928. The Waugh family, who also owned the building, offered sales, repairs, and records. {43, 85}

©JEFF THIEBAUTH

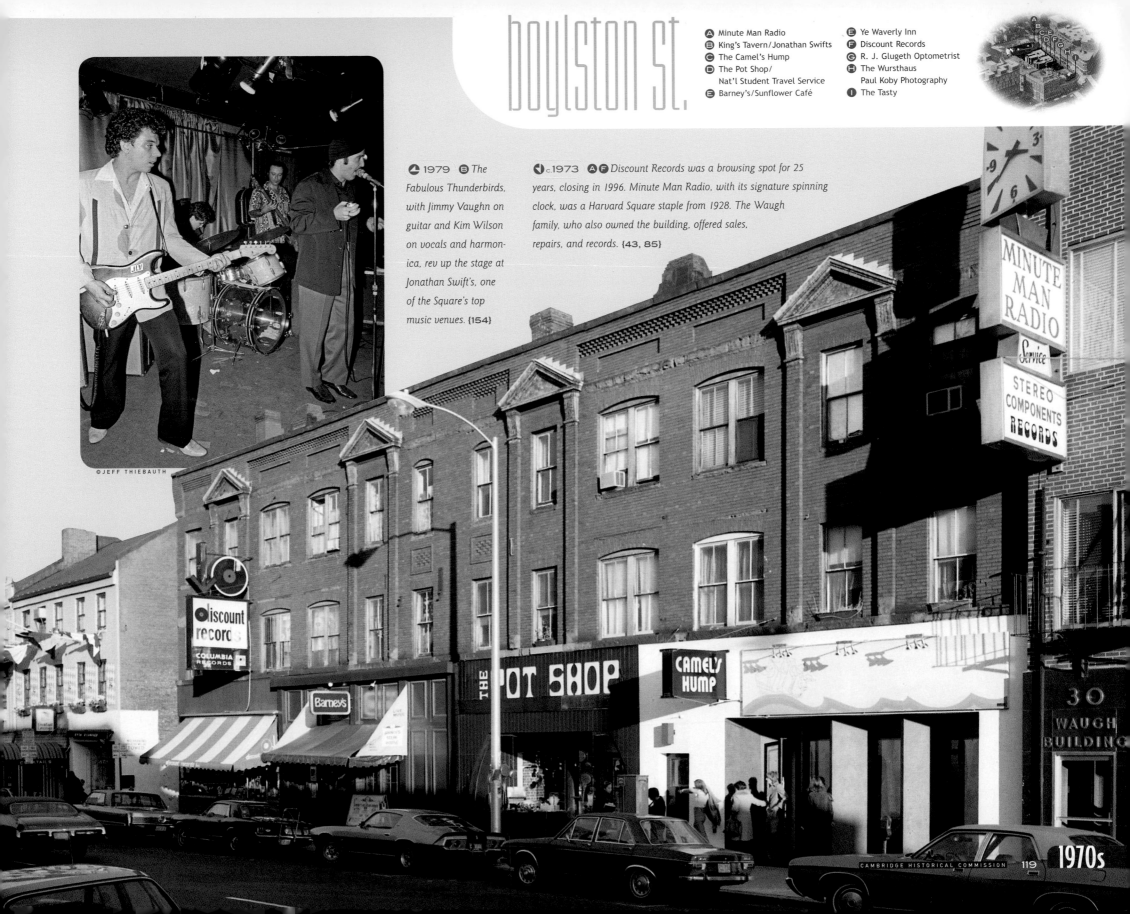

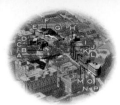

A The Garage
Cave Atlantique
Tech Hi-Fi
Underground Camera
Hooper Ames
B Antartex Sheepskin
Paco's Tacos
Mykonos

C Off the Square Gallery
The Hungry Persian
BoJo Records
Jasmine Boutique
The Tannery
Patisserie Française
Leather Design
D Iruña

E Fromage
Clothware
Swiss Alps
My T-shirt
Rest. Brasilia
Logo's
Duck Soup

F Zwicker Bros. Gulf
G Crimson Garage/Galeria
H Grendel's
I Crimson Travel
J Whitney's
K Charlie's Snack Bar/
Leo's Place
L Rix

M George Grillo
Oriental Rugs
Goods
Dazzle
N Temple Bar Bookshop
O Lowry Opticians
P Charlesbank Trust

boylston st.

CLIF GARBODEN

THE GARAGE

A sizable

part of Harvard Square's enduring charm is the pastiche of new and old that exists not only side by side, but also in layers that reveal hints of history within a single building.

This 1860 railway car barn was turned into an actual garage in 1917. It remained so until 1972, when owner Max Wasserman, who inherited the unremarkable property from the late Bertha Cohen, sought to capitalize on the Square's burgeoning thirst for retail. Thus the garage became The Garage, a compact mall that retains the car ramp (and some might say the uninviting atmosphere) of the original to this day.

It began with a short-lived bazaar of 24 stands on the second floor before assuming its later configuration of small, sometimes kitschy vendors and quick lunch spots. Kite shops, roll-ups, junk jewelry, deadhead garb, and longtime tenant Newbury Comics conspired to make it a favorite teen hangout.

However, a few substantive local traditions were born here in the '70s, including George Howell's Coffee Connection, which grew into a beloved regional chain; Formaggio, which purveyed its massive gourmet sandwiches on homemade bread for 20 years; and the career of Judy Rosenberg, who turned the cheesecake chain Baby Watson into a launching pad for her own bakery, which would later become local fave Rosie's.

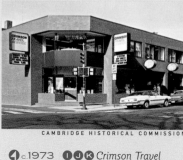

CAMBRIDGE HISTORICAL COMMISSION

◀ c.1973 I J K *Crimson Travel (now AmEx), Whitney's, and Leo's Place enjoy their new home—where they all remain to this day. The previous 50-year-old structure was razed in 1971.*

◀ c.1970s A *George Howell created The Coffee Connection in 1975 to introduce Boston to the joys of fine, single-estate roasts. From one delightfully funky shop in The Garage, he launched a regional chain of 24 cafés, sold to Starbucks in 1994.*

KEN KOBRÉ

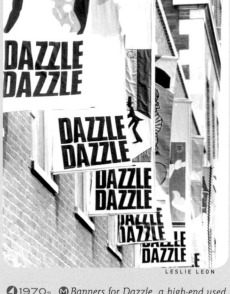

LESLIE LEON

◀ 1970s M *Banners for Dazzle, a high-end used clothing store, add some pizzazz to Boylston Street.*

◀ c.1972 A *The Harvard Square Garage finishes its conversion into a mall. The third story, which is noticable for its lack of stone corner detailing, was added to the pre-existing building.* (226, 228)

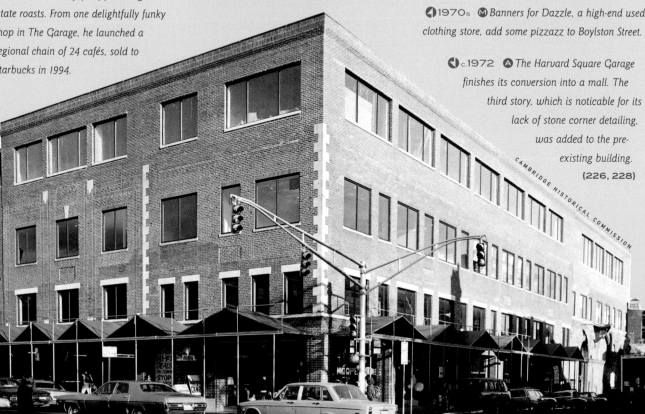

CAMBRIDGE HISTORICAL COMMISSION

IRUÑA RESTAURANT

◀ 1972 ▣ Spanish restaurant Iruña survived, hidden in an alley, for more than 40 years. It was opened in the early '60s by Josefina Yanguas of Café Pamplona. {195}

◀ c.1971 ▣ Leather Design was typical of the small owner-operated boutiques that populated the Square.

STEVE NELSON/SNPIX.COM

◀ c.1973 ▣ One more element of Harvard Square's grubby past awaits destruction. The Crimson Garage, on the corner of Winthrop, would be razed in 1974 for the Galeria mall.

STEVE NELSON/SNPIX.COM

◀ c.1971 ▣ A colorful customer enjoys the paper in the Patisserie Française, a major hangout. Genevieve MacMillan opened what was one of the first basement businesses in the Square in 1950, naming it the Patisserie Gabrielle after a mistress of Henri IV. It survived under several owners under its newer name until 1996. {84, 88}

◀ c.1973 ▣ 52–54 Boylston (built in 1876) and its twin, 56–58, have long brought color to the Square with their striped orange paint jobs. {*227, 157}

Grendel's Den

dinner menu
89 winthrop st
cambridge, mass. 02138
(617)-491-1757

◀ 1970s ▣ Grendel's, on adjacent Winthrop Street, is a Harvard Square original that endures. It opened in 1971, enticing crowds with an enormous salad bar, healthy international food, and cheap prices. {153, 186, 225}

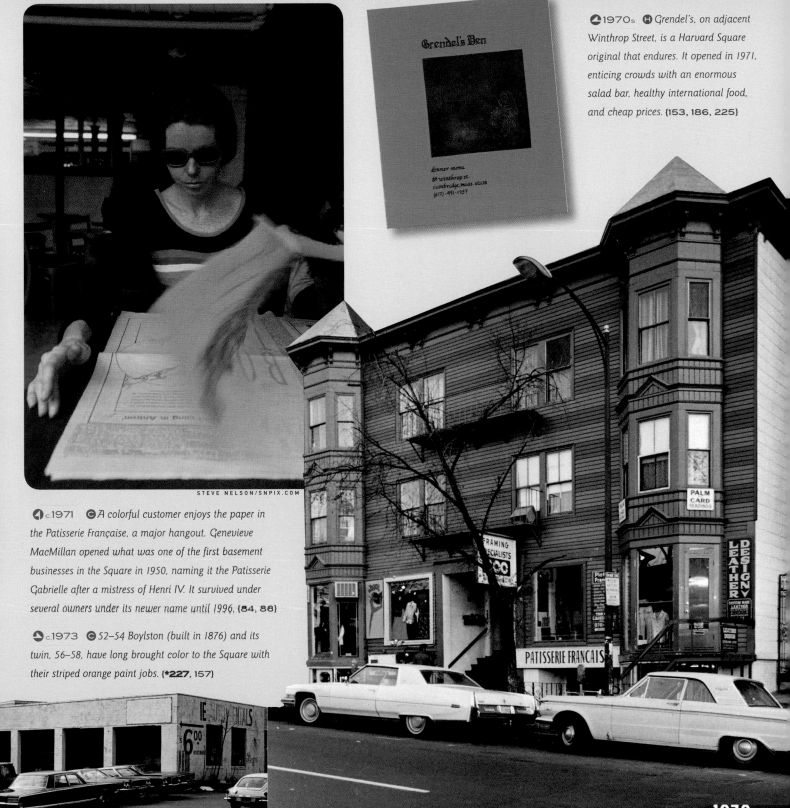

A Harvard Provision
B Miguel Gusils, Goldsmith
 University Typewriter
C J. Press
D Elsie's Lunch
E Tennis & Squash Shop

F The Harvard Lampoon
G Gold Coast Valeteria
H Tommy's Lunch
 Serendipity
 Cahaly's
 Hemispheres/The Voyagers

lower mt. auburn st.

↘ **1976** *Gilda Radner takes a trip down Mt. Auburn St. on the shoulders of Dan Aykroyd as the cast of the new hit comedy show Saturday Night Live arrives for a "symposium" at the Lampoon.*

↖ **c.1973** A *Harvard Provision was a survivor. When it was evicted in 2003, it was more than 100 years old and the only liquor store left in the Square. The 1895 triple-decker was razed for Harvard's new library administration building.*

↙ **c.1973** H *Grease and pinball. That pretty much sums up the experience at Tommy's Lunch, which was a staple for late-night munchies and lime rickeys. Opened in 1958, Tommy Stefanian's counter became a ritual for Harvard students and longtime regulars such as Mel Dorfman, who—with his white beard, beret, and stack of books—was a constant. Stefanian closed up shop in 1992, but his name lives on, now as part of a neighboring convenience store. {39}*

CAMBRIDGE HISTORICAL COMMISSION

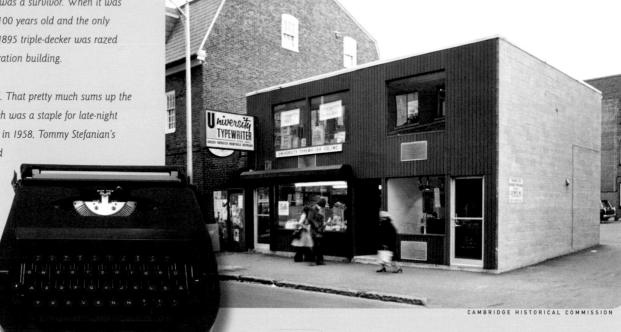

CAMBRIDGE HISTORICAL COMMISSION

↖ **c.1973** B *University Typewriter proves to be one of the more resilient Square businesses, surviving at least four locations and long after the advent of the personal computer. It resided in this cinder-block box for more than 30 years. The building would be demolished for a sleek glass cube housing Harvard's library administration in 2004.*

CAMBRIDGE HISTORICAL COMMISSION

A. Cronin's/Swiss Alps
B. US Post Office
C. The Idler
 The Blue Parrot
 Ferdinand's
 The Ha'Penny
D. Sphinx Book Store

E. Brattle Sq. Svc. Station
F. Hamilton Liquors/
 Tweeter, Etc.
G. Gnomon Copy
 Ali Baba
 Fluid Dynamics
 The Needle Point

G. Tumbleweed
 The Million Year Picnic
 Multi-Photo Services
 Nature's Body
 Rowinsky's Cheese
 Cake Shops
H. Hertz

c.1973 **C** *The Blue Parrot's second location was a favorite mellow hang-out for artsy types. It was connected to the Idler, a basement bar with live music in the back. In the same building, the owners also created the French restaurant Ferdinand's and the Ha'Penny Pub, named after their dogs.* {74, 76, 160}

c.1973 **A** *Cronin's, once a Harvard legend, comes to the end of its run in its shabby second location.* {18, 40, 57, 85, 194}

SOUND SYSTEMS

underwent a popular explosion that peaked in the early '70s, goosed by Cambridge know-how; unsurprisingly, Harvard Square became a hi-fi hotbed. At one time, six or eight shops competed for ears, dealing in belt drives, cartridge mounts, reel-to-reels, and talk of "flutter and wow." Acoustic Research revolutionized the industry and introduced the world to Henry Kloss, a man whose name is synonymous with high-end sound. Their AR Music Room opened on Brattle Street in 1960. Kloss would go on to form KLH and later Cambridge Soundworks. Tech Hi-Fi, on Boylston Street, was launched by MIT students in 1968 and grew into a 70-store chain. Tweeter, Etc., opened one of its first stores on Mt. Auburn in 1972. And MIT professor Amar Bose would develop his theories of psychoacoustics just down the road. A smaller sales and repair shop, Audio Lab, founded on Eliot St. in 1955, survives in The Garage to this day.

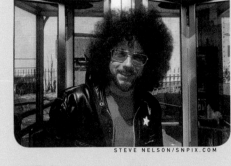

STEVE NELSON/SNPIX.COM

c.1971 **E** *Magic Dick of the J. Geils Band stands on the corner of Mt. Auburn and Eliot.*

c.1974 **F** *This 1869 house was Hamilton Liquors before being home to Tweeter for more than 25 years. It also was moved—twice. First, it was rotated sideways in 1924. Then, in 1998, the top two floors were rotated again and moved onto a new foundation facing Winthrop Park.* {83, 229}

CAMBRIDGE HISTORICAL COMMISSION

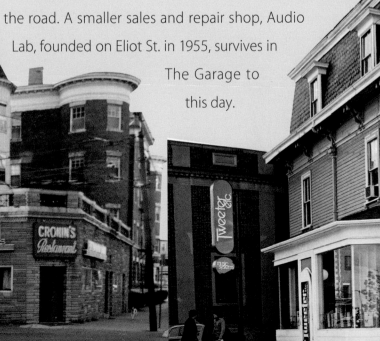

CAMBRIDGE HISTORICAL COMMISSION

1970s

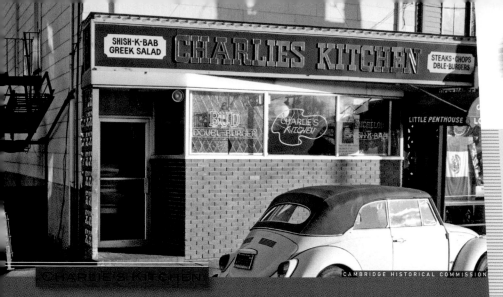

Ⓐ Grotto Blue Rest.
House of China
Science Fantasy Bookstore
Ⓑ Audio Lab
Stereo Lab
Stereo Sound
Eardrum
La Piñata

Ⓒ A Wine For All Reasons
Shawah Jewelers
Taj Mahal/
The Hungry Persian
Pier 1
Record Garage
Ⓓ Charlie's Kitchen
Ⓔ Treadway Motor House

Eliot St.

Helen Metros,

nearly eighty years old, ambles up to the red vinyl booth and begins speaking quietly with a pair of customers. Minutes pass. No orders are taken, nor drinks consumed. There's no hurry; Metros has been waiting tables here since 1953.

Likewise, Charlie's Kitchen has been having an ongoing conversation with Harvard Square since 1951. It's the kind of chat that you can hear only if you get up close. Too nice to be a dive, and too gritty to be stylish, Charlie's exists in a parallel track from the increasingly upscale surrounds, where authenticity itself has now become exoticism.

Authentic would describe Charlie Lambros himself—an honest, generous man who nonetheless knew how to have a good time. He'd sit at the end of the bar, dragging on a stogie, rolling up wads of dollar bills from the lunch rush to convert to his other passions: belly dancers and poker. He made out OK; the Kitchen was one of three Square establishments he won in games.

Though the two mix comfortably here, Charlie's has always been more town than gown. Ink's best use is on skin, not paper. Semi-goth waitresses project the ideal proportion of hot and sullen to keep hopeless admirers too intimidated to act. Downstairs is about the plentiful and shockingly cheap pub grub, upstairs is about the scene, where acolytes wink at the indie, too-cool jukebox. For the last few years, live bands, karaoke, and trivia keep the ramparts full.

The tin ceiling, stained glass hanging lamps, and bar stools downstairs are original. Upstairs, the ceiling tiles are perhaps *too* vintage (were they always that sickly yellow color?). Paul Overgaag, who bought the place from Charlie in about 2000, wisely took nothing away, but he did make some additions—the lobster roll and a surprisingly pleasant beer garden—which have proven immensely popular. But truly, little has changed.

That includes Metros. A touching mix of shy and loquacious, she shows a genuine concern for those she meets in her rounds. And they form a Zelig-like ledger: Charlton Heston, Uma Thurman, Al Gore, Jay Leno, Judy Collins, Mario Cuomo, and a prepapal John Paul II. She's even had a personal invitation to the White House. More often, there are police officers, firefighters, teachers, and, of course, the first-year students. "They're homesick and they try to act so big and you know that at any minute they want to cry," she said. "Those are my favorite people."

Will Metros ever call it quits? "I retired for three days and I got bored," she said. When told by a graduate that he'd see her at the reunion, she responded, with little irony, "If I'm not here you can look for me in lot 239 in Mt. Auburn Cemetery." {230, 231}

In the '60s, the upstairs was briefly Charlie's Little Penthouse, a piano lounge with hot and cold hors d'oeuvres, jacket & tie required.

◣ c.1973 Ⓑ
Audio Lab, one of the first stereo shops, is visible in the basement. This building would be consumed by fire in 1988. {125, 160}

CAMBRIDGE HISTORICAL COMMISSION

◣ c.1973 Ⓒ *Pier 1 added some color to Eliot Street for close to two decades.* {*230}

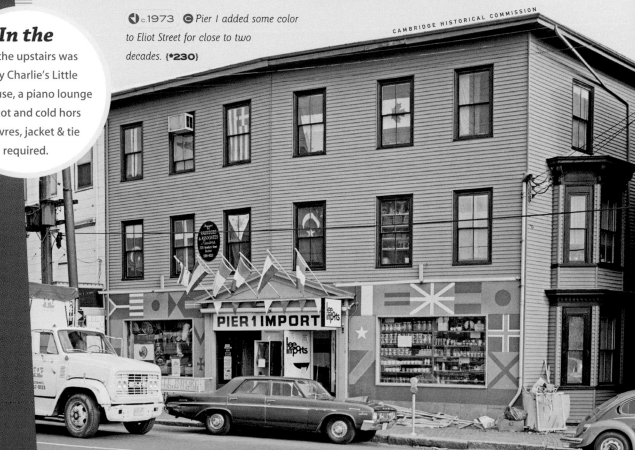

CAMBRIDGE HISTORICAL COMMISSION

bennett st.

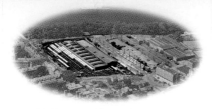

🕐 c.1978

Harvard's new Kennedy School of Government looks out on the transformation of the MBTA rail yards into what would eventually be a lush riverside park. {41, 158}

🕐 c.1978 Workers survey the developing Harvard/Brattle Red Line stop, one of two temporary stations used during construction of the subway extension. {160}

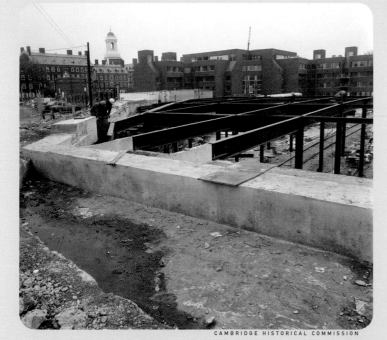

CAMBRIDGE HISTORICAL COMMISSION

🕐 c.1979 Riders wait at the temporary station, in service between March 1979 and September 1983.

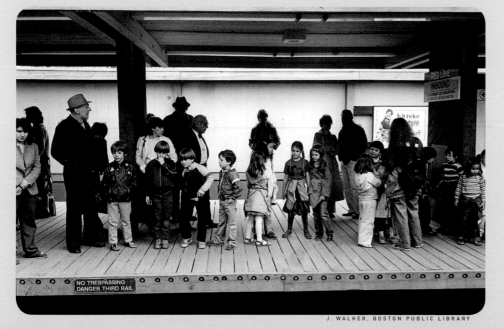

RED LINE INBOUND

NO TRESPASSING DANGER THIRD RAIL

J. WALKER, BOSTON PUBLIC LIBRARY

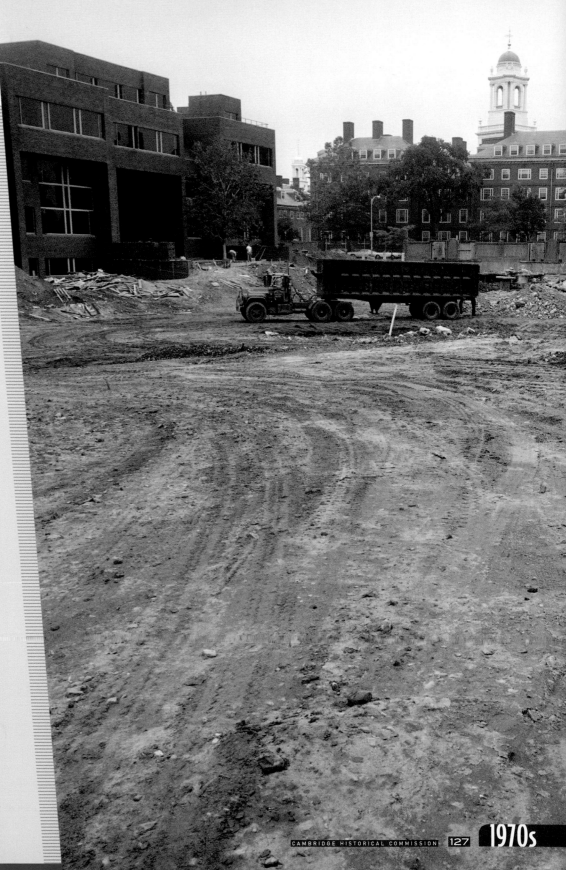

BILL McKIBBEN

TO WALK THROUGH HARVARD

Square in the 1980s was to become, temporarily, an archaeologist, someone who poked through the easily visible layers of history. Some of the digging was literal: most notably the MBTA closed the old subway station (the "headhouse," which used to house the wooden escalator, and the "8 Minutes to Park Street" sign became the new home of Out of Town News) and opened the new, spacious, and highly uncharismatic replacement. But other transitions were less obvious: you could still see the smoky layers of the collegiate past at Leavitt and Peirce, but serious inhalers of the present day were buying their glassware at the almost unbelievably grungy Store 24. The '60s still echoed—actual hippies, albeit graying, still wandered by, like hirsute salmon drawn to their original stream. But the crowd that gathered daily by Holyoke Center was self-consciously punk, safety-pins and all. And the next wave was already gathering—the university was buying up the vacant parcels and parking lots that would become the much-expanded Kennedy

School and the yuppie condos and "retail" that would soon nestle near it. (Yuppie—another 1980s coinage. Rent control, which still existed in Cambridge in the 1980s, meant that there were fewer than you might expect, but you could see them coming.) There was never any question in my mind which was the better version: I was a conservative, partisan of all the old and often dingy haunts: Tommy's Lunch, Elsie's, Grolier's, Grendel's, Brine's Sporting Goods, Brigham's, the Kong, One Potato. What was coming was not, I knew, going to be as interesting. But the bittersweet quality of watching a place erode sharpened its attractions. To wander the slightly grimy streets late at night, a copy of the next morning's *Crimson* fresh from the press under my arm, was to be old and a little world-weary when I was still young.

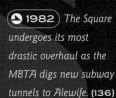

NANCIE BATTAGLIA

1982 *The Square undergoes its most drastic overhaul as the MBTA digs new subway tunnels to Alewife.* {136}

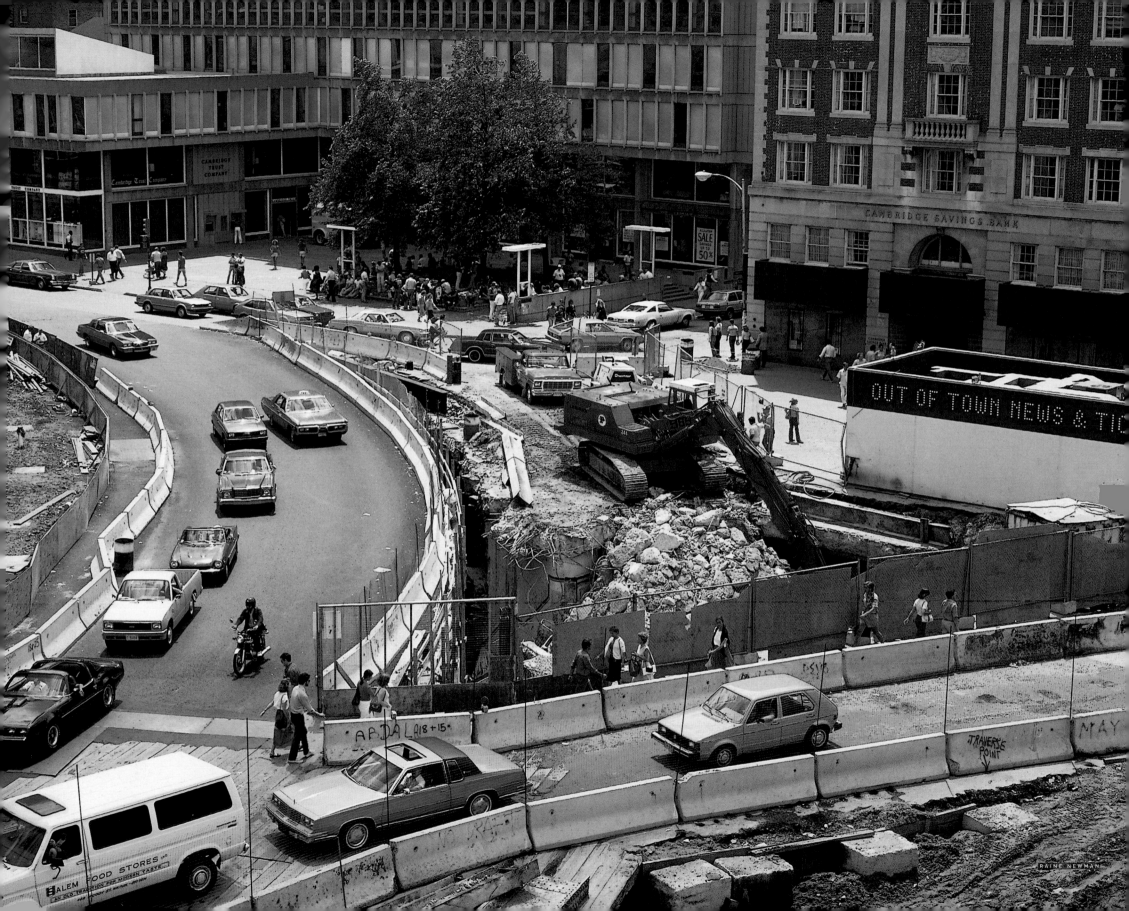

OUT OF TOWN NEUS & TIC

CAMBRIDGE TRUST COMPANY

CAMBRIDGE SAVINGS BANK

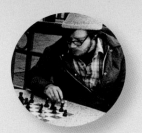
Ⓐ Lower Mass. Ave.

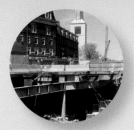
Ⓑ The Center

Ⓒ Upper Mass. Ave.

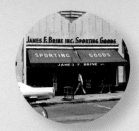
Ⓓ Lower Brattle St.

Ⓔ Upper Brattle St.

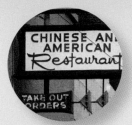
Ⓕ Church St.

MOST PLACES UNDERGO

constant evolution where alterations pass, hardly noticed, until they accrete into a retrospectively recognized transformation. By contrast, what happened in Harvard Square in the '80s was a near total reimagining of its physical identity. The catalyst was the subway's extension to Alewife, which set in motion a cascade of cosmetics and construction even as it permanently siphoned off commuters. That one development arguably changed the Square more than any other single event in its modern history.

Once the streetscape's ventral chasm had been sewn shut, a brand-new Square emerged. Pocked asphalt crumbled under a wave of marching brick. Monuments of progress—parking structures, multistory office buildings, gleaming glass retail façades—sprouted in concert with well-heeled professionals and tourists, felling grubby gas stations along the way. It was as though the whole neighborhood had been turned over with a hoe, both literally and figuratively. The slick additions included Charles Square, a hotel/condo/shopping complex; the lush JFK Park, where the MBTA's rolling stock once rested; and a contemporary brick and stone replacement for several of the Square's long-standing businesses on Mass. Ave.

These projects combined to change not only the look of Harvard Square, but also the mind-set. It was added to the National Register of Historic Places. An "overlay district" was created by the city council to limit and oversee development. Harvard Square had become self-aware.

People began to see the Square as something worth preserving, though many would differ on what exactly they were trying to preserve or how to do so. Newly flush with ice cream, croissants, and T-shirts, was the Square becoming too touristy, or just catering to a youth market that now had some buying power? Did the arrival of chain stores such as the Gap, Urban Outfitters, and Banana Republic signal the

end of the Square's quirky individuality, or were they just inevitable by-products of success? Those questions would continue to be asked as Harvard Square's identity developed an existence separate from the Square itself.

Meanwhile, life went on. Harvard's gala 350th anniversary celebration took place in September of 1986, replete with a 600-foot balloon rainbow, visiting VIPs (including Prince Charles and several Supreme Court justices), and even a John Harvard postage stamp. A 22-year-old pinstriped Ralph Reed (future director of the Christian Coalition) led a pro–Granada invasion rally with about fifty college conservatives in 1983. And Harvard Stadium was briefly touched with Olympic gold dust when it hosted the 1984 soccer prelims.

Despite the incoming chains and rapidly increasing rents, Harvard Square's essence remained and even flourished. It was still a vital center for recorded music, crammed with bookstores, and alive on summer evenings with a Mardi Gras of street theatre. CDs replaced vinyl and punks replaced hippies, but the kernel was the same. *Boston Globe* columnist Paul Hirshon, whose beat was Cambridge, described it at the time as "an international crossroads, a hub of hot consumerism, a haven for scholars and bibliophiles, a paradise for street performers, a magnet for the young of all ages, a maze of dark bars and coffee shops, a rich stew of languages and lifestyles."

Ⓖ Palmer St.

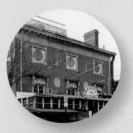
Ⓗ Winthrop St.

Ⓘ JFK St.

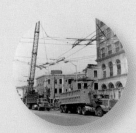
Ⓙ Mount Auburn St.

Ⓚ Eliot/Bennett Sts.

THE 1980s

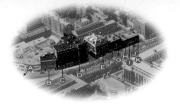

Ⓐ Gulf
Ⓑ The Hong Kong
Ⓒ Bartley's
Ⓓ Harvard Book Store
Ⓔ Briggs & Briggs
Ⓕ One Potato Two Potato
Ⓖ Schoenhof's
Ⓗ Stonestreets
Ⓘ Pangloss
Ⓙ Bob Slate
Ⓚ Claus Gelotte

lower mass. ave.

◆1980s Ⓓ-Ⓙ *This block's slate of shops was almost unchanged for thirty years. Most were displaced in 1984 as the two 1880s structures on the right would be razed for a modern, five-story office building (below). Slate's, One Potato Two Potato, and Stonestreets would return the following summer.* {12, 51, 92}

PARKING,

some will tell you, is the origin of all the Square's problems. The '80s was a turning point—for the worse. Car ownership was steadily on the rise, even among students. Add to that the changed traffic patterns and expanded sidewalks that eliminated on-street spaces, and you've got serious supply-and-demand issues.

Even with the addition of new (expensive) garages, finding a spot became, more often than not, a nightmare.

Never mind that the T is right there and the Square is best on foot. As Ormand Humphreys of Briggs & Briggs said at the time, "I've been hearing about the parking problems for over fifty years. Only back then, it was horse and buggy parking."

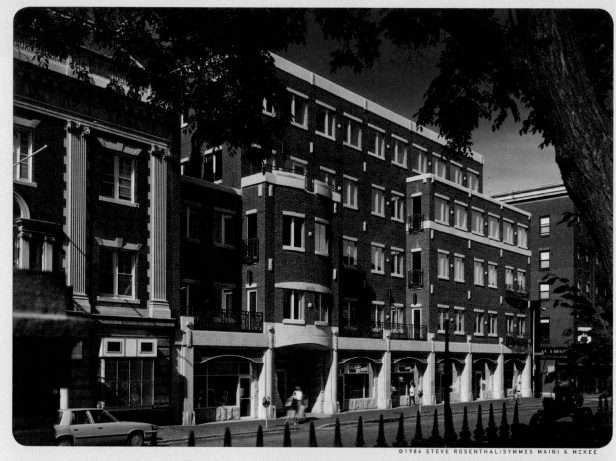

©1986 STEVE ROSENTHAL/SYMMES MAINI & MCKEE

◆1986 *The Niles Company's brick and stone building is one of the more architecturally pleasing modern additions to the Square, an admittedly meager distinction.*

◆1988 Ⓐ *The grande old dame of gas stations fades into the sunset. It would also succumb to the wrecking ball to make way for The Inn at Harvard, an upscale hotel, which would open in 1991.* {50, 166}

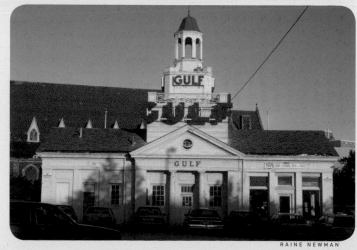

RAINE NEWMAN

1 HOUR LIMIT
7:00 AM - 6:00 PM
MONDAY TO FRIDAY
PUBLIC HOLIDAYS EXCEPTED

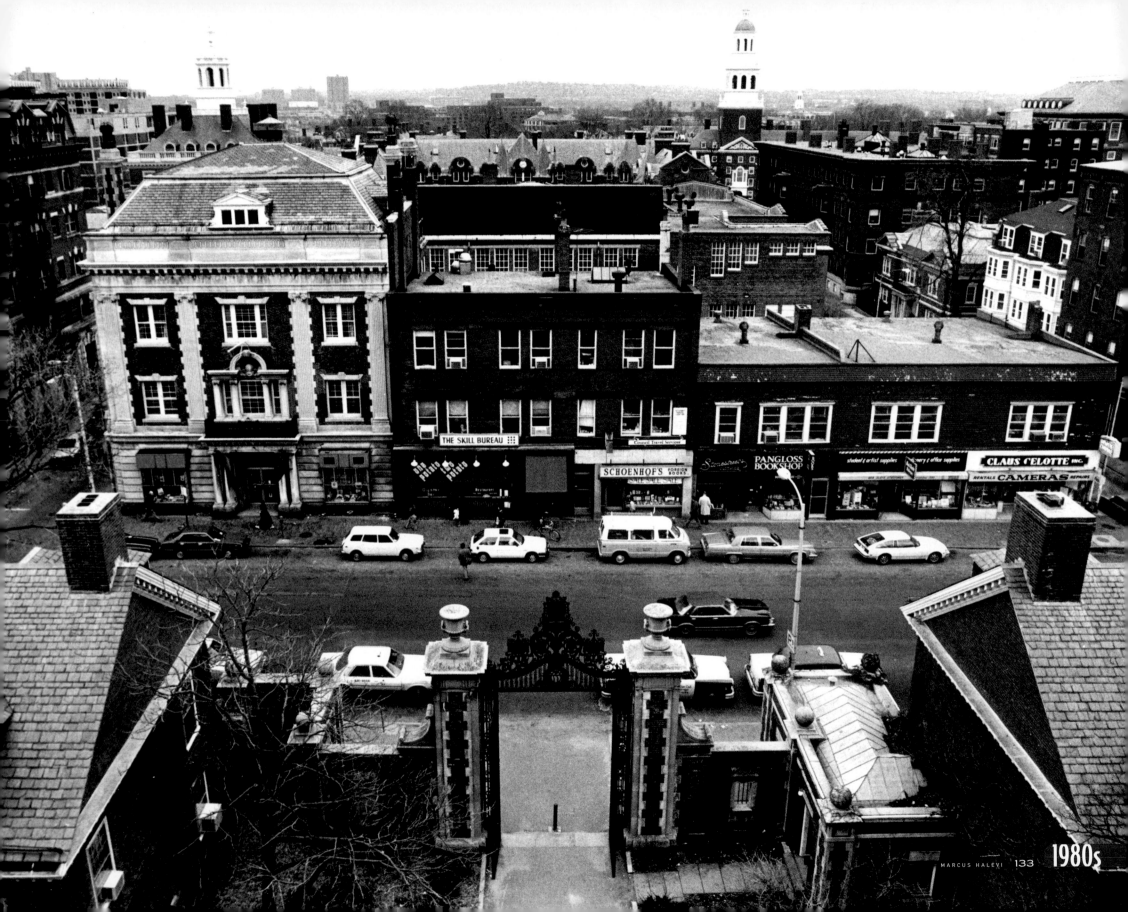

1980s

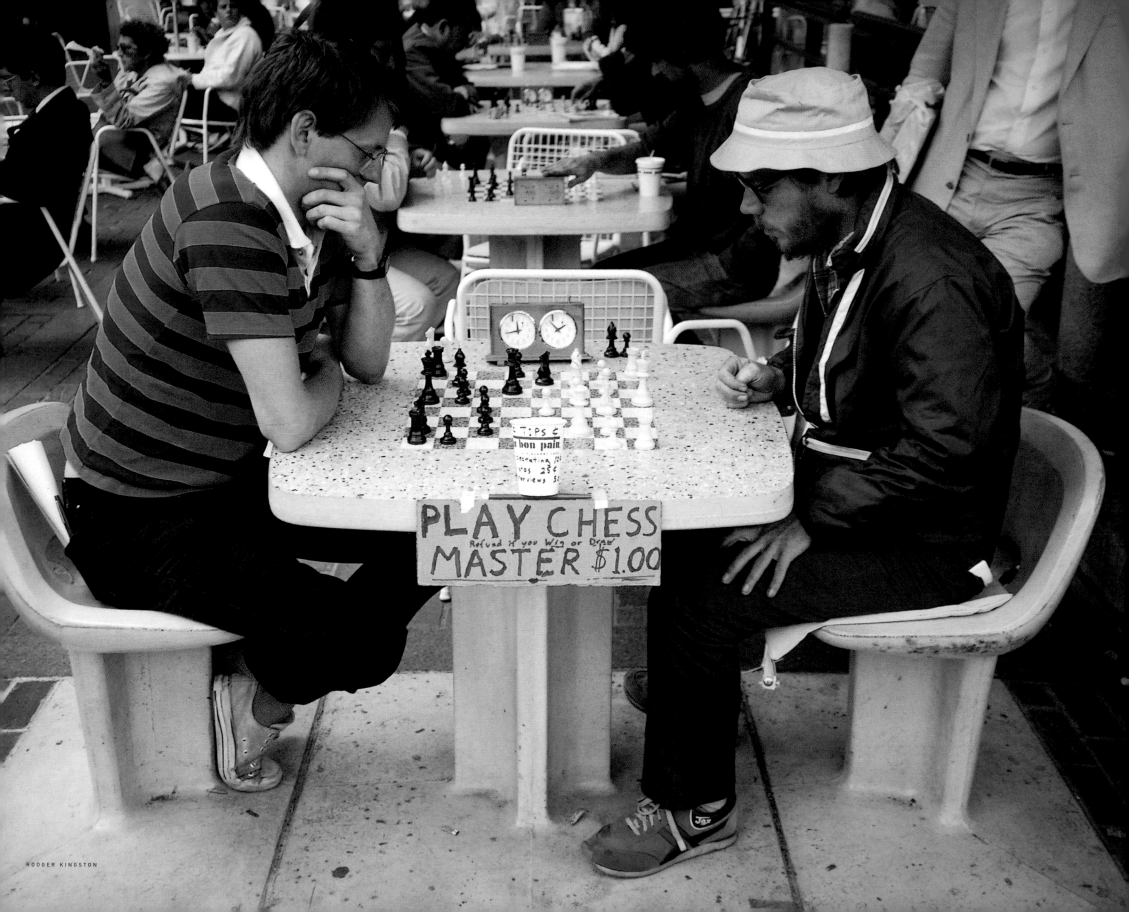

PLAY CHESS
Refund if you Win or Draw
MASTER $1.00

⬅ 1983 ❶

Murray Turnbull (right) is a Harvard Square institution.

{*204}

Ⓐ Ferranti-Dege
Ⓑ Gnomon Copy
Ⓒ Emack & Bolio's
Ⓓ Serendipity
Ⓔ Leavitt & Peirce
Ⓕ J. August
Ⓖ Yenching
Ⓗ Cambridge Trust
Ⓘ Holyoke Center

HARVARD ARCHIVES

THE CHESS MASTER

Expect to

be cut down with ruthless efficiency. There won't be a lot of banter nor a warm smile at the end of your transaction. Murray Turnbull does his speaking with a chess board.

It takes a particular skill to eviscerate opponents in this, the most complex of board games. To hone that skill to the point of being a Life Master, as rated by the U.S. Chess Federation, is an accomplishment shared by an elite few. But to sit outdoors at a concrete table for up to twelve hours a day, two hundred days a year for more than a quarter century— that is the province of one man alone.

Of all the Square characters over the years, Murray Turnbull is probably the easiest to find. Provided the weather's halfway decent, he will be seated on the right side of the very first chess table as you stand facing Holyoke Center. With a small sign that says "Play the Chess Master, $2" (up from the original $1), he invites any and all comers to a blitz—a timed game of chess, loser pays, with three minutes a side. Except he's so confident, he'll spot you an extra three minutes.

Turnbull, having enrolled at Harvard, probably could have gone on to any number of lucrative careers. Instead, he dropped out in 1970, and after some time as a homeless hippie and a tradesman, decided to parlay his passion into a career.

When he first hung his shingle in 1982, there were neither chess tables nor a café. He likes to think he encouraged both. Crowds gathered to watch the matches and a crew of other players formed. When Au Bon Pain opened the following year, the owner Louis Kane, himself a player, put in the tables. They have been here ever since. So has Turnbull, scratching out a meager living. "The income that you make isn't sufficient for family purposes," he acknowledged. But if forgoing the American Dream means getting to play chess all day, that seems a bargain he's willing to make.

No longer lean, his red beard now mostly gray, he's depleted a panoply of brimmed caps and an infinity of cigarettes. He has been bowed by neither the ravages of time nor the elements. But can he be beat? "I'm not immune to check and checkmate," admitted the Chess Master, "But I win far more than I lose." {204}

1980s

ERIC ANTONIOU

⬅ 1980s ❶ *A street musician draws a huge crowd on Holyoke Center's plaza. The Au Bon Pain, opened in 1983, has a decidedly different flavor than most, which gives finicky locals cover for patronizing an international chain. With its large outdoor seating area and very late hours, it quickly developed into Harvard Square's living room, encouraging activity and people-watching day and night.*

⬅ 1983 ❶ *What is this strange new "break dancing"? People crowd Holyoke Center to find out.* {59, 95, 170, 205}

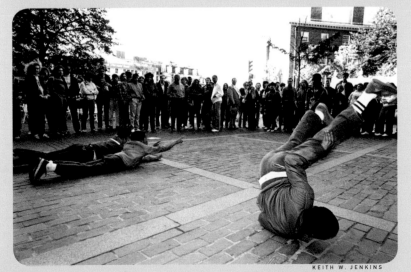

KEITH W. JENKINS

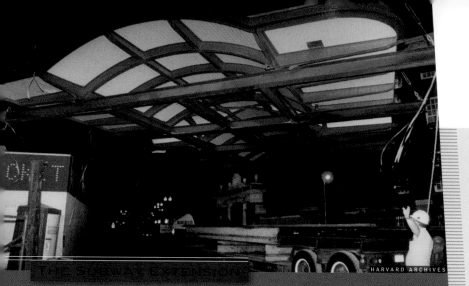

THE SUBWAY EXTENSION

HARVARD ARCHIVES

If the

copper-topped kiosk is its heart, then from 1978 to 1985, Harvard Square got the equivalent of a quintuple bypass. It was a project decades in the making: extend the Red Line three more stops out to Alewife in North Cambridge to improve public transit and ease traffic. The results of that half-billion-dollar project, intentional and otherwise, were epochal.

The construction was endlessly punishing with lane shifts, shut streets, and dust shrouds. Pedestrians were funneled into cattle chutes, a gaping maw opening beneath them with throbbing veins of infrastructure exposed. Cranes and mechanical jaws crunched rubble and lifted landmarks in a disorienting ballet.

It was a complex operation, which took place in phases. The bricks in Harvard's periphery wall had to be dismantled, numbered, and later reassembled in order. Two temporary subway stations were built, opening in 1979 while the 1912 original was completely gutted. In 1981 the famous kiosk entrance, built in 1928 and designated a national landmark in '77, was permanently closed and the iconic roof loaded onto a flatbed for restoration (above). Later that year, the entire forty-ton Out of Town News structure was lifted by crane and turned 90 degrees, one of several such operations.

Then slowly, dividends emerged: in September of '83, the Church Street and Johnson Gate entrances to the new station were opened and the temporary stations closed. Seven months later, concrete was poured for the central plaza, what would later be known as "the Pit." Finally, in March of 1985, the complete $72 million station was dedicated.

In its wake it left an expanded brick plaza, an information booth, new sidewalks, lamps, and streetscapes. Out of Town News moved into the beautifully restored kiosk. Grubby Harvard Square was no more. But the unintended impact was far wider.

Commuters who caught buses from Harvard Square to nearby neighborhoods were now served directly by the subway. Those commuters used to pick up flowers, groceries, or a slice of pizza. "You had such an influx of people in the morning and at night, you couldn't move on the sidewalks," merchant Al Brown remembered. Now they were gone. An average of 45,000 trips daily originated or ended at Harvard Station in the '70s. A few years after completion, the figure was down by 8,000. Harvard Square's pedestrian traffic has never recovered. Said shopowner Frances Cardullo, "That one event, as far as I am concerned, changed the face of Harvard Square forever." {105, 127, 129, 138, 160}

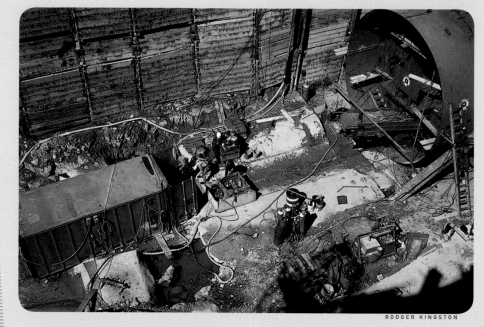

◄ 1980s *A man on a ladder gives a sense of scale of the massive tunnels.*

◄ 1983 *Square watchers might be pondering just when the massive project will end.*

RODGER KINGSTON

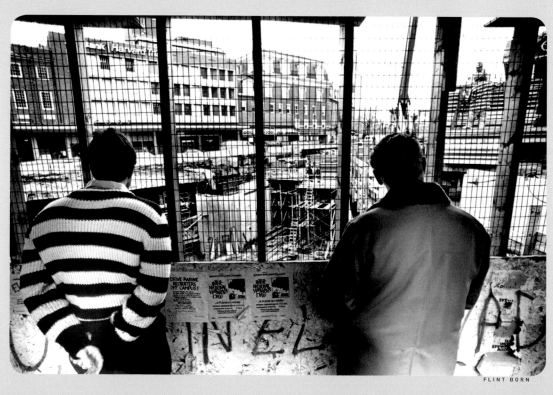

FLINT BORN

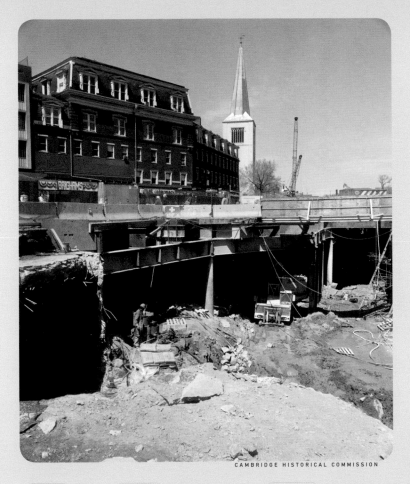

◀ **1981** *The tunnel works its way northward.*

◀ **1983** *The new subway station begins to take shape a few months before the first passengers arrive.* {***209**}

◀ **c.1982** *Passengers on the Red Line get a once-in-a-lifetime view.*

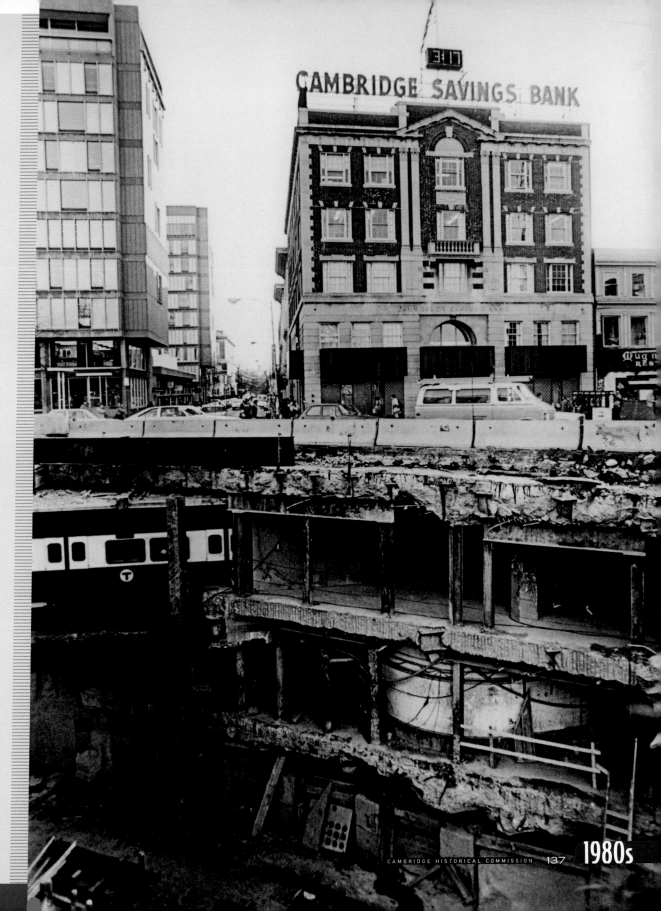

CAMBRIDGE SAVINGS BANK

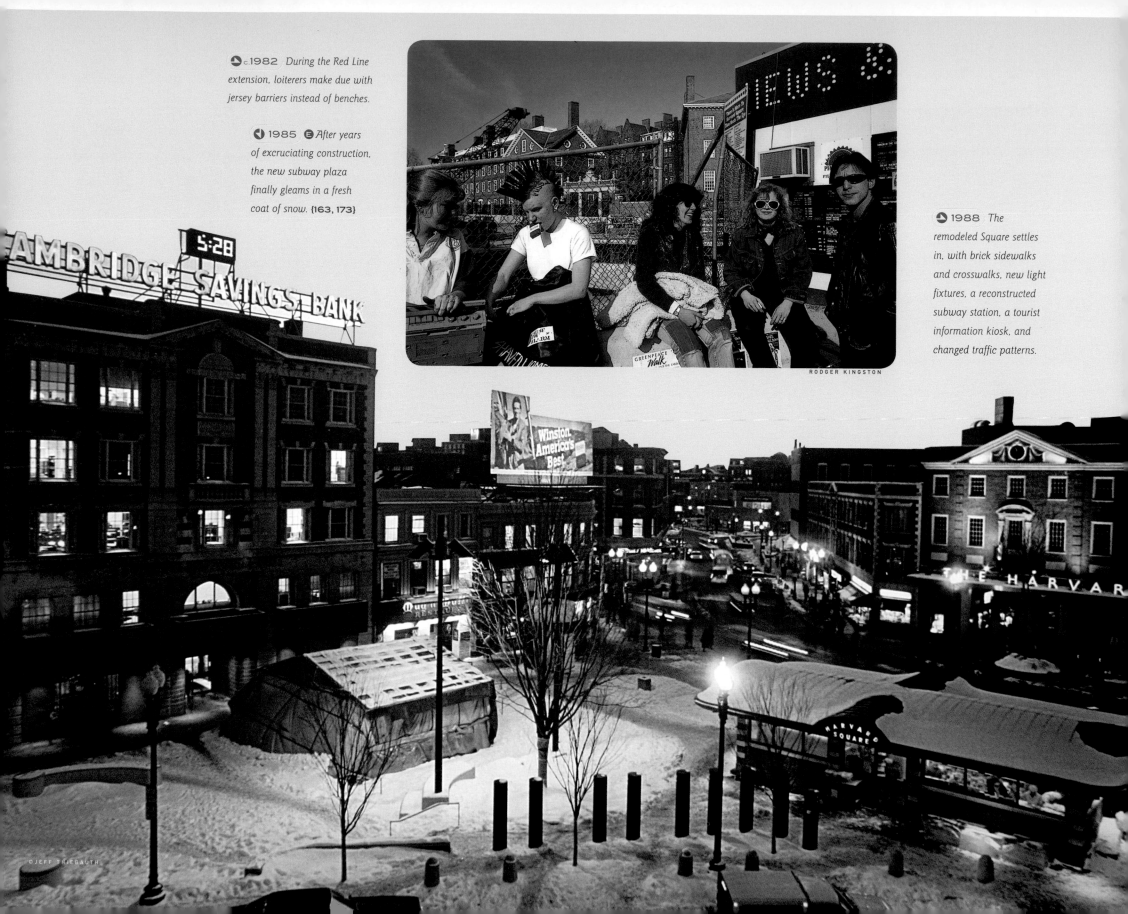

🚇 c.1982 *During the Red Line extension, loiterers make due with jersey barriers instead of benches.*

◄ 1985 Ⓔ *After years of excruciating construction, the new subway plaza finally gleams in a fresh coat of snow.* {163, 173}

🚇 1988 *The remodeled Square settles in, with brick sidewalks and crosswalks, new light fixtures, a reconstructed subway station, a tourist information kiosk, and changed traffic patterns.*

RODGER KINGSTON

© JEFF THIEBAUTH

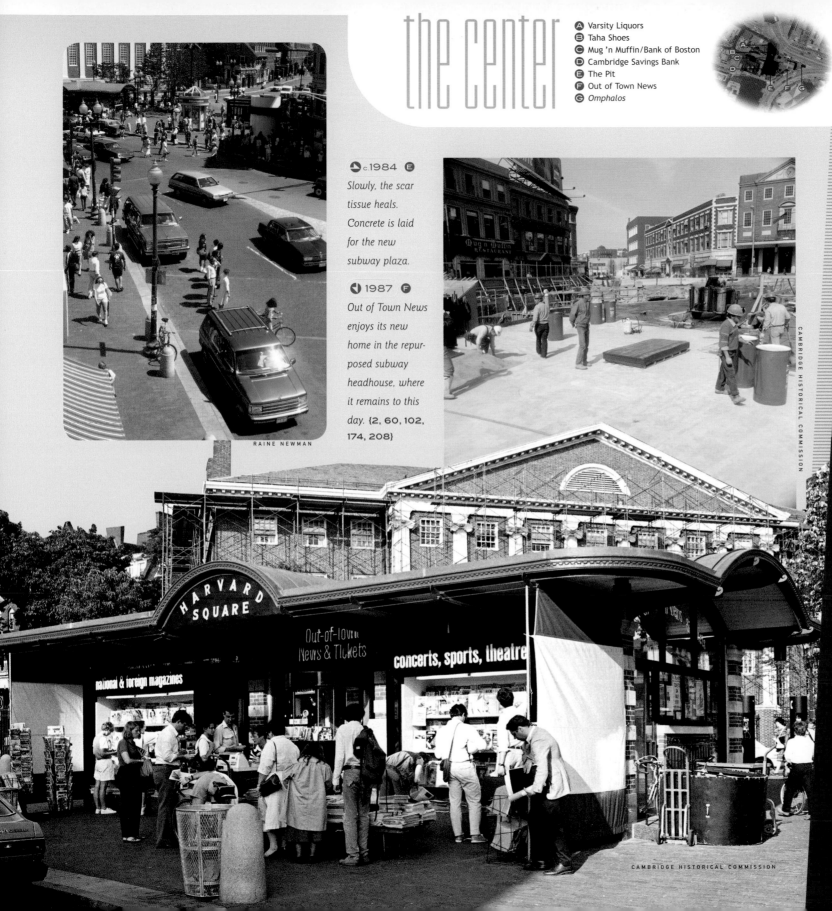

the center

- (A) Varsity Liquors
- (B) Taha Shoes
- (C) Mug 'n Muffin/Bank of Boston
- (D) Cambridge Savings Bank
- (E) The Pit
- (F) Out of Town News
- (G) *Omphalos*

c.1984 (E)

Slowly, the scar tissue heals. Concrete is laid for the new subway plaza.

1987 (F)

Out of Town News enjoys its new home in the repurposed subway headhouse, where it remains to this day. {2, 60, 102, 174, 208}

RAINE NEWMAN

CAMBRIDGE HISTORICAL COMMISSION

HARVARD ARCHIVES

HARVARD SQUARE
Out-of-Town News & Tickets
national & foreign magazines
concerts, sports, theatre

CAMBRIDGE HISTORICAL COMMISSION

OMPHALOS

Greek

sculptor Dimitri Hadzi had been teaching at Harvard for about a decade when he was given the type of commission most artists would envy. The completion of subway construction would create a new island with Hadzi's sculpture standing at the prow, smack dab in the middle of the Square.

Inspired by the international flavor, the education, and the uniqueness of Harvard Square, he gathered seven types of granite from all over the globe and painstakingly polished and ground the stone in his Cambridge backyard for six months. He termed his work *Omphalos*, after the stone of Delphi, which was to the Greeks the center of the universe. He explained not long after, "I see Harvard Square as the navel of the educational universe."

Since 1985, the 21-foot-tall totem has stood at the knife's edge of the traffic triangle. Hadzi is often critical of his own work but of *Omphalos*, he said, "It really has held up beautifully."

1980s

A Harvard Coop
B Baybank Harvard Trust
C Brigham's
D CVS
E Harvard Valeteria
F Ruggles
G Store 24
H Golden Temple Footwear

RED LINE
AINS AND

den Temple Footwear

AMERICAN INDIAN
Jewelry & Art

Colombo
yog

MARK MORELLI

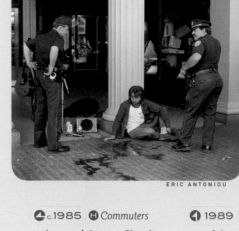

ERIC ANTONIOU

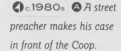

ERIC ANTONIOU

↻ c.1980s Ⓐ *A street preacher makes his case in front of the Coop.*

↺ c.1980s *Punks were a common sight in the Square in the '80s and '90s.* {173}

↺ c.1985 Ⓗ *Commuters make use of the new Church Street subway entrance.*

◁ 1989 Ⓐ *Vagrancy has been one of the, uh, messier features of the Square since the '60s.* {205}

◁ c.1984 Ⓕ *Construction wraps up. Not everyone knew what to make of Ruggles, the cheddar cheese pizzeria.*

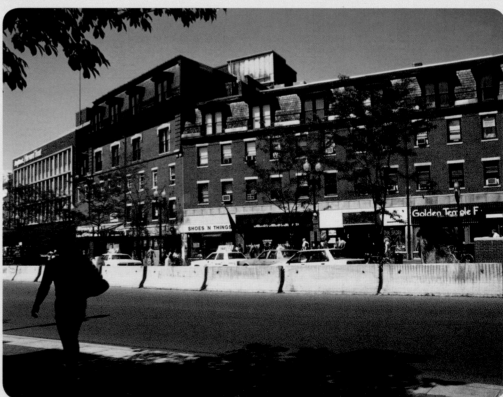

SHOES N THINGS

Golden Temple F

CAMBRIDGE HISTORICAL COMMISSION

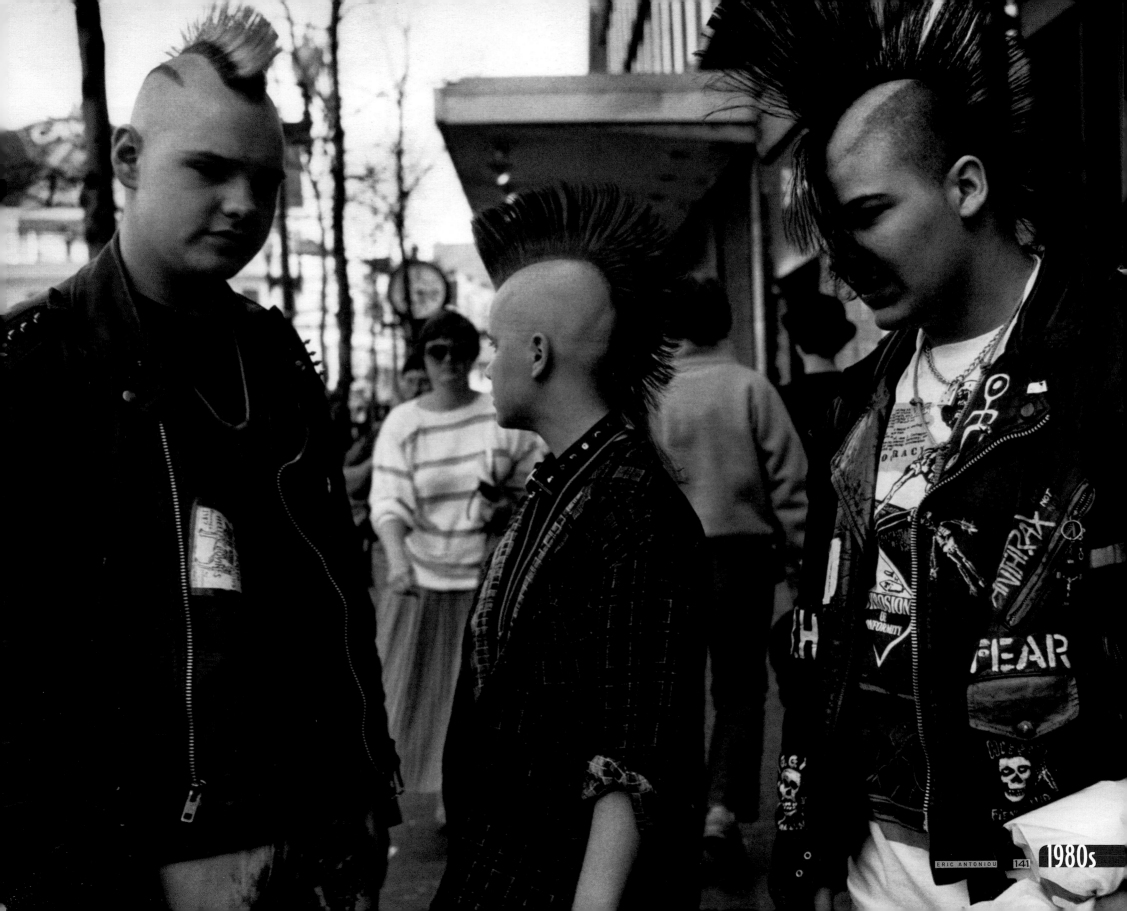

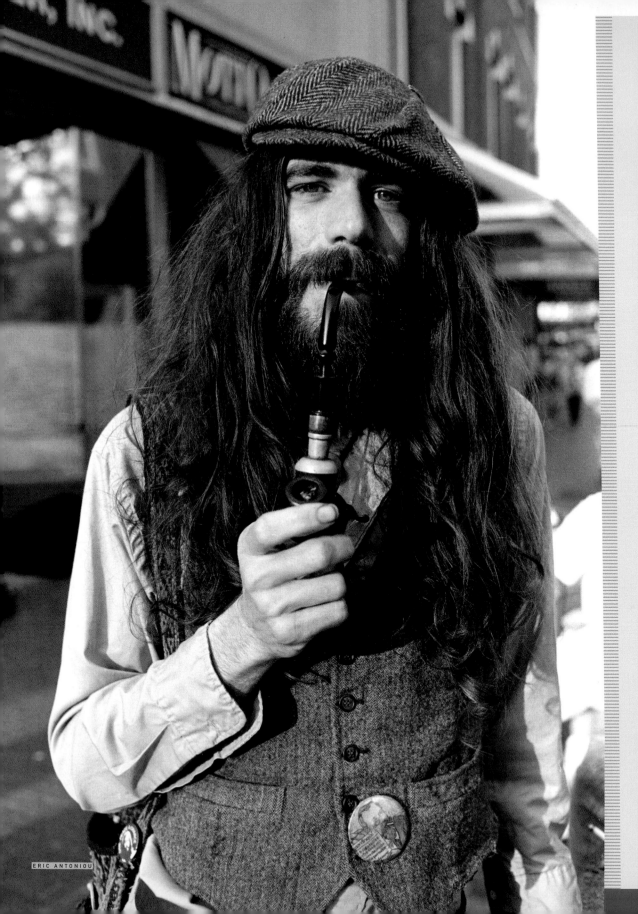

❷ c.1989 Dana often hung out in Brattle Square dressed in his anachronistically hip outfit.

❸ c.1987 ❶ A recurring treat was a man who wheeled a player piano into the Square, offering the tune of your choice—and the resultant impromptu sing-alongs with passersby—for tips.

❹ c.1986 ❶ The Tannery gained a foothold in the Square with one of the largest shoe stores in metro Boston at the time. At 10,000 square feet, up to 28 salespeople would work the floor at peak hours. Nike, Reebok, and Clark's would consult with founder Sam Hassan or his son Tarek and develop new products based on their expertise. Their success led to an even larger store on Brattle Street in 2007.

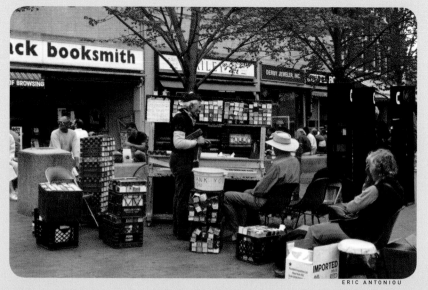

A Brattle Sq. Florist
B Brine's Sporting Goods
C Warburton's
D Paperback Booksmith
E Bailey's
F Derby Jeweler
G The Jewel Box
H The Gap
I The Tannery
J The Coop Annex
 Benetton
K Kupersmith Florist
L Cardullo's
M Montgomery-Frost-Lloyd's
N Greenhouse Coffee Shop
O Nini's Corner

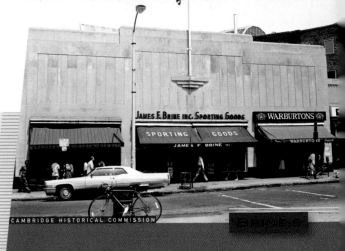

CAMBRIDGE HISTORICAL COMMISSION

▲ 1983 ○ *Morris Baratz pets Louis, the resident mouser at Nini's Corner. Nutche Nini founded the well-located newsstand in 1960 with his sons Phil and Joe. Joe later opened the neighboring restaurant the Greenhouse (bottom photo). Nutche's grandson Chris Kotelly now runs the stand, renamed Crimson Corner in 2006. {2, 64, 68, 102, 109, 178}*

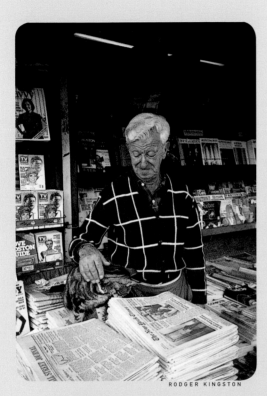

RODGER KINGSTON

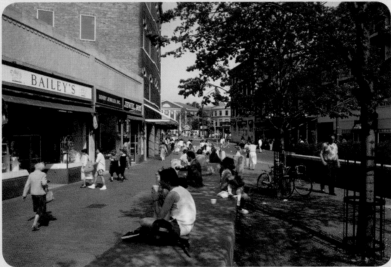

ERIC ANTONIOU

▲ c.1987 E *Brattle Street's expanded sidewalk plazas were another by-product of the subway construction.*

▲ 1987 N O *The Greenhouse served up turkey clubs and massive slices of cake in a mirrored interior, painted with whimsical plants. The place remained essentially unchanged from its opening in 1977 until its closure 30 years later. {212}*

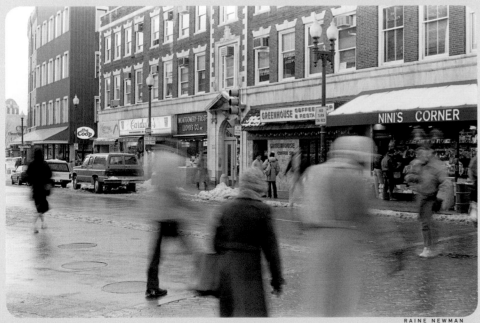

RAINE NEWMAN

If you happen

to be invited to the Brines for dinner, don't ask James to pass the peas. "My great-grandfather was James also," says proprietor James Brine, "He was James W. My grandfather was James F. and that's the name on the front awning...my father was James W. and I'm James W. and my son's James W. and his son is James W."

What the family lacks in creativity they more than make up for in consistency, because five James Brines have been working at Brine's Sporting Goods (with the sixth perhaps next) since 1870, making it the oldest sporting goods store in the country. Though it moved to Belmont in 2004, Brine's spent a staggering 137 years in Harvard Square (it actually started in 1867 as just a clothing store). And yes, they are related to W. H. Brine, famous for lacrosse gear and soccer balls—William Brine was James F.'s nephew.

Brine's original location was in the College House building on Massachusetts Ave., on the same block as the Harvard Coop. It subsequently spent about three decades lower on Massachusetts Ave. near Cambridge Trust (briefly with a second storefront a few doors down), before being booted by Holyoke Center over to the two-level shop at 29 Brattle Street, where it remained for about 38 more years.

It was never a fancy place but it served up tennis rackets, baseball mitts, volley balls, swimming goggles, and most of all sneakers for generation after generation of Cambridge children and Harvard students. Bins overflowed with mittens and hats. Christmastime was big, and skis were very popular. During the Blizzard of '78, Jim recalled that they moved the mounting equipment upstairs to street level, "and as soon as somebody bought a ski we'd mount the bindings on and they go out the door."

Fortunately Brine's did discontinue one of its traditions. "Well, they had a machine, and you stood in the machine and they took X-rays of your feet so you could look down and see," explained Brine. "You don't go back to the X-ray days." Thank goodness. {17, 70}

lower brattle st.

A WordsWorth F David's Cookies
B Bob Slate's Swenson's
C Dickson Bros. G Cappy's Shoe Repair
D The Lodge H US Trust
E Corcoran's/
 Urban Outfitters

▲ c.1987 *Crowds of several hundred would often gather around performers on summer weekends.*

◀ 1985 *College student Tracy Chapman plays for pennies before hitting it big.*

JOEY HARRISON

RAINE NEWMAN

▲ 1982 *Jim Turner plays the glass harmonica for transfixed listeners.*

▲ c.1987 *Mark Farneth makes fire his friend during his wire-walking routine, a summer staple in the Square in the '80s and '90s.*

◀ c.1987 *Brother Blue draws people into his own explosive brand of story-telling. He brought his routine to the Square for about 30 years.* {178}

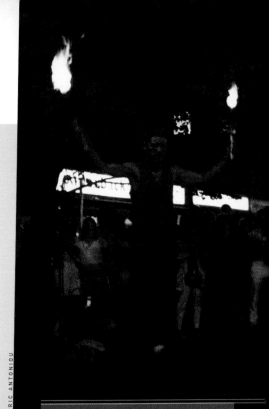

ERIC ANTONIOU

STREET PERFORMERS

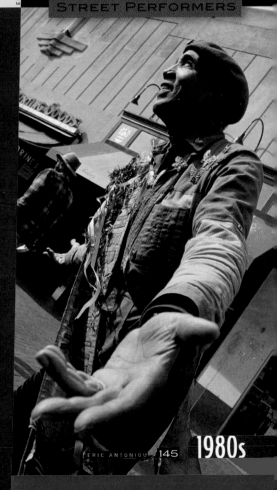

The warm

crackle of tumbling torches, the grace of lithe, coiled rope-walkers, and the finger-picking confessionals of sidewalk troubadours—beginning in the '70s, street theatre became one of the Square's biggest draws. On sparkling summer evenings, there was often a festival atmosphere, crowds of up to a few hundred pressed in for the best acts, breathing, gasping, and applauding in unified bursts.

With the subway construction makeover, Harvard Square stretched its pedestrian zones into widened sidewalks and small plazas with perimeter benches, veritable microtheatres that encouraged a multiplying horde of musicians, acrobats, and prestidigitators. The Square, almost literally, cemented its reputation as one of the premier busking venues in the nation.

Performers would need to arrive early in the morning to secure the choicest locations for their evening acts. Many held years-long engagements, ensconcing themselves into Harvard Square lore, such as Mark Farneth, who walked a tightrope strung across Brattle Square for nearly 20 years, or storyteller Brother Blue, who rapped and strutted for 30. {178}

"The mood was electric," recalled Trent Arterberry of the '70s scene. His group, The Shakespeare Brothers, was one of the first-wavers along with Slaphappy, The Amazing Fantasy Jugglers, and The Locomotion Circus. {110} The Brothers combined mime, comic wordplay, and shtick, like a "mind-reading" bit. Added Arterberry, "And then the pass the hat, the most important part. From which we retired handsomely."

For some, those tips were gravy. For others, such as Gerry Mack, a blind keyboardist, they were a living. Few people bewitched by his soulful Stevie Wonder homages during the '80s and '90s knew he commuted by bus from Cape Cod and busked day and night to support a family.

Amanda Palmer, before founding the punk cabaret group The Dresden Dolls, spent countless hours atop a small box in Harvard Square as a "living statue" called the Eight Foot Bride where she would stand stock still, painted white and dressed in a wedding gown. She explained the benefit: "I think that nothing can steel you and strengthen you to be a performer like street performing. It's the most vulnerable position you can put yourself in as an artist: you in front of the world with no safety net." {162, 171}

Palmer was one of many Square performers who went on to (or back to) fame, including Tracy Chapman, Martin Sexton, Patty Larkin, Howie Day, Bela Fleck, and Mary Lou Lord. {177, 178}

For others, Harvard Square was their fame, their idiosyncratic acts remembered fondly or otherwise. There was Leonard Solomon and his Majestic Bellowphone, a seven-foot-tall conglomeration of horns and pipes, and Eric Royer, the one-man band whose pedal-operated apparatus included a bobbing rag doll. Thomas Newell, aka Blue, still arrives almost daily on a giant tricycle and has been urging the legalization of hemp via his giant "Uncle Scam" puppet since 1991. He expressed what has drawn many here, saying "I have never been hassled for being strange in Harvard Square." {214}

These days the crowds are much smaller and the big juggling acts and full-band rock sessions are rare, but solo musicians still sprinkle themselves around the street, developing material or garnering new fans. It would be hard to imagine it otherwise. Street performances turn us into bit players in a theatre of daily life that can be funny or moving or dramatic, but—in Harvard Square—rarely boring.

ERIC ANTONIOU 145 **1980s**

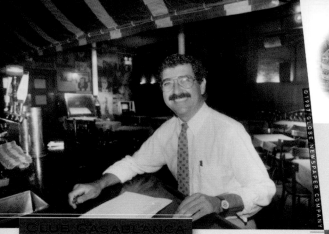

CLUB CASABLANCA

Ⓐ Freedom Federal/ Northeast Savings	Ⓒ The Bijou The Dutch Garden Looks	Ⓖ Cardell's Billings & Stover	
Ⓑ Cherry, Webb, & Touraine	Ⓓ Calliope A. Cahaly's Men's The Oxford Shop Sola Shoes	Ⓕ J.F. Olsson	
Ⓒ The Brattle Theatre Casablanca Algiers Berk's Adams Apple Candles	Ⓔ Jasmine Boutique	Ⓖ Reading International Ⓗ Colonial Drug Craftsman's Corner Custom Barber Hillside Cleaners	

◀ 1987 Ⓒ *Sari Abul-Jubein, as steward of the Casablanca since 1976, has a lot to smile about.*

◀ 1980s Ⓒ *Downstairs at the Casablanca, as most remember it. This version would be lost to the wrecking ball when the Brattle Theatre complex underwent a massive renovation in 1990.*

Murder at the Casa B

Harvard Square has seen all kinds of action over the years: riots, drugs, homelessness, and even the occasional robbery. But a brazen, public slaying? That seemed beyond imagination.

"The old upstairs would attract all sorts of people…" remembered Sari Abul-Jubein of the popular nightclub one story up from the red-awninged bar. In those days it was popping on any given Saturday night with folks bumping up against sweaty jukebox dancers, gin-swillers, and make-out artists. On January 29, 1972, like most weekends, a line formed to get in. One hundred patrons partied inside. At the door, as usual, was co-owner and manager Govert Van Schaik, known to most people as Van. "At times he did it almost à la Studio 54, you know, you can get in and you can't," continued Abul-Jubein, who was tending bar at the time.

Carl Griffin probably had an inkling he wasn't going to make it past the threshold that evening. He had been to the Casa B many times before, and been carried out, too drunk to walk, at the end of the night. Van had had enough. But some thought Van racist; Griffin believed he was being turned away because he was black. He ascended the stairway. "If he doesn't let me in, I'm gonna off him," he said to his friend, according to Abul-Jubein.

Griffin and his friend approached Van Schaik. The men argued and Griffin was summarily bounced at the door. For a little while, that seemed to be the end of the episode. John Chaprales was sitting at a table near the swinging doors when Van Schaik appeared. "Suddenly he comes through the doors and he says, 'John, I've been shot.'" He collapsed on the floor.

Griffin had returned, walked right up to Van Schaik and put one .32-caliber bullet in his chest. He was pronounced dead on arrival at Mount Auburn Hospital.

Cy Harvey, who cofounded the Casablanca and the Brattle Theatre was one of several who gave up on Harvard Square in a time of upheaval. "That was the end. I said this is enough, this is sort of crazy. And we moved to Connecticut."

Cy

Harvey and Bryant Haliday knew they had a hit on their hands when their Brattle Theatre resurrected a certain forgotten Humphrey Bogart film from the dust bin and put it on rotation for Harvard's reading period. The pair were nothing if not successful entrepreneurs. But can you turn a film into a bar? When the film is *Casablanca*, it so happens you can squeeze out two or three.

When the Brattle went from stage to screen, the green room and the dressing room became disposable so the pair created Club Casablanca and The Blue Parrot, the latter being the namesake of the rival bar to Rick's in the film and a popular spot in its own right for 30 years.

More homage than reproduction, the Casablanca began in 1955 as just a basement tavern, dark and smoky, with the signature red and white striped awning hanging over the central bar, tables splayed all around it. It quickly became known as one of Cambridge's few hot spots and one of the few places that really catered to the rainbow. Merchant Charlie Davidson remembered it as a mixture of "everything: sexes, cultures, leanings." It started drawing artists, writers, and intellectuals. Future senator Daniel Patrick Moynihan, *Spenser* author Robert Parker, cartoonist Al Capp, and TV chef Julia Child were some of the regulars. Former bartender Harry Fotopolis recalled that, in the days of three-martini lunches and legal happy hours, "five o'clock it would open and by 5:05 it was full."

Harvey and Haliday kept expanding their juggernaut and opened a restaurant/bar above the Casablanca called The Grand Turk, inspired by the masthead of a ship they found

Owner

Sari Abul-Jubein returned to the restaurant one day after trying, unsuccessfully, to catch a glimpse of Ingrid Bergman in Boston. She had come to the Casablanca while he was gone.

in an antiques shop. Where the Casablanca was down and dirty, The Grand Turk was all cool concept and exotic cocktails. Thus was introduced the wicker. The ceiling was wicker, as were the fans, and most importantly a few hooded wicker settees, resembling porch swings sans swing. The Grand Turk didn't last long, but the wicker did, becoming incorporated into the new, two-story version of the Casablanca that resulted.

The persistence of memory inclines the nostalgic to swear the entire place was filled with the wicker settees, but there have only ever been three, sandwiching two wicker benches, which migrated downstairs and quickly installed themselves into mythology. You can still find them in the back bar of the Casablanca today, even though the newer incarnation of the place is decidedly more refined. "If these benches could talk! Holy moly!" said current owner Sari Abul-Jubein, recalling make-out sessions, proposals, and even weddings taking place on them. "God knows what else happened," he said provocatively, "in the darkness of the night."

Whatever it may have been, it took place to the sound track of the famous jukebox. The original had 78s such as *And Now Mrs. Betty Boo, if You Please* and 45s that were custom-made from snatches of dialogue from the film. The wide-ranging contents would later include Edith Piaf and Bob Dylan.

Meanwhile, above the sinuous fog of the cellar, upstairs Casa B's went through phases that took it from seedy dance club to "the center of the Prep universe," according to no less an authority than 1980's *Official Preppy Handbook*. It was here that the restaurant service debuted, amid the backdrop of David Omar White's famous murals depicting cartoonish scenes from the film. Those murals were saved when the entire Brattle complex went through a wholesale renovation in 1990, and they have been reinstalled in the newest iteration of Casablanca. This one features fine dining with Middle Eastern influences that the original lacked. But there are some elements that remain consistent; there is one song that has always remained on the jukebox. Abul-Jubein averred, "Man, there isn't a night that goes by that we don't hear somebody playing the theme from *Casablanca*. Drives the staff nuts!" (75, 88)

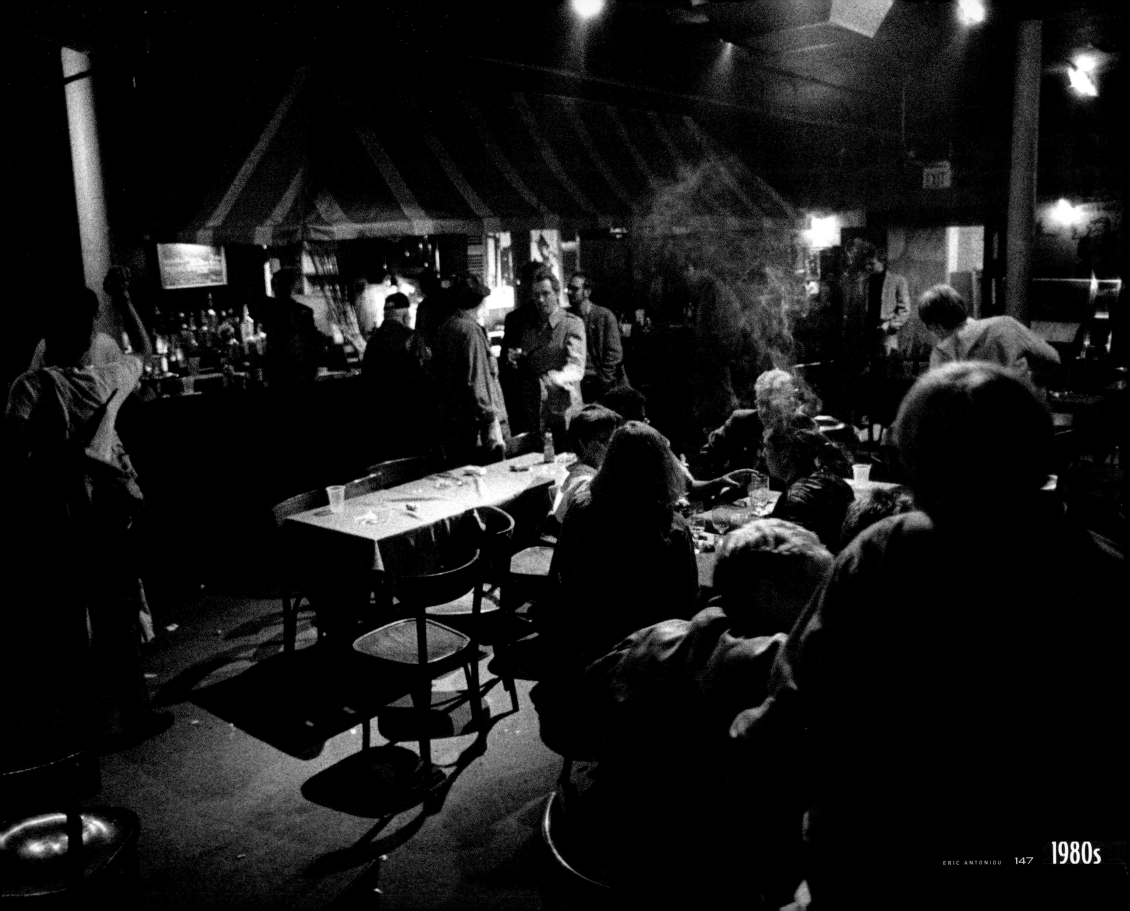

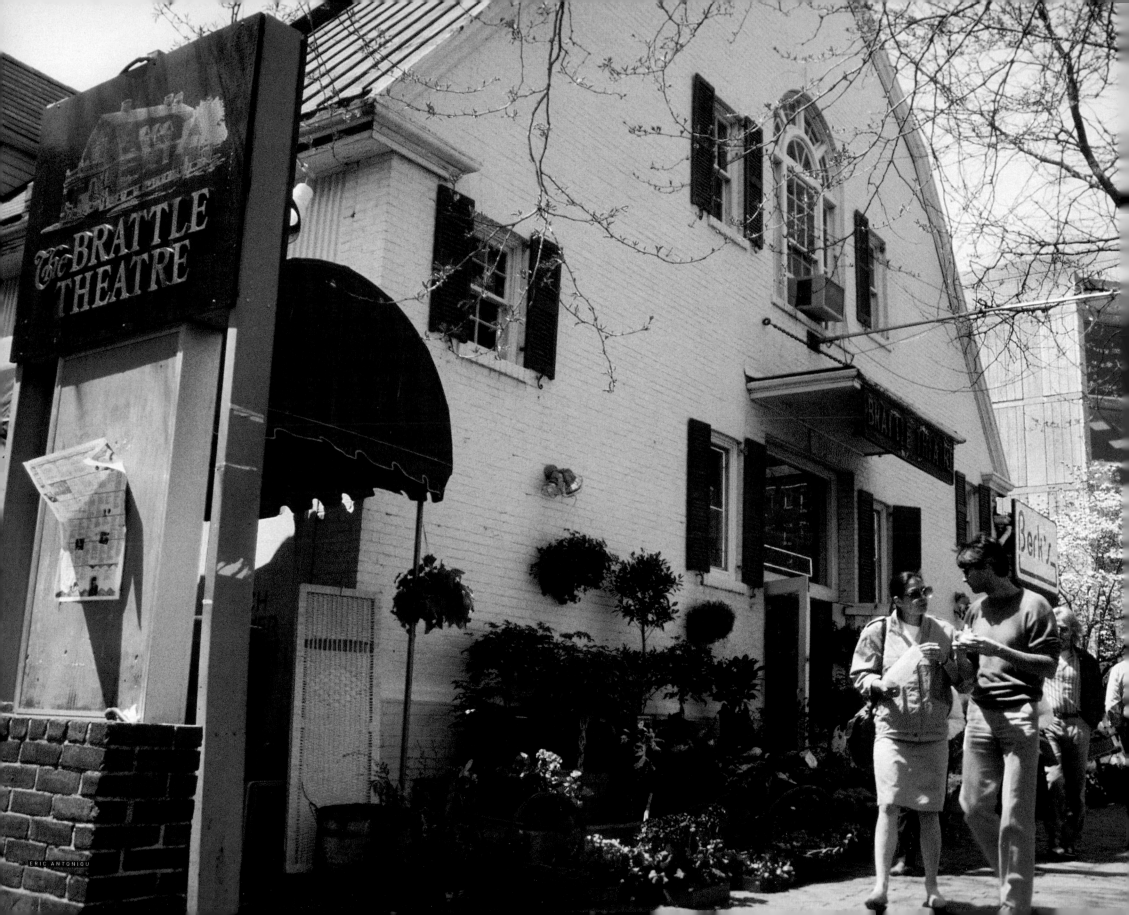

upper brattle st.

A The Brattle Theatre
 Berk's
 Algiers
B Camb. Ctr. for Adult Ed.
C Ahepa Travel
 Ann Taylor
 Stone Reprographics
D Crate & Barrel

E Clothware
F Eleganza
G Flour Child/
 Croissant du Jour
H Taj Boutique
I Bernheimer's Antiques
J Blacksmith House Bakery
K American Rep. Theatre

🔺 1980s A The Brattle Theatre looks lovely on a spring day. Its appearance would soon change with a 1990 renovation. {30, 72, 76, 111}

🔻 1984 C People are not shy about broadcasting their political views in Harvard Square.

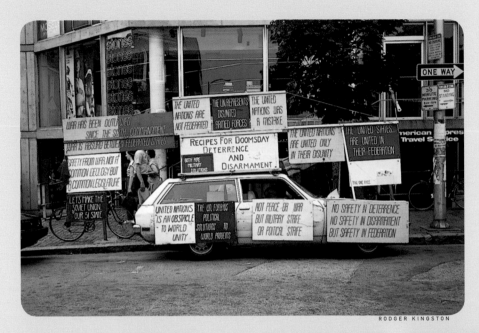

RODGER KINGSTON

🔺 1987 B The Cambridge Center for Adult Education looks as inviting as a storybook cottage. {73, 110, 219}

CAMBRIDGE HISTORICAL COMMISSION

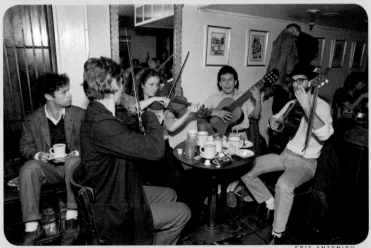

ERIC ANTONIOU

🔺 c.1989 A An impromptu jam breaks out Algiers, in the basement of the Brattle Theatre complex. {183, 216}

🔻 c.1989 A A server froths milk with the vintage copper espresso machine at Algiers. It was originally gas-fired. {183, 216}

ERIC ANTONIOU

SAGE'S

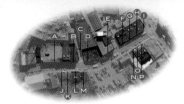

Ⓐ Harvard Sq. Theatre Ⓔ Kenmore Camera Ⓚ Bennett & Sons
Ⓑ Globe Corner Bkstore. Ⓕ Gertrude Singer's Ⓛ Young & Yee
Ⓒ Passim Christopher Flowers Ⓜ Steve's
Ⓓ Oxford Ale House/ Ⓖ The Swiss Watchmaker Ⓝ Baak Gallery
 Border Cafe Ⓗ Rizzo Tailor Stork Time
Ⓔ The Atrium Café Ⓘ Sage's Market The Underling
 The Bakery Ⓙ Christian Sci. Rdg. Rm. Ⓞ Nornie B's/Lee's
 The Café Lounge Ⓚ London Harness Co./ Ⓟ Merchants Bank

church St.

Tory Row

is the nickname for the mansions that line the residential end of Brattle Street. Here is where the loyalists lived during the Revolution; old money in America doesn't get much older. It was to these homes, searching for another kind of loyalty that Edwin R. Sage rode his horse and wagon, scribbling orders so that he could buy fresh produce in the markets and deliver them later in the day. Rodney, as he was known, was very relieved when the telephone eventually reached prominence.

Sage had arrived in Cambridge in 1898, where he worked for the grocer Daniel H. Dean, whose shop at 21 Brattle was eight years old. When Dean retired in 1908, Sage bought the market. His name would be synonymous with groceries and Harvard Square for the next 92 years.

The permanence of this relationship was etched into stone, literally, as the 20,000-square-foot Sage Building rose on the corner of Church and Brattle in the late twenties. From there Sage, his sons Edwin D. and Rodney, and later his grandson Charlie, would cater to the alimentary needs of Cambridge and beyond. The hard work and success turned into a second store in Belmont and eventually a small local chain, including, for about a decade, a petite version on the other side of the Square called Sage, Jr.

By the '60s, the market had added foreign foods and wines, keeping in step with Cambridge's burgeoning cosmopolitanism. What didn't change was the personal service. Those same Brattle Street addresses kept stocking up on Sage's victuals. Children would snack on complimentary sugar cookies from the bakery counter. Elsa Dorfman was a longtime customer who received regular deliveries, invoiced monthly. As she recalled of the driver, "I lived on a fourth-floor walk-up; he had a key to my apartment."

Customers fell off with the subway extension and Harvard Square became less and less a residential neighborhood. Ultimately, the Sage family trust, which owned the property, came to a conclusion that many Square-watchers feared: with skyrocketing rents, it would be more lucrative to simply lease the space than operate the last remaining grocery in the Square. Sage's shuttered on June 3, 2000. Charlie Sage, who had spent more than 40 years in the business, manned the register up to the end. In a classic understatement, he said, "I'm a little disappointed." So are we, Charlie. {35, 224}

ICE CREAM

For reasons that defy logic, Massachusetts, where it has been known to snow in eight of the twelve months, is the ice cream capital of America. In the '70s, soft-serve frozen yogurt was launched from Brattle Street. In the '80s, we consumed more scoops, by one half, than the national average. Harvard Square, with as many as nine separate parlors simultaneously— Bailey's, Baskin-Robbins, Brigham's, Cahaly's, Emack & Bolio's, Gelateria Giuseppe, Häagen-Dazs, Herrell's, and Steve's—became the capital of the capital. Seven of them, including four franchises, had local roots.

Whether you preferred Victorian charm or a punk aesthetic, a cheap cone with sprinkles ("jimmies" in local parlance) or high-butterfat licks with candy mix-ins, the Square in the '80s was an overflowing sundae of options.

🍦 1980 *Though not on Church Street, Dance Free (now called Dance Freedom) took place in Christ Church on Garden St. and was a fervent expression of faith—in the power of spontaneous dance. An outgrowth of the '60s Cambridge Common concerts, it became a movement that spread across the country. The barefoot free-for-all (more recently at First Congregational) remains a bastion for the bohemian spirit.* {107}

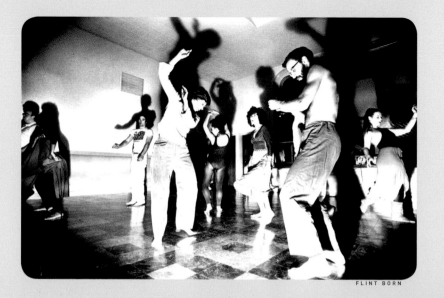

FLINT BORN

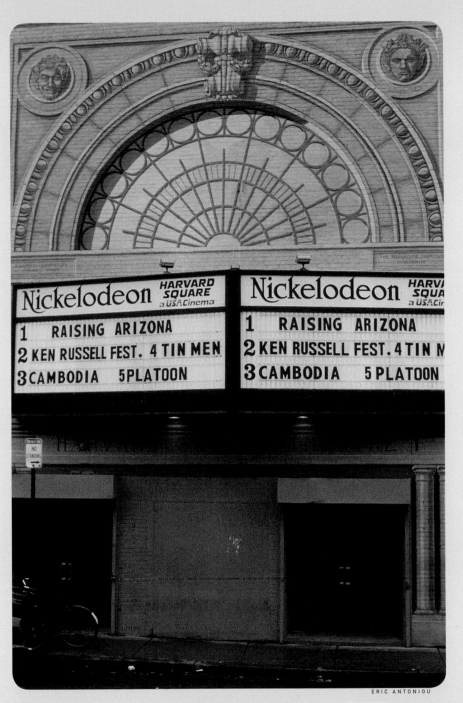

ERIC ANTONIOU

◀ 1987 🅐 *A renovated Harvard Square Theatre reopened in*
December of 1982 with its marquee now on Church St. The single-
screen house, which had opened on Massachusetts Ave. in 1926
as the University Theatre and hosted rock legends in the '70s,
was expanded into three, and then in 1985, five theatres. Added
was the trompe l'oeil mural (above). Subtracted were the double
features, the balcony, and the sagging velvet. {26, 64, 91, 223}

🔽 1980s 🅛
Young and Yee (pre-
viously Young Lee)
would spend about
50 years in this
location. It closed
in 2001. {34, 79}

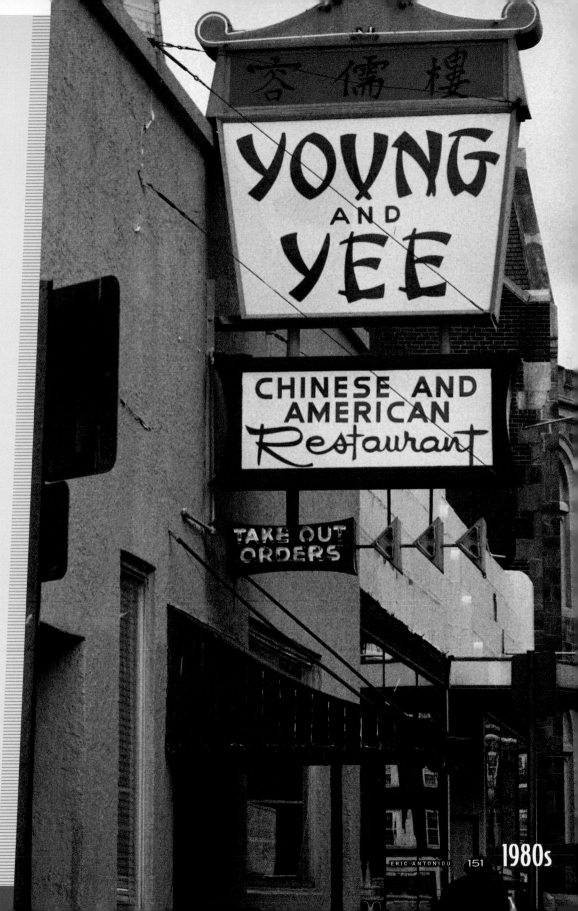

ERIC ANTONIOU 151

WWW.SUSANWILSONPHOTO.COM

HARVARD ARCHIVES

continued from Club 47, p. 81

In 1969

(after a brief stint as Eugene McCarthy campaign headquarters), the basement of 47 Palmer Street was turned into a new bookstore/coffeeshop/art gallery and named Passim. Owners Renée and Walter Juda hired Bob and Rae Anne Donlin to manage the space. Although it was almost 20 years before the Donlins had full financial ownership, you could say they had spiritual ownership of it almost immediately. Because the ghosts of the legendary folk venue Club 47, which had just vacated the space a year prior, have a way of haunting people. They pestered the Donlins until they had no choice but to bring back the music.

Though perhaps not business geniuses, the Donlins were second parents to a quarter century of folkies, parents who kept your room just as you left it. Bob was notoriously gruff—if he allowed you a two-song encore, you might be the Second Coming— but he was kind, and Rae Anne had that midwestern sweetness that made performers feel at home. With the legacy of Club 47 and the high bar for performing, Passim easily slid back into the role of premier venue. The faces were different but the passion and honesty of both performer and audience were the same.

Even as folk music fell out of fashion, Passim remained the pilot light, surviving disco and drum machines to usher in a new folk revival begun in the '80s, which continues today. This generation borrowed from the old traditions but were thoughtful songwriters in their own right. Once again the basement on Palmer Street made household names of young unknowns who cut their teeth on the narrow

stage, people such as Suzanne Vega (above), Nanci Griffith, and Ellis Paul.

Running a nightclub without liquor is no mean feat, and staying afloat has always been a challenge. Thus in 1995, when the Donlins retired, Passim went nonprofit, just like the old 47, and was rechristened Club Passim. But the new board still struggled to make it work. Then the ghosts whispered again.

Betsy Siggins, a classmate of Joan Baez, was married to Bob Siggins of the Charles River Valley Boys and had been on the original board of Club 47 from 1961 until it closed. Nearly 30 years after she left, she was called back to help save it. As executive director, with an expanded board, she used decades of experience in community organizing and promotion to transform Club Passim into the best version of itself, an entity recognized for its cultural contributions, a steward of that heritage, and a breathing musical destination that still breaks new talent, even more effectively than it has in the past, she professed, "'cause this time around we know what we're doing." Under her stewardship until 2009, (and with the added income from the eatery Veggie Planet that shares the space), the place is thriving. It now runs a music school and a cultural exchange program for children.

To this day, taking in a show at Club Passim is a special occasion. The room often crackles with synaptic fire between performer and the often-full house. The reputation of the room brings top talent night after night, and in turn the warmth of reverent listeners—many musicians in their own right—is palpable. As Siggins said, a half century after first coming to the club, "It's still magic." {80, 118}

If you are an aspiring songwriter having difficulty getting a gig at Passim, don't feel too bad. Billy Joel, Bruce Springsteen, and Willie Nelson were all turned away from the notoriously hard-to-book club.

◀ c.1980 Ⓐ *Browsers enjoy the best record selection in New England at the Harvard Coop.* {24, 36, 67, 104, 118, 177, 210}

◀ 1989 Ⓐ *The skywalk connecting to the two Coop buildings across Palmer Street dresses for the holidays.*

ERIC ROTH

winthrop St.

Ⓐ The Galeria
Ⓑ Henri IV
Ⓒ Wei Ta
 Lata Carta/Mavens
Ⓓ Grendel's
Ⓔ Winthrop Park

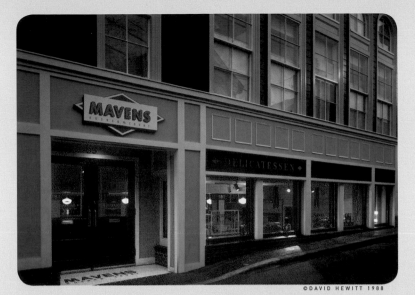

©DAVID HEWITT 1988

Ⓐ 1988 Ⓒ *One of the most hyped and powerfully backed restaurants in the Square's history was Mavens Kosher Court. The authentic Jewish deli was the brainchild of Harvard constitutional super lawyers Alan Dershowitz and Harvey Silverglate, partnering with Mitch Kapor of Lotus software and a panel of "mavens" including Yo-Yo Ma, Itzhak Perlman, and Red Auerbach. Apparently, oral arguments didn't persuade the court of public opinion; the eatery closed after about seven months. This building was later razed during a real estate development in the late '90s.* {186}

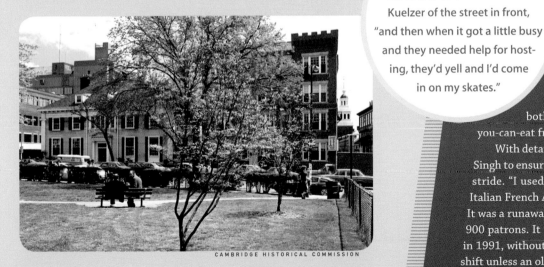

CAMBRIDGE HISTORICAL COMMISSION

Ⓐ 1980 Ⓔ *Winthrop Park, this small swale of green less than one block square, actually predates Harvard, when Cambridge was called Newtowne. It was purportedly a local marketplace going back to 1631, making it three years older than Boston Common. After years of neglect, it would get a historical makeover in 1986 with new trees, a granite marker, and a restoration of the post and rail fence and diagonal paths from its 19th-century iteration.* {86, 186, 225}

"I would be roller skating out there," said owner Herbie Kuelzer of the street in front, "and then when it got a little busy and they needed help for hosting, they'd yell and I'd come in on my skates."

To come

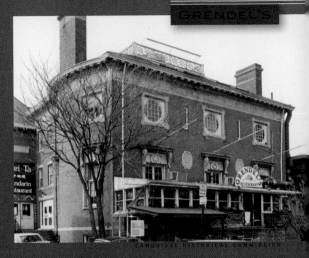

CAMBRIDGE HISTORICAL COMMISSION

to Grendel's—with its stately, high-ceilinged dining room, fireplaces, classical music, and a lamp at each table—felt like pampering yourself. Reading the menu put you at the intersection of hippie health food and international haute cuisine. And standing in the narrow hallways with the crowds waiting for tables on a weekend meant you were part of a scene. Amazingly, all of this was yours at very reasonable prices. Said Kari Kuelzer, current proprietor of Grendel's Den and daughter of founders Herbie and Sue Kuelzer, "It was casual gourmet."

People came in droves for the beautiful sixty-item salad bar. They came for the fondue. And they came for the Beggar's Banquet—inspired, oddly, by McDonald's. Mondays were slow at the restaurant, so Grendel's made your first menu selection 95 cents. The second and third items were each 85 cents. There was also an all-you-can-eat lunch buffet for two dollars. Tom Magliozzi of NPR's *Car Talk* recalled that in his indigent days in the 1970s he took advantage of the four-hour window to eat both breakfast and lunch. "After all, it was all-you-can-eat from 11 to 3, wasn't it?"

With detailed recipes and the indefatigable cook Aftar Singh to ensure consistency, Grendel's hit its multicultural stride. "I used to say we have Indian Middle East Greek Italian French American Mexican Swiss food," said Herbie. It was a runaway success. On a single Saturday, they served 900 patrons. It was popular with the staff as well. Sue said in 1991, without much irony, "No one gets a Saturday night shift unless an old waitress dies."

But Grendel's didn't just break ground in the restaurant business, it broke ground in constitutional law when the Kuelzers challenged a Massachusetts statute giving churches and schools veto power over the distribution of liquor licenses within 500 feet of their property. They decided to file suit when the Armenian Church located next door blocked the eatery from serving alcohol, although they had legally purchased a license.

Thus began a six-year-long odyssey, complete with appeals, unusual legalistic maneuvers, and alleged harassment by the health inspector that culminated with renowned Harvard Law professor Laurence Tribe arguing on Grendel's behalf in the U.S. Supreme Court. On December 13, 1982, the Court ruled by a vote of eight to one that the Massachusetts statute violated the Constitution. Chief Justice Warren Burger wrote, "The framers did not set up a system of government in which important, discretionary governmental powers would be delegated to or shared with religious institutions." The Kuelzers popped the champagne and received phone calls from around the country thanking them.

When the building was renovated and the adjacent areas redeveloped in 1999, Grendel's Restaurant had to relinquish the perch it held over Winthrop Square since 1971. But the basement bar, Grendel's Den, survives, and it still has easy charm, cheap eats, and especially at happy hour (where food is half price), folks in seats. Kari describes Grendel's successful philosophy well: "We always want to have the prices be so low that it's always populist. But not populist in the way that Budweiser is. We're populist for the rest of the populace."

It's rare enough to create a great community gathering spot that has lasted approximately 40 years. But how many can say, like the Kuelzers, that they changed the law in nine states? {86, 121, 186, 225}

153 **1980s**

COURTESY OF FRANCES CARDULLO

Ⓐ Crimson Travel
Ⓑ Whitney's
Ⓒ Leo's Place
Ⓓ Rix
Ⓔ Urban Outfitters
Ⓕ Temple Bar Books
Ⓖ Vision House
Ⓗ Charlesbank Trust/

Ⓗ US Trust
Ⓘ Hooper Ames
Ⓙ The Garage
Ⓚ Underground Camera
Ⓛ Minute Man Radio
 Jonathan Swifts/
 Catch a Rising Star
 Radio Shack

Ⓜ Pennsylvania Co.
Ⓝ Nat'l Stu. Travel Svc.
Ⓞ Pizzeria Uno
Ⓟ Discount Records
Ⓠ Glugeth Optometrist
Ⓡ The Wursthaus
 Koby-Antupit
Ⓢ The Tasty

jfk st.

c.1981 Ⓡ

Revelers take to the streets at one of the first Oktoberfests

Oktoberfest & Mayfair

For those

who like even more of a festival atmosphere than Harvard Square normally provides, twin traditions bookend the warmer half of the year: Mayfair and Oktoberfest. Fittingly, each was promoted by one of the Square's legendary personalities.

It was Frank Cardullo's Wursthaus restaurant that provided the initial inspiration for Oktoberfest, which began in 1979, modeled on the traditional German celebration. Beer flowed freely on a shut-down and shimmying Boylston Street, with an oom-pah band, sizzling bratwurst, and the occasional glimpse of lederhosen. Cardullo (above, left) also had a businessperson's eye on keeping people coming to the Square during the disruptive subway construction.

Sally Alcorn of the Harvard Square Business Association was the brains behind Mayfair. She worked closely with Sheldon Cohen, known as the "mayor of Harvard Square," to create a festival on Cambridge Common in 1984 that would rival Cardullo's autumn celebration. Mayfair was originally an opportunity to travel the world in miniature, with booths under striped tents representing different countries via music, costumes, and food. It soon migrated to the Square itself, where it remains to this day.

In 1986, Cambridge nixed the open containers, defanging Oktoberfest's entire raison d'être, and Mayfair's cultural exchange agenda fell by the wayside. Both festivals gradually transformed themselves into generic street fairs with largely the same crafts vendors and lemonade stands. On the plus side, they have both grown in size dramatically—expect 100,000 these days—and now include local bands on a series of stages.

Frances Cardullo had not completely given up on her dad's original inspiration, looking to the pedestrian makeover of Palmer Street. "My vision is that when that happens, is to use Palmer Street," she said a few years before her death, "and have a beer garden with brats for Oktoberfest and the oom-pah band. I think it'd be a lot of fun!" {209, 223}

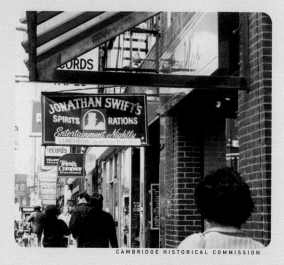

CAMBRIDGE HISTORICAL COMMISSION

◀ 1984 Ⓛ *Jonathan Swift's, during its twelve years of existence, developed into one of the top music clubs of the area, hosting a range of styles broad enough to include James Brown, Stan Getz, John Lincoln Wright, and The Turtles.* {119}

BOYLSTON STREET, after some

grumbling by local merchants over changing their stationery, was officially renamed John F. Kennedy Street in 1982. The tribute was intended to make up for Cambridge's bitter controversy over—and eventual rejection of—the Kennedy Library. {158, 234}

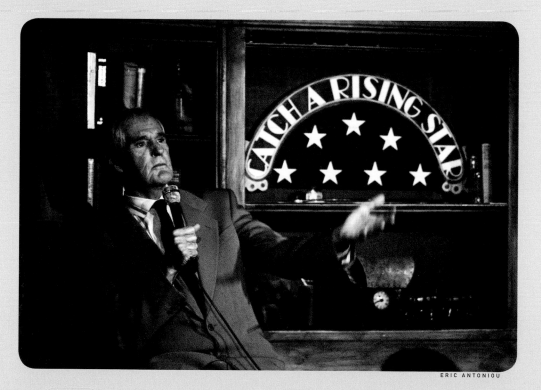

ERIC ANTONIOU

◀ 1989 Ⓛ *Where else but Harvard Square could you enjoy the surreality of Timothy Leary doing stand-up? Catch a Rising Star replaced Jonathan Swift's in 1987 with Jerry Seinfeld headlining, when Boston was a renowned comedy proving ground. It closed in the mid-'90s.* {52}

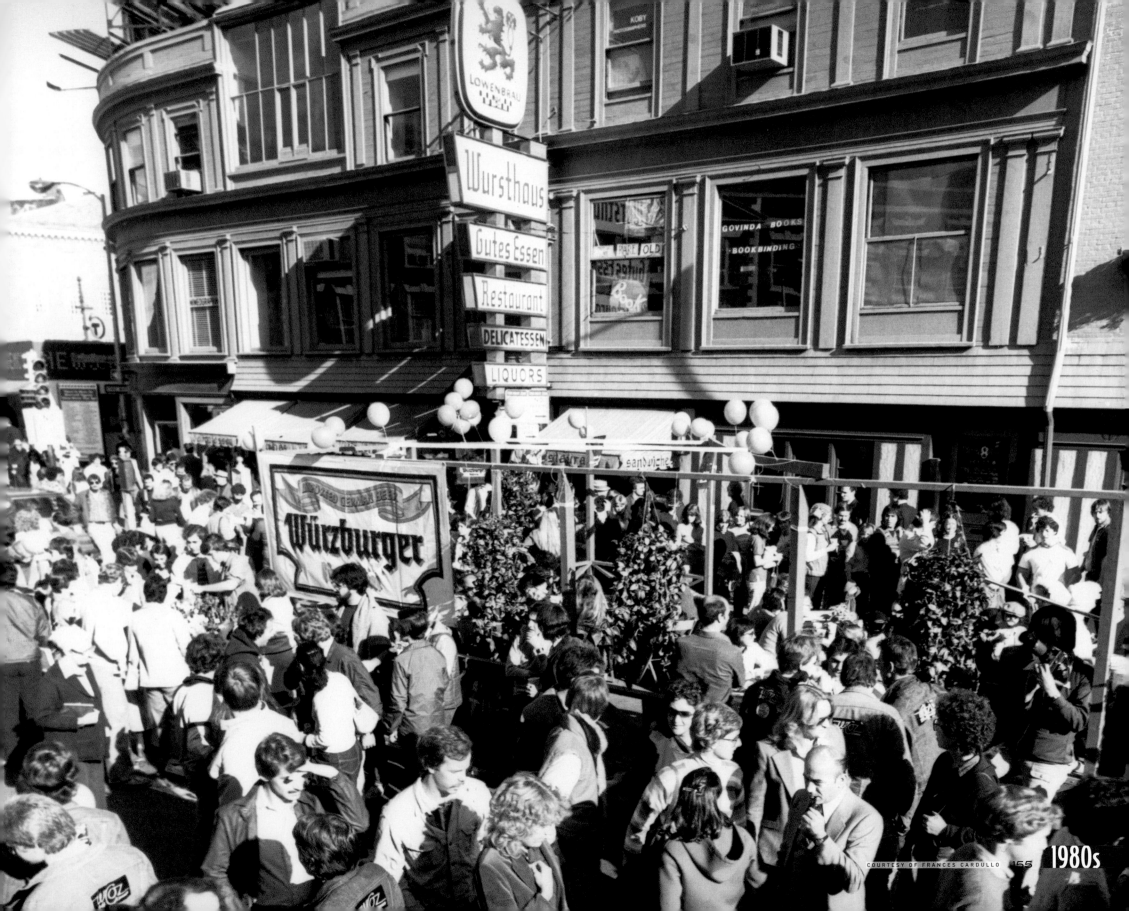

155 **1980s**

A Zwicker Bros. Gulf
B The Boathouse Bar
 For Eyes
 Shambhala Books
 Arkadia Restaurant
C Patisserie Française
 Delhi Int'l Boutique
 Alfred Hair Design

C Beggar's Banquet
 Le Bon Voyage
 The Harvard Shop
 The Tannery/Confetti
D Iruña
E Mykonos
 Paco's Tacos/Bangkok House

1980s **S** *Sodas and smokes were two food groups at The Tasty, Harvard Square's most beloved (and tiniest) eatery. {3, 43, 102, 188}*

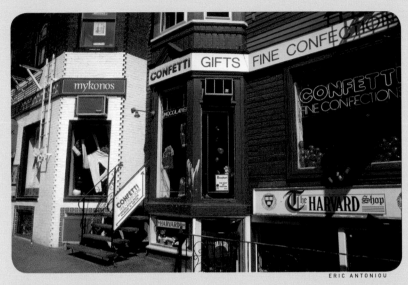

ERIC ANTONIOU

1987 **C** *Paul Corcoran of Corcoran's department store opened The Harvard Shop on a lark in 1983, selling exclusively Harvard insignia. It was often mobbed.*

1985 **B** *Shambhala Booksellers, specializing in spirituality, was one of a seemingly endless number of bookstores in the Square.*

1986 **B** *The Boathouse Bar draws a cast of characters. Henry Hamilton set a Guinness World Record for "indoor rowing" of 477 miles here the same year.*

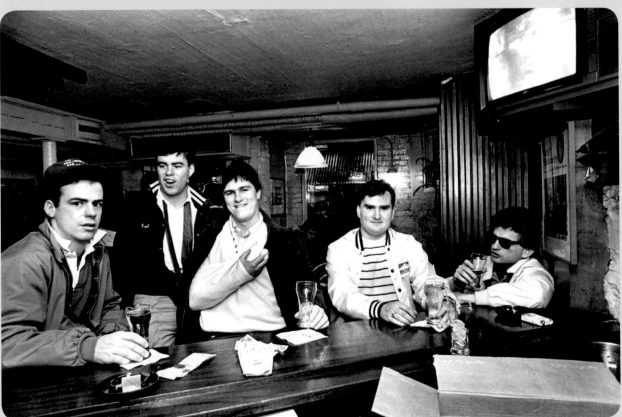

JOHN NORDELL

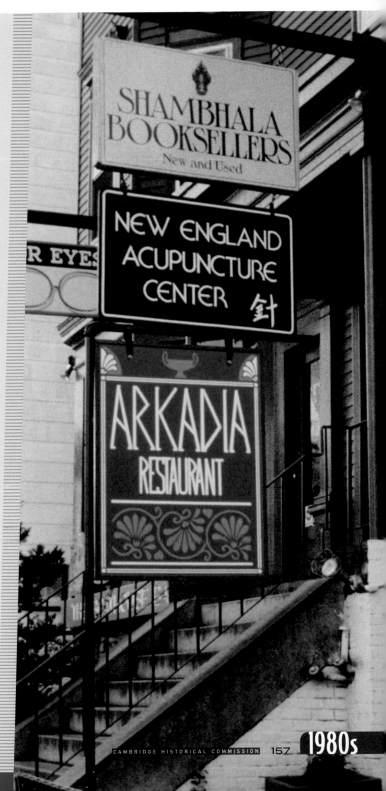

Ⓐ JFK Park

jfk st.

PETER SOUTHWICK

1987 Ⓐ *After a circuitous path filled with noble dreams, acrimony, delays, and healing, JFK Park is finally dedicated on what would have been the president's 70th birthday. His legacy still evoked tears from Senator Edward Kennedy, Governor Michael Dukakis, and Jackie Onassis 24 years after his death. The site, previously the MBTA rail yards, was intended for the Kennedy Library; it was ultimately rejected in 1975 after years of review and intense opposition. A memorial park was then proposed, which took more than a decade to bring to fruition.* {154, 234}

1989 Ⓐ *JFK Park is nice for relaxing on a sunny spring day.*

HARVARD ARCHIVES

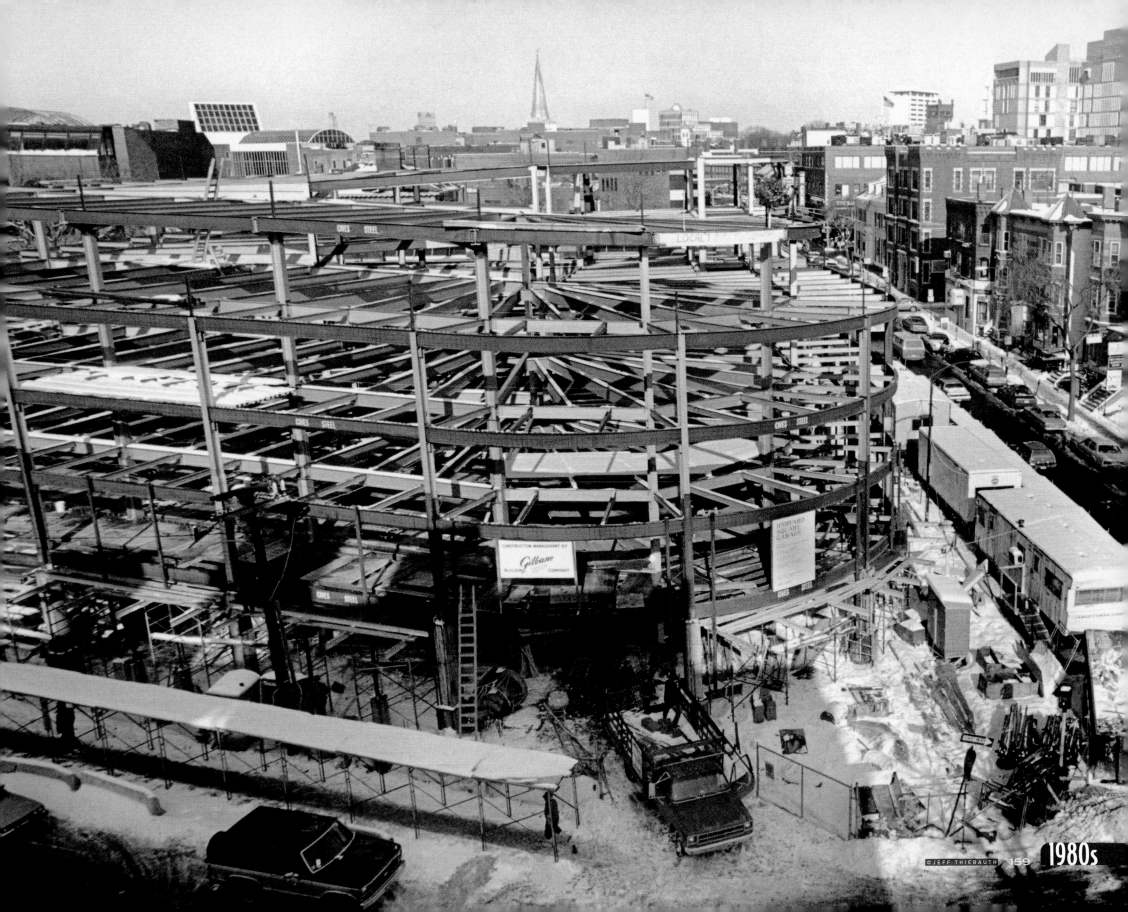

 1980s

Parcel 1b (Future site of The Charles Hotel)
Harvard/Brattle station
Harvard Motor House
Chicago Frank's
Charlie's Kitchen

Pier 1
Vintage
Needle in a Haystack
The Hungry Persian
A Wine For All Reasons
Roka

Ta Chien
Science Fantasy Bookstore
Diamond Comics
La Piñata
Goodwin's
Stereo Lab

Eliot, bennett, & mt. auburn sts.

CHERYL A. MILLER

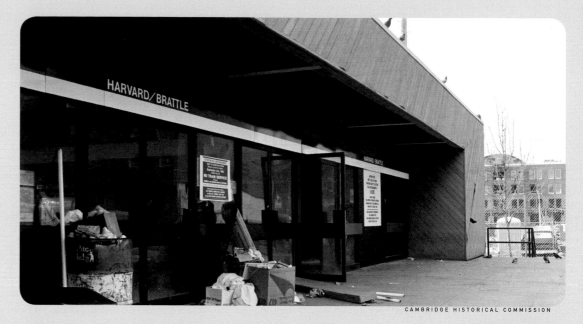

CAMBRIDGE HISTORICAL COMMISSION

⬆ **1983** Ⓑ *The Harvard/Brattle station reaches the end of the line, after 4 ¹/₂ years of service. The Church Street and Johnson Gate entrances to the brand-new subway station opened in September, making this temporary stop obsolete.* {127, 136}

⬅ **1988** Ⓖ *An unintentional makeover happened when 16–18 Eliot Street went up in flames. The electrical fire caused $750,000 worth of damage and spread to 98 Winthrop Street. The building was demolished in 1990.* {126}

⬇ **1987** Ⓘ Ⓙ *In yet another face-lift for the Square, 119–123 Mt. Auburn is razed for a modern stone structure. Some favorite bars and restaurants were lost in the process, including The Blue Parrot, The Ha'Penny Pub, Vincent's, and Picadilly Filly, replaced by Kinko's and the short-lived Barillari Books.* {*229, 194}

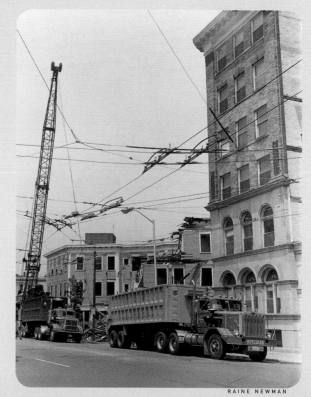

RAINE NEWMAN

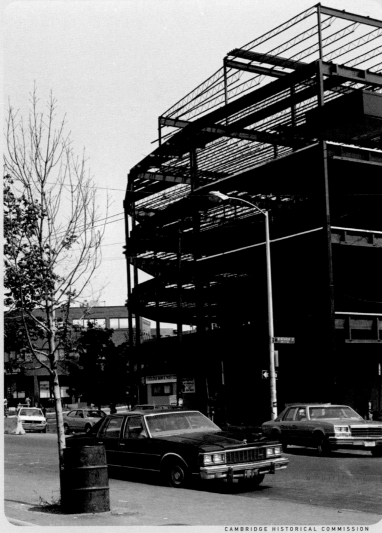

CAMBRIDGE HISTORICAL COMMISSION

◀ 1983 *Another new building rises, adding 40,000 square feet of office and retail space on five floors. The curved building at the corners of Mt. Auburn, Eliot, and Winthrop replaced the runty Coolidge Bank building, previously a service station.*

◀ 1985 ◭ *The brand-new Charles Hotel cuts a geometric figure at the southern end of the Square. This project, more than any other, added an upscale flavor to the previously grubby Square, with expensive rooms, condos with river views, fine dining, a spa, and a jazz club.* {192}

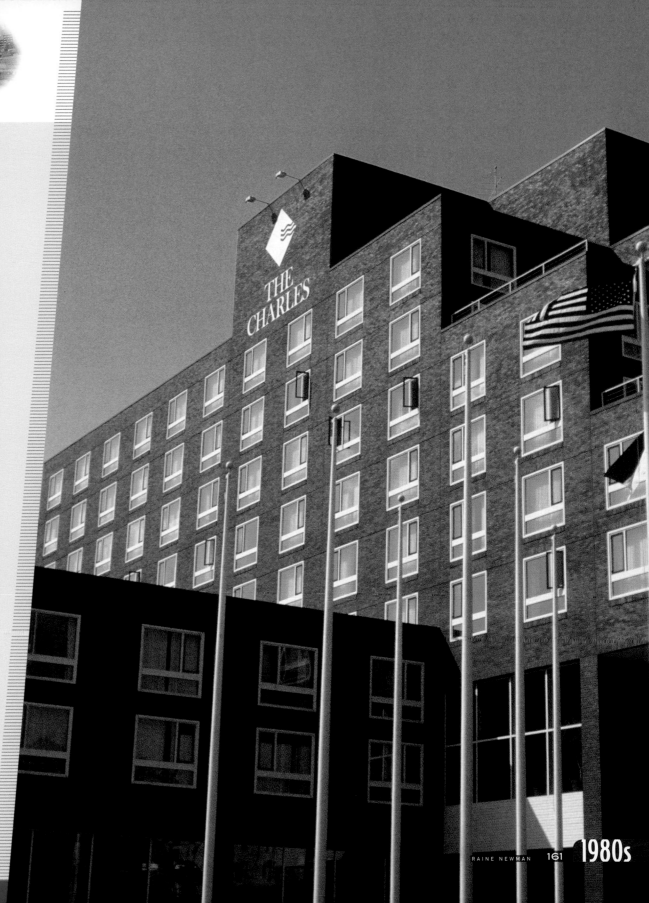

AMANDA PALMER

THERE WAS

Lexington, where I grew up, which was safe and suburban and which I, naturally, hated with a vengeance. And one long bus ride and four subway stops away there was Harvard Square, where my best friend, Holly, and I would head every Saturday during those angsty and delicious midteen years. Emerging from the Harvard Square T station into the Pit, that smell would wash over and intoxicate me… the sounds of traffic and vinyl and life would hit us with chaotic force and we would feel all velveteen-rabbity. Real. Lexington would never understand us. Here we were with Our People: the pierced, the tattooed, the mumbling, the musical. I had a personal circuit of used-record stores (I think it went Second Comings, then Mystery Train, then Looney Tunes, then In Your Ear, then Planet) where I would trowel through piles of bootleg tapes and records looking for… anything interesting really. I bought based on cover art back then. We would buy used dresses from the '50s to cut up into skirts, incense and earrings to put in the many holes we also collected in the Garage (I think the order went ear piercing, incense buying, pizza at Café Avventura). I admired the punks in the Pit from a distance before I finally joined them in the summer of 1992. That was the summer that I dated Ben, who had beautiful long blue hair and called himself Stu. And Ira, who had a pink mohawk and the most beautiful smile and tattered checkered coat. I reclused into the back corners of Café Pamplona, reading alone, feeling like this little basement was the womb to which I must return for solace even if it meant a two-hour drive from college in Connecticut, books under arm, clove cigarettes waiting to be lit in endless succession while the Harvard boy from the philosophy department sat two tables away in his broken shoes, dirty shirt, and volume of Heidegger resting on the marble table, making me fall in love with him.
I did, I did, I did…

COURTESY OF AMANDA PALMER

1990s *The Pit, the sunken brick plaza next to the subway station, became home to a community of punks and wanderers.* {173}

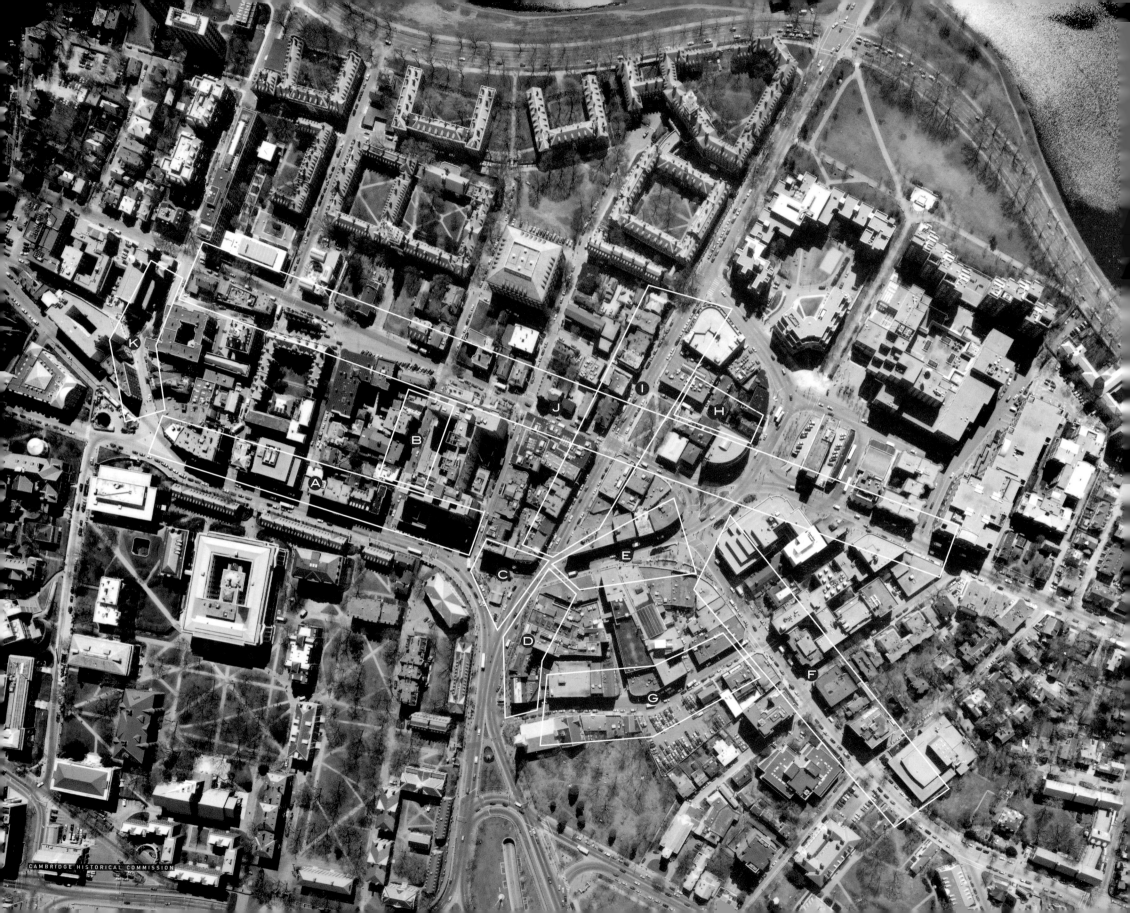

CAMBRIDGE HISTORICAL COMMISSION

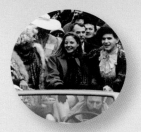

Ⓐ Lower Mass. Ave.

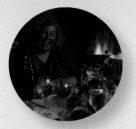

Ⓑ Holyoke St.

Ⓒ The Center

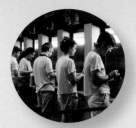

Ⓓ Upper Mass. Ave.

Ⓔ Lower Brattle St.

Ⓕ Upper Brattle St.

"HARVARD SQUARE,

once a bastion of alternativism, quaint shops and inexpensive restaurants, is now being gentrified," said the *Crimson* in 1995. Though not the first such observation, during the '90s the sentiment gathered the weight of quantifiable evidence. The place was hardly dead. But as the decade matured, a number of trends, many having nothing to do with the Square, conspired to create a slow-motion snowballing of change.

In 1994, by statewide referendum, rent control was abolished in Massachusetts, shivering through the Cambridge real estate market. Commercial rents in Harvard Square, always high, were hitting the $100-per-square-foot threshold. The Internet began transforming commerce everywhere. Harvard Square, filled with used books and CDs, was especially vulnerable to this new modality.

The University opened Loker Commons in 1995, an on-campus pod of convenience eateries. Roundly criticized since, it nonetheless signaled a trend: Harvard, and colleges in general, were beginning to look inward for student services. Resident Andrew Hermann reflected at the time, "The sad thing is that it's not really a college town anymore."

Whether from these external pressures, bankruptcy, or merely retirements, a series of high-profile store closures seemed to herald the end of an era. Iconic eighty-year-old restaurant neighbors The Tasty and the Wursthaus both expired within a year of each other. Elsie's doled out its last roast beef special, The Patisserie Française its parting croissant, and The Bicycle Exchange its terminal tire. Grendel's Restaurant fell victim to redevelopment. Sheldon Cohen sold Out of Town News to Hudson. Even the venerable Coop, listing in choppy financial straits, abandoned its quirky general store and remanded its book business to Barnes & Noble.

At the same time, an unprecedented deployment of regional and national chains gained purchase: Tower Records, HMV, Express/Structure, TCBY, The Body Shop, Abercrombie & Fitch, Sunglass Hut, Souper Salad, Starbucks, and Dunkin' Donuts, among others.

There were other losses. Bookstores, with decades-old patinas of dust and academic fingerprints, began their inexorable decline as Pangloss, The Book Case, Booksmith, and Reading International expired. Finally, the Steve Prefontaine biopic *Without Limits* closed out the Janus Theatre's quiet 22-year run in the basement of the Galeria.

However, like the theatre's namesake, there were two faces to the Harvard Square of the '90s. Bookstores closed, yet there were still far more than any other neighborhood could hope for. Favorites folded, but many more remained. Chains could drain character, yet some, like HMV, brought huge crowds that patronized other shops and added street life. Remodeling projects like the gutting of the Brattle Theatre complex iced familiar haunts, yet allowed beautiful, new iterations of Algiers and Casablanca to emerge.

The strengths of the Square—the street performances, the punks, international crowds, people watching, theatre, music, cinema, food, poetry, discourse—never went away. For those who knew no nostalgia, the '90s in Harvard Square were stimulating, effervescent, and intoxicating. For the young, the Square still represented freedom and opportunity, the thrill of discovery and the comfort of connection. Coming back to it always felt like home.

Ⓖ Church St.

Ⓗ Winthrop St.

Ⓘ JFK St.

Ⓙ Mt. Auburn St.

Ⓚ Bow St.

THE 1990s

FLINT BORN

lower mass. ave.

Ⓐ The Inn at Harvard
Ⓑ The Hong Kong
Ⓒ Bartley's Burger Cottage
Ⓓ Harvard Book Store

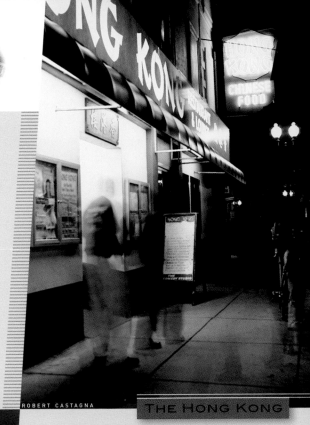

🔼 **1993** Ⓐ *Harvard bought the former Gulf station, razed it, and built The Inn at Harvard, an upscale hotel that opened in 1991. {132}*

🔼 **1997** Ⓓ *Harvard Book Store, with its late hours, is an inviting nighttime diversion. {92, 202}*

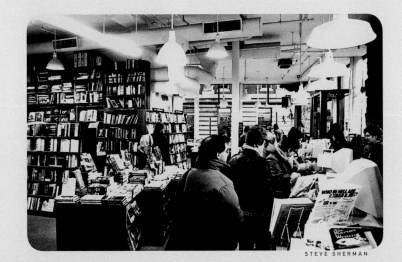

STEVE SHERMAN

🔼 **1999** Ⓑ *The neon lights offer an evening of fun, food, and potential debauchery at the Hong Kong.*

ROBERT CASTAGNA

THE HONG KONG

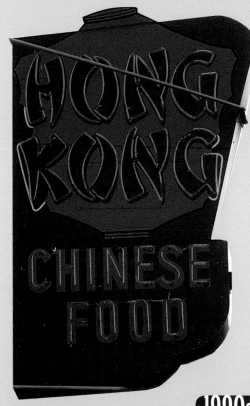

Three

friends are going out on a Saturday night. One likes Chinese food. One wants to go to a comedy club. One is looking to get wasted, possibly pick a fight, and stay out until 2 a.m. Thankfully, they can all go to the same place, that Harvard Square original, the Hong Kong.

Chinese immigrants Sen Lee and his wife, Buoy, began their nightspot humbly in 1954 as a basic Americanized Chinese eatery on half of the first floor of 1236 Mass. Ave. Their business partners soon offered to buy them out, but Buoy thought the Lees could do better. At her insistence, they raised money, took over the business and, by 1970, the building. A liquor license quickly followed, cementing the Kong's destiny as a temple to exotic tippling.

It was a time when 18-year-olds could drink, when happy hours were legal, and bar brawls often spilled into the street. The second floor, originally an overflow dining room, eventually got the bar and a small dance floor, which created the scene for which the Kong is known.

The pink-painted palace became one-stop shopping for grease, gropes, and booze, located conveniently close to a dorm near you.

Two floors could not quite contain the fun to be had at the Hong Kong, so the third was opened to dancing in 1993. Breaking out salsa moves amid pagoda lamps and dragon motifs was a cognitive dissonance to be savored in that uniquely Harvard Square way.

Soon thereafter, an equally unlikely, and far more successful, tradition took hold—stand-up. The Comedy Project laid the groundwork, but it was the successor, the Comedy Studio—founded, booked, and run by comics—that would prove to be the winning recipe.

Opened in 1996, the Comedy Studio has installed itself as one of the most important training grounds for the Boston, and sometimes national, comedy scene. Far more casual, intimate, and sophisticated than a typical room, the Studio has been used as a place to workshop material or attempt other styles of comedy that wouldn't go over in the regular clubs. Consequently it is scouted by networks looking for fresh talent like Eugene Mirman and Dwayne

Perkins. It's also returned to by veterans such as Jimmy Tingle looking to sharpen acts. Rick Jenkins, who founded the place with Thom Brown and Jim DeCroteau, still emcees shows, now six nights a week up from the original one. The comedy club is also, as he is fond of reminding you, inside a Chinese restaurant.

Sen Lee passed away in 1994 and a marker was dedicated in his honor across the street from the restaurant. However, the Hong Kong, now under his son Paul's management, is as alive as ever. The once-fuschia exterior has long been a sensible beige. Recently renovated, the downstairs dining room and bar now look positively classy, a far cry from the dim, peeling-paint version of yore. It is of a piece with the new Harvard Square, and if anything, confirms the Lees' business savvy; you have to adapt to the times. However, this hardly means that the Scorpion Bowl-fueled inanity of the second floor or the off-kilter comedy on the third has abated. The Kong has long proven that it can accommodate many tastes. {92, 200}

🔵 **1999** The sight of a worker on a pay phone would become rarer in coming years.

🔵 **1991** Ⓐ Christos Soillis pauses for a photo in his throwback shoe repair workshop beneath Ferranti-Dege. His shop retained the name Felix from the long-standing Mass. Ave. newsstand/ shoeshine where he cobbled since 1963. In 2008 he would move Felix back into its original location after 38 years in exile. {15}

🔵 **1991** Ⓙ The main floor at Leavitt & Peirce looks much as it always has.

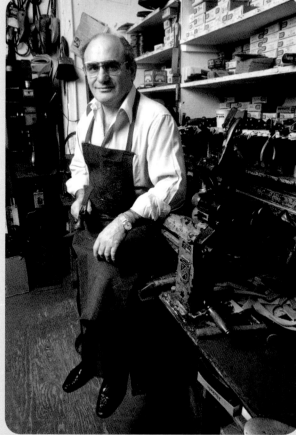

MARK MORELLI

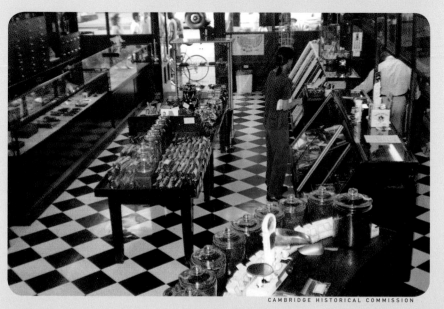

CAMBRIDGE HISTORICAL COMMISSION

lower mass. ave.

- **A** Felix
- **B** Briggs & Briggs
- **C** One Potato Two Potato/ Grafton Street
- **D** Stonestreets
- **E** Bob Slate, Stationer
- **F** Ferranti-Dege
- **G** Gnomon Copy
- **H** Ultimate Bagel/ Toscaninni's
- **I** Serendipity
- **J** Leavitt & Peirce
- **K** J. August
- **L** Yenching

LEAVITT & PEIRCE

🕐 c.1990s **J** *Paul Macdonald Jr. sits in the balcony chess lounge he created.*

LEAVITT & PEIRCE

> **The** Arturo Fuente Opus X, arriving only thrice per year at $20 each, is so coveted that one customer dons a disguise to circumvent the two-cigar-per-day limit.

Paul Macdonald

Jr. doesn't use a computer. "I write my figures in a leather-bound ledger book," he said. Owning Leavitt & Peirce, the tobacco shop that spiritually remains squarely in the 19th century, is probably the perfect job for him. "I'm not really a modern man," he admitted, "I like the old way."

It doesn't get much older, in Harvard Square terms, than this emporium of hand-rolled cigars and sweet-smelling pipe tobacco with names such as whiskey cavendish and twainberry. If smoking, generally, is at a low ebb of popularity, then this shop trades in on something even scarcer and more valuable: longevity and authenticity. It would be the oldest business here in its original location, except that it predates the 1885 building that houses it by two years.

Like a good tobacco leaf, the store has been aged, toasted, and cured, with an intoxicating aroma leaching permanently from the time-tanned wainscoting. The sensual pleasures that invite the browser are enough to charm even the most hardened antismoker. They go well beyond pipe paraphernalia to include shaving soaps and bristle brushes, triple-weighted chess pieces, cuff links, card cases, and hip flasks.

From the earliest, the burly Frederick Leavitt and diminutive Wallace Peirce insinuated their haven into Harvardalia, bearing them both on intertwined wisps of history. With no freshmen nor women admitted, the men's club atmosphere was further secured by an 82-foot-long pool room with maple flooring, cushioned seats, wire-strung scoring lozenges, and seven ornately carved oak tables with green woven pocket baskets.

It was a time when cigarettes had names like Sweet Caps, Richmond Straight Cut, or Pharaoh's Daughter. Algerian briar pipes were de rigueur for the academic set, often filled with a personalized mixture of tobacco brands. Leftover scraps were put in an open cake tin on the counter as a complimentary indulgence for loyal customers. It was thus that the enduring tradition of Cake Box Mixture was created. This particular blend became the shop's signature, eventually growing a following and shipped all over the world. The formula modified since, it nonetheless still exists today.

The store also became an institutional clearinghouse for university-related information, a sort of flesh-and-fountain-pen Craigslist of its day. This made it indispensable for purchasing tickets for events, arranging steamship or train travel, or leaving leads in the *Harvard Crimson* drop box. Meanwhile, the plate glass windows brimmed with winning trophy cups, sports scores, and crew practice-time notices—the latter only discontinued in 2000. There was even a lost and found where one could reclaim such things as a fox terrier, as was once posted in 1890.

Eventually the original tobacconists passed in 1919, and Frank Knapp and Fred Moore took over the tradition. The collection of sports memorabilia continued through the '20s or '30s. At some point, the pool tables were moved upstairs and a lunch counter was installed, where you might sit next to Henri Matisse's grandson on a crimson stool and slurp beef stew or a ten-cent hot chocolate.

That counter is long vanished, as is the upstairs pool room. Instead,

Paul transformed the walkway to the second floor into a cozy chess parlor, which doubled as a smoking lounge. That was one of very few changes effected since Paul Macdonald Sr. took ownership in 1973 after a seventeen-year run by the David P. Ehrlich Company. A steady hand has been the steward of the Leavitt legacy. Paul Jr., who has been running the store for over twenty years now is clear about his mission. "This is my life."

Today, a buxom maiden bearing a fistful of cigars still juts from the façade like a ship's prow. She shares the totemic continuity with an 1860s wooden Indian and a portrait of Wallace Peirce. "He's always got this glare, no matter where I am, he's looking at me," said Macdonald. It's hard to conjecture what the cofounder might find more surprising—that his creation still exists, or that it is now illegal to smoke there.

There have been other adjustments over the years. Sports scores are no longer posted in the window. Women are welcome. But University final clubs still have their own private humidors in the back. The tin ceiling, wooden paneling, glass cases, and pantheon of team photos would all be recognizable to a time-traveling Harvard student. Or even a real one, such as a 102-year-old Hamilton Fish III, who visited in 1990 and was belatedly asked to sign his winning 1908 football.

And, of course, tobacco, in all its forms, is still celebrated. For Macdonald—who hates cigarettes—smoking should not be a mindless addiction, but a sensual ritual, to be savored like wine. "It's about slowing down." That sums up the Leavitt & Peirce philosophy. As John Bradley, class of 1921, wrote years later, "At least one tiny island on a fluxing planet has remained the way one likes to remember it." {14, 54, 95, 202}

How a

A The Hasty Pudding
B Cambridge Trust
C Holyoke Center
Campo de' Fiori
Selletto
D Au Bon Pain

lower mass. ave.

small, secret men's club grew into a cross-dressing, touring theatrical group with over-the-top productions and an annual pair of world-renowned parades is a pudding-rich tale indeed. But this narrative has nothing hasty about it; rather it has been slow-cooked in the mustiest Harvard tradition.

The origins of the group go all the way back to 1795, when a score of juniors assembled in the dormitory of one Nymphas Hatch. The social club, Harvard's first, was meant to help establish lasting friendships. As the tradition carried on, the boisterous crew began to stage mock trials, a sort of geek humor for the well-bred. To fuel these shenanigans, each member had a rotating duty to provide what was basically the 18th-century version of nachos—a pot of hasty pudding. If cornmeal mush doesn't sound particularly appetizing, bear in mind there weren't any all-night diners at the time.

The trials became more elaborate and eventually scripted until, in 1844, a brazen soul decided to stage an opera. Hasty Pudding Theatricals has put on a show, save for the World Wars, ever since. Originally adaptations of existing works, by the late 1800s the members were writing their own big-budget musical comedies, even taking them on the road. Current versions bear names like *Acropolis Now* and *The Jewel of Denial*.

Being an all-men's club, naturally the parts of women were played by men in drag, setting the tone squarely at low-brow burlesque. One might therefore assume that this was a fringe organization, but no, members have included William Randolph Hearst, Charles Sumner, Oliver Wendell Holmes, and Teddy Roosevelt. (Women are now admitted to the social club but do not perform.)

The Woman of the Year plaudits, which have brought the club wider fame, are of much more recent vintage—1951, to be exact. Like the mock trials, they started in jest, but quickly grew into a spectacle now anticipated gleefully and covered by the national and international press. The list of award winners would not differ tremendously from an Oscar roll call, with a few singers and comedians thrown in for good measure. Past Women of the Year include Katharine Hepburn, Shirley MacLaine, Lauren Bacall, Julie Andrews, and Glenn Close. Often, however, the pudding pot goes to someone recognized more for her "feminine qualities" (translation: hotness), e.g., Catherine Zeta-Jones or Scarlett Johansson.

The Man of the Year award was chartered in 1967. Bob Hope, Dustin Hoffman, Warren Beatty, Robert DeNiro, Clint Eastwood, and Harrison Ford have all captured honors. For both awards, the winners are chaperoned through the Square in a convertible through throngs of admirers, and then taken back to the theatre for a roast, the awarding of the ceremonial brass pudding pot, and to watch that year's show.

The tenor of the award and roast has changed—matured would be the wrong word—over time. Carroll Baker, the Woman of the Year for 1957, declined to buss the club's president, saying "Let's not make it too corny." The 2006 winner Halle Berry, by contrast, grabbed senior Samuel Gale Rosen's crotch and tongue-kissed him onstage.

The appeal of the pudding pot is hard to quantify. For the stars, it's a bit of the Harvard gold dust that is hard to resist—an affirmation that comes from outside the superficial Hollywood echo chamber. For the club, it's a major publicity stunt and a thrill for the undergrads. But mostly, it's just a hell of a lot of fun, and the parades through Harvard Square each February, replete with cross-dressing club members, brass bands, and barnyard animals, is the very definition of irreverence. Carol Channing put it best after the roast at her expense in 1971, "I'm sure my status in the legitimate theatre is now secure." {19, 57, 206}

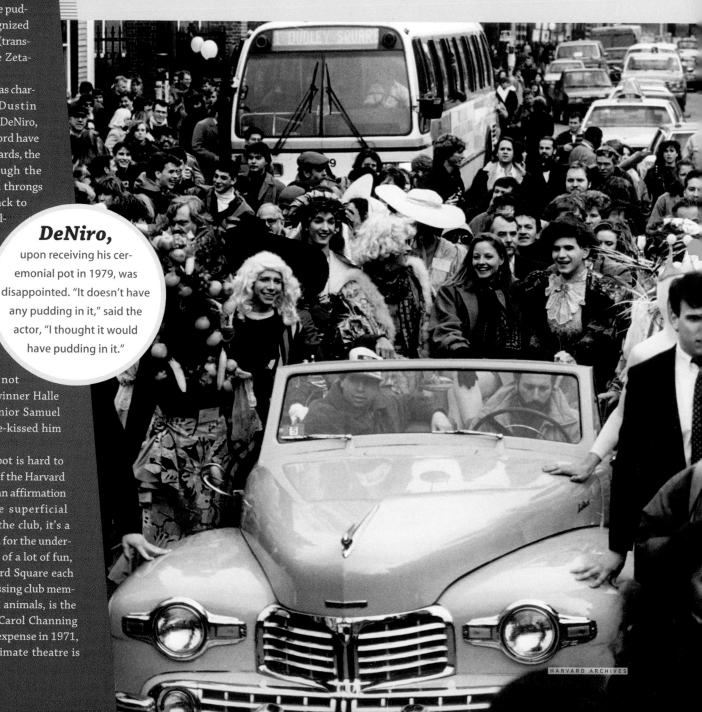

1992 *Jodie Foster enjoys her Woman of the Year parade.*

DeNiro, upon receiving his ceremonial pot in 1979, was disappointed. "It doesn't have any pudding in it," said the actor, "I thought it would have pudding in it."

HARVARD ARCHIVES

1999 *Amanda Palmer brings her famous bride statue to life in front of Holyoke Center.* {145, 162, 173}

1992 *Mary-Catherine Deibel (left) and Deborah Hughes show off their restaurant, Upstairs at the Pudding (around the corner on Holyoke Street). The eatery was high in status and altitude, featuring a roof-deck above the Hasty Pudding Theatre. The alligator was purportedly hunted by Teddy Roosevelt.*

DAVID LIU, DAYLIGHTPIX

1990s

PAUL DRAKE

Ⓐ Photo Hour
Ⓑ The Wursthaus
Ⓒ Bank of Boston
Ⓓ Cambridge Savings Bank
Ⓔ The Pit
Ⓕ Out of Town News

🔼 1995 Ⓔ *Pit denizens, like Conan, were largely left to their own devices.*

Corrigan 1994

BARBARA CORRIGAN

◀ 1994 Ⓔ *This genteel, idealized Pit was often in contrast with reality. Nonetheless, both versions held some truth.*

◀ 1993 Ⓔ *Phone towers make an interesting pattern at the Pit's edge.*

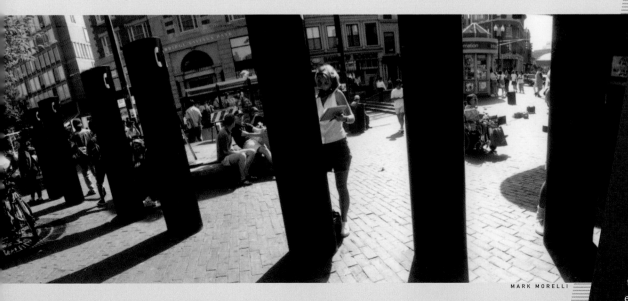

MARK MORELLI

PAUL DRAKE

THE PIT

A by-product

of the subway extension was the creation of the triangular recessed brick plaza in the center of Harvard Square known both affectionately and derisively as the Pit. In a consequence unforeseen by civil engineers, this urban grotto became an alluringly seamy gathering spot for disenfranchised, misunderstood, frustrated, or rebellious youth. Whether homeless punks, suburban refugees, or abused runaways, they were drawn to the misfit community that coalesced under the night light of the Cambridge Savings Bank clock, and the promise of acceptance that only Harvard Square could offer.

You have to go back to the '60s to set this table. The churning social mores of that explosive era initially drew the hangers-on and hangers-out to a colorful and intellectually curious Square for free exchanges of music, conversation, spirituality, and drugs. The first major gathering spot for such activity had been Forbes Plaza, fronting Holyoke Center.

As children's songs persist unaltered through generations, so too has the Square's reputation as a refuge for all comers. As an outdoor café replaced the original nesting ground, the new Pit seemed tailor-made for life's wanderers and nonconformists. Superficially, they seemed nearly the opposite of their hippie antecedents; in reality the two groups probably had more in common than either would admit.

Singer-songwriter Amanda Palmer remembered the appeal that the place offered. "The punks in the Pit were my idols. I actually joined them for a summer, that caused some brain damage, but it was worth it. At age 15, I felt like my existence was validated and that I was now a card-carrying member of the Cool People."

Some combination of piercings, tattoos, dishevelment, and copious nicotine use was generally enough for entry; especially during the '80s and '90s heyday, the aggregate effect could be intimidating. But the Pit rats, as they were sometimes called, rarely bothered anyone and were more often friendly than not.

The Pit was intended as an amphitheatre for spontaneous street performances. It certainly has seen many of those, including break dancers, jazz combos, a popular Beatles cover band, and countless political demonstrations. But its longest-running engagement was as home for a generation of Day-Glo seekers.

Pit kids are a rare breed these days. Edginess is way down in today's Harvard Square, piercings are mainstream, and punks are long in decline generally. Some folks are no doubt happy that the Pit has been, more or less, scrubbed clean. But to others, even those with conformist haircuts and a distinct lack of studded leather, the place looks wistfully empty. {138}

1990s

the center

◀ 1999 Ⓕ *Out of Town News is still ground zero in the Square, though the stand was sold to Hudson News in 1994.* {2, 60, 102, 139, 208}

◣ c.1991 ⒶⒷⒸ *The Read Block looks much as it has for generations; a few years later it would be gutted (bottom photo), the businesses evicted, and the billboard permanently removed.* {189, 191, 235}

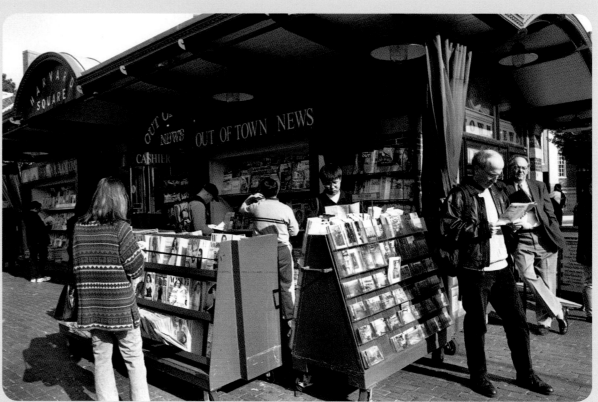

ERIC ANTONIOU

▲ 1999 Ⓔ *A performer demonstrates the Rajasthani folk art of Bhavai, balancing brass pitchers on her head while dancing.*

◣ c.1998 ⒶⒷⒸ *A sheath covers the Read Block as it is gutted. The curved wooden façade was saved and restored, but not without a preservation battle with Cambridge Savings Bank.*

CAMBRIDGE HISTORICAL COMMISSION/TURNER CONSTRUCTION

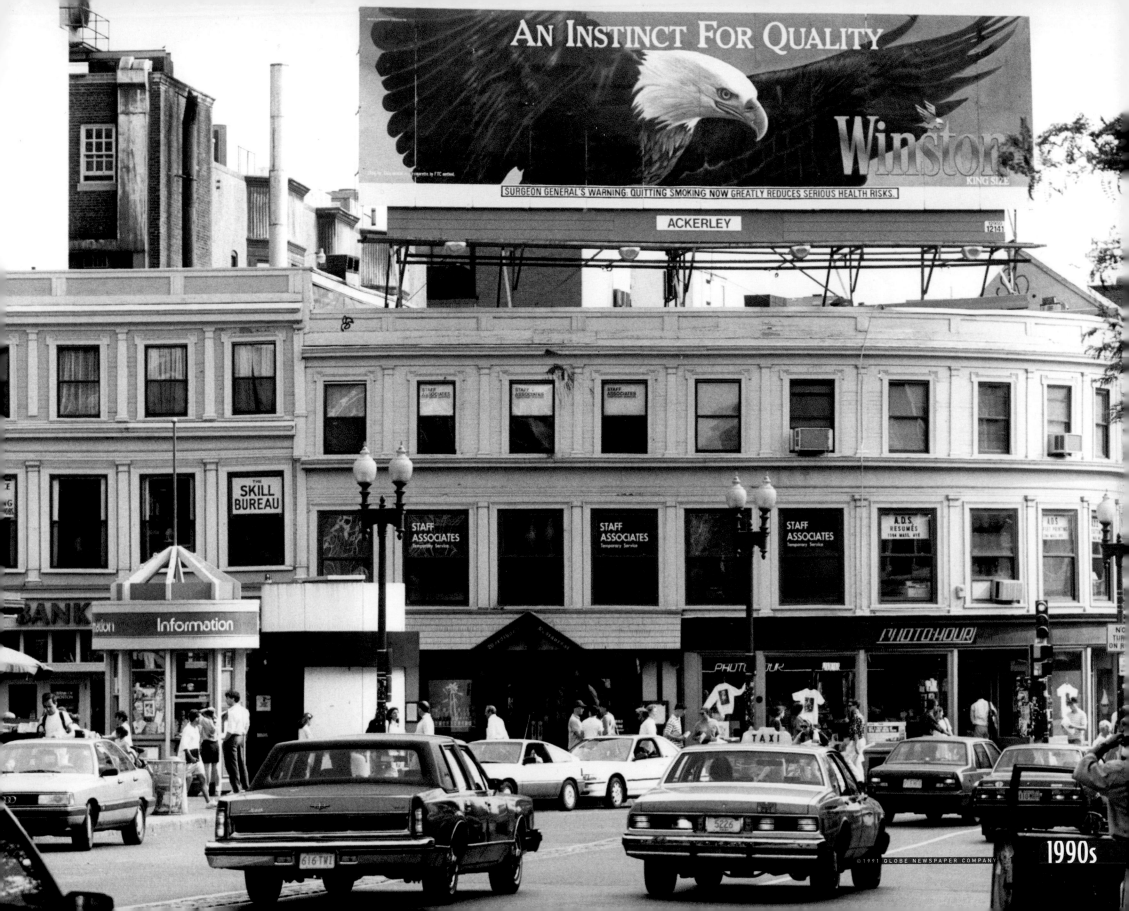

AN INSTINCT FOR QUALITY

Winston
KING SIZE

SURGEON GENERAL'S WARNING: QUITTING SMOKING NOW GREATLY REDUCES SERIOUS HEALTH RISKS.

ACKERLEY

THE SKILL BUREAU

Information

STAFF ASSOCIATES
Temporary Service

STAFF ASSOCIATES
Temporary Service

STAFF ASSOCIATES
Temporary Service

A.D.S. RESUMÉS

BANK

PHOTO·HOUR

TAXI

1990s

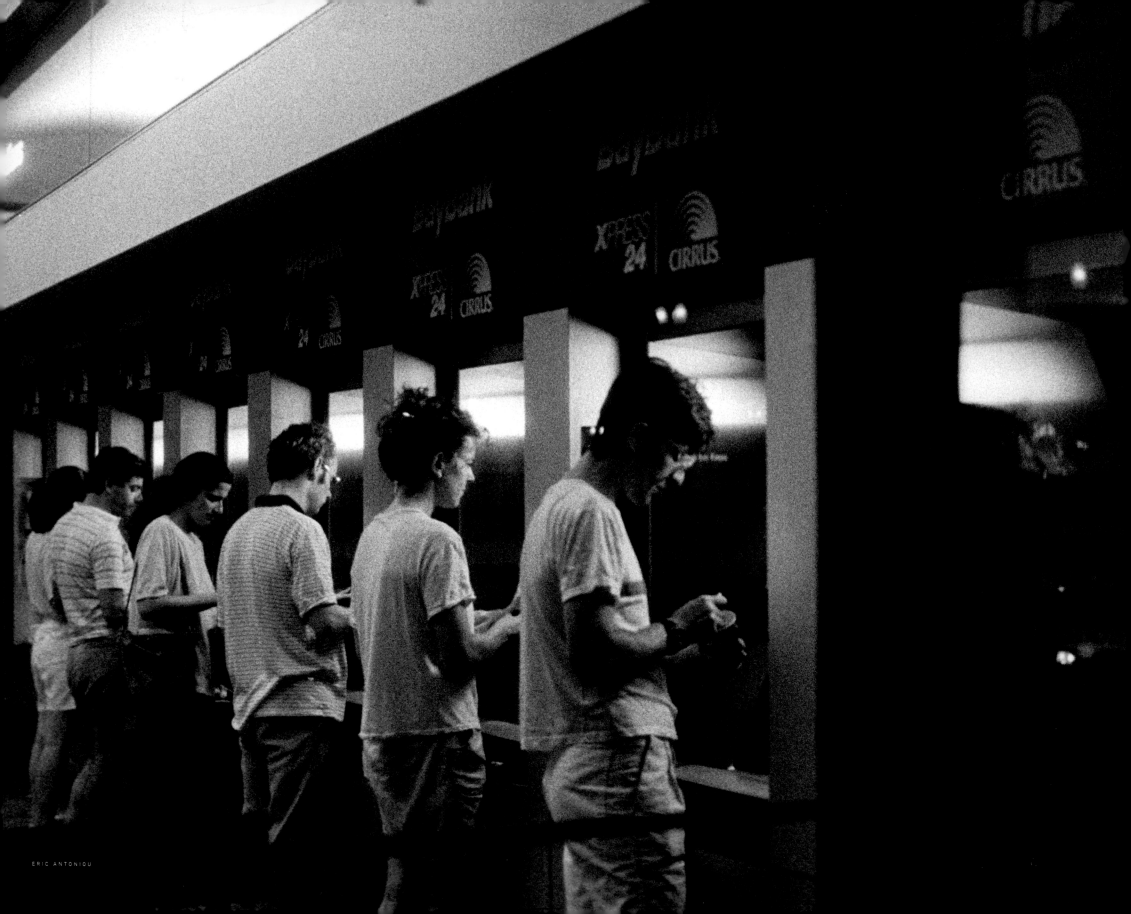

upper mass. ave.

A The Coop
B BayBank/BankBoston
C CVS
D C'est Bon
E Mass Army Navy
F Store 24
G The Body Shop

c.1990s B Banks began to have an increasingly large presence in the Square. This ATM lobby, and the enormous BayBank branch it was attached to, were nearly always crowded.

BOOKSTORES

and Harvard Square have long been synonymous, with innumerable stacks spread out through dusty basements, grimy alleys, cluttered attics, and shiny storefronts. In the early '90s, before the Internet and economics changed the equation, the Square offered pretty much any type of reading material imaginable, with entire stores—most independent—dedicated to science fiction, spirituality, communism, children's, travel, comics, and architecture. Also on the list were the oldest all-poetry (the Grolier), foreign (Schoenhof's), and college cooperative bookstores in the nation. With a peak of approximately 25 shops, used and new, highbrow and low, the unprovable yet irresistible mantra was that there were more bookstores per capita in Harvard Square than anywhere else in the world.

STEVE SHERMAN

1990 F Dan DeLellis manages the Coop, the largest of the Square's many bookstores.
{24, 36, 66, 67, 104, 118, 152, 210}

1990 F Mary Lou Lord strums away on a slow evening for busking. She was one of the most visible and consistent of street singers in the Square. {145}

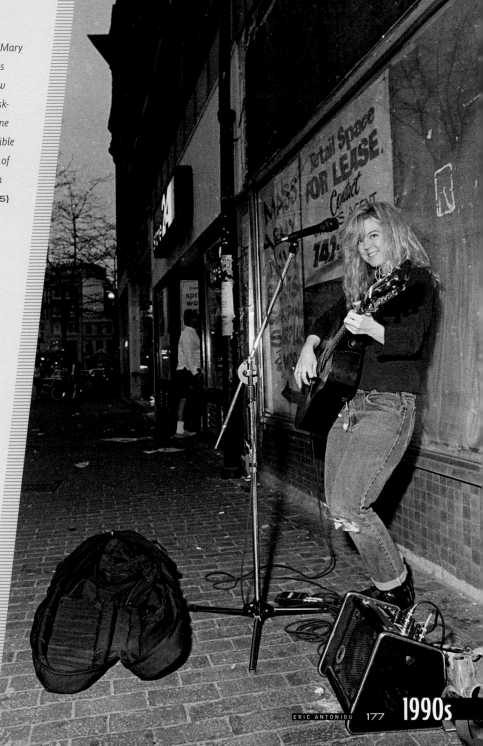

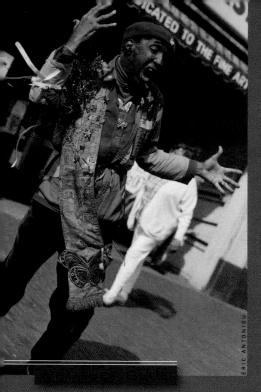

ERIC ANTONIOU

"Look

at that little sparrow! You know I like sparrows?" said storyteller Brother Blue on a beautiful summer afternoon. "They're strong little birds. The pigeons are like bullies, man." For most of his life, Brother Blue has been sticking up for the sparrows.

Deeply shaped by his early struggles with poverty, racism, and caring for his mentally challenged brother, who would die very young, Brother Blue carries an intensely spiritual mission in his heart to every interaction with the world around him. To spend any time with him is to glimpse a world where there are no coincidences, where how you choose to be impacts those around you viscerally and immediately. He remains in thrall to the beauty of the mundane, in love with people, and ready to reveal all passersby to themselves through his flattering lens.

Even among the eccentric characters of Harvard Square, Brother Blue stands out. Practicing an art that last flourished centuries ago, he would strut, snap, and sashay, barefoot, through rhetorical improvisations while bedecked in ribbons, feathers, and blue but-

terflies, some of which were inked onto his light brown palms and cheeks, explaining, "All humans, we're like caterpillars. There's something in us that wants to fly out. There's something that wants to transcend this sullen earth."

You would be forgiven for not recognizing this behavior as that of an ordained minister with a B.A. (cum laude) from Harvard, an M.F.A. from the Yale School of Drama, a Ph.D., and a personal invitation from the dean to work at Harvard Divinity School. Dr. Hugh Morgan Hill, as Brother Blue might be listed in a phone directory, is perhaps the most credentialed street performer in the world.

If you ask how he created his storyteller persona, he will speak of a calling to tranform the world. "See, I didn't invent the character. See, I'm a phenomenon. I just jumped off the tongue of God, finger popping!"

This calling has pulled him to Paris, London, and New York. He has had a radio program and appears weekly on Cambridge Community Television. But prisons and the streets are still his favored locales. From 1968 through the '90s, Harvard Square was the place he kept coming back to. "You know why I go in the street and do this?" he asked. "To remind all of us that we're more than our body, the way we look, your color, whether you're so-called good-looking or not, whether you're strong, whether you're male or female, whether you're old or young. There's something valuable in a human being."

His success cannot be appreciated without recognizing the work of his wife and partner, Ruth, whom he met as an undergraduate. She is the Type A to Blue's Type B, and makes sure he gets where he needs to go, remembers to eat, and stops when he's tired. It helps that she is an oral history archivist at Harvard's Schlesinger Library; her husband is clearly her biggest project of all.

"To stop is to die. I hope I die out in the street. I'm telling a story and I fall down dead, and when I get through, some kid stands on my chest and finishes the story," spoke Brother Blue. "Even after I'm dead, out of my mouth will come a butterfly." {145}

lower brattle st.

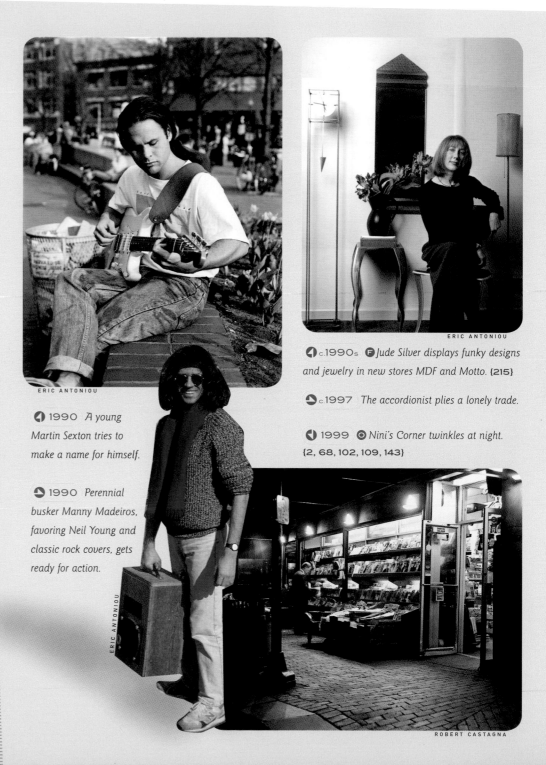

ERIC ANTONIOU

(F) c.1990s (F) Jude Silver displays funky designs and jewelry in new stores MDF and Motto. {215}

(A) c.1997 The accordionist plies a lonely trade.

(O) 1999 (O) Nini's Corner twinkles at night. {2, 68, 102, 109, 143}

ERIC ANTONIOU

(A) 1990 A young Martin Sexton tries to make a name for himself.

(A) 1990 Perennial busker Manny Madeiros, favoring Neil Young and classic rock covers, gets ready for action.

ERIC ANTONIOU

ROBERT CASTAGNA

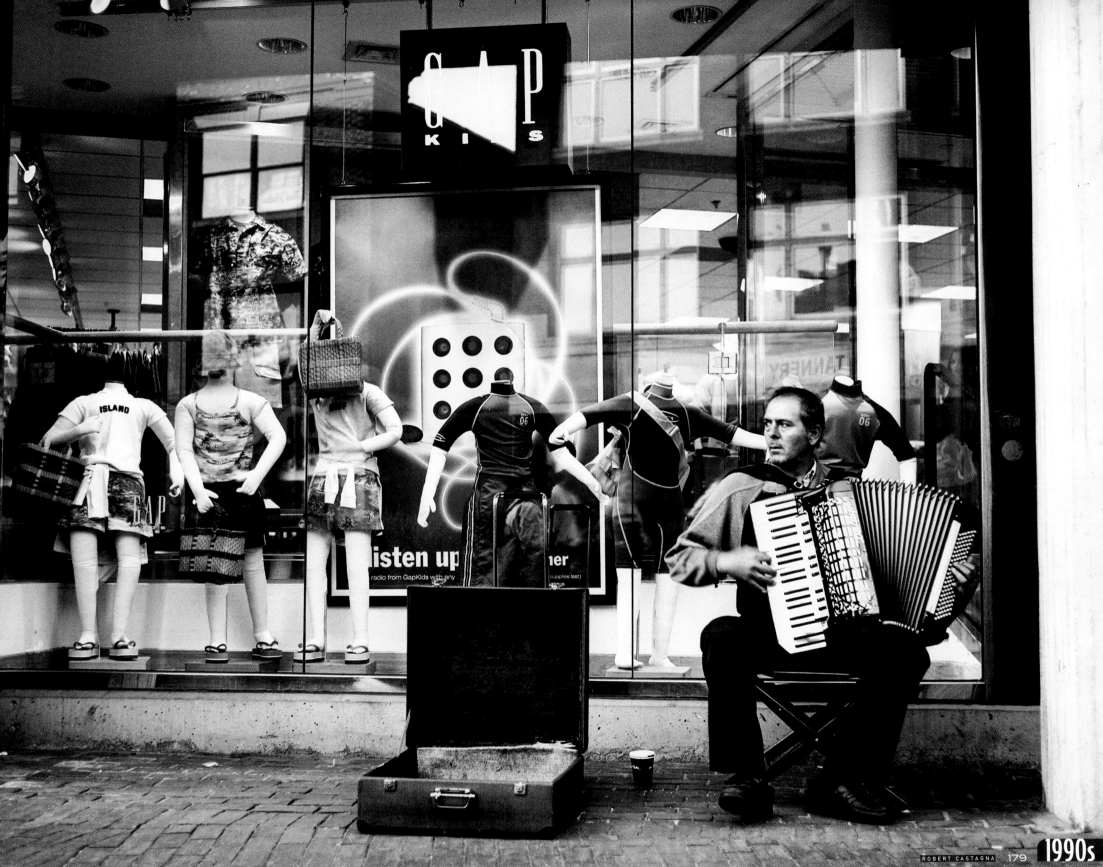

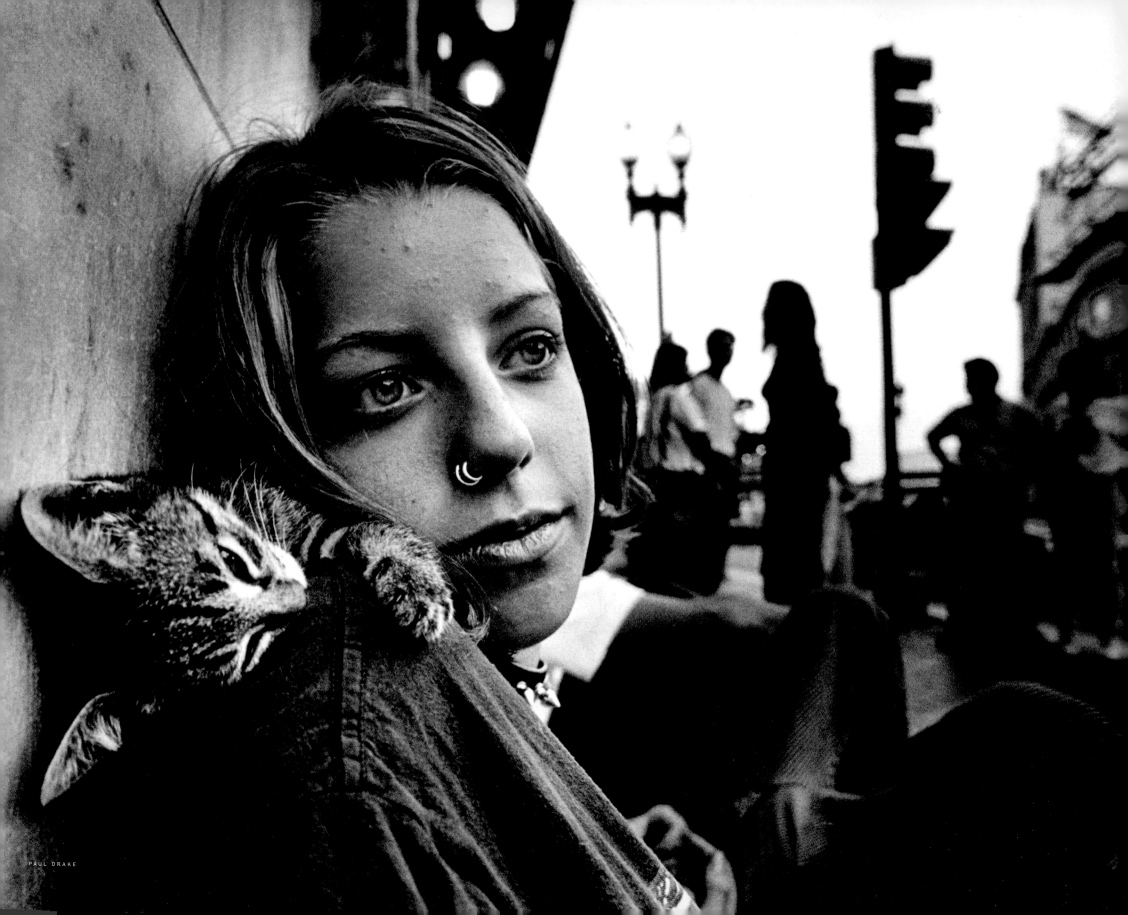

lower brattle st.

A WordsWorth
B Bob Slate's
C Dickson Bros.
D The Lodge/Tess
E Urban Outfitters

F David's Cookies
Swenson's/Tealuxe
G Cappy's Shoe Repair
H US Trust/Curious
George Goes to
WordsWorth

DOUG MINDELL

WORDSWORTH

RICHARD HOWARD

A c.1992 *H* *Brothers Tom (left) and Ray Magliozzi of NPR's Car Talk get into the holiday spirit from their new office overlooking the center of Harvard Square. Famous for bad puns and wordplay, the guys named the business they created to handle the show's affairs Dewey, Cheetham, & Howe.* {153}

A 1995 *Teen runaway Caroline seeks solace in the Square with her kitten Ginseng.*

A fat,

delicious, blue book with a giant bite taken out of it was the logo for WordsWorth. This was fitting not only in describing its loyal patrons' voracious appetite for reading but the deep, automatic price discounts that helped lure them in encyclopedic numbers to the slender stacks during Harvard Square's bookselling heyday.

> ### Regular
> Stephen King, who mentioned the shop in *Bag of Bones*, would occasionally come in and straighten up the Stephen King section.

In boom times, particularly just before the Internet changed the game, it was not unusual for lines of 25 people to be waiting at the register, morning till night, as runners waited in the wings to fetch books. A separate help desk was staffed just to answer questions. On Saturday nights, the new releases on the white square tables near the main entrance were jostled over like cookies.

With 10 percent off the list price for all paperbacks, 15 percent for hardcovers, and 30 percent for *New York Times* best sellers, the tomes were consumed in such numbers that WordsWorth would turn over its entire inventory six times per year, more than any other bookstore in the nation. Up to five employees would work every night, just restocking, from store closing time at 11:00 p.m. until 7:00 the next morning.

WordsWorth's layout was unusual, with two floors connected by a small, curved staircase, and after a modest expansion, a section reachable only by briefly stepping outside. Navigating it required liberal applications of "excuse me's." But this was no musty, venerable attic; it was a bright, well-oiled machine of a bookstore that skimped on the frills such as chairs or magazines in favor of stuffed inventory and ninjalike customer service: quiet, quick, and highly trained.

"Always have an answer, never leave people hanging," is how Peter Swanson described the employees' attitude. That meant that no book, whether in print or not, was too hard to track down. When Swanson worked there during the early 1990s it was competitive to get in; only college graduates were considered. There was a demanding tiered system and months of training before employees would be allowed to work the golden assignment of the help desk. "Some people never made it," Swanson recalled.

Such was the vision of Hillel Stavis, who, with his wife, Donna Friedman, ran the shop from its 1976 inception to its 2004 closure. With an early interest in computers (one of the store's best sections), Stavis hired programmer Eric Albert in 1983 to create an inventory control software package that could run on PCs—something that did not exist at the time. The resultant WordStock innovated the book business as hundreds of shops all over the world, including Barnes & Noble, were transformed by this time-saving application. WordsWorth had installed itself among the elite. Albert stated, "Anybody who ran a bookstore in the United States and cared about selling books knew who they were."

The success allowed some spin-offs. WordsWorth Gifts at 5 Brattle had greeting cards and pens and quirkier items until it closed in 2001, while Curious George Goes to WordsWorth at 1 JFK Street continues to be a very popular children's bookstore, with plush toys and games since 1996. The latter was a marriage of two Cambridge institutions, WordsWorth and Curious George cocreator Margaret Rey.

Like many other Square establishments, WordsWorth had its share of celebrity regulars, including Robert Parker (of *Spencer* fame), radio host Christopher Lydon, and former governor Bill Weld. Even one of their own employees, Jhumpa Lahiri, would go on to literary acclaim with *Interpreter of Maladies*.

Then there was Ed. With long gray hair and a beret, the quiet man lived under the stairs for 25 years. He wandered into the shop occasionally, especially on rainy days, and though he may have lacked good grooming, he was accepted. Sandwiches and an annual winter coat made their way to him; it was the Cambridge way. Said Swanson, "It seemed like a nice thing. People really looked out for him."

1990s

Ⓐ Express
Structure
HMV
Ⓑ Calliope
Cahaly's Men's/
Baak Gallery
Sola Men
Ⓒ Jasmine/Jasmine Sola
Billings & Stover
Ⓓ Olsson's/April Cornell
Ⓔ Brattle Theatre
Casablanca
Algiers
Ⓕ Camb. Ctr. for Adult Ed.
Ⓖ Charrette

Ⓖ Ann Taylor
Wainwright Bank
Ⓗ Harvest
Ⓘ Reading International/
Harnett's
Colonial Drug
Custom Barber Shop
Hillside Cleaners
Ⓙ Crate & Barrel
Ⓚ Clothware
Café of India
Settebello
Eleganza/L.A. Burdick
Ⓛ Blacksmith House
Bakery/Hi-Rise Bakery
Ⓜ American Rep. Theatre

upper brattle st.

🔺 1992 Ⓔ *A beautiful new version of Algiers, following the renovation of Brattle Hall, is something to smile about.* {149, 216}

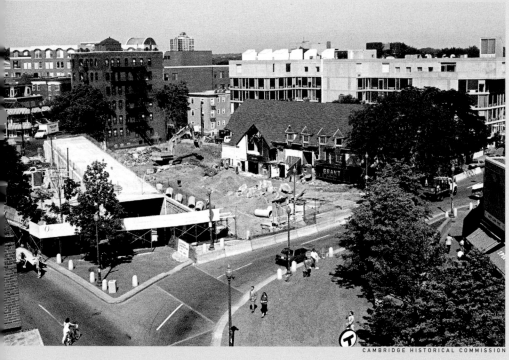

CAMBRIDGE HISTORICAL COMMISSION

FLINT BORN

◀ 1990 Ⓐ *A mishmash of buildings, including those housing Northeast Savings and Cherry, Webb, & Touraine are demolished to make way for the new One Brattle Square complex (right) while Brattle Hall gets a makeover.*

◀ 1993 Ⓐ *The block-long One Brattle Square building capped a building boom while adding more national chains to the retail mix.* {110}

◀ c.1997 Ⓗ *Harvest Restaurant has survived since 1975 despite being hidden down a walkway between Brattle and Mt. Auburn streets.* {113, 229}

🔺 1994 *Doo Doo was a favorite marionette of Igor Fokin and his audience.*

🔺 c.1994 *Igor Fokin was revered far and wide for street shows featuring his own hand-carved marionettes. Only two years after emigrating from Russia, he tragically died at age 36. A tiny gilded statue was later erected in Harvard Square in his honor.*

CHRIS YEAGER

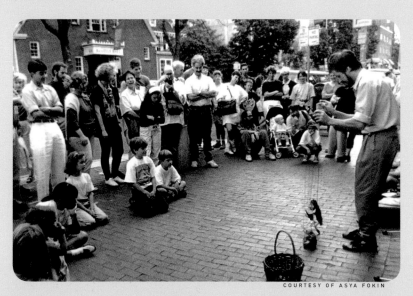

COURTESY OF ASYA FOKIN

HOWARD DININ

Church St.

A Harvard Sq. Theatre
B The Globe Corner Bookstore
C Passim
D Border Cafe Cybersmith
E The Atrium Café Café Fiorella

E The Black Rose Brew Moon
F CD Spins
G The Swiss Watchmaker
H Rizzo Tailor
I Sage's Market
J Christian Sci. Rdg. Rm.
K Beadworks

L Young & Yee
M Steve's/Starbucks Carriage House Salon
N Cambridge Artists Cooperative
O Lee's
P Bob Slate, Stationer

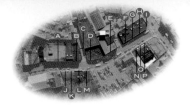

↖ c.1990s **J K** *23 Church with its Art Deco façade has long housed the Christian Science Reading Room on the right and a number of businesses on the left, including, since 1990, Beadworks.* {35, 79, 222}

CHAINS

cut both ways. During the '90s, many Square denizens worried about national stores ruining the local color. But at the same time, Harvard Square was launching a number of chains of its own, including The House of Blues (with 12 venues), Origins (now with 125 stores), John Harvard's Brew House (up to 14 restaurants), and Fire & Ice (look for the eighth eatery in Dubai!).

The trendsetting began earlier. Design Research expanded in the '60s, spreading Marimekko designs throughout the country. Joan & David Shoes was founded by the Helperns here in 1967. Coffee Connection was a 24-store caffeine fix begun in 1975. Jasmine/Sola had 23 locations of hip young women's clothing when it closed in 2008 after 30-plus years. And Crabtree & Evelyn began in 1973 in the old cleaning equipment room of the Brattle Theatre complex. Not all ideas were winners (see Cybersmith, right), but for a neighborhood of a mere few blocks, the Square's commercial concepts have been surprisingly successful.

↖ c.1997 **D** *What is this newfangled Internet we keep hearing about? Cybersmith tried to answer that question in 1995 with pay-by-the-minute Web access and interactive games (debited from your Cybersmith card, right). There was also café service with online ordering, naturally. By 1999, nearly everyone was connected and the shop, suddenly obsolete, closed.*

↖ 1990s **E** *Boston-based Brew Moon, a popular, moderately upscale brew pub, filled the atrium space at 50 Church Street from 1996 to 2001. Perhaps the only business to have thrived in that location, it tried to expand too quickly and failed.*

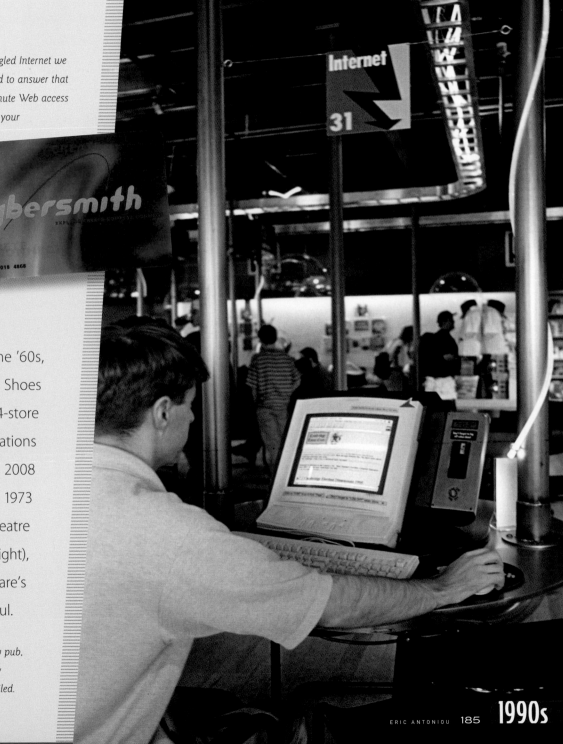

ERIC ANTONIOU 185 **1990s**

Ⓐ The Galeria
Ⓑ The House of Blues
Ⓒ Shilla
 Spaghetti Club
Ⓓ Grendel's
Ⓔ Winthrop Park

Winthrop St.

Filled with genuine folk art from the Deep South, the upstairs walls were a pastiche of color, texture, and whimsey constructed of found objects, driftwood, and vernacular glyphs. On the upper level, along a navelike ceiling, was a pantheon of plaster reliefs; each was the bust of a Blues notable, illuminated in colored light. The overall effect was singular.

But the true gift of the setting was its intimacy. The restaurant's seating was divided over three floors, and at concert time, the entire top floor had to be cleared of all the tables in order to make room for the audience. With a general admission capacity of between 200 and 250, a fan had the sense of being crammed into a neighbor's attic. It was a laid-back vibe that fostered chats with strangers and spontaneous shimmying. Show up early and you could be spitting distance from Koko Taylor, Lou Rawls, Marcia Ball, Jimmy Smith, or Dr. John.

The food, fussed-over Cajun meets Cambridge yuppie, was far better than it had any right to be. The Sunday Gospel Brunch, with family-style seating at 10 a.m., noon, and 2 p.m., was often sold out. By the end of 1993 the tiny nightclub had grossed about five million dollars.

Few venues have ever been launched with such fanfare or celebrity backing. Founder Isaac Tigrett had been the mastermind behind the Hard Rock Café. He enlisted Dan Aykroyd and John Belushi's widow and brother, Judy and Jim, to create a tie-in to the *Blues Brothers* brand. Other investors included Aerosmith, George Wendt, Paul Shaffer, John Candy, River Phoenix, and even Harvard University itself. The November 1992 opening party was star-studded, with Aykroyd, Shaffer, Junior Wells, Luther "Guitar Junior" Johnson, Joe Walsh, Ronnie Earl, members of Aerosmith, and Governor Weld in attendance.

When the club closed in September of 2003, it had wandered somewhat from its original stated purpose of promoting the blues. Instead it had widened its scope to become a place to hear great rock, danceable funk, and even folk, filling Winthrop Street with music fans every night. For that reason, it is one chain that Harvard Square will miss. {86}

Dan

Aykroyd nicknamed blues guitar wunderkind "Monster" Mike Welch, saying at the opening, "That kid's got a real future in the blues if he wants it." Welch was 13 at the time.

You would

think a bunch of millionaire white guys commodifying a poor, rural, black art form in lefty Cambridge would have sent folks running for the proverbial hills. Surprisingly, though, even with plans already in pocket to package and export the concept all over the country, for 11 years the original House of Blues was one of the coolest places to hear music in the region, let alone Harvard Square.

The source of its tremendous appeal as a venue was also the seed for its demise; it was the house itself. The 1845 Hyde-Taylor house was one of a handful of wood-frame buildings still left in the Square, receiving landmark status in 1989. With creaky floorboards and narrow staircases, it was the perfect container to capture an old-time roadhouse atmosphere. It was also small enough to be discarded when the corporate juggernaut mushroomed to include a dozen venues five to ten times larger.

Instead of creating a faux retro-Delta, the House of Blues wisely opted to make a completely original space.

BRUCE HILLIARD

COURTESY OF THE TRUSTEES OF WINTHROP PARK

Hot Pasta . . . Cool Place

the **SPAGHETTI** club

restaurant & bar
93 WINTHROP STREET – HARVARD SQUARE

◀ 1991 Ⓔ *A celebration of Winthrop Park includes (r–l) Out of Town News founder Sheldon Cohen, Historical Commission director Charlie Sullivan, and real estate scion John DiGiovanni. Also visible is Grendel's co-owner Sue Kuelzer (right of sign).*

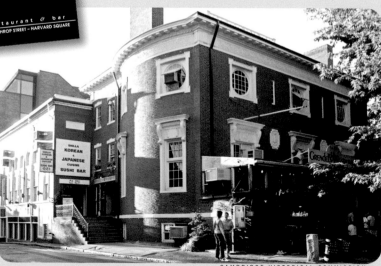

CAMBRIDGE HISTORICAL COMMISSION

◀ 1996 Ⓓ *Grendel's Restaurant and the Spaghetti Club enjoy their twilight. Development would soon overtake them.* {86, 121, 153, 225}

◀ 1993 Ⓑ *Coco Montoya is on fire during a performance with John Mayall at the House of Blues.*

↩ 1994 ⓗ

The door was always open (or unlocked anyway) at the Square's last 24-hour eatery.

jfk st.

Ⓐ Crimson Travel
Ⓑ Whitney's
Ⓒ Leo's Place
Ⓓ CVS
Ⓔ Urban Outfitters
Ⓕ Mudo
Ⓖ Vision House
Ⓗ The Tasty

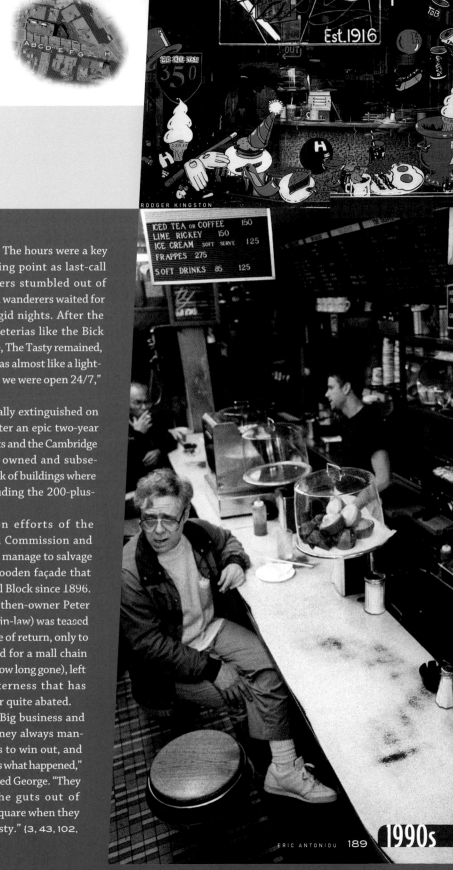

RODGER KINGSTON

> **George** remembered a regular who insisted on dark toast. "I said, 'Mary, why dark toast?' She said, 'Dark bread is better for you than white bread.'"

"When

they took The Tasty away, they took part of me away," said Charlie Coney, the beloved longtime cook of the greasy spoon. It is a sentiment that echoes through Cambridge again and again.

More than any other ghost, the late Tasty Sandwich Shop haunts Harvard Square's collective consciousness. As metaphor, it takes up more space and is arguably more impactful than the actual grease-and-countertop establishment. Not much more than an indoor hot-dog stand in both square footage and culinary options, The Tasty represents the epic David-versus-Goliath battles of literature and film. This one didn't have the Hollywood ending.

It did, however, make it into two Hollywood films. Minnie Driver smooches Matt Damon there, midchew, in that paean to Cambridge and Boston, *Good Will Hunting*. And look closely, that's Ryan O'Neal and Ali McGraw slipping out of The Tasty in *Love Story*, a film that could serve as metaphor for the devotion and loss Harvard Square feels about its favorite 24-hour joint.

The Tasty opened in 1916, a ventricle-sized eatery in the heart of a much simpler Harvard Square, right across from the subway kiosk on the curved Read Block at the corner of Massachusetts Avenue and Boylston (now JFK Street). The Square grew up around it, but The Tasty remained virtually uncorrupted by modernity, with original floor tiles, a yellow Formica counter dating from the 1950s and a handful of stools in a cramped, triangular stainless-steel cocoon.

George Avis, who steered The Tasty through about half of its 81-year existence, had an explanation for its longevity. "A cup of coffee is a cup of coffee, I don't care where you buy it from. Somebody says, 'Hey Jack, how are you?' that's what coffee is. And that's what The Tasty is."

George's counterside aphorisms, and the ball-busting banter between him and Charlie, was a continuing thread that bound the patrons together in a cross-class camaraderie. The braid of community woven out of java, doughnuts, and "frankfurts," as George called them, was a source of pride; former students returning with their own grown children was a milepost of success. Regulars and friends could be charted, literally, from all over the world—George had them sign a register and put a numbered pin in the wall-mounted map.

"You could walk in at any time of day and you could sit down and on your right you would have a Harvard University professor and on your left you would have a homeless person and you would have a conversation," said Federico Muchnik, who made a documentary about the place. "This went on 24 hours a day."

The hours were a key selling point as last-call revelers stumbled out of bars and wanderers waited for buses on frigid nights. After the Square's all-night cafeterias like the Bick closed down one by one, The Tasty remained, the last holdover. "It was almost like a lighthouse at night because we were open 24/7," said George.

That light was finally extinguished on November 2, 1997, after an epic two-year battle between residents and the Cambridge Savings Bank, which owned and subsequently gutted the block of buildings where The Tasty stood, including the 200-plus-year-old Read House.

The preservation efforts of the Cambridge Historical Commission and motivated citizens did manage to salvage the familiar curved wooden façade that has embraced the Read Block since 1896. But the way in which then-owner Peter Haddad (George's son-in-law) was teased with the promise of return, only to be rebuffed for a mall chain store (now long gone), left a bitterness that has never quite abated.

"Big business and money always manages to win out, and that's what happened," reflected George. "They tore the guts out of Harvard Square when they closed The Tasty." (3, 43, 102, 156)

ERIC ANTONIOU 189

1990s

ICED TEA or COFFEE 150
LIME RICKEY 150
ICE CREAM SOFT SERVE 125
FRAPPES 275
SOFT DRINKS 85 125

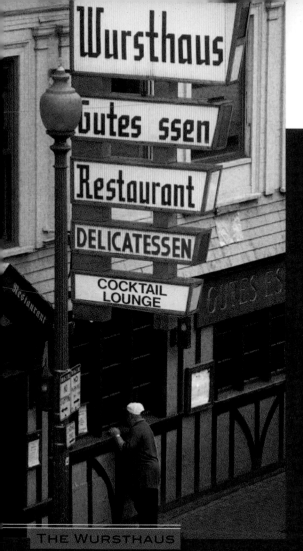

jfk st.

THE WURSTHAUS

Always

mentioned on the most-missed list, the Wursthaus closed in 1996 after nearly 80 years serving schnitzel and sauerbraten along with what it claimed was the world's largest international beer selection. But it was also where Cambridge's power brokers discussed politics, whether it was owner Frank Cardullo's kaffee klatches with the mayor or the Harvard intelligentsia working out policy issues in dark wooden booths.

What was the appeal of the German-themed restaurant run by the Sicilian Cardullo with a Chinese cook and Spanish-speaking help? It certainly wasn't the cuisine. "The Wursthaus's food was awful," said Jim Smith, who runs the Cambridge Center for Adult Education. "Worth avoiding," echoed the *Crimson*.

And yet, Derek Bok, who as Harvard University president for about 20 years spent many a morning

in the chiaroscuro corners of this Bavarian outpost, saw it for the lovably quirky community nexus it was. "There are certain restaurants, bookstores, and establishments that do a lot to define the special quality and tradition of the Square," he said in 1993. "The Wursthaus is one of those establishments."

To call it a landmark would be cliché, but the truth is it was one in both senses of the word because, in addition to its longevity and popularity, the Tudor façade and the cascade of signage proclaiming "Gutes Essen" (good eats) were hard to miss.

Combine those elements with wooden barrels, plastic grapes, flags, and costumed waitresses, and you've got some theme-park kitsch on your hands. In an age before irony, however, these touches were adequately evocative, and the beer menu was genuinely comprehensive, with well over one hundred bocks, pilsners, and ales to choose from.

The Wursthaus, in addition to its own estimable standing, also inspired Cardullo to birth two other evergreen Harvard Square brands: Cardullo's, which was an extension of the deli case, and Oktoberfest, launched in 1979. Nonetheless, though he expanded its capacity nearly tenfold, it was not Cardullo who founded the place (he was two years old when it opened in 1917), but a young Harvard dropout named Harry London whose parents ran a New York deli. Cardullo became the third owner, in 1943.

It was the spin-off Cape Cod Wursthaus that hemorrhaged money and ended up dooming them both, although certainly business was off and the restaurant was shabby and anachronistic by the '90s. Twinned with The Tasty, which shared a wall and a nearly identical life span, the Wursthaus was long an embodiment of the Square's quirky village mystique. When they fell, many saw a chapter, if not a book, close.

That chapter was fondly recalled by brainiac Robert Reich, former U.S. Secretary of Labor, who remembered being "squeezed into one of those wooden booths, disagreeing vehemently about some or other economic issue. Larry Summers and I went at it over industrial policy. John Dunlop hammered away at labor policy...The benches were hard on one's ass and the food was not very good, but the conversations were always spirited and great fun." {28, 43, 84, 155}

> "If you could somehow capture the smell of the Wursthaus," said one patron, "it was the combination of pumpernickel bread, dill pickles, and pastrami."

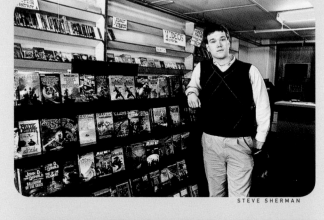

🔺 1990 Ⓜ Tyler Stewart shows off Pandemonium, a book store specializing in sci-fi, animation, and horror.

STEVE SHERMAN

◀ c.1996 Ⓜ Frances Antupit stands outside the photo studio where she spent 40 years. She, like all tenants in the Read Block, was evicted in 1997 when the buildings were gutted. {84}

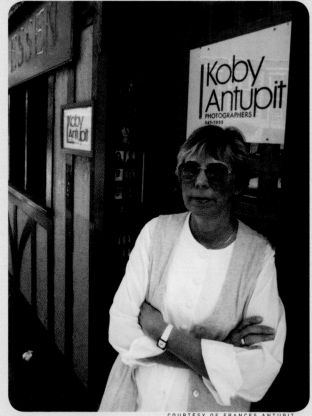

COURTESY OF FRANCES ANTUPIT

🔺 c.1999 Ⓜ The Read Block's slick renovation is complete. Many people found the replacement of the Wursthaus with Abercrombie & Fitch to be the ultimate indignity. {174, 189, 237}

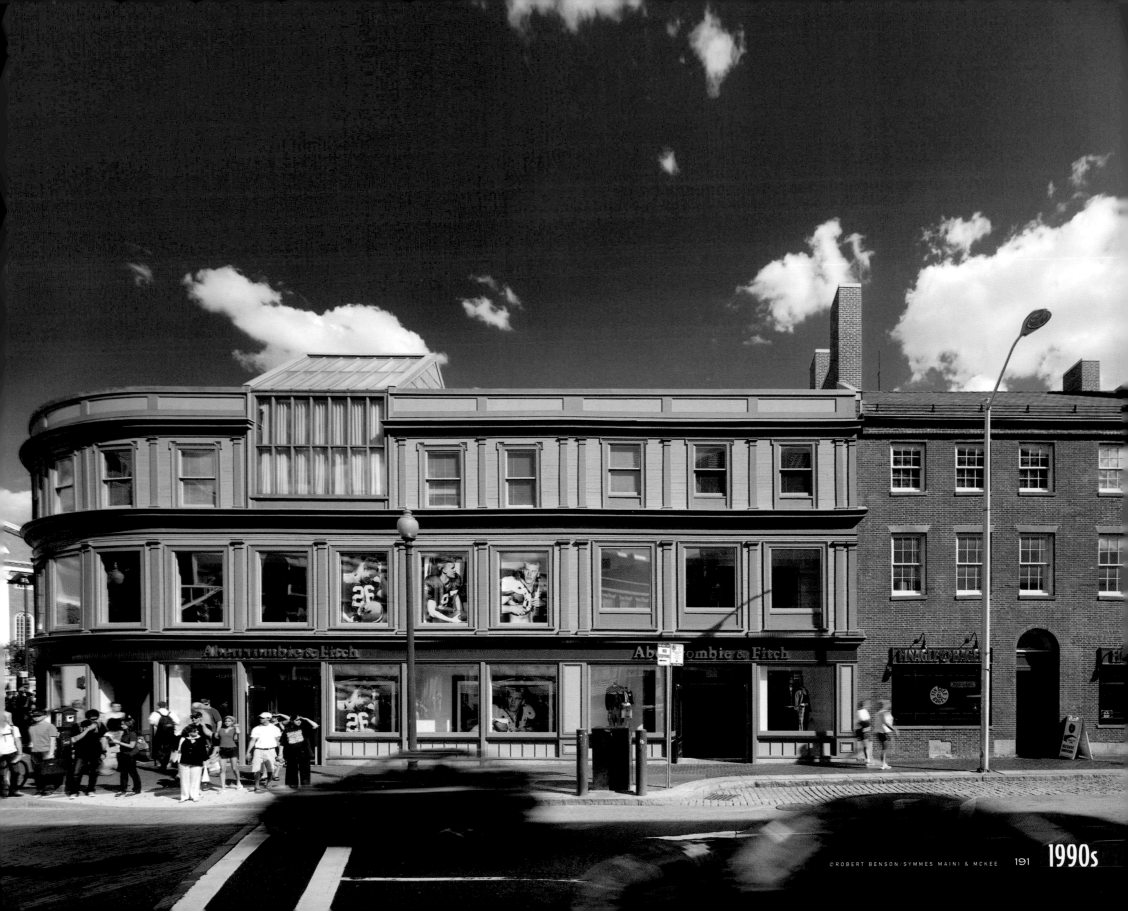

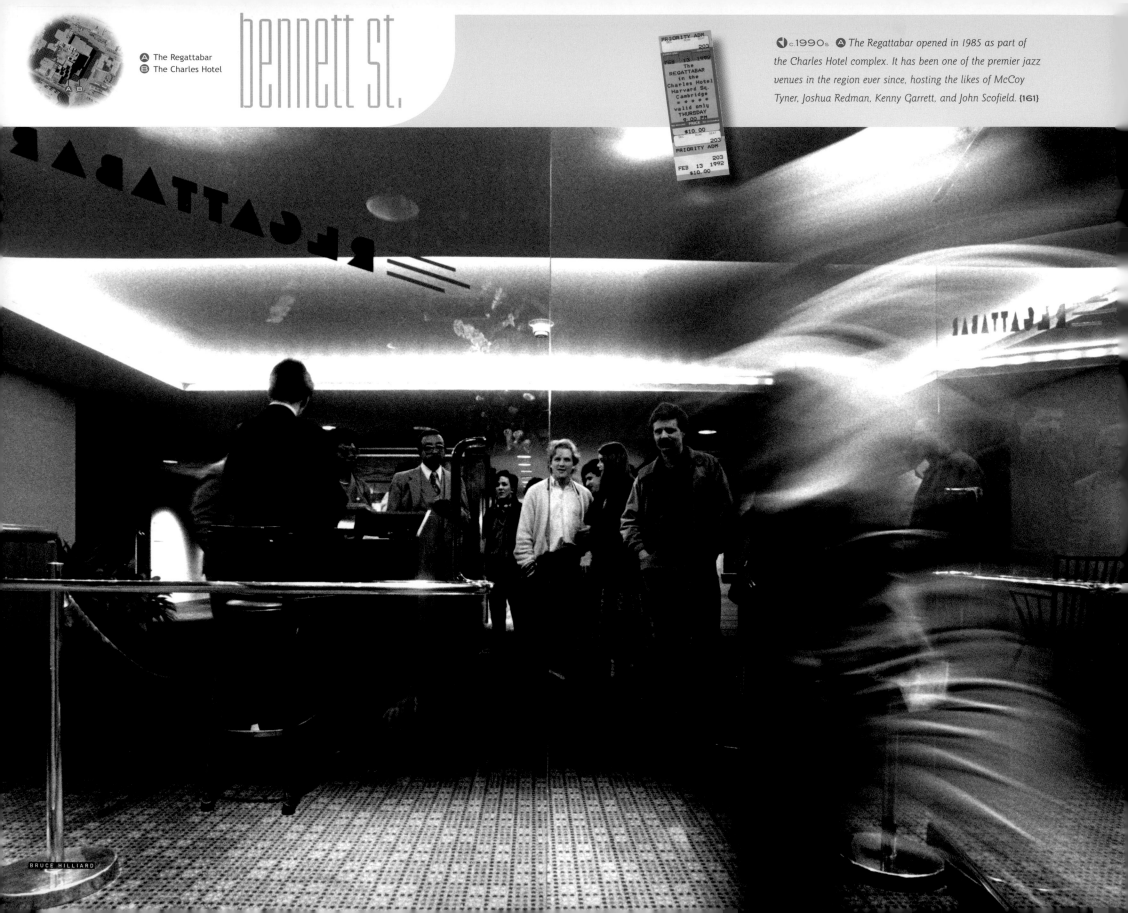

◀ c.1990s Ⓐ *The Regattabar opened in 1985 as part of the Charles Hotel complex. It has been one of the premier jazz venues in the region ever since, hosting the likes of McCoy Tyner, Joshua Redman, Kenny Garrett, and John Scofield.* {161}

BRUCE HILLIARD

lower mt. auburn st.

STEVE SHERMAN

▲ 1990 (F) *Herb Hillman shows off some large-format books in Pangloss's second location at 65 Mt. Auburn. Hillman opened the secondhand shop, featuring scholarly titles, in 1957 on Mass. Ave.* {11, 133}

◀ 1996 (N) *The Holy Cross Armenian Church spends its last remaining days in Harvard Square after 40 years. The 1929 building would be razed in 1997 as part of a Winthrop Park development that included moving and rotating the top two floors of the wood-frame building next door and plopping it down here.* {*229}

▲ c.1990s (E) *The Harvard Lampoon castle, with its brightly colored door and facelike tower, has been a noticeable feature of the Square since 1909 and on the National Historic Register since 1978. The copper ibis on top has vanished repeatedly as part of a decades-long rivalry with the Crimson, showing up most famously at the UN's Russian delegation as a "gift" to Moscow University.* {39, 82}

CAMBRIDGE HISTORICAL COMMISSION

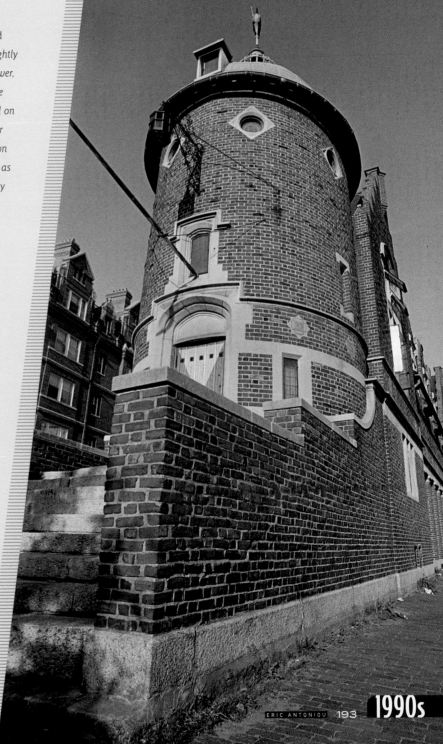

ERIC ANTONIOU 193 **1990s**

Ⓐ Great Cuts
Ⓑ Caffé Paradiso
Ⓒ Sky Light Books/
Global Village Books
Ⓓ Chili's
Ⓔ Barillari Books/Kinko's
Ⓕ US Post Office

upper mt. auburn st.

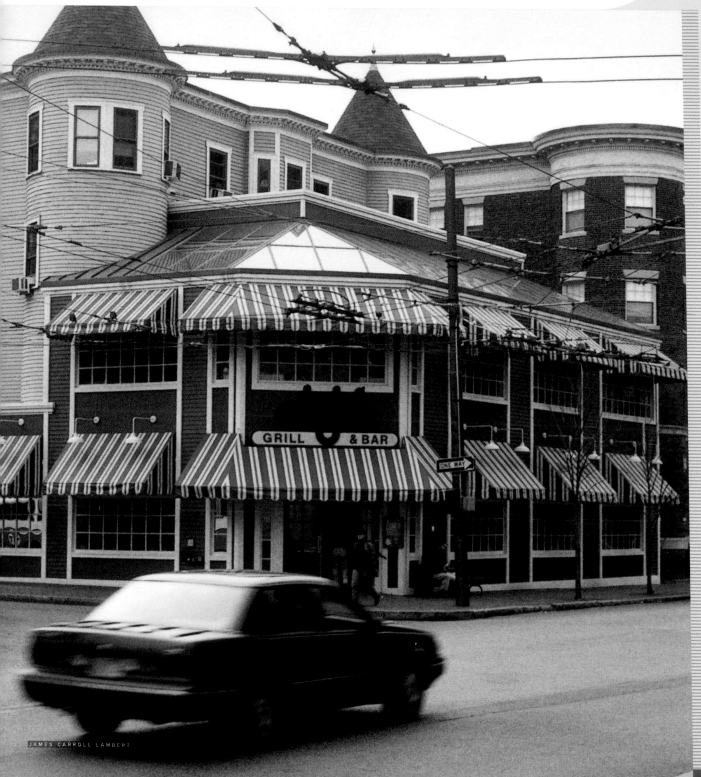

JAMES CARROLL LAMBERT

⬆ 1990 Ⓔ *Barillari Books was a short-lived superstore at Mifflin Place that coincided with the peak and fall of Harvard Square bookstore richesse.*

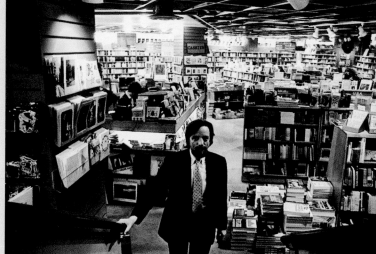

STEVE SHERMAN

STEVE SHERMAN

◀ 1990 Ⓒ *Sky Light Books provided New Age reads.*

⬆ 1993 Ⓓ *The onetime home of Cronin's and The Swiss Alps became a Chili's franchise. With an influx of such chains during the '90s, many feared the Square was losing its unique character. Later, many of those same franchises (including this one) would fold.* {125}

bow st.

Ⓐ Baskin-Robbins
Ⓑ Bow & Arrow Pub
Ⓒ Bicycle Exchange/Omni Travel
Ⓓ Classic Tuxedo
Ⓔ Audio Replay
Ⓕ Café Pamplona
Cambridge Architectural Books

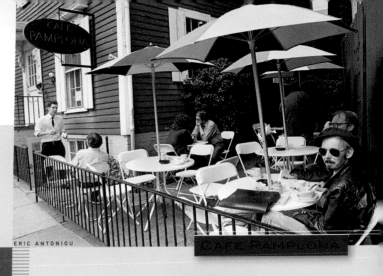

↘ 1993 Ⓕ *The patio seating at Pamplona allows one to escape the cramped interior.*

ERIC ANTONIOU

CAFE PAMPLONA

With

Starbucks on every corner these days it's hard to remember life before the café culture. Once, the Square teemed with luncheonettes, cafeterias, and family-style restaurants. But what of the solo adventurer of the mind, who liked to wash down philosophy scribblings with dark, bitter espresso? For that person, a new kind of place, European in sensibility and intellectual in affect, arrived in Cambridge in the late '50s—the coffee shop. From that first wave, only one remains standing: Café Pamplona.

Josefina Yanguas came here from Pamplona with little family, having left behind a broken Spain in the aftermath of its civil war. When 12 Bow Street appeared on the market in 1959, her mission was crystalline. She would open a coffeehouse. The wanderers of the world needed a place to go.

Her creation was as much a limbic vestige of her hometown as anything else. Café Pamplona's uniqueness stems not from screaming individuality, but from the no-frills, bare-bones atmosphere it offers. The monochromatic cave provided a blank canvas and invited patrons to fill it with colorful conversation or profound gazes into infinity.

Josefina herself was warm and engaging, if a touch irascible. Yet when it came to her café, her asceticism was legendary. There was no decaf. There was no skim milk. There was no cash register. No music, ever. For many years it was not even possible to order tea. "In the early '80s people were asking for herbal tea," remembered David Zarowin, an employee from that era. "She said, 'Absolutely not, I don't serve anything but coffee.' Eventually she caved and served chamomile tea. We thought she did that because it was the most disgusting tea she could find."

Gazpacho and garlic soup were nods to Spanish tradition, previously unfindable in Cambridge. So were the cigarettes and all-male waitstaff, which filled the café until

One of the geraniums in the window is the descendant of the original that Josefina put on the sill in 1959.

the late '90s. But woe be to tall men who sought work in the notoriously short-ceilinged cellar. "I can't," said the no-nonsense and witty Josefina, "I will have to cut [off] your head or your feet, one of the two."

Josefina made other contributions to the Square. In the '60s, she was prodded by friends to open the Spanish tapas restaurant Iruña, tucked away down an alley off of JFK Street. She soon sold it to the waiters, whose families ran it up until its closure in 2006. She also co-owned the Hoffman-Yanguas art gallery above Pamplona, which featured some of the best Boston-area artists, including Maud Morgan, who became a friend. The unusual arrangement allowed the artists to pay rent instead of commission.

But Pamplona was Josefina's mission, and she steadfastly tended to its studied austerity decade after decade. In December of 2004, Josefina attempted to retire and sell the café she had owned and lived above for nearly a half century, but the lawyers were taking a long time with all the details. Meanwhile, the restless former denizens of Pamplona kept calling and writing and prodding. Flattered and proud, she reopened, despite illness, in the summer of 2005; it was a gratifying coda to a dream made real. "It worked very well," she said, "because you need a place to go." Josefina passed away in 2007 at age 90. (40, 45, 239)

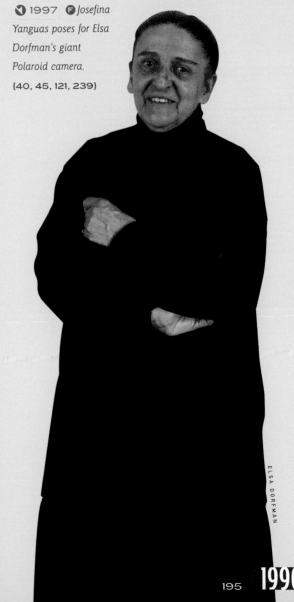

↖ 1997 Ⓕ *Josefina Yanguas poses for Elsa Dorfman's giant Polaroid camera.*
(40, 45, 121, 239)

ELSA DORFMAN

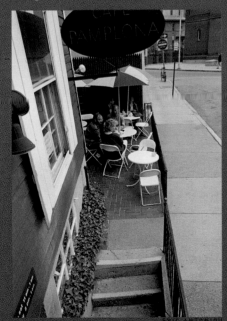

ERIC ANTONIOU

195 **1990s**

PAUL
BARANAY

RECENTLY, as I took the T back home from Harvard Square, it occurred to me that the subways are the veins of Boston. All at once, I envisioned an entire circulatory system, spreading out from the downtown heart in a crisscross of red and orange, green and blue—and I knew, in the same instant, that the Square had to be Boston's lungs, giving life to the entire city.

Harvard Square is, as it always has been, the place to be for Boston's self-styled young and hip. Heavily commercialized, too, like almost everything else in the country these days. The used bookstores and traditional family-owned cafés vie for space and attention with sprawling retail giants and national banks—although sometimes I wonder how many people notice that silent struggle, let alone care about it. But there's still the faithful rumbling T station, and the musicians in the Pit, and the famed chessmasters sitting stoically at their tables, and everything anchored together by that newsstand whose name no one can ever remember.

Some nights, I do nothing more than wander aimlessly up and down the dusk-deepened streets, my eyes not on the storefronts but on the faces of the people I pass. If they took away the shops I would still come to the Square just for that: the people. The townies and the tourists, the preps and the punks, all the cultures and subcultures that mix and mingle somewhere between Mass Ave and JFK and never emerge exactly the same. Because as we change, so does the Square; as the Square changes, so do we.

This is the Harvard Square I have come to know and love: walking, talking, always on the go—a living and breathing organ, with a slow and steady rhythm, historic and modern, evolving and ageless. Far more than a mere collection of stores or a busy confusion of streets, the Square calls me back time and time again to seek, discover, explore.

Paul Baranay

MO LOTMAN

2005 *Brattle Street appears magical under a dusky winter sky.* {84}

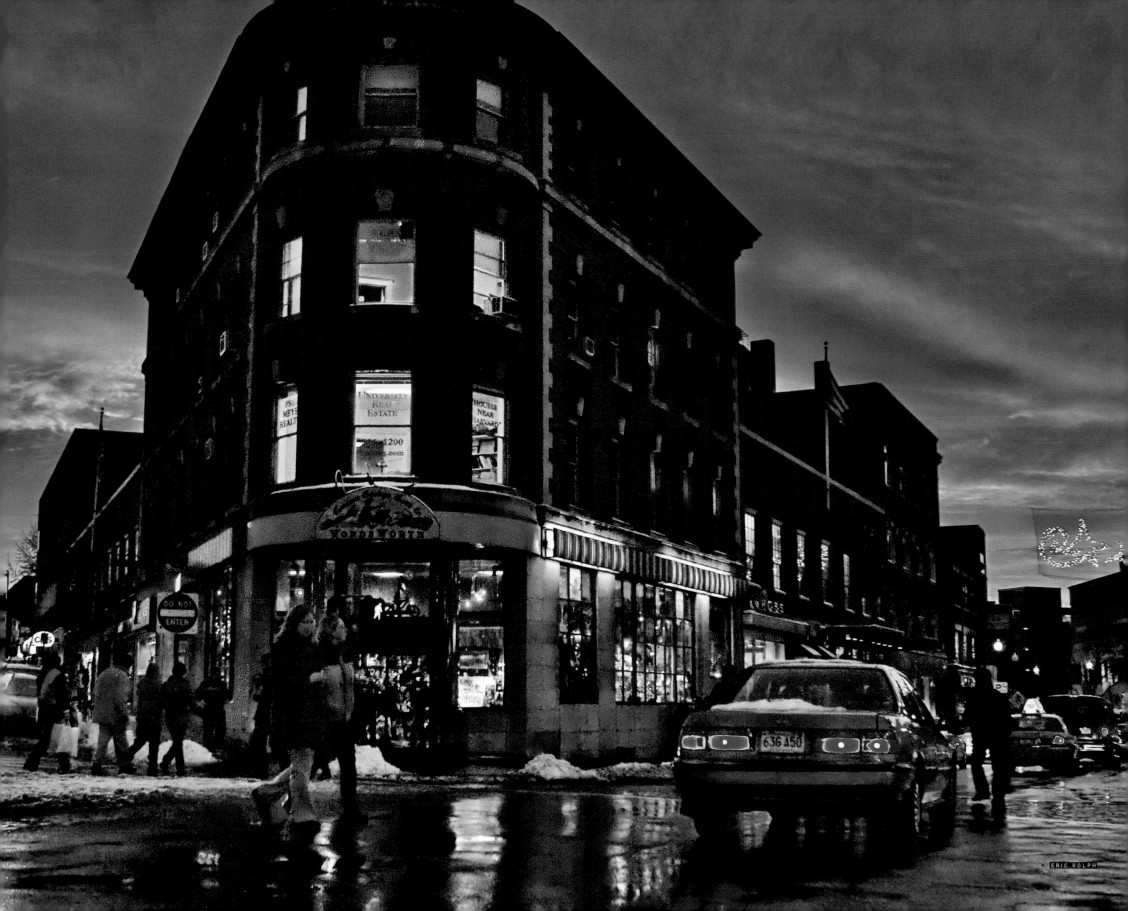

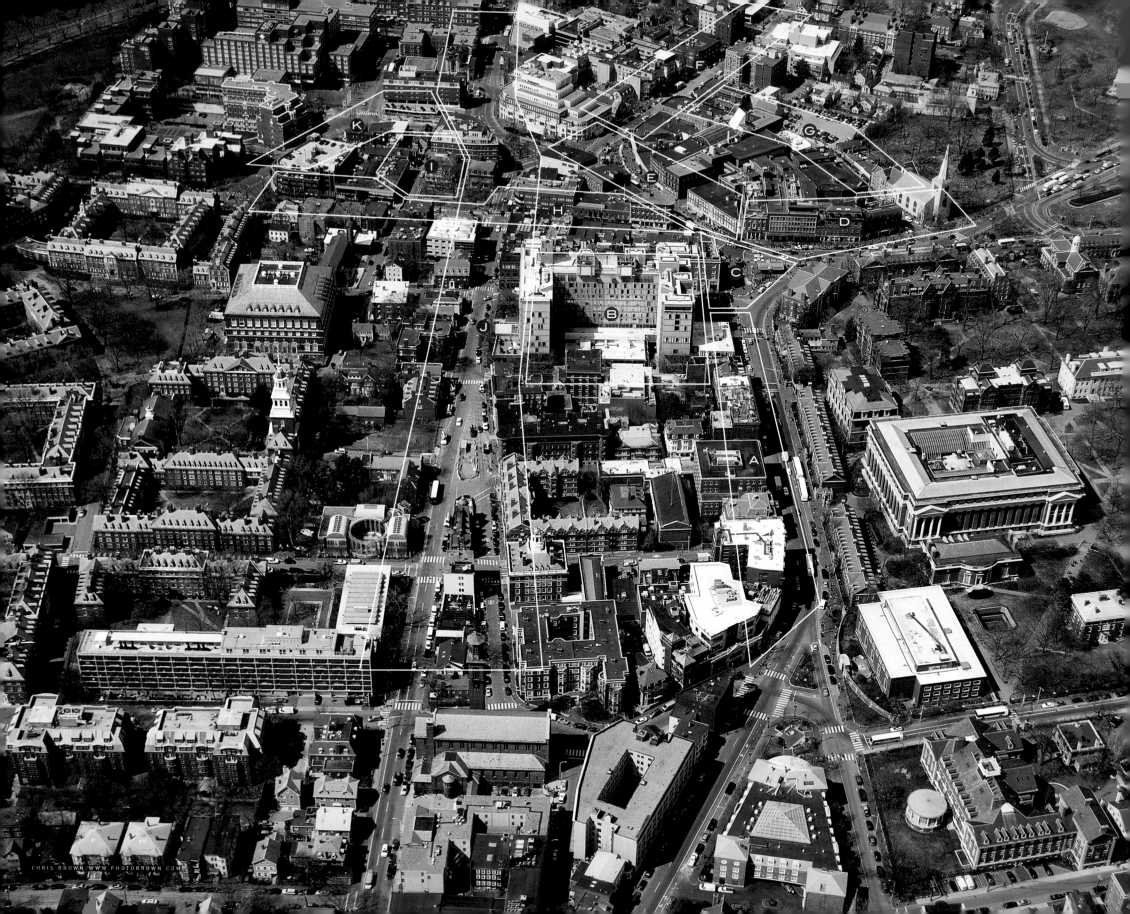

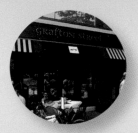
Ⓐ Lower Mass. Ave.

Ⓑ Holyoke & Dunster Sts.

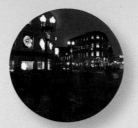
Ⓒ The Center

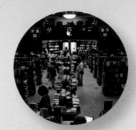
Ⓓ Upper Mass. Ave.

Ⓔ Lower Brattle St.

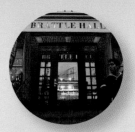
Ⓕ Upper Brattle St.

CHANGE IS

inevitable in all things, and yet we often cling to the past as if we had not already learned that lesson a hundred times. The first years of a new century were not kind to the Square, as vacancies, once unthinkable here, proliferated and lasted. Tourism went off a cliff after 9/11. The Internet sucked the life out of brick and mortar staples such as CD stores and bookshops. Anchors such as WordsWorth crumpled, slackening foot traffic. Nightlife dimmed with the closure of the House of Blues, and dwindling audiences at the Brattle Theatre. In turn the street performers started their disappearing act.

The central outdoor "room" facing the kiosk had become nearly wall-to-wall banks, with their sterile, uninteractive storefronts. Many felt that the unique color of Harvard Square was draining slowly away. The Square seemed lost and unsettled.

Wait long enough, though, and the change changes, too. Many of the mall chain stores—Abercrombie & Fitch, Sunglass Hut, Structure, California Pizza Kitchen—that were held responsible for the so-called demise of the Square failed even more spectacularly than the independents. As the first decade of the 2000s drew to a close, quite suddenly a new iteration of Harvard Square emerged. It is decidedly different from the village main street of the '50s, the funky mecca peopled with crafts-peddlers and hippies of the '70s, and the bookstore capital crammed with street performers in the '90s. This new version is a shiny, upscale shopping district with locally owned boutiques and restaurants.

A street beautification project has widened sidewalks, improved crossings, added new lamps with flower baskets, and turned Palmer Street into a pedestrian mall with glowing benches. Brand-new spots such as an all-night market with a hot food bar, a beautiful café with balcony seating and homemade English muffins, and a row of hip clothing stores have begun to give the Square a sheen it has recently lacked. An outdoor beer garden at Charlie's Kitchen. Patio seating behind a faux temple wall at the über-hip Om. Vacancies are being filled. Nights shimmer. Programmed events, such as Shakespeare in Winthrop Park, a Harry Potter festival, and an ever-expanding Mayfair, have brought big crowds back, if only on an event-by-event basis.

There's no question that the countercultural edge that branded the Square for so long is all but gone. The artists, musicians, activists, and alternative-lifestylers have decamped to Somerville and Jamaica Plain. But it's hard to look at Harvard Square with fresh eyes and argue that it is dead. It is a tremendous mix of tradition and modernity, J. Press and bubble tea, an ever-transforming soup of appetites, talents, and identities that sways through serpentine streets layered with the patina of its many stories.

In early 2009, Hudson News declined to renew its lease for Out of Town News. The neighborhood's touchstone teetered on a precipice. A last-minute rescue still left the imponderable hanging. Would its loss be a body blow or an opportunity? Cynicism is a flourishing art, but it would be a mistake to count the Square out. Entwined with a university that predates the United States by 140 years, ever-replenished with new people and ideas, Harvard Square remains resilient and alive.

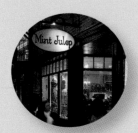
Ⓖ Church St.

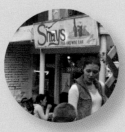
Ⓗ JFK St.

Ⓘ Winthrop St.

Ⓙ Mt. Auburn St.

Ⓚ Eliot St.

THE 20 00s

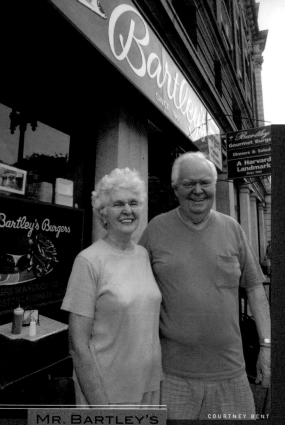

MR. BARTLEY'S

COURTNEY BENT

The Ted

Kennedy is a "plump, liberal amount of burger with cheddar cheese, mushrooms and french fries." The People's Republic of Cambridge has Russian dressing. The Larry Summers was axed, much like its human counterpart. These are just a handful of the twenty-plus themed options at Harvard Square's reigning hamburger joint, Mr. Bartley's Burger Cottage.

An eatery cannot survive on jocular platter names alone, however, and Bartley's delivers the goods. The hamburger is probably the most ubiquitous menu item in America. Could these really be markedly better than any other? Surprisingly, yes. This becomes apparent to anyone who merely walks past the doorway and catches a nostrilful—the aroma is so florid you could almost stick that in a bun and eat it.

When Joe and Joan Bartley (above) started serving up their signature patties from a converted convenience store called the Harvard Spa in 1961, "There wasn't a decent burger in Cambridge," remembered Joe. Even today, the frozen, wax-paper-clad hockey puck is typical fare at your average greasy spoon. But the Bartleys did what no one else was doing at the time—served freshly ground beef to the proletariat in thick, handmade patties.

At 48 cents (2 more for cheese), the basic Bartley's burger was a little more expensive than most, but from a price-to-deliciousness standpoint, there was, and is, no contest. The Cottage has been, aside from a brief beef challenge from Buddy's Sirloin Pit in the '70s, the undisputed maestro of the medium. This is borne out by the lunch rush that still occurs virtually every day, where the restaurant might go through 300 pounds of onion rings (homemade, of course) a week. Plaudits have been heaped on by the local papers, travel guides, national magazines, and TV programs.

Resembling an overgrown, ruddy cherub, Joe Bartley has a twinkle in his eye and a mischievous humor that carries over into the dining room where, in addition to the sly sandwich names, there lives a dizzying assortment of kitschy signs and paraphernalia chock-a-block on walls and ledges. Seating in the center of the floor is family style—a good description of the operation as a whole. Joe and Joan count over 50 years of marriage and five children between them. Their son Billy now mans the grill and runs the show, though Joe still comes by, saying of his current role, "My son uses me like Colonel Sanders."

Aside from the burgers and boisterous atmosphere, people seek out raspberry-lime rickeys, oreo frappes, or other sandwiches such as the Britney Spears, a roast beef number "stripped of fat." Bartley updates the names—The Fonz and Kojak burgers are long gone—but the food and the experience remain stal-wart. If tastes change, the Bartleys seem justifiably unconcerned. As Joe put it, "People like hamburgers. They always have and they always will." {51, 92}

The city of Cambridge passed a resolution in honor of Bartley's 45th anniversary, with one councilor saying that the burgers go "above and beyond the call of duty in both flavor and aroma."

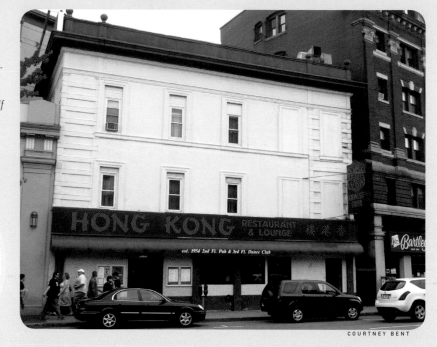

🔽 2005 Ⓑ The Hong Kong remains as popular as ever, after more than a half century. {*92, 167}

COURTNEY BENT

🔽 2005 Ⓐ Grafton Street, named after the Dublin pedestrian thoroughfare, has been part of the modern, slicker version of Harvard Square.

🔽 2005 Ⓒ Bartley's dining room is a cacophony of sight, sound, and smell on an August afternoon.

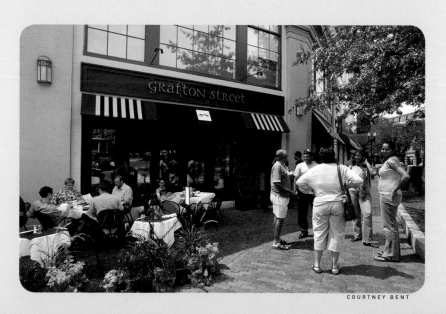

COURTNEY BENT

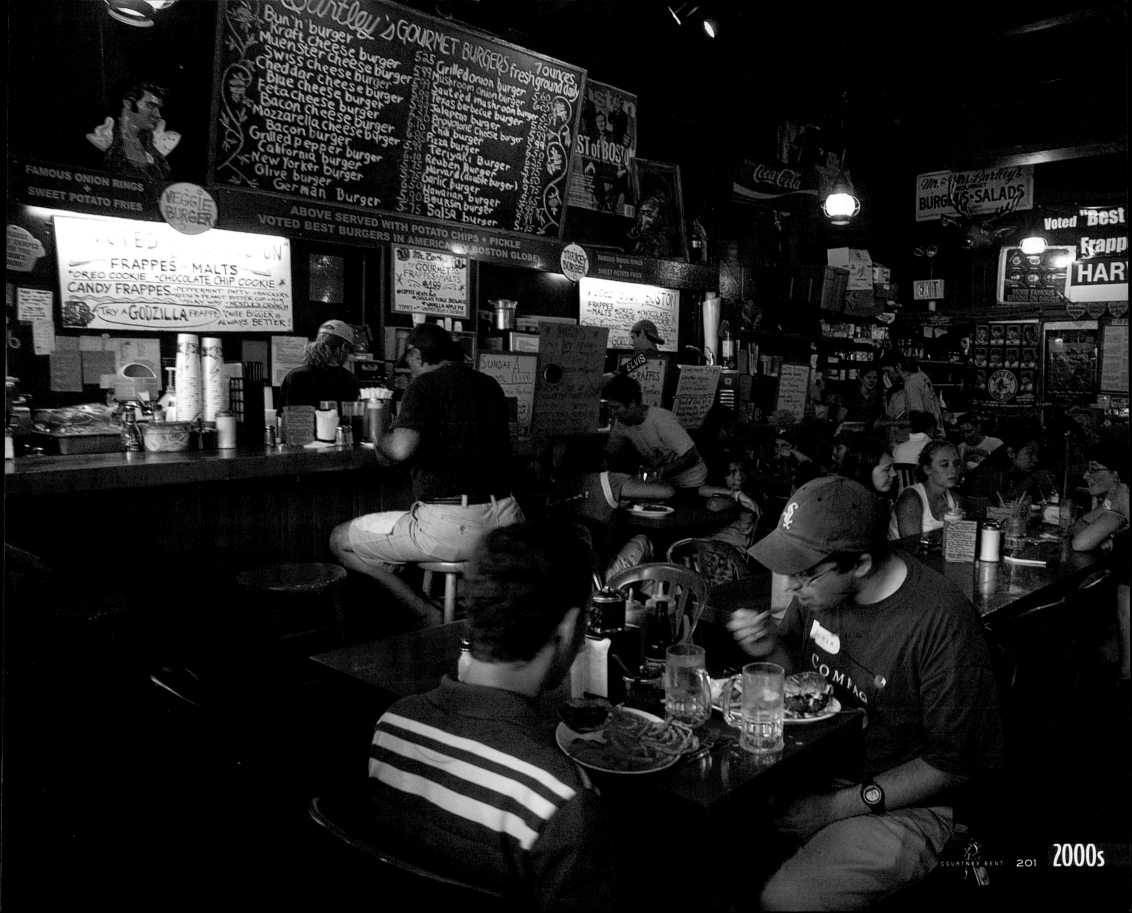

Ⓐ Harvard Book Store
Ⓑ Grolier Book Shop
Ⓒ Adidas Originals
Ⓓ Stonestreets/See
Ⓔ Grafton Street/Slate's
Ⓕ Bob Slate, Stationer
Ⓖ Cambridgeport Bank/Qdoba

Ⓗ Ferranti-Dege/Zinnia
Ⓘ Gnomon Copy/Felix
Ⓙ Toscaninni's/Gnomon Copy
Ⓚ Serendipity/Zinnia/JP Licks
Ⓛ Leavitt & Peirce
Ⓜ J. August
Ⓝ Yenching

lower mass. ave.

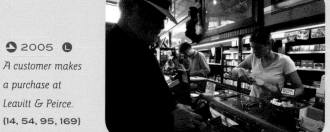

⌚ 2005 Ⓛ
A customer makes a purchase at Leavitt & Peirce. {14, 54, 95, 169}

COURTNEY BENT

⌚ 2008
Pedestrians stroll Mass. Ave. on a frigid December day. {*53}

COURTNEY BENT

MO LOTMAN

HARVARD BOOK STORE

The last

independent general bookseller in Harvard Square. The phrase sounds quasi-apocalyptic. Yet with the closure of WordsWorth in late 2004, Harvard Book Store has achieved that rare distinction. With about eight decades of service, it has outlasted and perhaps outsmarted—both in business and in selection—a litany of competitors.

Frank Kramer, who ran the store from 1962 until 2008, would probably be the first to say he wished they never went away. They all knew each other, and he was never in it for the money anyway. "It's not that lucrative a profession," he said. Selling books was a labor of love.

It was not always thus. Kramer had no intention of getting into the family business. It looked, quite frankly, boring. "I was not a heavy reader," he admitted. "Part of my youthful rebellion was not to read all the books I was surrounded by." Things changed when his father, Mark, died suddenly at age 55. Kramer, then only 20 years old, had the business, and an unenviable choice, thrust upon him. He could either get into books or watch his dad's 30-year-old creation bite the dust, leaving employees for whom he cared out of work.

We all know the choice he made, but what wasn't obvious was that Kramer would take to the job so well. He credits some of his employees, such as Margaret Keely and Walter Byrnes, with coaching him through the transition. The store's story, which could have

ended in disaster, instead arches gracefully toward the horizon.

Mark Kramer borrowed $300 from his parents in order to open Harvard Book Store in 1932. The original 600-square-foot shop, with creaky floorboards and used books stacked to the ceiling, was on what is now JFK Street, where Urban Outfitters would later be located. In 1950, the elder Kramer moved the operation to 1248 Mass. Ave. and got into the used textbook business, opening branches at Northeastern and Tufts.

When Frank took over, it would have been easy to be on lockdown. But he made a conscious decision to take risks and develop new directions for the store. In 1965, he expanded to the basement. He started a lucrative law books component. He branched out into new releases and paperbacks. When the corner of Mass. Ave. and Plympton became vacant in 1971, he expanded into it, despite the fact that for 10 years a camera shop was wedged awkwardly between the two storefronts. For 14 years, he even ran a spin-off bookstore-café on Boston's chic Newbury Street with a prefamous Jasper White as chef.

Kramer also partnered with the Boston Public Library to create an acclaimed author series, which has featured Gore Vidal, Kurt Vonnegut, Joyce Carol Oates, Saul Bellow, Toni Morrison, Robert Pinsky, and many others. "It was really the invention of the kind of author event that happens today," he said.

Since the '80s, Harvard Book Store has had its current 5,500-square-foot configuration and the continued adulation of sophisticated, intelligent

Before
publishers started selling regular revisions, the Kramers might have resold the same textbook eight or more times, until it literally began falling apart.

readers. Generally, they don't care so much for the latest Danielle Steel page-turners but will avidly seek out the index-card recommendations that the nerd-hip staff places below a particularly juicy tome. If the author has recently guested on NPR, so much the better.

The operation continues to be nimble, responding to a customer base that it has carefully cultivated over time, and showing prescience in a number of areas, not least of which was the Internet. Go to www.harvard.com and you'll find their Web site, not the University's. Good thing, as Kramer says, that his dad didn't name it "Mark's Book Store."

Frank Kramer's father, were he alive, would doubtless be impressed by his son's stewardship of his once-modest enterprise. In order to extend that legacy, Kramer knew he would need to seek new ownership that would outlast him. Thus, in September of 2008, the keys were passed to Jeff Mayersohn, a semiretired high-tech employee who had adored the store since he courted his wife among its shelves in the '70s. Mayersohn went to a bookstore school and insisted on learning every position in the shop. Kramer obviously chose his replacement carefully.

If the era of a bookstore on every corner is over, then its successor, the era of big chains, may also be dimming. A newfound resurgence in thinking locally has appeared. It is fitting then that Frank Kramer's new job is helping to run Cambridge Local First, a network of locally owned independent shops. Like Harvard Book Store, they are what made Harvard Square what it is. {92, 167}

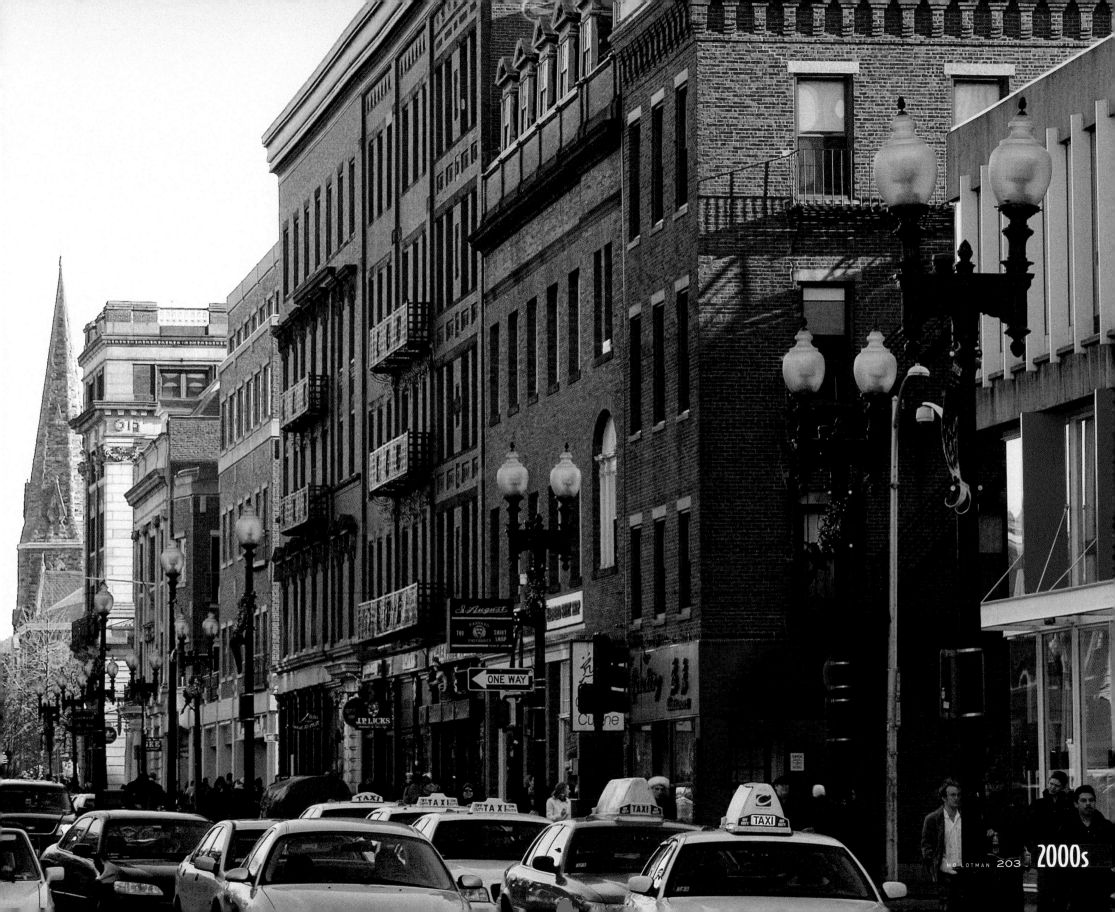

2000s

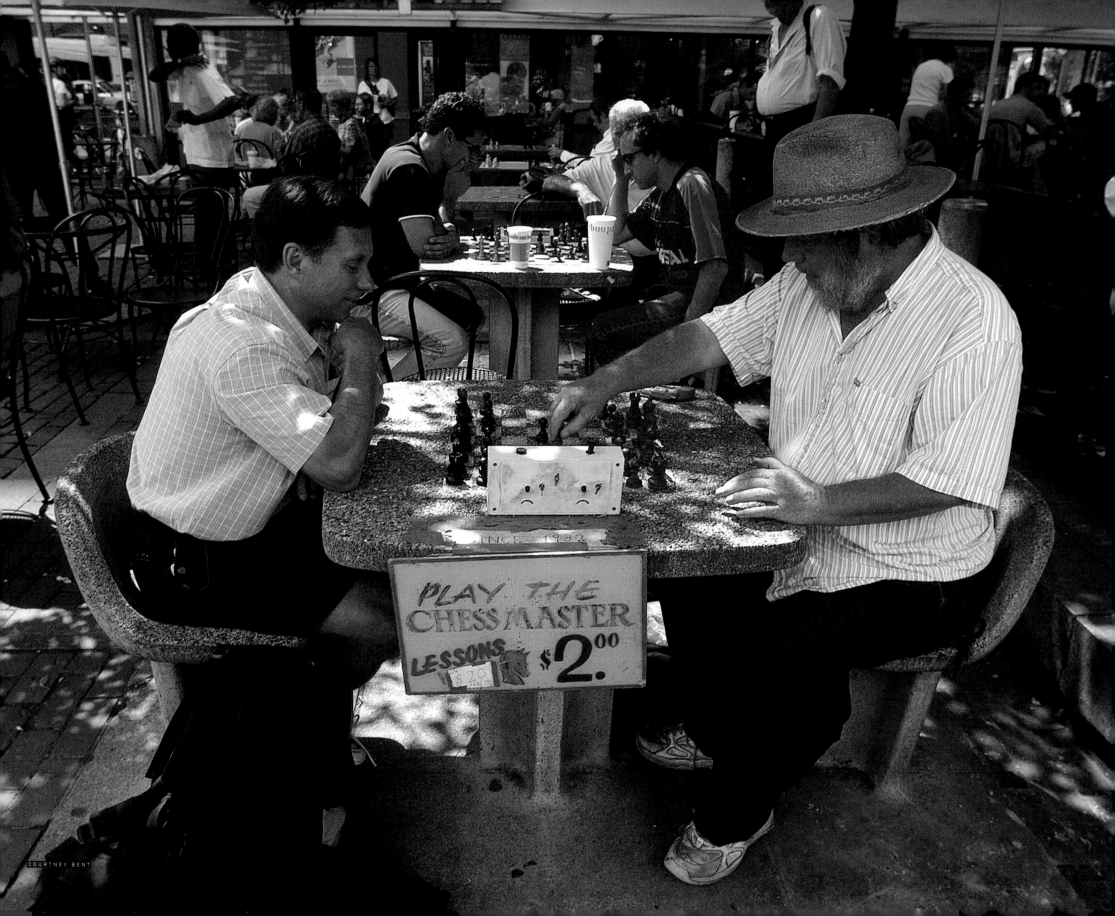

Ⓐ Holyoke Center
Ⓑ Cambridge Trust

Please Help with any change. We live on the street. Still have hopes and dreams. Need to Eat!

CHRIS TESO

THE HOMELESS

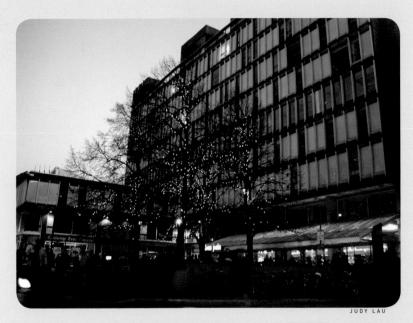

JUDY LAU

🔺 2005 Ⓐ *Chess Master Murray Turnbull begins another game, likely to end in victory. He has been playing the masses in front of Holyoke Center since 1982.* {**134**, 135}

◀ 2005 Ⓐ *Early dusk and holiday lights presage the coming winter on a November eve at Holyoke Center.*

EILEAN SIAR

🔺 2008 Ⓐ *The Holyoke Center Arcade was wisely glassed in in 1999 (prior, it was open air all the way through, a chilly prospect six months of the year). Inside is Harvard's "front door" with an information center, ticket booth, and the Harvard University Press display room. But there have also been shops, like Oggi, which offers pizza and sandwiches.*

"Have a

heart, have a heart, have a heart!" So goes the sing-song plea from the indefatigable Gregory Daugherty (below). If you have spent any time in Harvard Square since 1991, then you have surely seen him in front of Au Bon Pain hawking *Spare Change*, a homeless advocacy newspaper. Daugherty is simply the most visible of a rather resilient breed: the Harvard Square panhandler.

Some, like Daugherty, are salesmen, working the street like a regular job and punching out at day's end. Some are vagabonds, incorrigible youth on their way to something else and looking for a temporary score. Still others dwell here, huddled in sleeping bags in front of the Coop, laying flat-backed on a bench outside the post office, or tucked in shadowy doorways. Harvard Square, with heavy foot traffic, streams of tourists, and liberal attitudes, has attracted a host of homeless and a cottage industry of solicitors.

Butch Lifred worked his corner of Brattle and Church with a soft-sell approach that relied not on slick technique but on his authentic personal charm. "You know what makes him interesting?" asked street performer Brother Blue, "His face, man! It's the greatest face." (216)

His moon wide smile obscured a familiar story that Butch might share in his Louis Armstrong baritone. It was an awe of Harvard's glow that drew him to Cambridge, and personal demons that kept him in its shadow. By the late '80s, he found himself on and off the streets. His struggles with alcoholism took a turn for the worse when his sister was killed. "When that happened, everything wasn't right for me. I just couldn't function or nothing," he admitted.

Eventually, though, Butch went into detox and lived in a halfway house in Brockton, doing the 12-step program and getting sober. Meanwhile, a friend told him about *Spare Change*, where you buy each paper for 25 cents and sell it for a dollar. For about 15 years, he peddled it from his crate on the Cambridge corner. "I got back on my feet with the paper," he said.

The permanence of the Square's street personalities makes for a paradox. The continuity of familiar faces is comforting, even while the underlying realization is unsettling—change is spare indeed. About this, Butch was no Pollyanna. "I always tell people," he said, "Don't deal with long term, right? Deal with short term." He added, "Anything can happen."

For Daugherty, from Boston's Roxbury neighborhood, his horizon expanded. Business must be decent; he's put on some pounds since his two seconds of screen time in *Good Will Hunting*. "Feels good, because I never thought I was going to be in other people's life before," he said, adding of Cambridge that, "It kept me out of harm's way. I got a chance to grow in a way I never thought." One of the things he learned? "How to sit down and do an interview."

On a cold, sunny day, he approaches an attractive woman with a flirtatious "Well, hello young lady!" When rebuffed, there is not a split second of remorse. He moves on to his next mark. A few blocks away, on Brattle Street, the corner is quiet. Butch Lifred passed away in 2007.

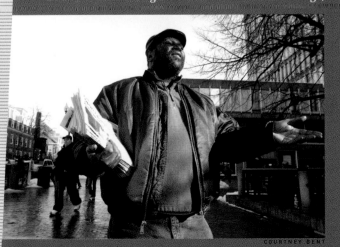

COURTNEY BENT

205 **2000s**

holyoke & dunster sts,

COURTNEY BENT

COURTNEY BENT

COURTNEY BENT

▲ 2005 J *Who doesn't enjoy eating ice cream in a bank vault? This hideaway at Herrell's, painted with undersea murals, is a holdover from the location's days as Reliance Bank.* {57}

▲ 2006 B *The Andover Shop, with an 80-something Charlie Davidson at the helm, still brings in the discriminating preppie.* {*97}

▲ 2006 C *Gino Ruotolo presides over the 19th-century house that has contained his salon since 1972.* {97}

▲ 2008 D *The Hasty Pudding is looking fresh after a recent gutting and makeover.* {19, 57, 170}

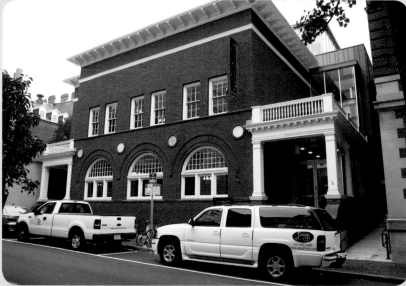

MO LOTMAN

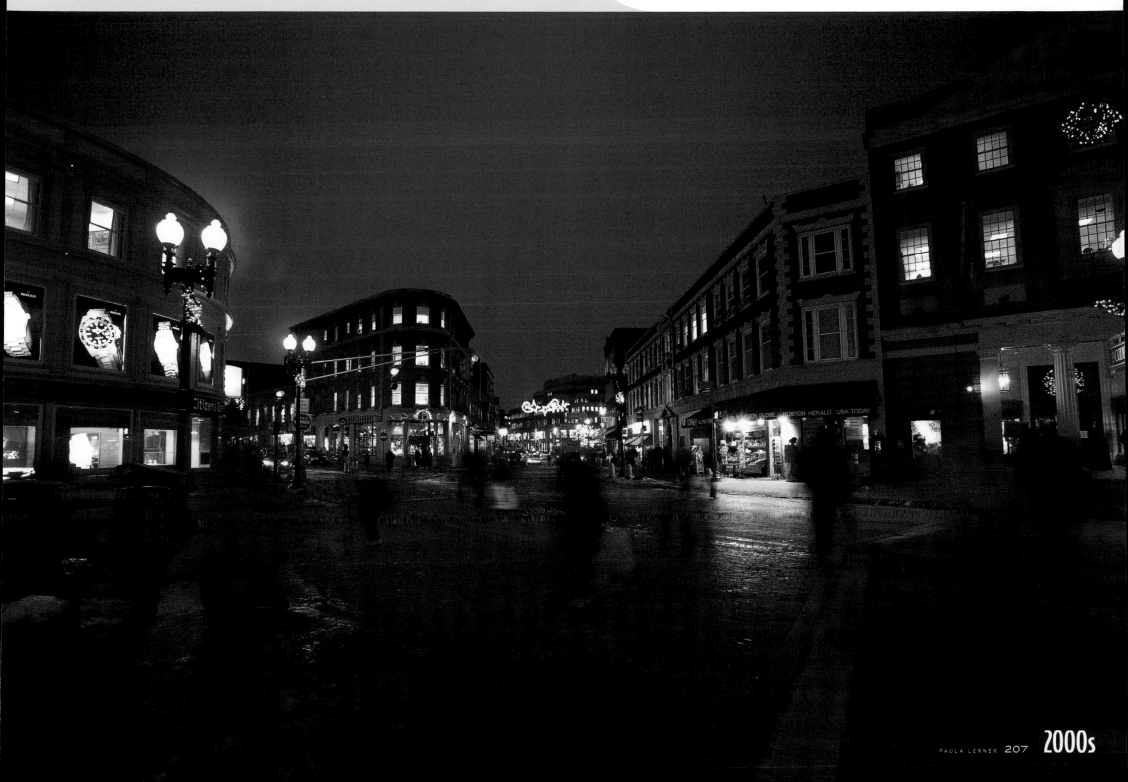

🌀 2007 *The ghosts*
of Christmas present haunt
the Square by twilight.

the center

Ⓐ Out of Town News
Ⓑ The Pit
Ⓒ The Subway
Ⓓ Cambridge Savings Bank
Ⓔ Pacific Sunwear/Alpha Omega

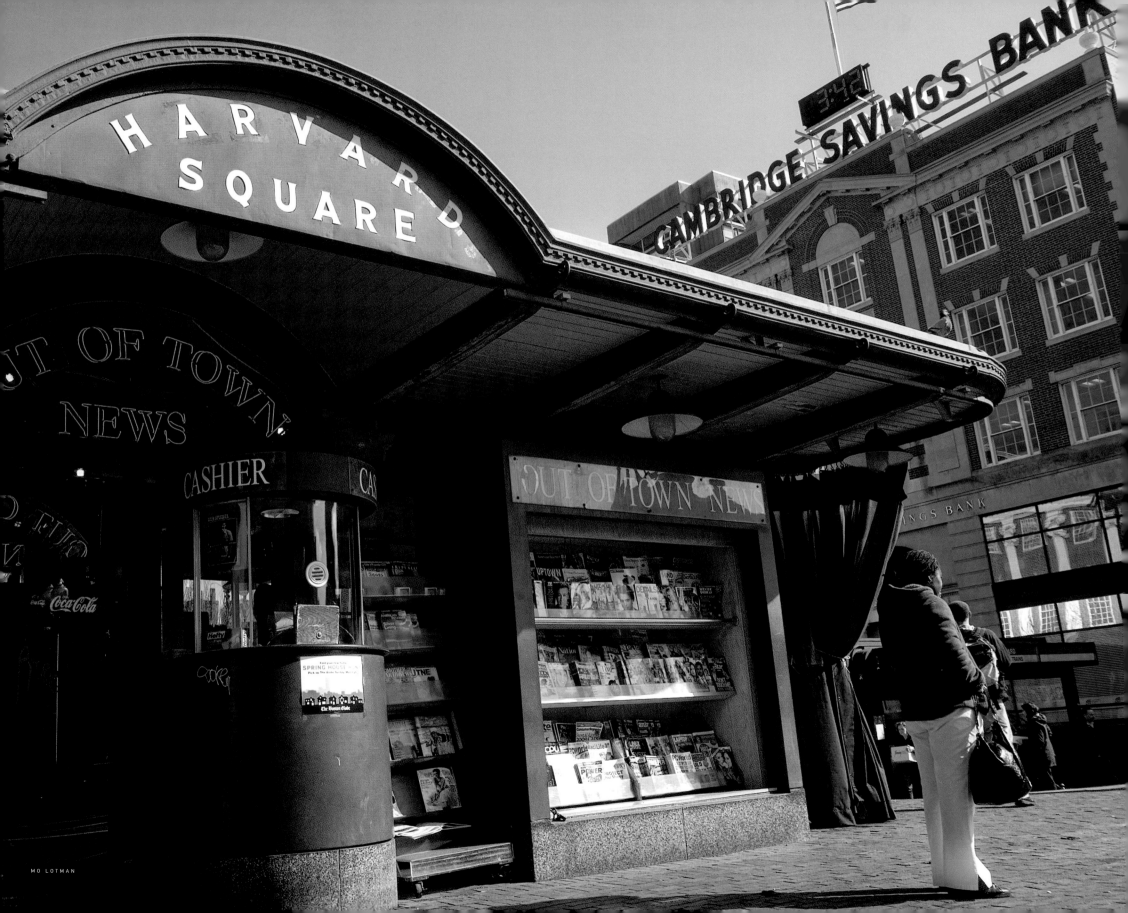

the center

Ⓐ Out of Town News
Ⓑ The Pit
Ⓒ The Subway
Ⓓ Cambridge Savings Bank
Ⓔ Pacific Sunwear / Alpha Omega

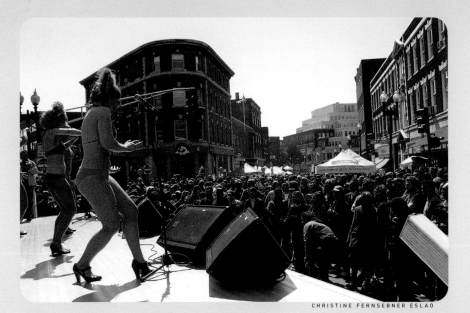

CHRISTINE FERNSEBNER ESLAO

⬆ **2003** Ⓐ *Out of Town News would escape closure after a 2009 sale.* {2, 60, 102, 139}

⬉ **2007** *Witches in Bikinis perform at the annual Mayfair.* {154}

⬉ **2007** Ⓒ *Lights create an interesting pattern inside Harvard station. 14 bus routes and the Red Line connect here.* {**137**}

⬊ **2008** *The Free Hugs campaign, begun in 2004 by Juan Mann in Sydney, Australia, arrives in Cambridge.*

©CHARLOTTE KEYS

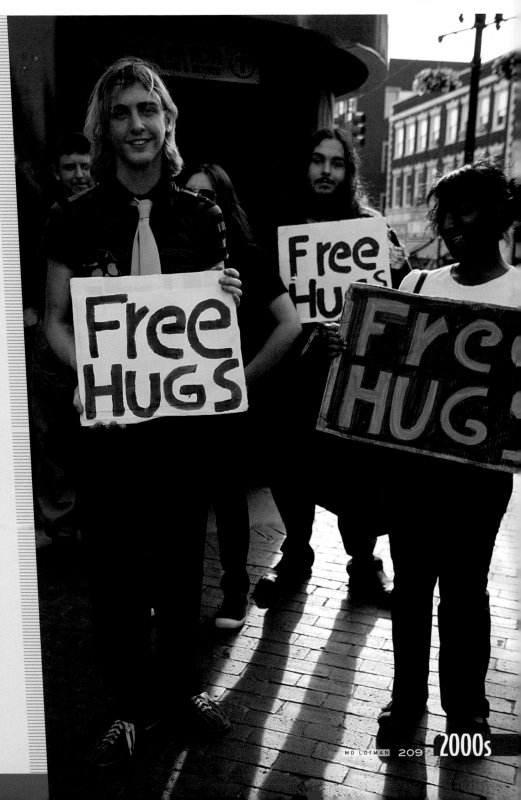

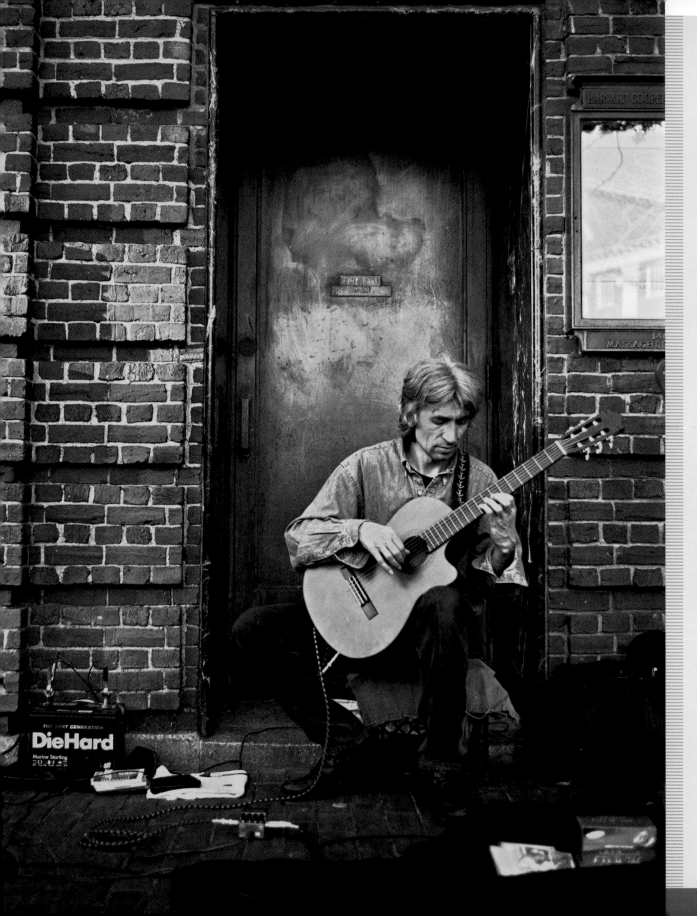

2001

Peter Podobry maintains a keen concentration as he plays classical guitar. He has been a fixture throughout the decade.

2005 Ⓐ

The Coop sparkles at Christmastime.

2008 Ⓐ

Since 1997, the Coop has been devoted to its book business, managed by Barnes & Noble, and always crowded. {24, 66, 104, 177}

upper mass. ave.

- Ⓐ The Coop
- Ⓑ Bank of America
- Ⓒ Sovereign Bank
- Ⓓ CVS
- Ⓔ C'est Bon/
- Ⓔ Finagle a Bagel
- Ⓕ C'est Bon Convenience
- Ⓖ Store 24/T-Mobile
- Ⓗ The Body Shop
- Ⓘ The First Parish Church

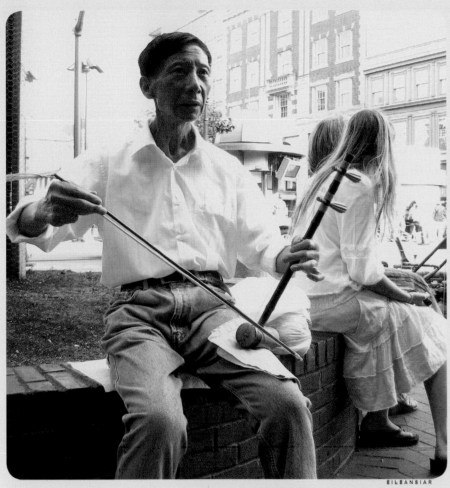

EILEANSIAR

🔺 2008 Ⓐ
The Chinese fiddler has been squeakily planted in front of the Coop since 2001.

🔺 2005 Ⓘ
The First Parish Church hosts an August wedding. {9, 105, 117}

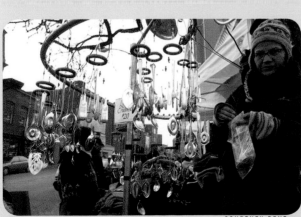

COURTNEY BENT

🔺 2005 Ⓘ The Holiday Fair is a popular annual tradition in front of and in the basement of the First Parish Church, with dozens of booths of local artisans selling unique gifts.

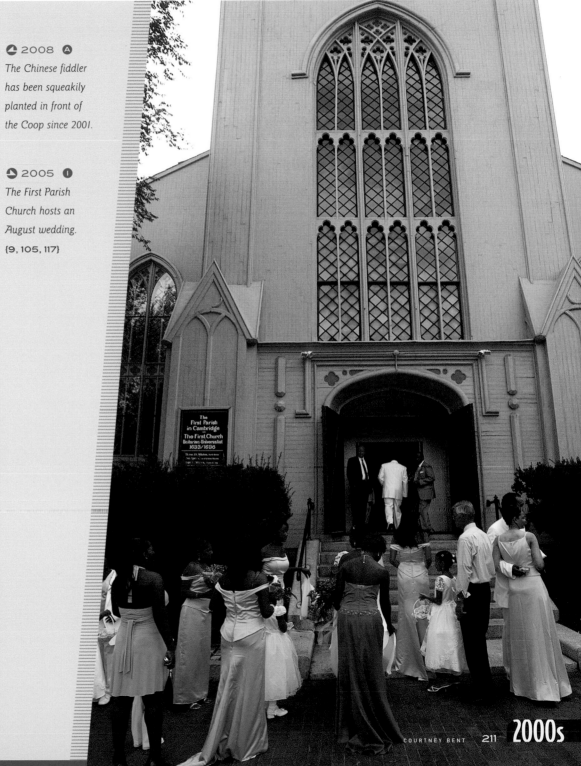

COURTNEY BENT

211

2000s

lower brattle st.

🔺 2005 Ⓗ *Holiday shoppers pass Cardullo's on a snowy evening.*

🔺 2005 Ⓗ *Frances Cardullo waits on a customer ensconced in a virtual cocoon of chocolate at Cardullo's.* {28, 190}

🔻 2005 Ⓕ *An academic young gent peruses the menu at the Greenhouse, two years prior to its closing.* {143}

🔻 2000 Ⓑ *Edmund "Sonny" Capasso mans the counter at Cappy's, a shoe repair joint unfazed by time. Capasso spent 40 years in the family business, which shuttered in 2004.*

CARLETON ATWATER

COURTNEY BENT

FOR WORK LEFT
OVER 30 DAYS

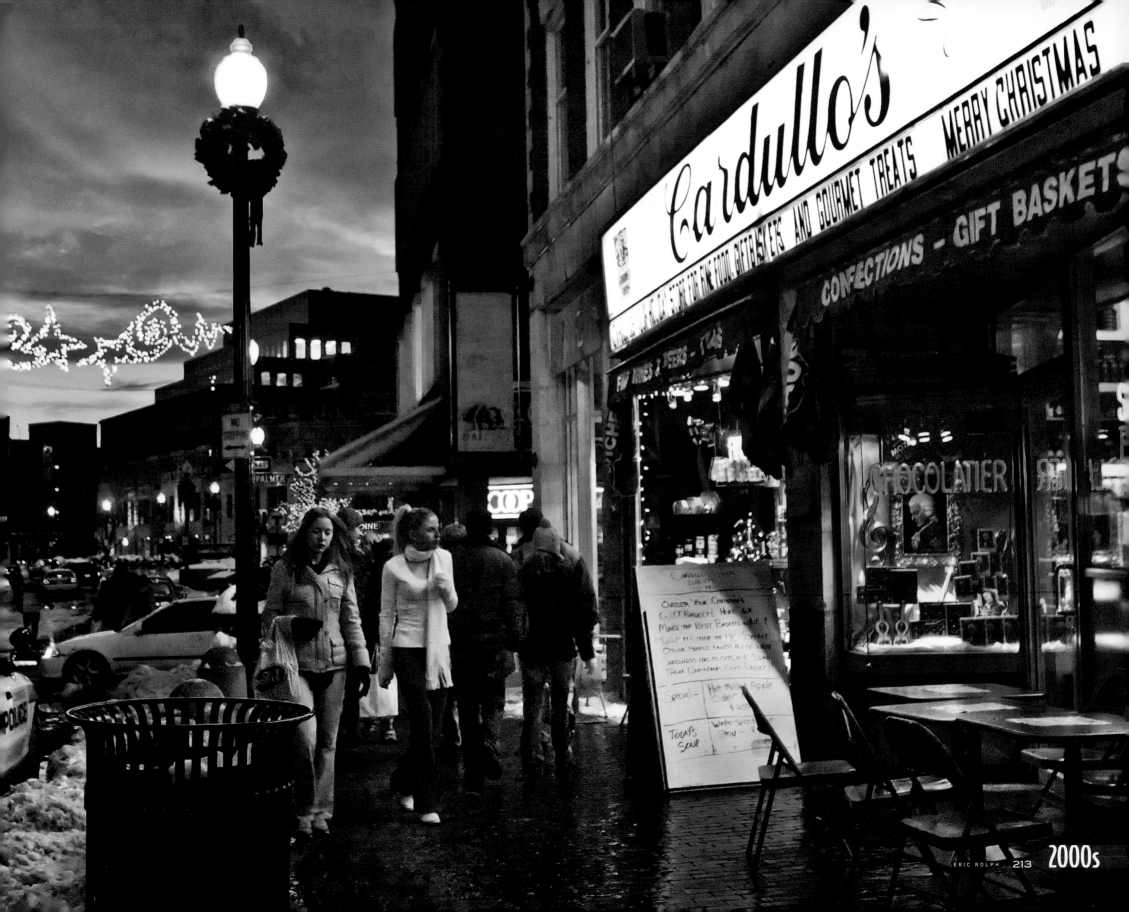

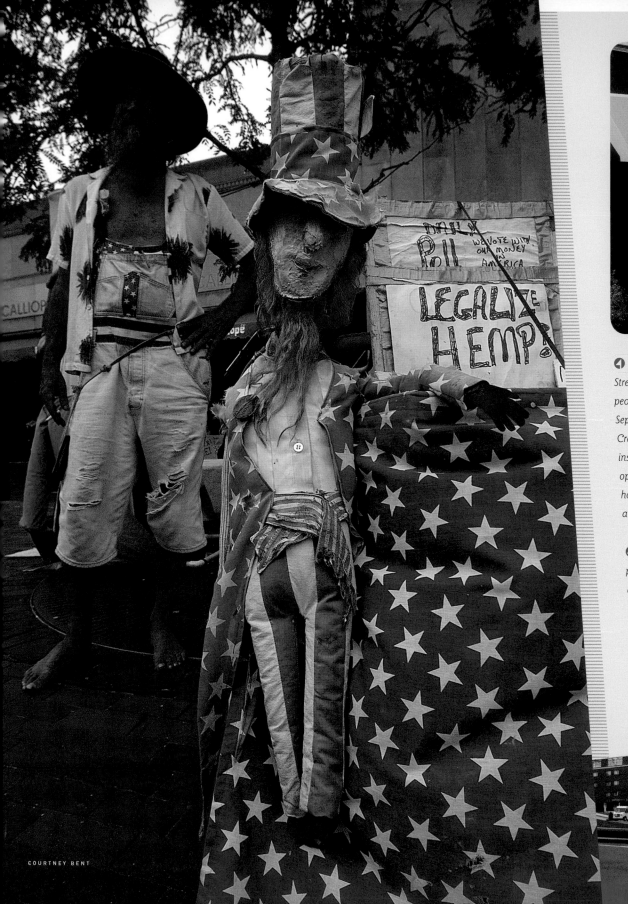

COURTNEY BENT

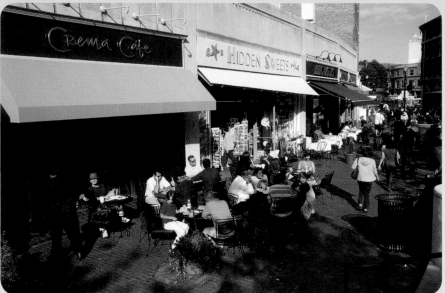

MO LOTMAN

◔ 2008 ⊙ Brattle Street is a great place for people-watching on a September afternoon. Crema Cafe became an instant hit when it opened in 2008 with home-baked goodies and a cozy bilevel interior.

JILL GUCCINI

◑ 2005 Blue, a.k.a. Thomas Newell, has been performing in Harvard Square since 1991 and intends to continue until he dies. If there's anything off-kilter about a 50-something grandfather riding an oversized tricycle and offering political diatribes via a sheet puppet, Blue is under no illusions. "I work to about 1 percent of the population." {145}

◔ 2005 ⊙ There has been a hardware store at 26 Brattle roughly since the 1916 building was erected. The VerPlanck family has operated Dickson Bros. since 1963, more than twice as long as Roy and Paul Dickson themselves.

lower brattle st.

EILEANSIAR

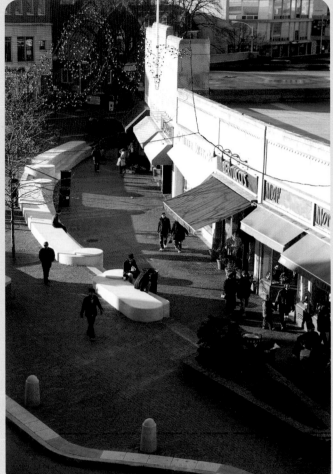

⬅ 2007 *Bill has been crooning war-era classics sotto voce for years.*

◀ 2008 *Christmas lights are threaded like spider silk over a Brattle Street tableau.*

◀ 2008 *Brattle Square is a mix of architectural styles from the '30s, '70s, and '90s.*

MO LOTMAN

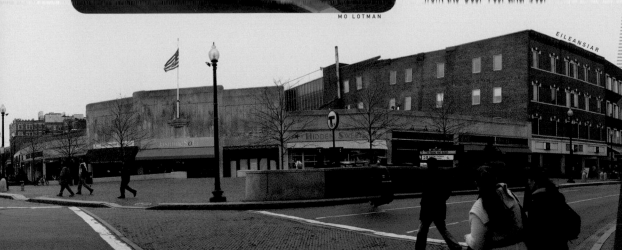

EILEANSIAR

COURTNEY BENT

BRATTLE SQUARE FLORIST

Leave

your notions of quiet preciousness behind when you step into Brattle Square Florist. Unlike your garden-variety flower peddler, this place is bustling. Walls are awash and floors amuddle in greenery to the point of being unnavigable. Stems, clippings, and old newspapers are strewn about as if in a vegetal Chicago chophouse. Someone's on the phone, someone's trimming a bouquet near the fridge, someone is helping a customer, and you are about to get stepped on. "We all had the work ethic," recalled Catie Zedros of her childhood. "We never were home, you know, just lounging around. Never."

They're still not lounging. Catie's clan, including her brother Teddy and her sons Steven and John, have all been part of this evergreen enterprise, which has kept one small corner of Harvard Square lush and verdant for over a century.

The Gomatos family tree has grown a wide canopy in Harvard Square terms. Three brothers arrived in Cambridge in the early 1900s, settling in a wood-frame three-decker right in the Square (since demolished). Stavros Gomatos, Catie and Teddy's father, ran a restaurant. John Gomatos had a fruit stand where Nini's Corner later stood, and George Gomatos started the florist, which also sold fruit. Cousin Nick would later open Christopher's Flowers around the corner on Church.

Cambridge old-timers would stroll in from Brattle Street for their weekly bouquets. Robert Frost bought grapefruits, and an occasional Rockefeller or Vanderbilt might assemble an arrangement. The family business grew to include a family of customers; there is clearly a fondness coming from both directions.

In addition to the regulars, the walk-in traffic, the FTD wire orders, the corporate work, and Harvard plant sales, Brattle Square Florist does special events. But don't expect a long sit-down negotiation. Booking weddings is more a matter of stand and point. Catie explained, "You know, if they say, 'Well do you have any pictures to show me?' when they walk in, I say, 'Here it is.' There's something coming in here every day, so it's fresh," she said. "Totally fresh."

Catie's son Steven Zedros, representing the third generation, is unfailingly warm and polite. He will duck through the loamy air and snatch an amaryllis here, a gerbera daisy there, and briskly provide you the bouquet that you didn't realize you wanted, and could not have invented yourself. Because flowers are so often about showing love, it's a slightly freighted transaction. When it goes well, gratitude runs deep. With Steven, you can see it flows both ways. It's rare not to find him there, which makes one wonder, does he ever wear out? "Even as you grow old, you never get tired because it's so full of energy with all the kids coming in," he said. "It still has the mystique." {70}

2000s

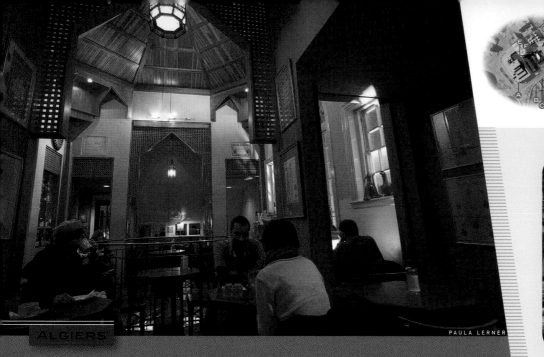

ALGIERS

PAULA LERNER

Ⓐ Express/EMS/Citibank
Structure/Chipotle
HMV/EMS
GNC
Wainwright Bank
Ⓔ Calliope
Baak Gallery
Ⓒ Jasmine Sola/Tannery

Ⓓ April Cornell/Caché/
Passport
Brattle Theatre
Casablanca
Algiers
Ⓕ Camb. Ctr. for Adult Ed.
Ⓖ Harvest Restaurant
Ⓗ Utrecht/City Sports

Ⓗ Ann Taylor
Ⓘ Harnett's/
American Apparel
Colonial Drug
Custom Barber Shop
Hillside Cleaners
Museum of Useful
Things/Upper Crust

The contra-

puntal latticework of Johann Sebastian Bach's organ pieces swirled first through Emile Durzi's fingers, then lodged in his mind, and now loft to the vaulted ceiling of his café, Algiers. "It's very important to tune a place," he said.

The image of resonance is meaningful to the former church organist and engineer Durzi, who has written a paper comparing Bach's masterworks to the architectural shapes we find pleasing. In a much less esoteric way, he has been tuning his coffee shop all along to the frequencies of his aesthetic sensibilities and those of his patrons.

Algiers has developed, sonatalike, from its earliest form. It opened in 1971 in the basement of the Brattle Theatre complex, in the original space of The Blue Parrot, one of the first places in the Square with dark roast. A year or two later, a below-grade patio with a stone bench appeared. Around 1975, it expanded into the old boiler room and office and introduced hummus to Cambridge.

When the entire complex was hollowed out in a massive 1990 renovation, Algiers reemerged in high baroque, a two-story ecumenical temple to the ritual of coffee. The totemic copper espresso machine—originally gas-fired—remained central. Today that metal leviathan is just for display, and smoking has long been banished from the upstairs den. But religious music, of any stripe, still gambols

lightly in the background because, Durzi believes, it "makes people humble."

That humility will come in handy while waiting for your server; there is a distinctly relaxed sense of time in Algiers. On the other hand, for the poets, readers, and romantic linger-ers, the unhassled rhythm is worth the pricey arabic coffees, strawberry frappes, and mint teas that are gradually savored. "Each customer feels like a king in his corner," said Durzi.

Born in Haifa, raised in Cairo, Durzi fell in love with coffee shops in Ostia, Italy, while also admiring the Turkish café style. Drawing from the diversity of these cultural skeins, he has woven a tapestry of sensual detail: lush scarlet walls, tasteful original artwork, mirrored panels, and decorative hookahs. It is all part of creating a haven for wanderers, such as Durzi himself sought as a lonely foreigner arriving in the United States in 1960. That, in fact, is the source of the name. "Algiers means island," he explained.

His success in creating that space is reflected in the accents that gently tumble from the tables. Though little discussed in local media, his café is often cited in European guidebooks. Durzi himself is world-traveled and erudite. Nonetheless, there is one place he's never managed to visit: Algiers. {74, 149, 183}

An Icelandic carpenter named Thor created custom jigs in order to hand-assemble the striking octagonal tables.

©2000 GLOBE NEWSPAPER COMPANY

↰ 2000　Ⓒ *Owner Phyllis Madanian and pharmacist Bob Landers share a smile at Billings & Stover near the end of its 147-year run.* {84, 114}

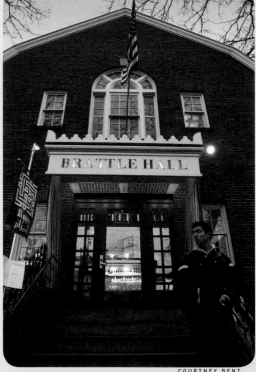

BRATTLE HALL

COURTNEY BENT

↰ 2005　Ⓔ *Brattle Hall, housing Algiers, the Brattle Theatre, and Casa-blanca, glows at dusk while a man pauses for a cigarette. Cambridge went smoke-free in 2003.* {31, 72, 148}

↰ 2005
Butch Lifred sold Spare Change at the corner of Church St. for about 15 years.
{205}

COURTNEY BENT

↰ 2002　Ⓘ *Joseph Botindari opened Colonial Drug in 1947. Now run by his children J. P. and Cathy, it is a secret cache of over 1,000 hard-to-find fragrances and high-end shaving supplies.*

↰ 2005　Ⓔ *The window at Calliope is a pun-filled display. Ann Lerner opened the children's shop in 1972.*

COURTNEY BENT

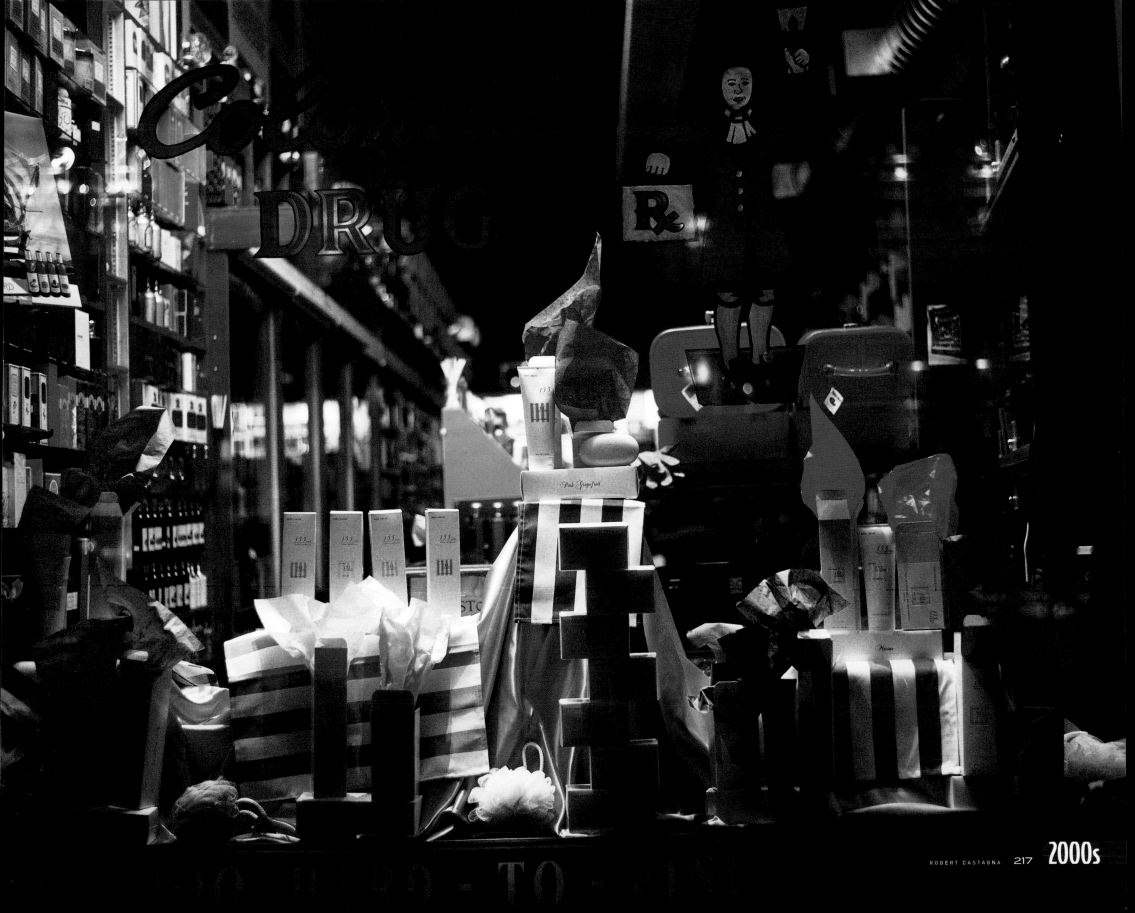

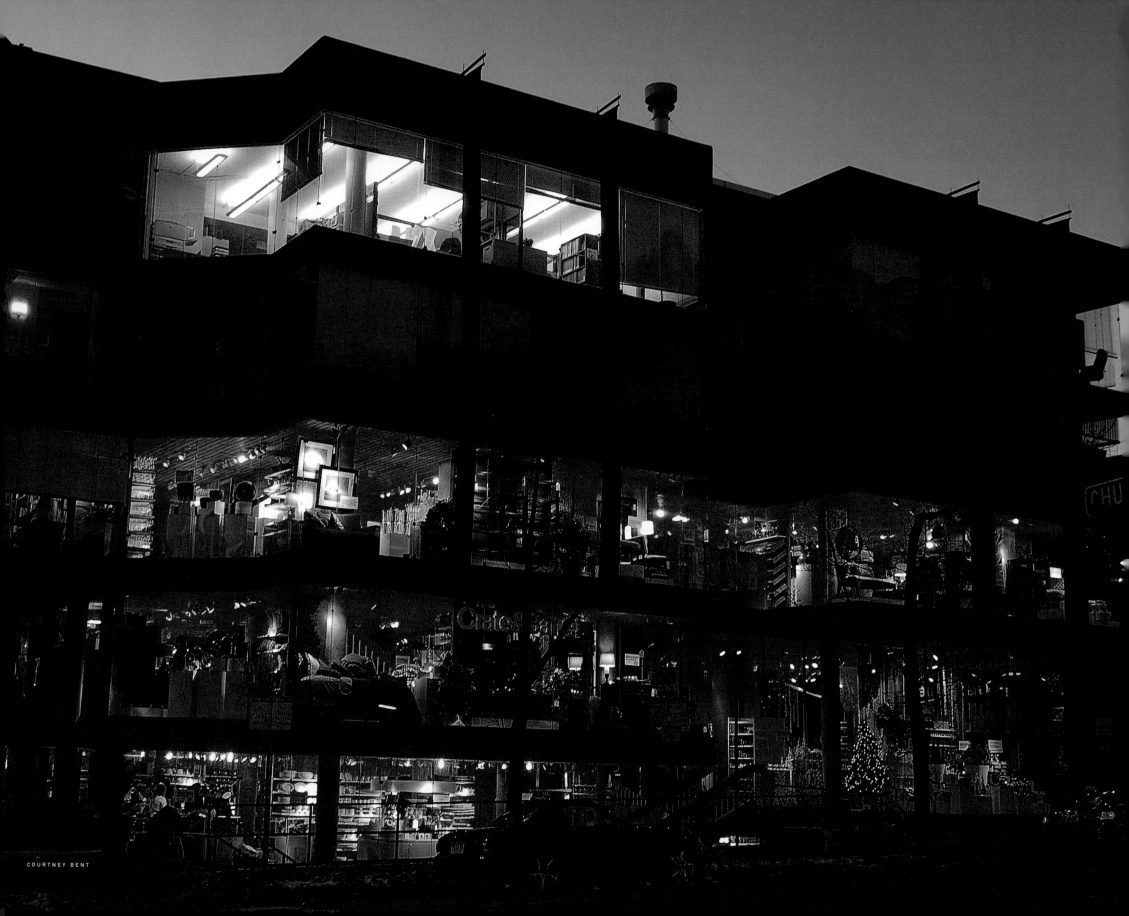

- **A** Crate & Barrel
- **B** Clothware
- **C** Café of India
- **D** Settebello
- **E** L.A. Burdick
- **F** Hi-Rise Bakery

2005 **A** *Crate & Barrel occupies Benjamin Thompson's award-winning building. The housewares chain would vacate this space after nearly 30 years in 2009.* {★112}

2005 **E** *A group enjoys L. A. Burdick's hot chocolate, an super-rich confection that has become a new Harvard Square tradition.*

2008 **F** *Holly Fair, the annual holiday crafts market, is put on by the Cambridge Center for Adult Education.*

MO LOTMAN

COURTNEY BENT

2008 **C** *Cafe of India has offered upscale eats since the early '90s.*

2008 **F** *Longfellow's famous 1839 poem "The Village Blacksmith" was immortalized in iron by Dimitri Gerakaris in 1989 (right). Dexter Pratt, the real-life blacksmith who inspired the verse, toiled "under a spreading chestnut tree" next to his home and workshop at 56 Brattle (above), which the sculpture now faces. The house was long home to the Window Shop and currently rented by Hi-Rise Bakery.* {32}

EILEANSIAR

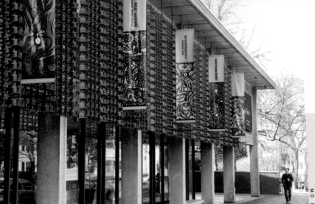

Ⓐ American Repertory Theatre

AMERICAN REPERTORY THEATRE

MO LOTMAN

● 2007 Ⓐ *Paul Benedict plays Hirst in Harold Pinter's* No Man's Land. *Henry David Clarke stands behind.*

◢ 2004 *Robert Brustein can be proud of an enduring legacy in American theatre.*

◣ 2006 Ⓐ *Riccardo Hernandez designed the striking sets for the ART's take on* Romeo & Juliet.

< ROSE LINCOLN/HARVARD NEWS OFFICE

T. CHARLES ERICKSON

Robert

Brustein, the founder of the American Repertory Theatre, is comfortable creating controversy. Provoking reactions, even when they include walking out of a show—as half the audience once did during a preview of Robert Wilson's *Civil Wars*—is all part of good theatre. Sometimes it's even part of baptizing an entire theatrical company. After a public rift with Yale, Brustein transplanted nearly the entire Yale Repertory Theatre, which he had founded in 1966, to Cambridge. The ART has been a training ground, a top resident theatre, and a firewall against what Brustein saw as the corrupting influence of Broadway, ever since.

His legacy has long outlasted the Yale president who dismissed him. As a nonprofit enterprise, the ART is freed from the constraints of commercial viability, and can devote itself to "advancing the art of the theatre," as Brustein put it. If that sometimes came with a cost—such as nearly half the membership canceling subscriptions after season two—then so be it. Where else can you watch a play that premiered in 430 B.C., such as Peter Sellars's 2003 production of Euripides's *The Children of Herakles*?

Despite the sometimes challenging fare, the ART did in fact win back audiences, accolades, and influence, even sending some productions, such as *Big River*, to the sometimes maligned Broadway. With a Tony, a Pulitzer, and a Jujamcyn award

under its belt, the *New York Times* called the ART "one of the leading resident companies in the country." *Time* thought it "perhaps the nation's most prestigious regional theatre." The National Endowment for the Arts gushed that it was "unsurpassed in exemplifying excellence in theatre," while handing it $1.6 million in grants in 1985 alone.

Sellars, an acclaimed and innovative director, himself is an ART example of excellence, staging one of the first season's plays, *The Inspector General*, while still a Harvard senior. That was pay dirt for Brustein's vision of a University-based troupe—discovering and developing new talent from the student body. Amazingly, prior to the ART's arrival in 1980, there had never been any for-credit theatre courses in Harvard's history.

This confluence of theatre and academia is the crux of what sets the ART apart. Brustein compared it to a research hospital, only in this case the patient is the dramatic arts. It helps to do that research with a group of people you can rely on, who will work together, and who are willing to take risks. Thus the resident company. Explained Brustein, "You know each other's plays, like a fine basketball team."

The teams that have come out of the ART have included some of the craft's finest directors, actors, designers, and productions. Marsha Norman's *'night, Mother* premiered here with Kathy Bates and took home the 1983 Pulitzer Prize for drama. Philip Glass's 1985 opera *The Juniper Tree*, directed by Andrei Serban, also was launched to critical acclaim. David Mamet directed the premiere of his own *Oleanna* in 1992. Anna Deavere Smith, Cherry

Jones, Felicity Huffman, F. Murray Abraham, and Christopher Walken are just a few of the notable actors who have graced the stage.

When Brustein finally stepped down as artistic director in 2002 (he remains active as founding director), he was replaced by Robert Woodruff, who shared the vision of breaking boundaries. With an interest in experimentation, deconstruction, and improvisation, he said at the time, "I want to know what's possible in theater, in music, and in history."

During his term, the ART added another jewel to its collection with the construction of a sparkling, $18 million complex at Zero Arrow St. in 2004. This 80' x 60' black-box theatre with movable seating pods is the ART's farm venue, where new productions by promising playwrights can be workshopped, alternated with occasional cabaret evenings.

If some were concerned that the ART had gotten comfortable or less relevant over the years, the 2008 appointment of Diane Paulus as the third artistic director sent a message that it was forging bravely ahead. Paulus's previous works include an opera version of David Lynch's *Lost Highway*, and *The Donkey Show*, an adaptation of *A Midsummer's Night Dream* that was performed in nightclubs to disco music, replete with seminude dancers. She said "ART needs to feel startling and radical again."

It is clear that the American Repertory Theatre has no intention of ceding the stage. Neither does Brustein, now in his eighties, whom some call the godfather of American theatre. "You present yourself to an audience as part of its family, and you both long for the next reunion."

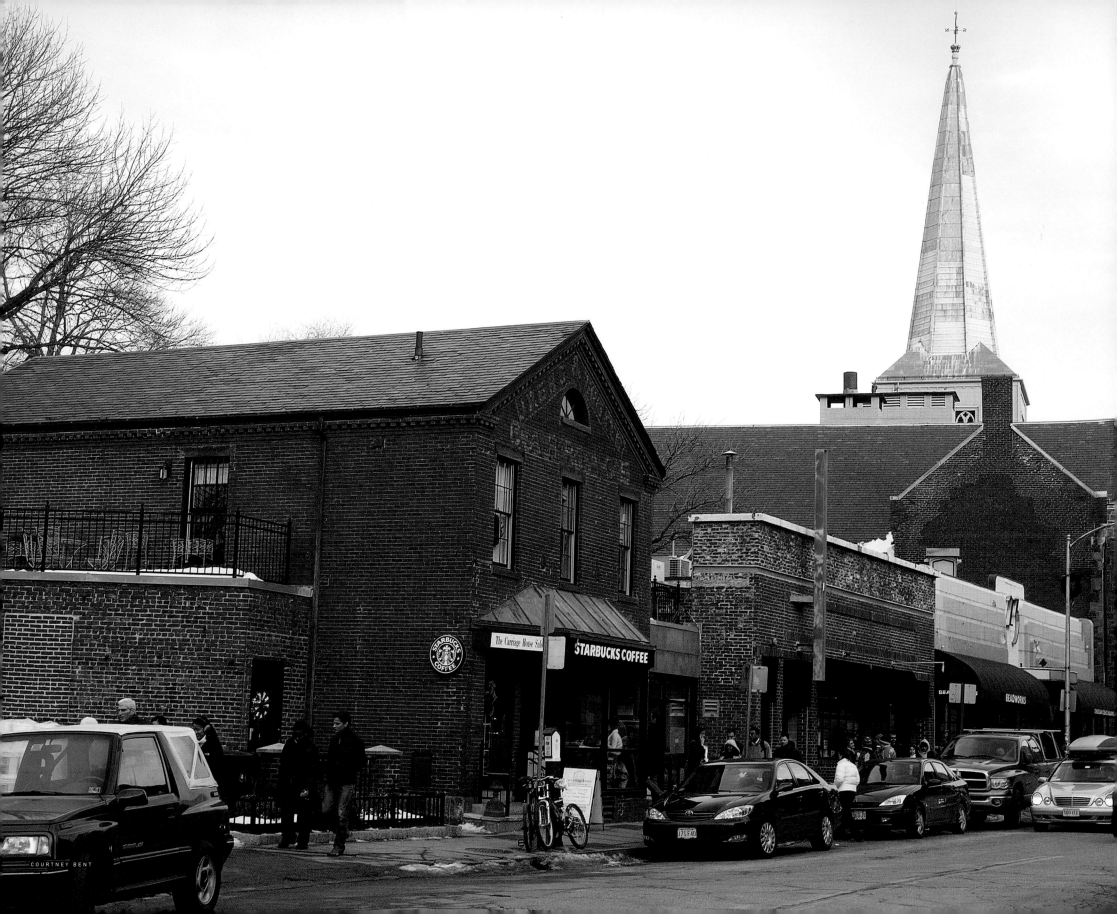

church St.

- Ⓐ Globe Corner
- Ⓑ Bookstore/LFS Stores
- Ⓒ Harvard Square Theatre
 Hidden Sweets/
- Ⓓ Mint Julep
 Starbucks
- Ⓓ Carriage House Salon
 Underground Camera/
- Ⓔ Lizzy's
- Ⓕ Cambridge 1
 Beadworks
 Christian Science
 Reading Room

🔺 **2005** Ⓔ *Church St. benefits from wider sidewalks and new businesses. Cambridge 1 (with the two black awnings), a trendy flatbread pizza restaurant, opened in 2001. The name came from a stone lintel uncovered during renovation. It had been saved from an 1854 fire station previously on site and incorporated into the 1922 brick building, then stuccoed over, where it remained hidden for over 50 years.* {*79}

CHRISTINE LIU

🔻 **2006** Ⓓ *Lizzy's casts its cones into the Square's discerning ice-cream market.*

🔺 **2008** Ⓒ *Mint Julep is one of a handful of locally owned boutiques that sprang up in the latter half of the decade.*

🔻 **2008** *The World's Longest Sofa, at over 168 feet long, visited Harvard Square for Oktoberfest, where it stretched along an entire block of Church St.* {154}

Rocky

Horror and Halloween go together like Santa and Christmas. The Halloween show is put in Theatre One, where it sells out all 560 seats annually.

MO LOTMAN ANTYDILUVIAN

ROCKY·HORROR

If there

is a place where a man in lipstick and fishnets would not raise eyebrows, Harvard Square is probably it. But since Friday, April 13, 1984, there has been added incentive to dress in drag: *The Rocky Horror Picture Show*. The Harvard Square Theatre has hosted a midnight showing of the cult film every weekend since.

Much has been made of the unlikely following for this bizarre 1975 musical about the transvestite omnisexual doctor Frank-n-Furter and his cohorts. Suffice it to say it is principally a gateway to controlled debauchery, especially for people who need an excuse for such things.

By now, many people are familiar with the drill: throw rice during the wedding scene, toast during the toast, and shout out raunchy lines to fill the spaces in the dialogue. The ritualistic audience participation has long been a cottage industry, with a group called the Full Body Cast selling goodie packs for a dollar and performing costumed, line-by-line mimicry in front of the screen. What the 80 to 100 audience members might not realize is that it takes about 30 people to orchestrate security, costumes, props, and lights every Saturday night. Throw in the alternates, and there are almost 90 people who belong to the Full Body Cast, not one of whom makes a dime from their devotion.

Though *Rocky Horror* is not an event unique to Harvard Square, this version does boast certain distinctions. Arthur Laurie (right) has yet to turn up anyone who has played Brad longer than he has—since 1979, when the cast (then unnamed) was about two years into its run at the now-vanished Exeter

Theatre in Boston. They believe theirs is the longest continuously performing troupe in the country. The Harvard Square Theatre also has the rare prestige of having hosted a 1980 revival of the stage production that inspired the cult movie.

The obvious question in all of this is, "Why?" Gary Greenbaum, who estimated he's performed in 1,500 shows over the last 14 years, said, "I joined out of sheer boredom." For others, the cast is like family. So much so that in some cases, they have actually become family; in 1986 there was a wedding of two performers during the show. Meredith Wish, a newer

MO LOTMAN

recruit who had to get her grandmother's permission to join the cast at age 17, described a social redemption: "I was awkward and weird," she said, and at *Rocky Horror* "awkward and weird's, like, cool!"

MO LOTMAN

BORDER CAFE

MO LOTMAN

BORDER CAFE

Ⓐ Border Cafe
Ⓑ Fire & Ice
 Rock Bottom Brewery/
 Dado Tea
Ⓒ CD Spins/On/TisTik
Ⓓ The Swiss Watchmaker
Ⓓ Rizzo Tailor
Ⓔ Cambridge Artists Cooperative
 Lee's Sandwich Shop
 Bob Slate, Stationer
Ⓕ Sage's Market/The Spint Store/
 The Square Market

Church St.

◀ 2000 Ⓕ *Charlie Sage rings up one of the last customers at Sage's after 92 years.* {35, 150}

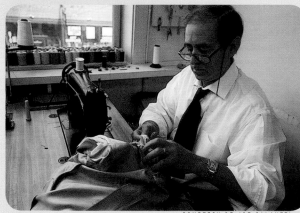

COURTESY OF JOE CALAUTTI

◀ 2008 Ⓕ *The Square Market, open 24 hours, gives the neighborhood a vital service missing since Sage's closed (right).* {*35}

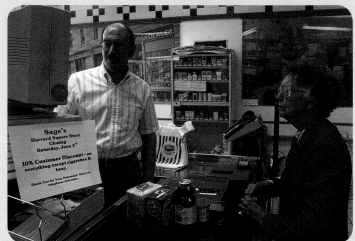

©2000 GLOBE NEWSPAPER COMPANY

To a cynical

eye, the Border Cafe is about as contrived as can be. It has all the elements of your average American megachain, cantina-style—bare wood, hokey wall murals, and Christmas lights. In reality, it is a Harvard Square original (there are six restaurants now), and their flour tortillas, salsa, and chips are made on-site. In terms of sheer volume, it is probably the most popular restaurant in the Square.

If you are looking for an authentic cultural experience, you are surely in the wrong place, and perhaps the service is overfriendly. But it's hard to argue with success. The place has been packed, night after night, pretty much since opening day in 1987. Finding a crowd waiting outside for tables on weekends, pagers in pockets, is as reliable as the tides. Peek inside the windows and the decidedly young-skewing crowd will be imbibing, jostling, and shouting to hear each other, while an army of waitstaff negotiates the bilevel terrain as if in an Aaron Sorkin teleplay. The margaritas are enormous, if mild, and the Cajun-Tex-Mex food is relatively cheap, plentiful, and better than expected. It is, in a word, fun.

However the buzz began at the Border, in over 20 years it has not abated. Snobs will steer clear, but for the rest, it's a tradition that never goes out of style.

◀ 2002 Ⓓ *Joe Calautti keeps the spool spinning at Rizzo Tailor. The Calabrian immigrant was hired by Rizzo in 1964 and has owned the shop since 1973, attracting a roster of high-end clients such as John Kerry.*

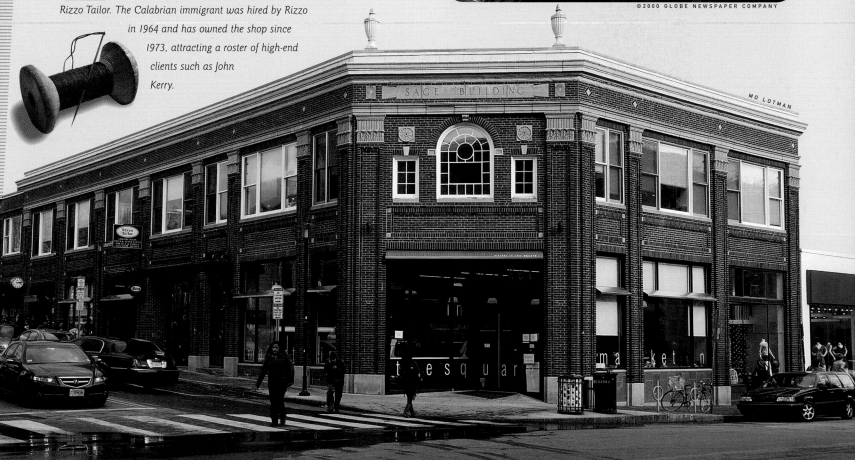

MO LOTMAN

winthrop st.

Ⓐ Pinocchio's
Ⓑ The Galeria
Ⓒ The House of Blues/
Tommy Doyle's
Ⓓ The Red House
Ⓔ Winthrop Park

Ⓕ Grendel's
Market Theatre/
Upstairs on the Square
Ⓖ Caffe Paradiso/
Shabu Square

EILEANSIAR

⬆ 2007 Ⓓ *The Red House is another in a new crop of restaurants. The converted c. 1806 residence has working fireplaces and landmark designation.*

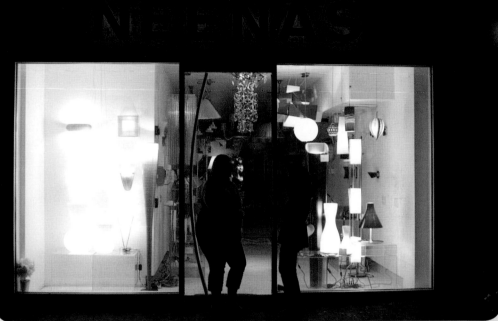

MO LOTMAN

⬆ 2009 Ⓐ *Pinocchio's has been a hidden fave, with its Sicilian slices, since 1966.*

⬆ 2008 Ⓔ *Guitarist Charles Locke serenades Winthrop Park loungers on a June afternoon.*

MO LOTMAN

MO LOTMAN

⬆ 2008 Ⓔ Ⓕ *Grendel's offers terrace seating overlooking a lush summer panorama at Winthrop Park. {86, 121, 153, 186} On the far left is Om, a trendy lounge and nightclub that opened in 2006.*

↗ 2008 Ⓑ *Two young women are silhouetted by Neena's lighting while coordinating late-night party plans.*

⬆ 2006 Ⓖ *Caffé Paradiso was a European-style café with delicious hot drinks, gelato, cakes, and pizelle. It closed in 2007 after 23 years.*

EILEANSIAR 225

2000s

jfk st.

⬥ 2008 ⒶⒷ JFK St. is often a visual mishmash.

⬥ 2008 Ⓔ A self-proclaimed modern-day healer practices on the street.

⬥ 2007 Stickers make for a colorful collage on the back of a street sign.

EILEANSIAR

EILEANSIAR

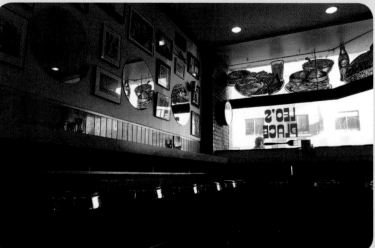

⬥ 2006 Ⓘ Leo's Place sits virtually unchanged since the early '70s. Leo Piantes sold it to brothers Richie and Raffi Bezjian in 1982, who cater to a fiercely loyal mix of police, tradesmen, and professors, mixed with the occasional celebrity. With comfort food and counterside warmth, they have made friends all over the world.

COURTNEY BENT

MO LOTMAN

jfk st.

A
Shay's
Alo
For Eyes
Doma Liquors
B
Planet Records
Carib. Afr. Creations/
Boston Tea Stop

B
University Typewriter/
Raven Used Books
The Harvard Shop
C
Bangkok House/
9 Tastes
Berk's
D
Iruña/Small Plates

▲ 2004 **A** Shay's is a cozy European-style pub and wine bar that has enticed with its patio seating and relaxed vibe since the '80s.

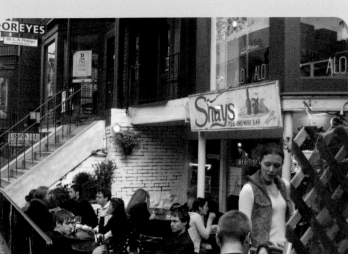

ANTYDILUVIAN

▲ 2006 **B** 52–54 JFK grabs the last rays of a winter sun. {*121}

▲ 2008 **B** Raven Used Books, which opened in 2005 against all trends, prides itself on its philosophy section.

▲ 2007 **B** The Boston Tea Stop offers some colorful varieties of bubble tea.

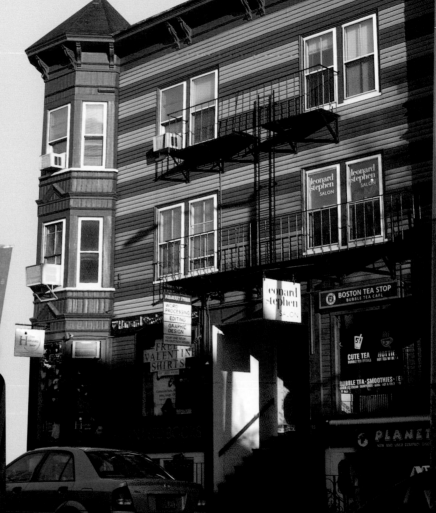

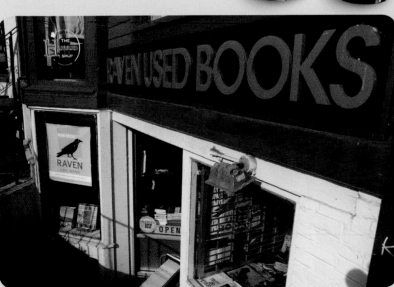

MO LOTMAN

COURTNEY BENT

Ⓐ Daedalus
Ⓑ Tommy's Value
Ⓒ Cambridge Cleaners
Ⓓ Tommy's House of
 Pizza/Papa's/Trata
Ⓔ *The Harvard Lampoon*
Ⓕ STA Travel
 Harvard Square Optical

Ⓖ Tennis & Squash Shop
Ⓗ The Wrap/Boloco
Ⓘ Schoenhof's
Ⓙ J. Press
Ⓚ University Typewriter
Ⓛ Harvard Provision
 The Skewers/
 Harvard Library Admin.

THE TENNIS & SQUASH SHOP

You could

frequent Harvard Square for years and never notice The Tennis & Squash Shop at 67A Mt. Auburn St. And yet, with little fanfare, this small boutique has persevered as a shrine to its sport and the luminaries thereof since 1924. Harry Cowles, Harvard squash instructor, partnered up with a man named Everett Poeckert to start the business, which originally was closely linked with the University and its squash program.

Generations of students came through its doors to buy their racquets, get them strung, and, eventually, if they were successful, hang them back on the walls much the way Clapton might give his guitar to the Hard Rock Café. It was Poeckert who started the tradition of collecting racquets and creating the gallery of sepia-toned team photos that still adorns the walls. "Any time there was a major championship we always tried to get the racquets donated," said Carl Fuller, who continued the hall-of-fame theme after taking over the shop in 1968.

At the time it was the number one tennis retailer in the nation. It almost didn't survive the riots. "We were plywooded in for three months," said Fuller, calling it "scary times." But survive it did, and though the students don't come in as much as they used to, the store, under the ownership of Bob Hare since the early '90s, is still catering to a strong and varied client base.

"I'll tell you what I bought...that stewardship," says Hare, cognizant that loyal customers will keep coming just because of its history. He keeps adding to that history, although he has run out of wall space to accommodate it all. "I've had people come in and offer me two-three thousand dollars for some of these racquets. I can't sell them. You know? And I wouldn't want to. It is part of what this whole store is all about." {38, 82}

🔺 2005 Ⓖ *Bob Hare readies a racquet for stringing at the Tennis & Squash Shop.*

🔺 2006 Ⓘ *Over 700 languages are represented at Schoenhof's, the nation's oldest foreign-language bookstore. Founded in 1856 in Boston, it has been in Harvard Square in 1941 and at this location since 1984.* {133}

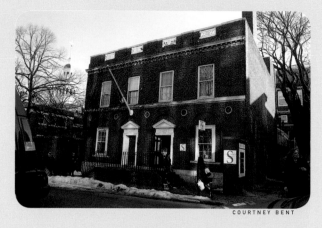
COURTNEY BENT

🔺 2008 *Garage signs add splashes of color to the night.* {120, 162, 226}

MO LOTMAN

🔻 2005 Ⓖ Ⓗ *67–73 Mt. Auburn, with the green awnings, houses the Tennis & Squash Shop and, upstairs, Harvard Student Agencies, which publishes the renowned Let's Go budget travel guides.* {*82, 38}

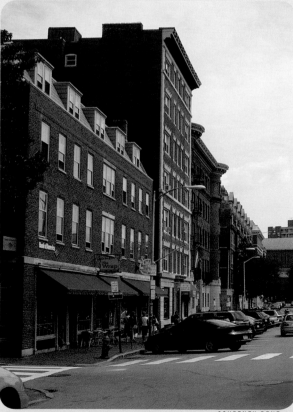
COURTNEY BENT

mt. auburn st.

SARINEE ACHAVANUNTAKUL

🔼 2005 Ⓒ *The Million Year Picnic invites you to geek out on comic books and graphic novels. The shop is about 30 years old.*

🔽 2009 Ⓖ *Trolley bus wires still cross the sky near Mifflin Place, where one can access the walkway connecting Mt. Auburn to Brattle via the Harvest Restaurant.* {✱**160**, 182}

🔽 2008 Ⓑ *Peet's Coffee was part of the Winthrop Park renovation, which involved moving and rotating the wooden structure to replace the razed Holy Cross Armenian Church.* {✱**193**, 83, 125}

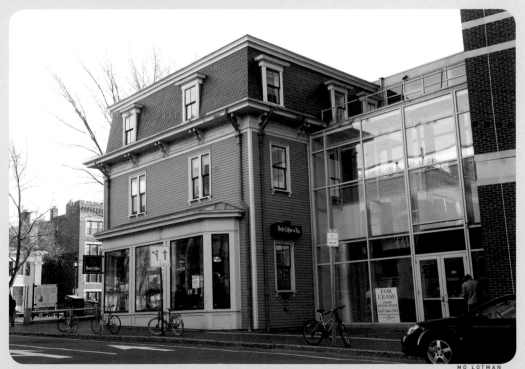

MO LOTMAN

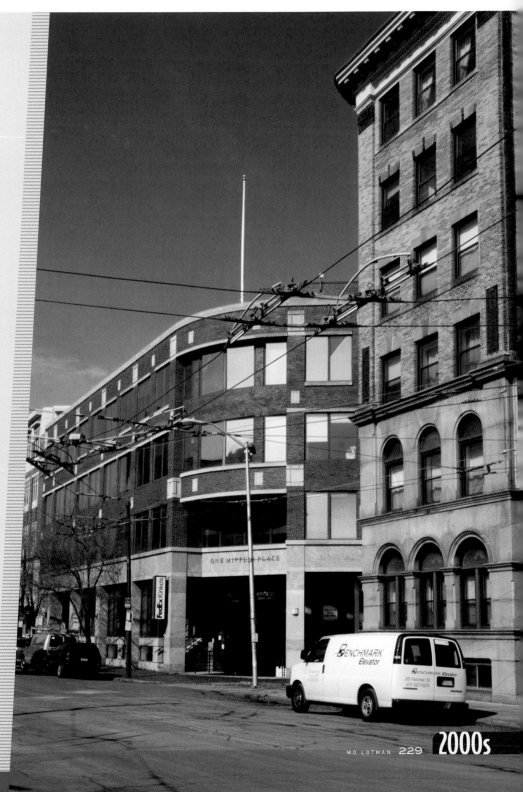

eliot st.

⬆ 2008 Ⓗ *The upstairs room at Charlie's Kitchen is still a scene on weekend nights.* {126}

⬆ 2008 Ⓗ *Helen Metros sits at the bar at Charlie's, where she has been waiting tables since 1953.* {126}

⬇ 2009 Ⓒ *Joseph Rizkallah slices shawarma at Sabra Grill, as he has done since the small eatery opened in 1990.*

⬅ 2008 Ⓖ *Lemlem's Gallery is another recent offering, with jewelry and gifts since 2006. Deeper underground, both literally and figuratively, is Twisted Village. Descend the staircase through the door on the right into a world of noise, psychedelia, experimental jazz, and anything else you've never heard of, often on vinyl.* {*126}

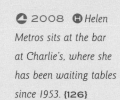

MO LOTMAN

MO LOTMAN

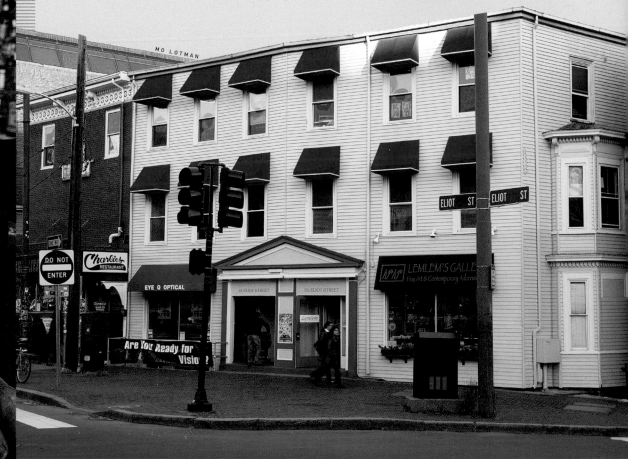

MO LOTMAN

BEYOND

the boundaries of this book, some places, whether or not one considers them to be technically in Harvard Square, have contributed to its culture. Here are few notables that lay behind the admittedly arbitrary lines.

◆ *2008* *Revels is another Harvard Square original that has since been exported all over the country. John Langstaff started the festivities in 1971 as a revivalist celebration of the winter solstice in song, theatre, and dance. Christmas Revels, the flagship program (pictured), still takes place in Sanders Theatre, in Harvard's Memorial Hall every winter. Culling centuries-old traditions from varied cultures and an enormous cast of amateurs and professionals, the performances elicit audience participation and a strong sense of community. Success has allowed the organization to expand into ten cities and all four seasons.*

PETER SOUTHWICK

ROGER IDE, COURTESY OF REVELS, INC.

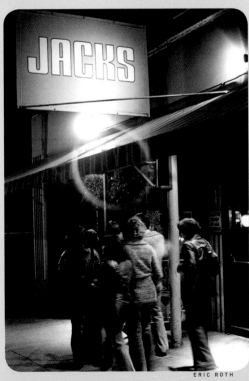

◀ c.1976 *The Orson Welles Cinema, at 1001 Mass. Ave., was inaugurated in 1969 with Welles's own Immortal Story, and became a favorite art house, with midnight showings, local films, and eclectic contemporary and vintage cinema. It succumbed to fire, traced to the popcorn machine, in 1986.*

◀ 2007 *A customer peruses the vast collection of baubles at Oona's, just past Bow St. at 1208 Mass. Ave. Owner Kathleen White (right) named the high-end vintage clothing store after one of her daughters. It has been helping folks scavenge Halloween costumes and one-of-a-kind finds since 1973.*

PAULA LERNER

◀ 1977 *Jack Reilly, late of the Casablanca and later of Ryles, opened his eponymous bar at 952 Mass. Ave. in 1970. The crowded pub hosted the likes of Bonnie Raitt and the J. Geils Band before it was consumed in a nasty 1987 fire. (88, 91)*

◀ 2005 *Memorial Hall remains arguably the most beautiful structure on Harvard's campus, if not in Cambridge as a whole. Sanders Theatre, taking up half of the building, hosts a full calendar of musical events including orchestral, choral, and jazz performances. (27)*

ERIC ROTH

Just off the Square

THE REAL PAPER

During

the heady days of DIY journalism in the late '60s, Cambridge was a fitting place for an alternative weekly to germinate. A number of such tabloids, cynical toward the mainstream press and geared toward a youth market interested in rock, raunch, and roommate ads, popped up all over the country. For a while, Boston actually read two of these papers, and their battles are the stuff of local journalism lore, drawing spilled ink in the national press, and even inspiring a film titled *Between the Lines*.

The Boston Phoenix, still going strong, is the more famous of the two. But the *Phoenix* name itself and some of its edginess is owed to *The Cambridge Phoenix*, a politically minded alternative paper. The Cambridge publication, which sprung up closer to Central Square in 1969, featured hot young local writers and was modeled on *The Village Voice*. In just two years, it went from a radical underground paper with a minuscule readership to a throbbing, investigative tabloid with a circulation of more than 50,000. That success was due to new business-savvy ownership that brought in reporter Harper Barnes from the *St. Louis Post-Dispatch* as editor and began an aggressive play for readers with its arch-nemesis, *Boston After Dark*.

Three years older, *Boston After Dark* was the more commercial weekly and was not about to roll over. The ensuing competition made for great journalism, even jolting Boston's venerable dailies awake. It also brought on a brutal street war over hawkers that required a court order to sort out.

Boston After Dark owner Steven Mindich figured he'd beat his rivals by the time-honored tradition of buying them out. His play for *The Cambridge Phoenix*, however, didn't exactly stay on script. The *Phoenix* writers, thinking the sale a betrayal of all they held dear, went on strike. When the merger went through anyway, a large number of the them left en masse and formed a new collectively owned tabloid, snidely named *The Real Paper*.

For nine years, the two coexisted and thrived, each claiming circulations of approximately 100,000 in the midseventies (about half of which were college giveaways). *The Real Paper*, setting up shop just outside Harvard Square on Mt. Auburn Street, continued to offer excellent reporting and community listings. When the collective model started holding them back, they later sought a buyer. In 1975, Ralph Fine and others bought the paper, and under the new management, the raw polemics diminished and the product got slicker.

Eventually, though, the financial tide turned and *The Real Paper* couldn't hold on. On June 18, 1981, the last edition hit the stands. The subscription list and whatever else remained were ultimately sold, in an ignoble irony, to none other than *The Boston Phoenix*. But *Real Paper* alumni survive and thrive. Jon Landau is a former *Rolling Stone* contributor, music producer, and currently Bruce Springsteen's manager. Joe Klein wrote the hugely successful Clinton analogue *Primary Colors*. And David Ansen is a movie critic and senior editor at *Newsweek*.

Despite

the hippie credentials, *The Real Paper* attracted some pretty starched-shirt investors, including David Rockefeller Jr., and future Massachusetts governor Bill Weld.

bizarro harvard square

◀◁▷ 1970s *Architectural models show two versions of the proposed JFK Library and Museum. The pyramid (left) was later nixed. The huge adjacent parking lot visible in the aerial model (now the site of the Charles Hotel) was one of the many sticking points with community groups.*

"It really

is a very sad story," said renowned architect I. M. Pei, describing the initial, exalted plan for the Kennedy Library and Museum and its crushing, slow-motion demise. How it ended up in Dorchester is a convoluted, decade-long tale filled with recriminations and vitriol that still reverberates today.

On its face, it seems a no brainer. Kennedy was a favorite son who graduated from Harvard and won the presidency. Almost immediately following his assassination, wheels were already turning to bring his library to Cambridge, as he had envisioned.

At first, there was excitement. In 1965, the city offered the Bennett Street Rail Yards, abutting the river, as the site. Converting the 12.2-acre eyesore into a productive and beautiful parcel of land would benefit everyone. In 1969, the property was legally transferred and things were on schedule for a 1972 groundbreaking and an opening in '76.

Unfortunately, it took over four years to relocate the trains, delaying construction. Meanwhile, the Square and the nation had become vastly different places than they were in the midsixties. The riots had shattered the peace, the neighborhood was already congested and full of transients, and the economy was tanking. Judy Boyle, a longtime resident, recalled "a very subtle anti-Kennedyism," which she traced back to the fact that he was not from Cambridge. Unlike today, there were many Republicans, and the luster of Camelot was wearing off in a time when trust in government was at a nadir.

But ultimately, it was the monumental scope of the project and its imagined impact that turned the tide against the library. Pei's initial design, with a 115-foot-tall glass pyramid at the center, struck fear into the hearts of longtime residents, who were told to expect one or two million visitors annually. A special lane just for tourist buses was to be created on the Larz Anderson Bridge. A gigantic 400-space parking lot would have taken up nearly half the parcel. "We panicked," said Pebble Gifford, a community activist.

Worried about a potential raft of tacky tourist shops and unremitting congestion, a citizens' group called The Neighborhood Ten Association fought the library. The battle split Cambridge into bitter factions, with some merchants eager for the influx of tourists, while some city councilors and residents lined up against what they saw as slick interlopers.

Community opposition mounted. Ada Louise Huxtable summarized the situation in a 1974 *New York Times* article, "Cambridge is changing, and the Kennedy Library will only make it change faster, impelled by an influx of Middle America, like the Goths overwhelming the intelligentsia."

The Kennedy Corporation attempted to mollify with redesigns and downscaling. The pyramid shrunk to 85 feet, then disappeared. The square footage and visitor estimates were winnowed. But the parties could not reach accommodation, and the delays were rapidly increasing costs.

By 1975, when the library's planners wouldn't release an environmental impact statement, Neighborhood Ten sued for its release. At that point, staring down another multi-year delay, the Library folks could read the writing on the wall. They rolled up their blueprints and left.

It's hard to know what the Square would be like today with the Kennedy Library, but one legacy of the fallout was the empowerment of community groups. Gifford would form the Harvard Square Defense Fund, which became an extragovernmental hurdle that developers had to clear if they wanted to get anything done in the Square. The HSDF itself has been polarizing, with some crediting them for barring fast-food chains and protecting the Square's scale, while others consider them snobs whose meddling has unwittingly hurt commerce. In either case, the days of rubber-stamped development deals were over.

Boston Globe architecture critic Robert Campbell reflected later, "I was fascinated by the power of citizen activism. The only people in favor of the Kennedy Library were Harvard University, the federal government, and the Kennedy family. That was all. And they got beat." {154, 158}

THE UN-SQUARE

The changes that have enveloped this historic locus since 1950 are striking enough. But things could have been even more radical if some proposed developments had gone through. Whether they would have sparked renaissances or signaled the end of the world as we know it depends upon your persuasion. But it's fun to think about.

In addition to the JFK Library (opposite), alternate Harvard Squares may have included:

Mini-Minneapolis · In 1969, The Architects Collaborative proposed a split-level skyway throughout the commercial district that would have included a stairway rising up near the legendary newsstand and second-story shopping (below).

Swimming in the Sky · A 23-story motel at the corner of Mt. Auburn and Winthrop, which would have been the tallest building in Cambridge, was two months away from construction in 1964. It was to have six floors of parking and a terraced pool.

CAMBRIDGE REDEVELOPMENT AUTHORITY

Cutting Corners · The curved Read Block, one of the Square's most recognizable features and longtime home to The Tasty and the Wursthaus, was renovated in the '90s amid outrage. However, at least the wooden façade was saved. The original plan would have replaced everything with a four-story modern shopping arcade with 60,000 square feet of retail space. (191)

Please Release Me · Some places in Harvard Square you'd actually like to see razed. The motel on stilts is one of them. This architectural abyss was to be demolished and replaced with a mixed-use high-rise with a 1988 groundbreaking. The Harvard Square Defense Fund stalled the project for three years until it died in the midst of the early '90s real estate bust. (86)

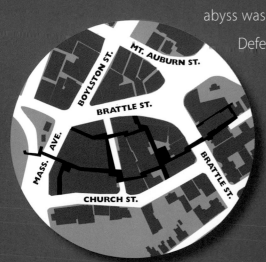

The Nuclear Option · In 1968, The Cambridge Redevelopment Authority fantasized about a radical re-creation of the entire Square that would have sent all vehicular traffic underground and wiped out 11 city blocks (above right). The plans included four 16- to 20-story office buildings at Brattle Square, subterranean arcades, a half-million square feet of retail, and—perhaps its only selling point—over 2,000 parking spaces. Unsurprisingly, this apocolyptic vision, which saved only the subway kiosk, was D.O.A.

index

Images credits can be found adjacent to images with the exception of visual indices, map illustrations, and objects. Credits for visual index photography can be found adjacent to the appearance of full-size photos within the chapter in question. All other credit information, including that which could not appear adjacent to images due to space considerations, appears below.

Institutional Archives: Images with the credit line "Cambridge Historical Commission" on the following pages are courtesy of the Cambridge Historical Commission: **12–13** Cambridge Engineering Department Collection; **21** Cambridge Savings Bank Collection; **22** ©Tichnor Bros. photo, CHC Postcard Collection; **25** (Harvard Trust x 2) Harvard Trust Company Collection; Cambridge Planning Board Collection; **29** Boston Elevated Railway Collection; **31** Robert E. Smith Collection; **34** (Dreyfus & Young Lee) Robert E. Smith Collection; (menu) C. M. Sullivan Collection; **35** (x 2) Robert E. Smith Collection; **37** Boston Elevated Railway Collection; **38** Cambridge Planning Board collection; **39** Cambridge Planning Board collection; **40** (Crimson) Robert E. Smith Collection; (Mobilgas) Boston Elevated Railway Collection; **41** (x 2) Boston Elevated Railway Collection; **43** (x 2) CHC Postcard Collection; (Howard Johnson's) A Colourpicture Publication photo **45** Robert E. Smith Collection; **51** (Briggs) Richard Cheek photo; staff photo; **55** staff photo; **59** staff photo; **64** staff photo; **67** *Guide to Cambridge Architecture: Ten Walking Tours* (1969) by R. B. Rettig; **71** Lois M. Bowen photo, gift of Richard A. Dow; **73** (x 2) staff photos; **77** (Inn) Roger Gilman Collection; staff photo; **82** R. B. Rettig photo; **83** (x 3) staff photos; **84** Richard Cheek photo; **86** (Treadway) ©Tichnor Bros. photo, CHC Postcard Collection; staff photo; **92** Gift of Paul Wong; **96** staff photo; **97** (x 4) staff photos; **104** Christopher S. Johnson photo, gift of Cambridge 350; **109** staff photo; **110** staff photo; **114** staff photo; **116** staff photo; **117** (x 4) staff photos; **119** staff photo; **120** (x 2) staff photos; **121** (x 2) staff photos; **122** (x 3) staff photos; **124** staff photo; **125** (x 2) staff photos; **126** (x 3) staff photos; **127** (x 2) Frank Cheney Collection; **137** (left) Frank Cheney Collection; (right) Cambridge Savings Bank Collection; **139** (plaza) Frank Cheney Collection; (newsstand) staff photo; **140** Courtesy of Roberts Associates; **143** staff photo; **149** Courtesy of BTA+; **150** source unknown; **153** (Grendel's) C. M. Sullivan photo; staff photo; **154** Cambridge Community Development Department; **157** Cambridge Community Development Department; **160** staff photo; **161** staff photo; **168** source unknown; **174** Turner Construction photo; **182** staff photo; **184** source unknown; **186** staff photo; **193** staff photo.

Images with the credit line "Harvard Archives" on the following pages are courtesy of the Harvard University Archives: **9** Call # HUV 80 (7-4); **10** Call # UAV 605.295.23; **14** Call # HUV 80 (10-10); **15** (Tutin) Call # UAV 605.295.10 p/N; (Bolter) Call # HUK 137A 3/8/52, p. 465; **16** (Phillips) Call # UAV 605.295.10 p/N; (monkey) Call # HUK 137A, 11/24/56, cover; **17** Call # HUV 80 (10-8); **19** Call # HUK 137A, 9/28/57, p. 25; **21** Call # HUV 80 (7-7); **24** (Trust) Call # HUV 80 (7-2); (Coop) Call # UAV 605.295.10 p/N; **27** (upper inset) Call # HUV 166 (3-8a); (lower inset) Call # HUV 166 (5-10); (fire) Call # HUV 166 (13-11); **36** Call # HUD 3137.3000.6p; **38** Call # HUK 137A 3/8/52, p. 464; **39** Call # HUV 80 (7-14); **42** (bike) Call # HUP-SF Student Life 191; (Mandrake x 2) Call # UAV 605.295.10 p/N; **44** Call # UAV 605.295.10 p/N; **45** Call # UAV 605.295.10 p/N (bicycles x 2); **52** Call # HUP-SF Student Life 364; **54** Call # UAV 605, Box 79, HC 1331; **55** Call # HUP-SF Student Life 372; **58** Call # UAV 605.295.1 p tr, Box 3; **59** (top left) Call # UAV 605.295.1 p tr, Box 3; (top right) Call # HUV 95 (2-5); (bottom left) Call # UAV 605, Box 79, HC 1332; (bottom 2nd from left) Call # UAV 605, Box 70, HC 1604; **66** Call # HUD 3137.3000.6p; **78** Call # UAV 605, Box 77, HC 1043; **79** Call # HUV 80 (7-5); **90** Call # HUV 15 (24-11); **92** (x 2) Call # UAV 605.295.6p, Box 1; **95** Call # UAV 605.295.6p, Box 1; **103** Call # HUK 137A, 1/72, cover; **123** Call # UAV 605.295.7 p, Box 8; **135** Call # UAV 605.295.6p, Box 2, Harvard Square; **136** Call # UAV 605.295.6p, Box 2, Harvard Square; **137** Call # UAV 605.295.3p/N, 6/3/83; **139** Call # UAV 605.295.3 p/N, 11/22/85; **152** Call # UAV 605.295.8p, 12/8/89; **158** (left) Call # UAV 605.295.8p, 5/29/87; (right) Call # UAV 605.295.8p, 7/2/89; **170** call #UAV 605.295.16p, 2/11/92.

Images with the credit line "Radcliffe Archives" on the following pages are courtesy of the Radcliffe College Archives, The Schlesinger Library, Radcliffe Institute, Harvard University: **16, 18, 20, 21, 24, 26, 37, 43, 57, 59, 73, 78, 84, 240**.

Images on pages **32–33** (except dirndl) are courtesy of The Schlesinger Library, Radcliffe Institute, Harvard University.

Images with the credit line "Harvard Theatre Collection" on page **37** are from the Poets' Theatre Records, Harvard Theatre Collection, Houghton Library.

Images with the credit line "Boston Public Library" on the following pages are courtesy of the Boston Public Library, Print Department: **22, 127**.

Images with the credit line "Boston Public Library" on the following pages are courtesy of the Boston Public Library, Print Department, and the Boston Herald-Traveler Photo Morgue: **15, 19, 45, 60, 87, 89, 99**.

Images with the credit line "Globe Newspaper Company" on the following pages are courtesy of *The Boston Globe*: **98–9** (background) photo by Tom Landers; **98, 99** (inset) courtesy of Cambridge Historical Commission, photo by Paul Hirshon; **146** photo by John Blanding; **175** photo by Pat Greenhouse; **212, 216** photos by Suzanne Kreiter; **224** photo by David Ryan.

Image with the credit line "New England Folk Music Archives" on page **81** is from the Byron Linardos Collection.

Other sources: Images with the credit line "Stephen H. Fenerjian" on the following pages are by Stephen H. Fenerjian: **40, 80, 81**.

Images on page **132** (Niles Co.) and **191** courtesy of Symmes Maini & McKee Associates, Inc., Architects and Engineers.

Image on page **182** (Harvest) is ©2009, Howard Dinin. All rights reserved.

Aerial Photography, including those used in map illustrations: **1950s** ©Bradford Washburn, courtesy Panopticon Gallery, Boston, MA; **1960s** Aerial Photos of New England, courtesy of the Cambridge Historical Commission; **1970s** Edward R. Pearson, Harvard University Archives, Call # HUV 15 (24-10) & (24-11); **1980s** ©Alex S. MacLean/Landslides Aerial Photography, see also 1970s & 1990s; **1990s** Air Photographics, Inc., courtesy of the Cambridge Historical Commission, see also 2000s; **2000s** Chris Brown, www.fotobrown.com; Keystone Aerial Surveys, Inc., courtesy of the Cambridge Historical Commission, see also 1990s.

Map illustrations by Mo Lotman and Liam Flanagan.

Object images by/courtesy of: Mo Lotman, **19, 21** (pennies), **60** (papers), **67** [photo illustration], **71, 80, 97, 100, 121, 125, 166** (x 2), **169** (x 2), **185** (x 2), **186, 189** (stool), **192, 202**; iStockphoto.com, **26**, blaneyphoto, **28**, Ekely [Alf Ertsland] (plums), cookelma [Andrey Armyagov] (pickles), **30**, (reels) Victor Burnside, **118**, YuriSH [Yury Shirokov], **122**, pvachier [Paul Vachier], **132**, hidesy [Amanda Rohde], **150**, perkmeup [Thomas Perkins], **177**, Michael Jay, **189**, (muffin) lucato [Luis Carlos Torres], **195**, alohaspirit, **224**, Cimmerian [Oleg Prikhodko]; Courtney Bent, **84, 108, 189** (mug); The Radcliffe College Archives, The Schlesinger Library, Radcliffe Institute, Harvard University, **20** (traffic tower); David Parsons, **21** (token); Poets' Theatre Records, Harvard Theatre Collection, Houghton Library, **37** (x 2); Retinafunk@gmail.com, **52**; New England Folk Music Archives, **81**; Christine Fernsebner Eslao, **225**; Theresa Holley, **227**.

Objects courtesy of: Cambridge Antique Market, **19, 71, 80, 189** (stool); Steve Nelson, **84, 108, 189** (mug); The Andover Shop, **97**; Kari Kuelzer, **121**; Woody Chapman, **125**.

Ads on page **30** courtesy of The Brattle Theatre.

Poem excerpt from "Bickford's Buddha" on page **55** is by Lawrence Ferlinghetti, from *The Secret Meaning of Things*, Copyright ©1968 by Lawrence Ferlinghetti. Reprinted by permission of New Directions Publishing Corp.

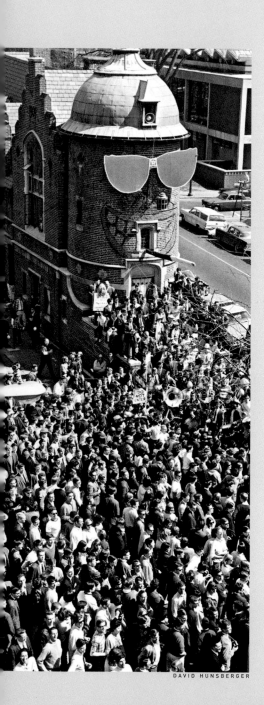

DAVID HUNSBERGER

MO LOTMAN

This book is dedicated to the memory of Josefina Yanguas and Genevieve MacMillan, whose quirky personalities, exotic life stories, and strength of character charmed this author in the very brief time I had the pleasure of their acquaintance. They exemplified the best of Harvard Square and will be missed.

I WOULD LIKE TO THANK

my friends and family for their steadfast encouragement and excitement about this project, and my agent, Albert LaFarge, who helped shepherd me through an unfamiliar process while always maintaining a sense of fun and optimism.

This book would not have been possible without the support of everyone at Stewart, Tabori & Chang, including my editor, Kristen Latta, Leslie Stoker, Galen Smith, and Liam Flanagan.

This project is so much richer for the wonderful chapter introductions by Tom Rush, Bill Weld, Bill McKibben, Amanda Palmer, and Paul Baranay; I am particularly grateful for and humbled by the contribution of John Updike, who was immediately receptive to a letter from a stranger.

SPECIAL THANKS · Certain people took a personal interest in this project and went out of their way to be helpful, above and beyond expectations. Supreme gratitude goes to Kit Rawlins at the Cambridge Historical Commission, who has been on this journey the whole way. I would also like to give special recognition to photographers Eric Antoniou, Steve Nelson, and Courtney Bent; Clif Garboden at *The Boston Phoenix*; and Kari Kuelzer at Grendel's.

RESEARCH · I would like to give thanks to the various archives that assisted me in my research: Sarah Burks and Charlie Sullivan at the Cambridge Historical Commission; Michelle Gachette, Kyle DeCicco-Carey, Barbara Meloni, Tim Driscoll, and Robin McElheny at the Harvard University Archives; Aaron Schmidt at the Boston Public Library; Jennifer Carling at *Harvard Magazine*; Sandra Clarey and Jeremy Mendelson at the

MBTA; Betsy Siggins and Millie Rahn at Club Passim; Diana Carey at Schlesinger Library/the Radcliffe Archives; Kristen Goodfriend and Katherine McGovern at *The Boston Phoenix*; Libbie Pilsch at *The Boston Globe*; Joe Wrinn at the Harvard News Office; Pamela Madsen at the Harvard University Theatre Collection; the Loeb Library; and Harvard Student Agencies. I would also like to acknowledge *The Harvard Crimson*'s online archives, which were invaluable in compiling information.

PHOTOGRAPHY · I am very grateful to all of the nearly 200 photographers who contributed to this work, many of whom did so generously. Extreme thanks go to David Hunsberger, who beautifully, and nearly single-handedly, documented Harvard Square in the 1960s. I would also like to especially acknowledge Hugh Blackmer, Flint Born, Robert Castagna, Rob Chalfen, the estate of Nick DeWolf, Howard Dinin, Tom Dolan, Elsa Dorfman, Ben Dunham, Christine Fernsebner Eslao, Alan Gass, David Heely, Bruce Hilliard, Rodger Kingston, Jim Lambert, Paula Lerner, David Liu, Cheryl Miller, Doug Mindell, Allen Moore, Bob O'Neil, Raine Newman, Bob Pringle, Daniel Reiff, Stephen Scalzo, Steve Sherman, Peter Southwick, Jeff Thiebauth, and Chris Yeager. Appreciation also goes to Boston Photo Imaging, Colortek, and the late Zona for scanning.

INTERVIEWS · Thanks to all the wonderful people who shared their stories with me, including: Sari Abul-Jubein, Eric Albert, Sally Alcorn, Frances Antupit, Trent Arterberry, George Avis, Joe Bartley, Jeff Benskin, Raffi Bezjian, Richie Bezjian, Nathalie Biddle, Blue, J. P. Botindari, Lyz Boudreaux, Judy Boyle, Jim Brine, Brother Blue, Al & Phyllis Brown, Robert Brustein, Janet Cahaly, Joe Calautti, Frances Cardullo, Woody Chapman, John Chaprales, Joyce Chopra, Louise Ciampi, Sheldon Cohen, John Byrne Cooke, Paul Corcoran, Gregory Daugherty, Charlie Davidson, Rupert Davis, Katerina Dervisevic, John DiGiovanni, Emile Durzi, Tony Ferranti, Harry

Fotopolis, Mac Freeman, Carl Fuller, Pebble Gifford, Richard Glugeth, Gary Greenbaum, Kitty Haas, Dimitri Hadzi, Bob Hare, Cy Harvey, Steve Herrell, Ilse Heyman, Joan Hill, Herb Hillman, Ned Hinkle, Fred Humphreys, Chris Kotelly, Frank Kramer, Herbie Kuelzer, Bob Landers, Robin Lapidus, Andy Lee, Paul Lee, Ann Lerner, Butch Lifred, Byron Linardos, Paul Macdonald, Gerry Mack, Phyllis Madanian, Ed Mank, Helen Metros, Ivy Moylan, Jerry Murphy, Rich Olken, George Papalimberis, Leo Piantes, Alan Powell, Robert Reich, Dick Sens, Betsy Siggins, Jude Silver, Justin Slate, April Smith, Jim Smith, Mark Smith, Marshall Smith, Sam Smith, Peter Solmssen, Peter Swanson, Murray Turnbull, Ed VerPlanck, Ned VerPlanck, Mike Volpe, Carol Weinhaus, Christina Williamson, David Zarowin, Catie Zedros, and Steven Zedros.

LOCATIONS · Much appreciation goes to the Writers' Room and the Boston Athenæum for providing a space to work surrounded by like-minded individuals, and also to the staffs of the coffee shops that became my many branch offices.

ET CETERA · Finally, thanks to those who have assisted in other ways: Bob Adams, Max Bernheimer, Cambridge Antique Market, Marianne Cutter, Dave Fortin, Jim of The Jim Show, Susie Leiper, Steve Lundeen, Doug Mayer, Danielle McCarthy, Gisela Mohring, Mary Lou Shields, Jean Valence, Howard Zaharoff, and Kitsch in Sync, which, with weekly zaniness, helped me (barely) maintain my sanity.

If you have photographs or information you believe should be included in any future edition of this book, please contact the author at www.harvardsquarebook.com.

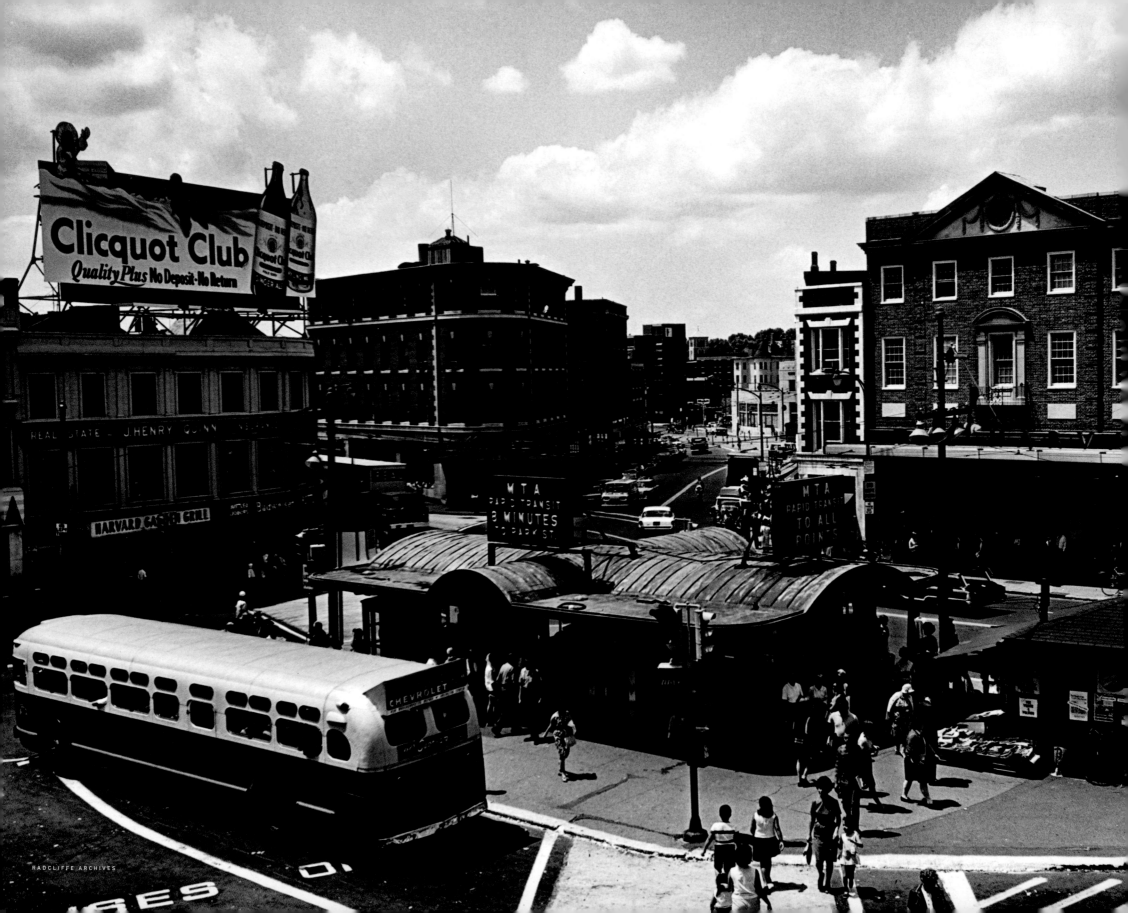

Clicquot Club
Quality Plus No Deposit—No Return

HARVARD CASH GRILL

M T A
RAPID TRANSIT
8 MINUTES
TO PARK ST.

M T A
RAPID TRANSIT
TO ALL
POINTS

CHEVROLET